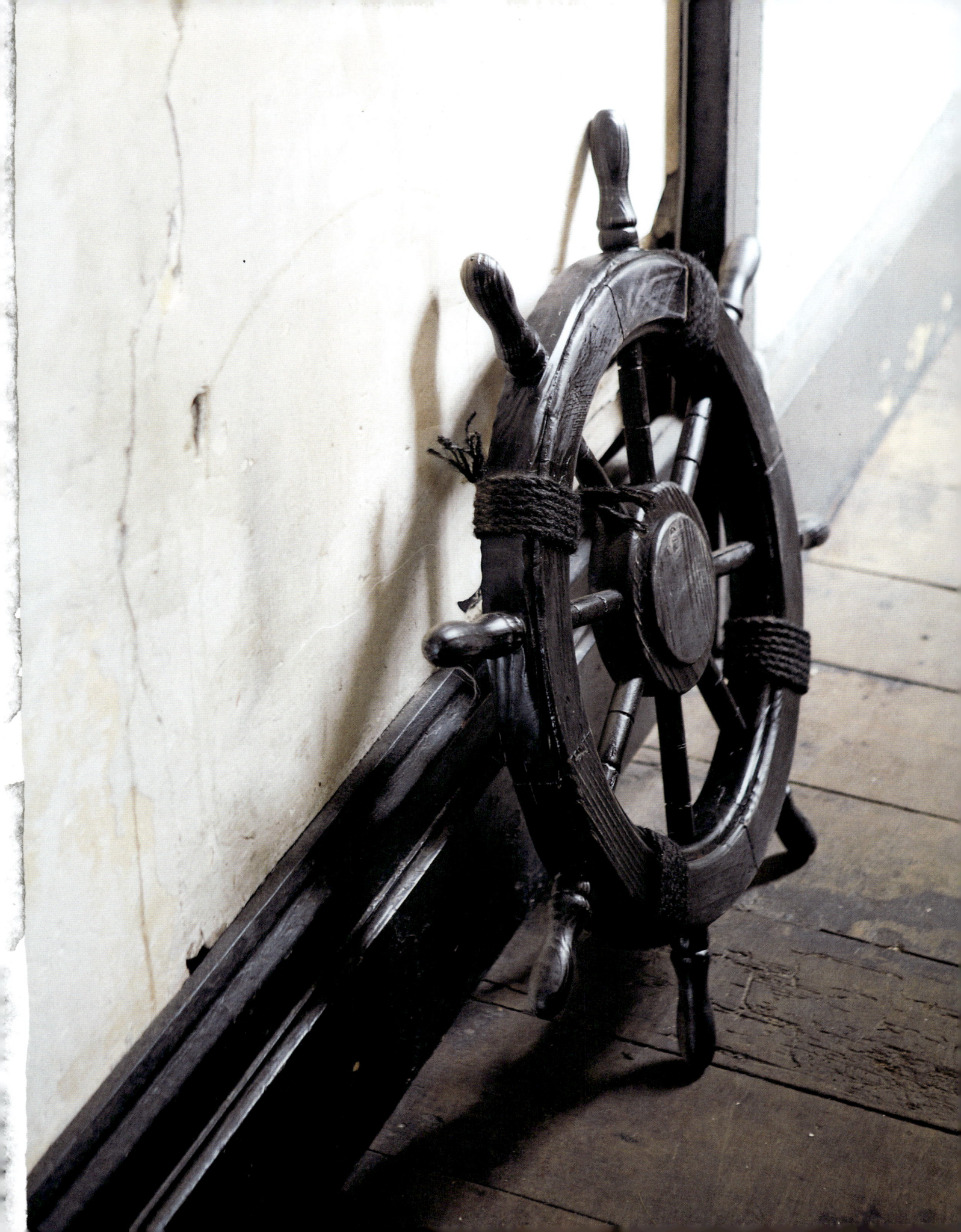

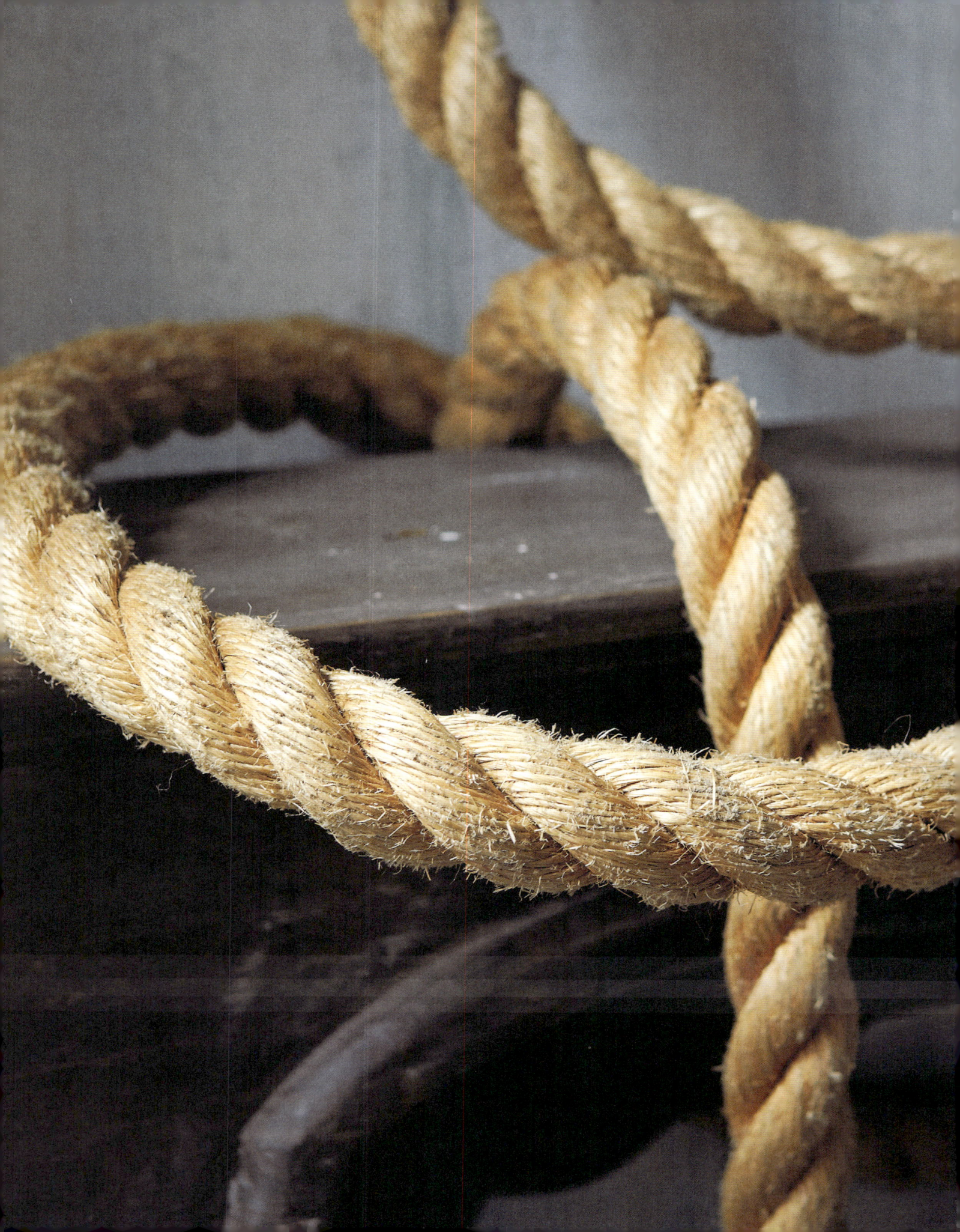

TIM NEVE
Photography by Johan Palsson

INTERIORS INSPIRED BY THE COAST

SAND CASTLES

An Imprint of HarperCollins Publishers

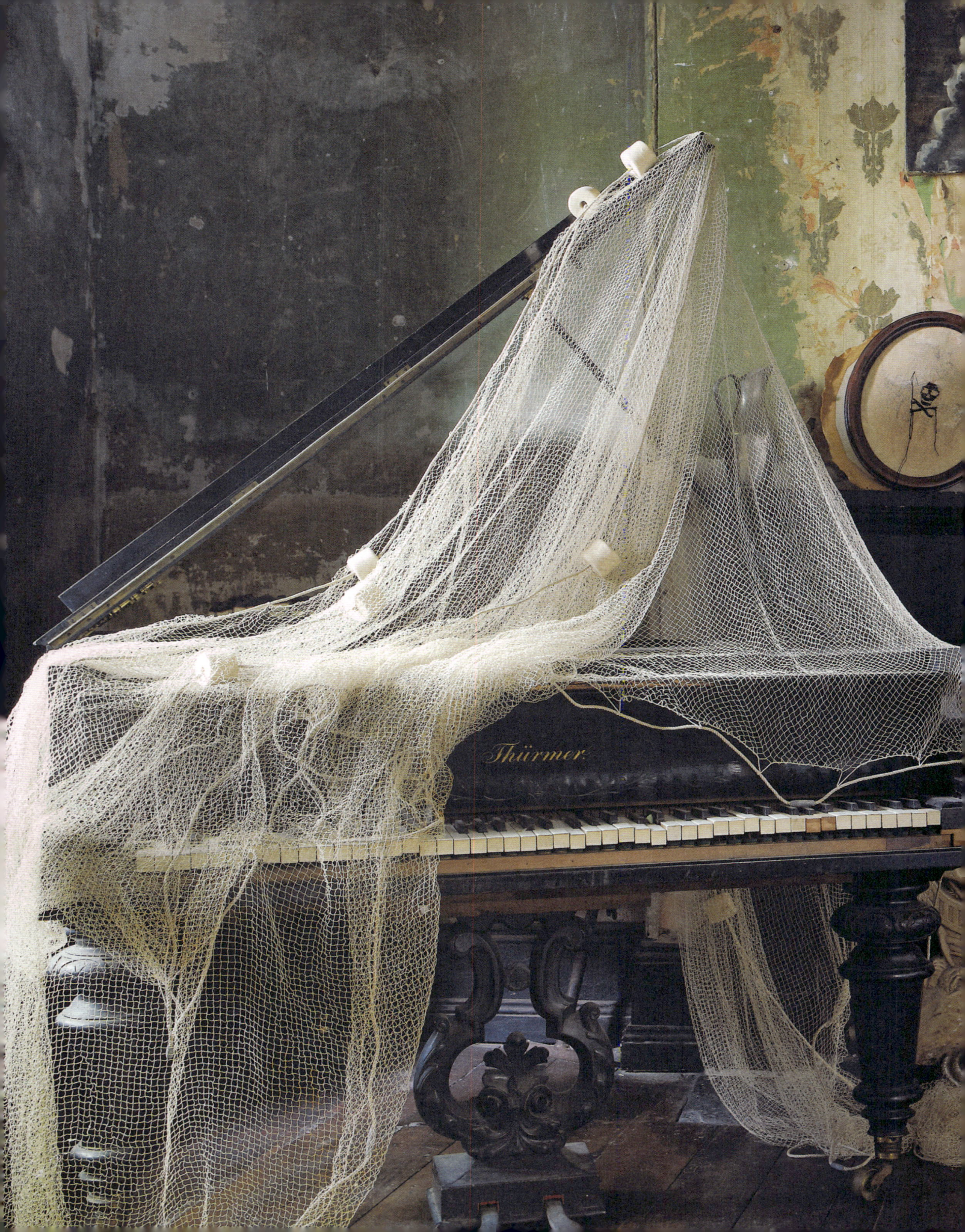

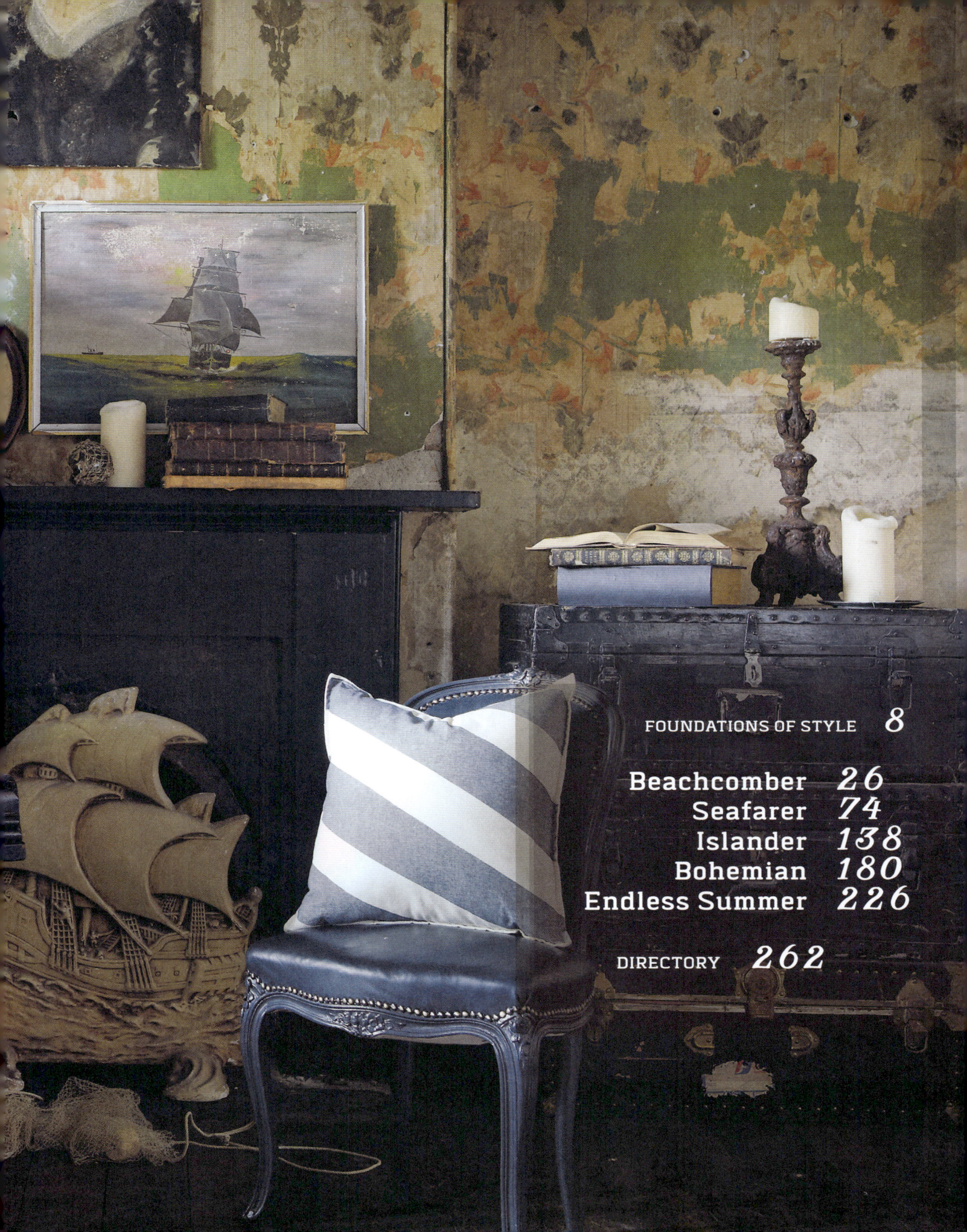

FOUNDATIONS OF STYLE 8

Beachcomber 26
Seafarer 74
Islander 138
Bohemian 180
Endless Summer 226

DIRECTORY 262

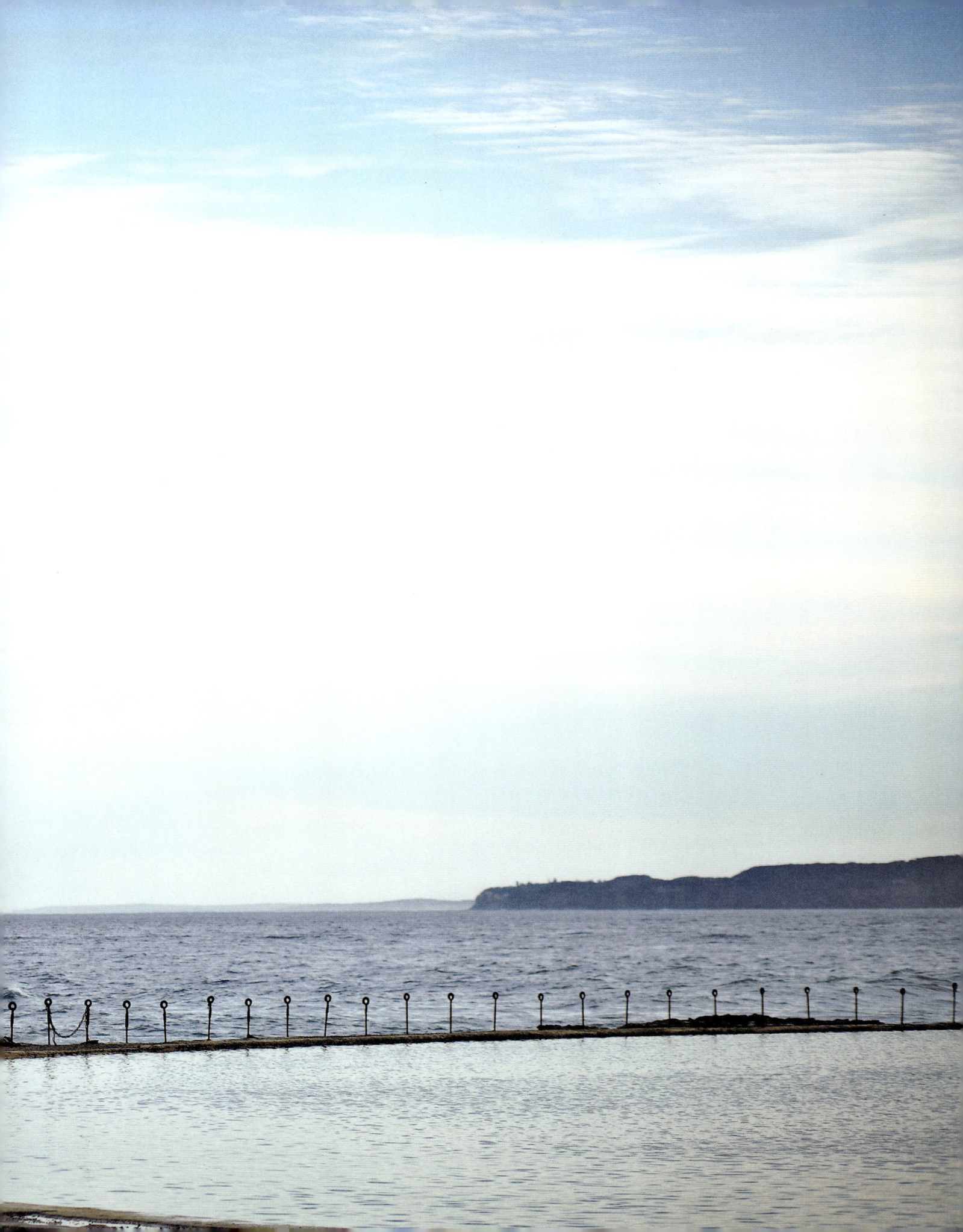

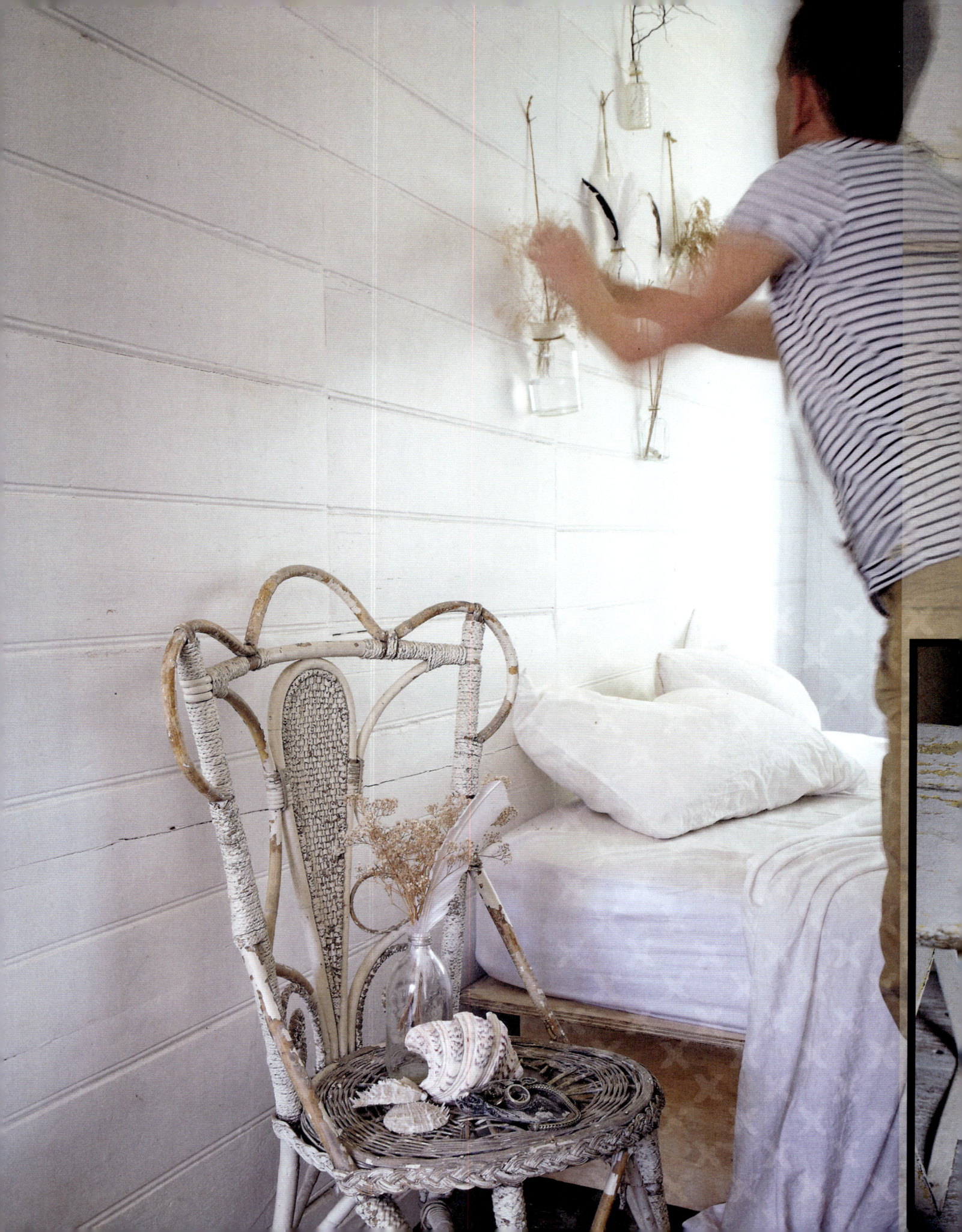

Foundations of style

THE WORDS SAND CASTLES CONJURE UP MEMORIES OF CHILDHOOD HOLIDAYS, DON'T YOU THINK?

Building sand castles is a wonderful activity: no two castles are ever the same; each pile of sand is crafted uniquely and takes on an esthetic that, perhaps, reflects the sculptor's personality. The most exciting part is the final decoration, a little like icing a cake but, in this case, the finishing touch might be a special shell or drape of seaweed to mark the design as one's own.

Such a metaphor seemed fitting on my journey to make this book, visiting homeowners who had created their own "sand castles." Each home was close to, or inspired by, the shore, and paid homage to the sea. What quickly emerged was how different they could be, from a revamped 1940s caravan on the water's edge in Frankston, Victoria, to a tepee structure in the laidback town of Bangalow, New South Wales. All lovingly created and cared for by their owners as their unique take on coastal style.

So, the question might be: if you were given time to sit in the sand and play, what kind of castle would you build to call home?

I had been working as a magazine stylist for a couple of years when my own coastal home was featured in *Real Living* interiors magazine. The article was such a success that I pitched the idea to my publishers to feature a series of similar homes. Photographer Johan and I traveled up and down the glorious eastern Australian coastline, capturing the style on film. That series instigated a whirlwind of positive reader feedback and, now that we had built up a portfolio, I suggested to the publishers that we launch a national title. *Australian Coastal Home* magazine was born.

It was wonderful to be the founder of something fresh and new. Personal passion had translated into a magazine that became an instant success with readers and I spent the next two years editing seven seasonal issues of *Australian Coastal Home* before embarking on my next publishing venture.

Foundations of style

WHEN YOU HEAR THE PHRASE COASTAL DECORATING, I DON'T BLAME YOU IF YOU SHUDDER. FOR TOO LONG FAUX STARFISH AND MASS-PRODUCED GONE FISHIN' SIGNS HAVE REIGNED SUPREME AND MUDDIED THE WATERS OF WHAT SHOULD BE THE CLEAREST, MOST AUTHENTIC, INSPIRATION IN HOME STYLING.

This book aims to return the style to its purest form, and to develop a once-clichéd decorating mode into further sister-styles. There's a true difference between tropical and nautical, bohemian and beach, as you'll see in the following chapters, each of which reveals a different take on the core inspiration.

Each chapter acts as a stand-alone interpretation of modern coastal style. You might find you are drawn toward one particular esthetic, or perhaps two or three. Notice how each uses a different palette; sometimes the variations are subtle but all are inspired by ocean lifestyles.

Those different esthetics were apparent to me while I was working on this book. By moving from one beachside locale to another I uncovered a distinct sense of modern coastal style. We took inspiration from the balmy tropics of northern Queensland, down to the serene fishing villages of Tasmania, and everything we discovered between. We traveled the east coast, the playground of my early family holidays—I love revisiting those places with adult eyes. Like so many people, I have enduring memories of those family holidays, packed into a car with siblings, on the long road trip to the endless summer beach vacation. Just the mention of those place names conjures up their own unique personalities: Byron Bay brings to mind a bohemian spirit, as opposed to the formal residences of Sydney's northern beaches, or the colorful European-style beach shacks of Melbourne. These instant place memories occur in all parts of the world . . . Consider a pebbly English beach, perhaps with a wave-lashed pier and a traditional seafaring culture, then contrast that with the classic esthetic that comes to mind at the mention of the Hamptons in the USA, or the paint colors of the vibrant Italian coast.

It's not all about feeling the salt on your skin, either. A large part of my work as editor of *Australian Coastal Home* magazine was reminding readers that you didn't need coastal views to embrace the carefree esthetic the seaside inspires. The magazine illustrated the point with real home tours in far-flung locations. This is a theme I have hoped to continue with this book. It might be hard to believe, but our first photo shoot location was a converted dairy farm four hours from the coast. There's a good chance that in such a remote country town some of the younger inhabitants might not even have seen the ocean. However, as a self-confessed sea-lover it was as far inland as I have ever traveled. It was a real eye-opener to discover that the same tranquillity I love about the coast can also be found on an isolated country property. I'm fairly confident you won't be able to label this inland house from the photographs, which is proof that effortless coastal style can be achieved anywhere, no matter which plot or pavement you might call home.

Another aim is to show that the coastal esthetic can be embraced all year round. With our enviable climate, we've become experts at blending seamless indoor and outdoor living: it suits our weather forecast, no matter which month. For those in cooler climates, take heart that within any four walls you can easily evoke a warmer season and be transported there. Dazzle and confuse the senses with carefully selected furnishings and a sunnier paint tone than is on offer outside.

The whole idea of an interior design book like this is to make you think about your personal tastes and approach to creating your home and its spaces. What I didn't count on is that writing the book would make me question my own interior esthetic and design choices. By testing out different looks in our "temporary style laboratories" on location, I discovered many new things. I encourage you to do the same.

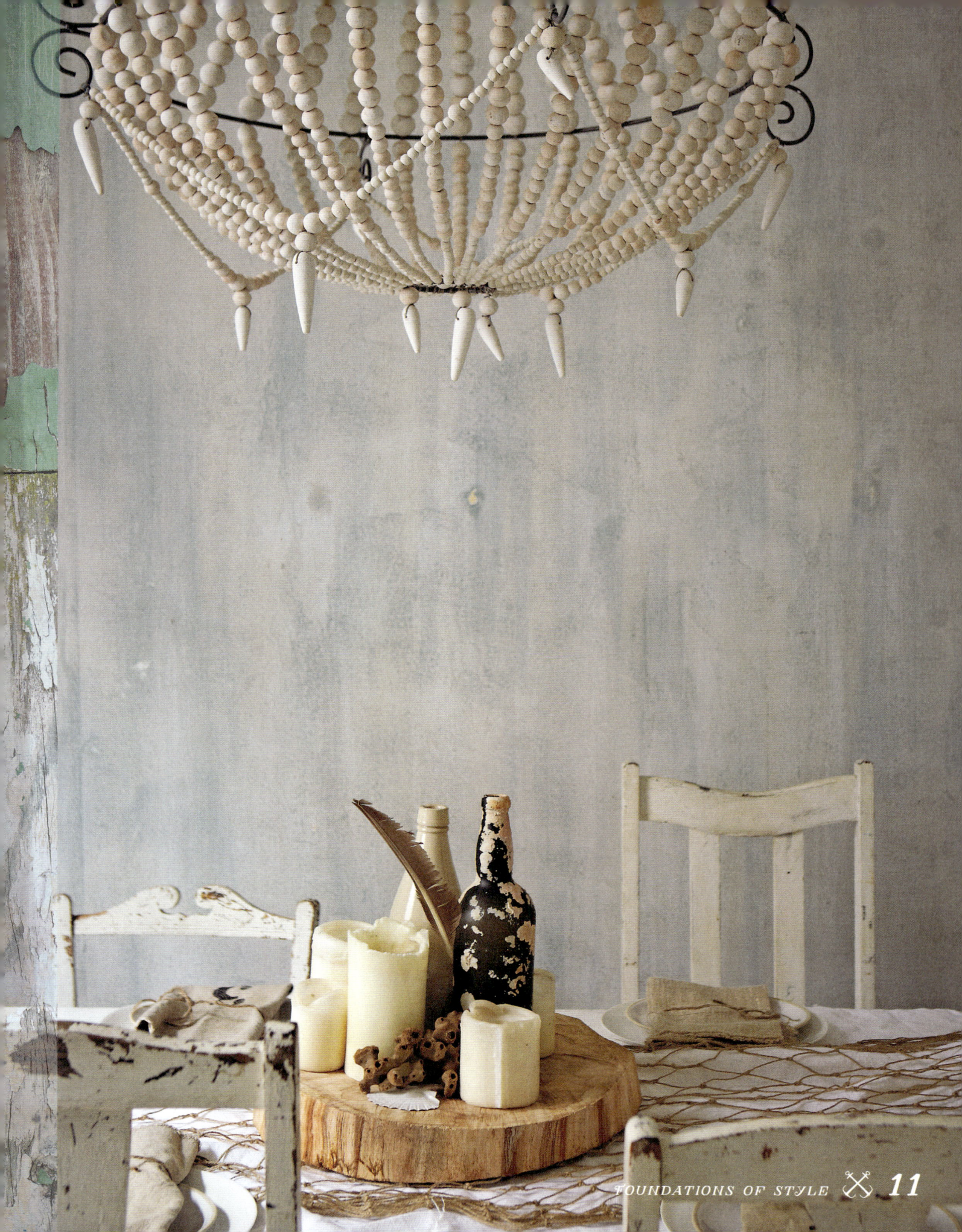

FOUNDATIONS OF STYLE 11

Foundations of style

My Coastal Ancestry

You could say interiors are in my blood. My not-too-distant ancestors were early furniture retailers in my hometown of Newcastle, New South Wales. My great great grandfather, Walter Neve, owned a series of shops with grand-sounding names, such as "The Neve Great Northern Furniture Bazaar" and "Reliable Home Furnishers." I like to imagine he was a Mr Selfridge of sorts, imparting interior style to the masses. Sepia photos from the early twentieth century (not only from our family archives but also historical cityscapes in local newspapers) are evidence of shops, workshops, and warehouses in numerous locations, all with the Neve name proudly displayed. An advertisement shows the range of ornate pieces he offered, from sea-grass lounge suites to satin cushions.

Walt had an interest in the coast, as testified by his business card: "Cabins refitted and ships' furnishing generally promptly attended to." A further link to the sea is far sadder: Walter was found drowned on Newcastle Beach in 1907. The *Sydney Morning Herald* of December 30 announced:

> One of the oldest and most respected citizens of Newcastle was carried out and drowned before help could reach him. As had been his daily custom for many years, he went onto the beach for his daily dip. The late Mr Neve, 66, was one of the oldest of Newcastle's citizens, having resided here for 41 years. He was universally respected as one of the most honourable and upright of men.

Archives show the Neve family business was sold to a bigger, national company in 1937. How I wish it had been kept in the family; I would have proudly taken the reins when my time came.

It is interesting to remember that coastal property was once very unfashionable. In the early twentieth century, cheap residences were often constructed on the shoreline, where the sandy soil was not desirable. Generations later, beach culture, ocean views, and better transport have changed this perspective.

In Civic Park, Newcastle's main public park, there is an anchor. When I was a child, my dad would take me there and tell how his father had worked with the Naval Association and helped place that anchor as a permanent landmark. That grandfather even had his ashes scattered in the sea off Newcastle. My family's anchor has always been dropped in my hometown—with such strong ties I guess that's why I'll always call Newcastle my home, and why I have such an enduring connection to the sea.

12 SAND CASTLES

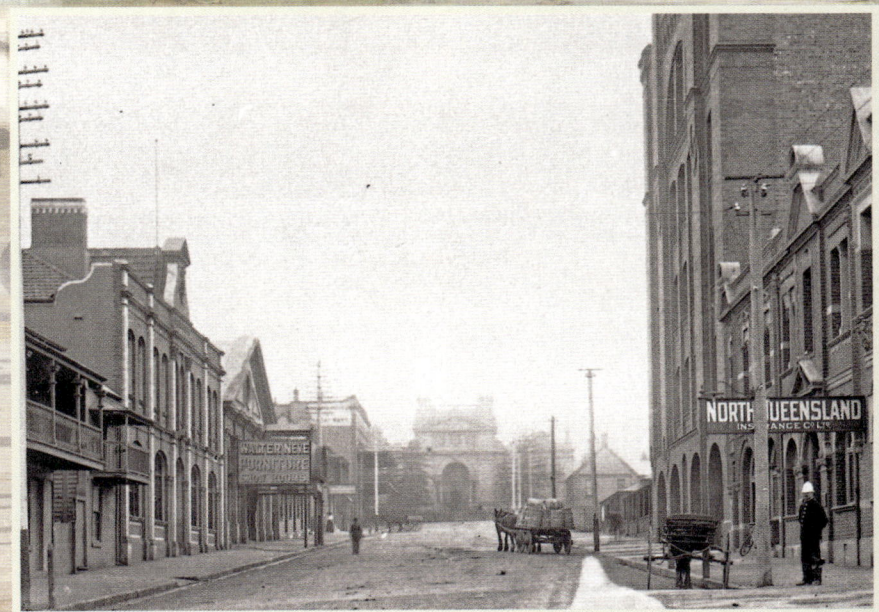

Walter Neve's Great Northern Furniture Bazaar, around 1912.

Easy Chair, adjustable back. Upholstered in tapestry 45/-

Mobile Trays, with folding tops. 47/6

Student's Table, with drawer and book-shelves 42/6

FOUNDATIONS OF STYLE 13

Foundations of style

TAKING AN INSPIRED APPROACH

More often than not, I go with gut instinct, something that just "feels right," when I am styling an interior. I'm drawn to the unexpected solution too, but I guess that's part of the job description—always looking for the most unique option.

However, in an effort to explain my approach here I've had to analyze my process more closely, and have come to realize that my styling solutions are usually more temporary than permanent. I tend to encourage redecoration rather than renovation. It's a mantra I followed for over a decade as a property renter who had to work within someone else's boundaries. More recently, with the purchase of my first house, I've taken the same approach. I haven't rushed in and knocked down walls; instead, I opted for a quick coat of paint and an influx of decorative items to build a fresh look around my staple furniture pieces (that I always buy in neutral tones).

I'm also spontaneous; I like the idea that I can make over a room, simply on a whim, to suit my current mood or obsession. The favorite tools for such easy updates are paint (not only on walls, but also on furniture) and easily movable objects, such as one-off homewares and small furniture pieces.

I'm also increasingly drawn toward vintage items, especially those with an industrial edge. Pieces from another era ensure a point of difference as they are often unique (I like to avoid that "off the shelf" look). Styling can even add functionality to such pieces, making them appear less decorative and perhaps more hard-working. Ropes and pulleys, for example, feature heavily throughout this book, styled with a sense of purpose to their surroundings. Overall, both vintage and industrial pieces usually offer a worn patina that suggests they have their own individual stories to tell.

From my magazine experience, I'm also familiar with encouraging readers to find the most cost-effective solutions on offer. By following such styling tactics you can adapt your home quickly to what is currently in vogue, if that's what you desire.

Above all, this "temporary" approach most probably comes from my formal tertiary training in set and costume design. In theater, all is mere impermanent scenery in make-believe worlds. Another aspect of modern theater design is metaphor: suggestion reigns supreme. I'm always interested in what the items in a styled scenario suggest to an observer.

I recently heard a self-help guru advise that if you are ever lost in your career, go back to what you loved doing as a child. Find inspiration there, rather than in the grown-up concerns of money and status. How appropriate then that as a child I spent hours turning cardboard fridge boxes and masking tape into make-believe worlds inspired by the sets of my youth theater group. The lesson here: never deny what truly inspires you.

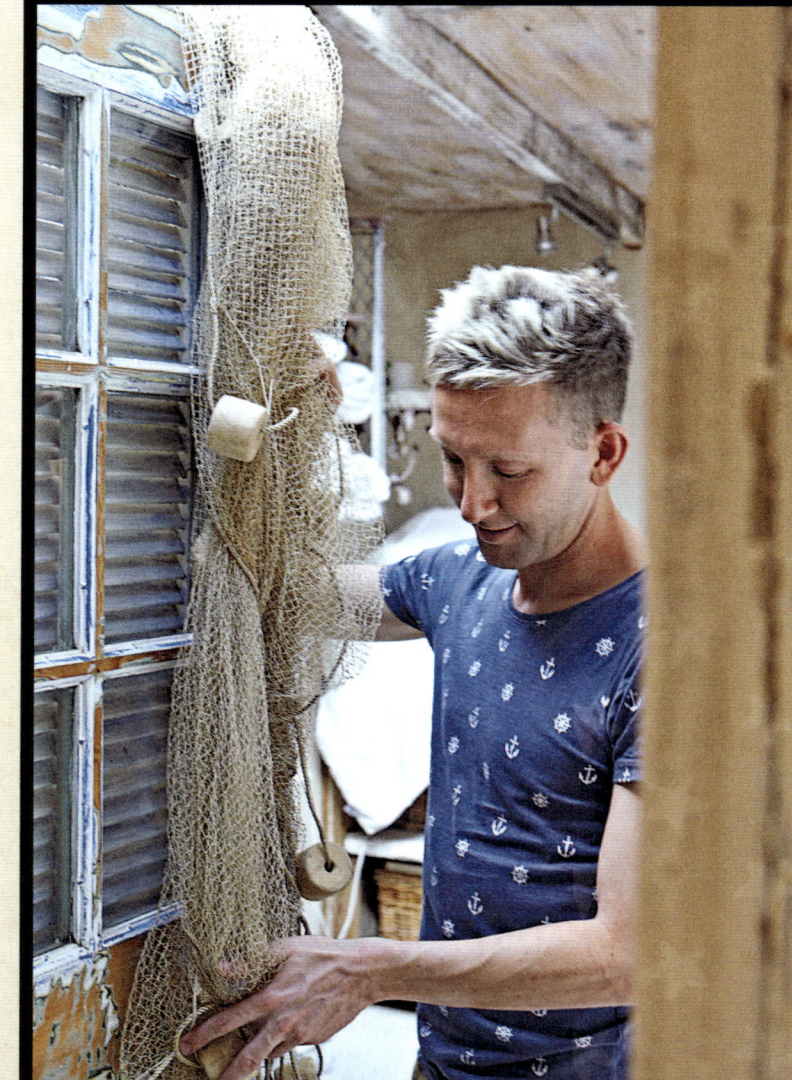

SAND CASTLES

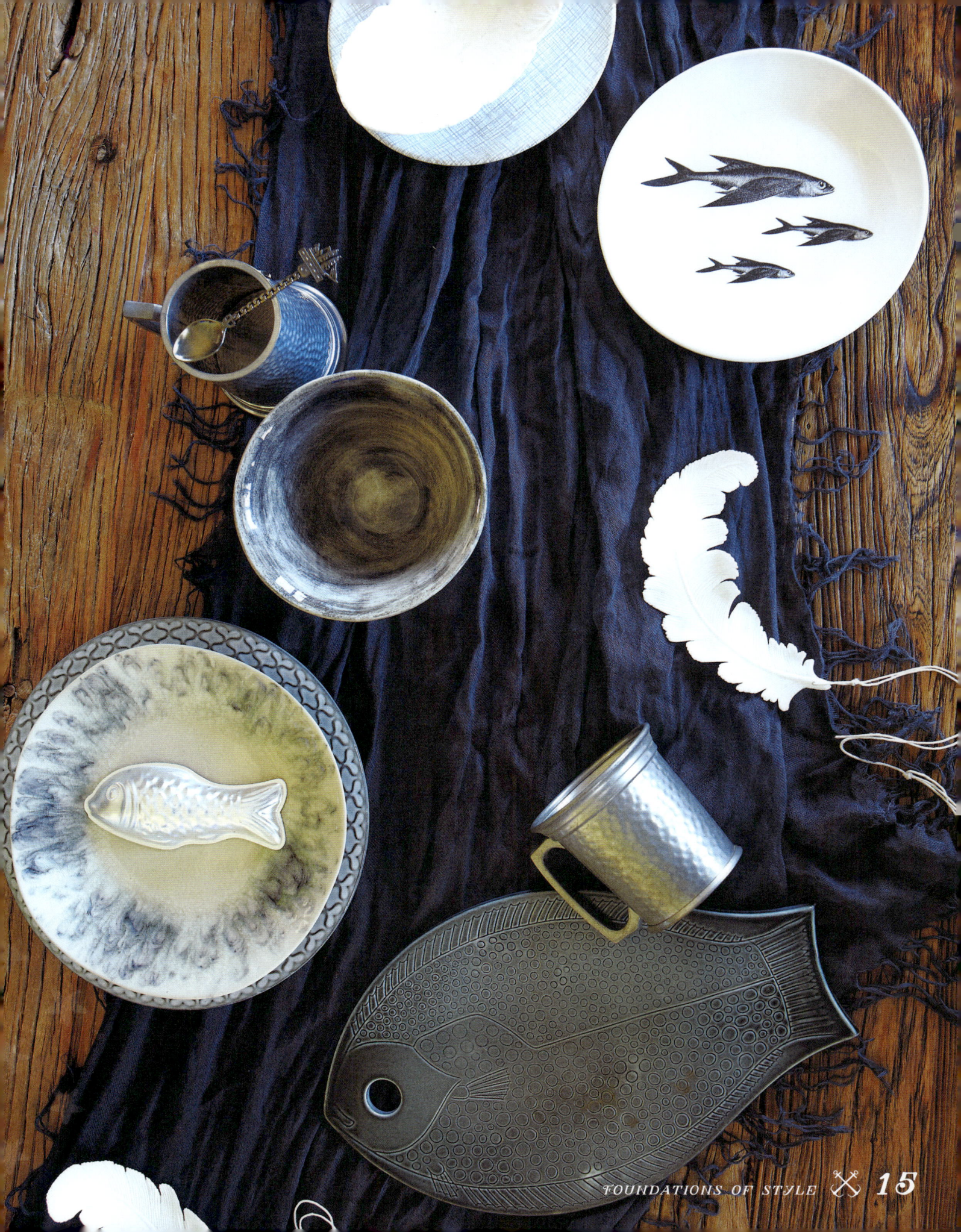

FOUNDATIONS OF STYLE 15

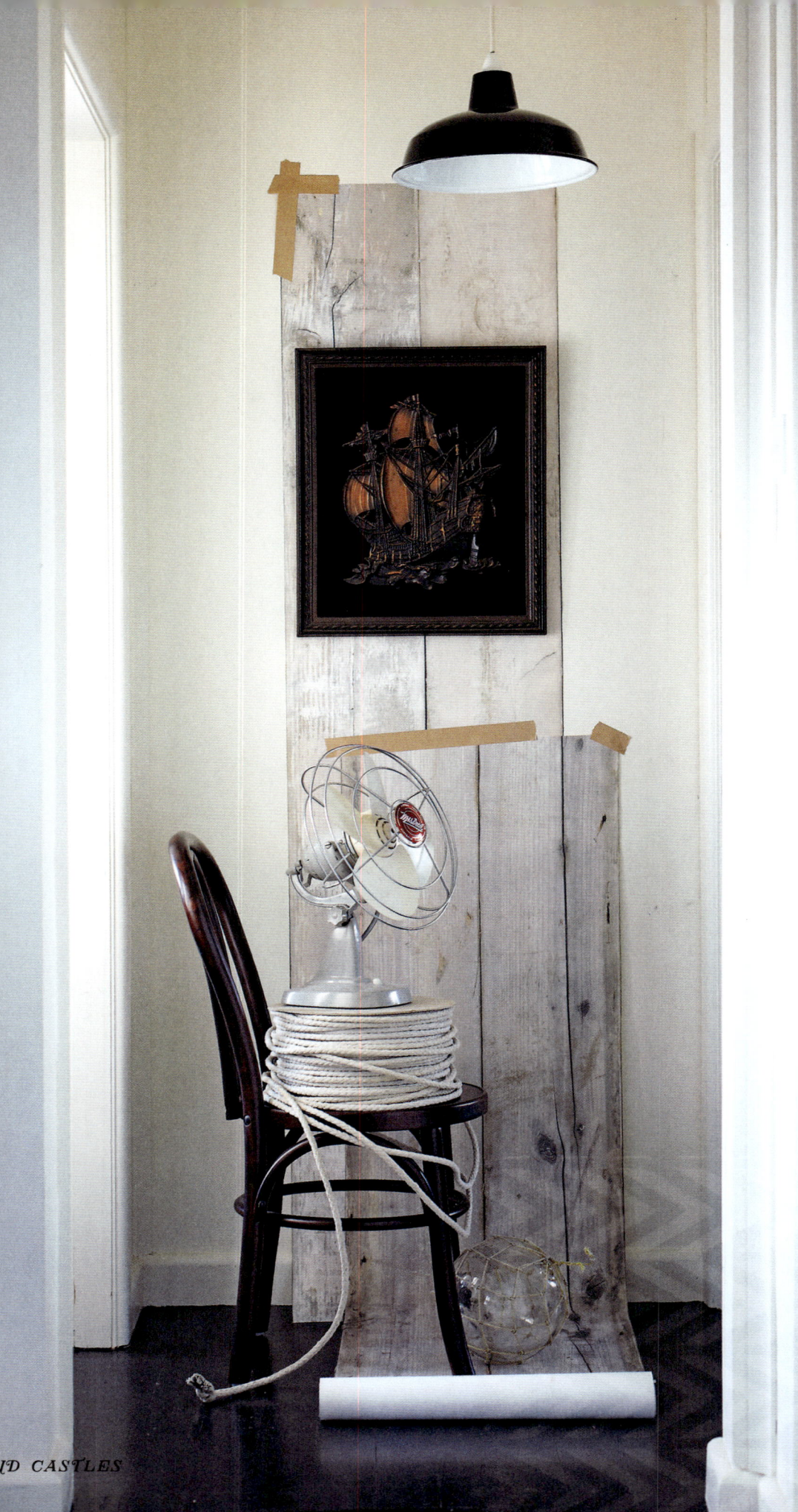

Foundations of style

HOW TO USE STYLED SCENARIOS

Throughout this book you'll notice that I refer to "styled scenarios," "settings," and "schemes" rather than rooms. These are the set-ups I create to demonstrate the style of each chapter. It's important to realize that, as scenarios, these aren't intended to represent fully fledged interior styling throughout a home. They are usually set up in real homes but require no sense of purpose or logic. Rather, they are drawn from whimsy and aim to engage in an exploration of style.

In a way, these set-ups resemble the window displays I create for retailers I work with: perhaps a single chair, a side table, a backdrop of fabric or wallpaper, and one single statement piece that come together as a group in a perfect balance of scale to tell a story. They demonstrate a heightened take on reality, a little like a fashion magazine editorial spread. It's not often you would lift a look straight from the glossy pages into your everyday wardrobe; if you did, you might end up going to work with a blown-out Afro and no pants on . . . Instead, you take inspiration from the colors, textures, and patterns demonstrated and, perhaps, pick and mix individual pieces to create your own look. In the same way, you might be encouraged here to translate the single chair into a family chaise sofa, for example. Looking at these ideas will be an individual process that unveils what you are inherently drawn to as your own style.

To take the idea a step further, these styled scenarios are akin to real-life pin boards. Like the mood boards at the start of each chapter, ideas on a pin board are brought to life in a setting of furniture and homewares. Each piece on the board represents a color, texture, or pattern you can expand on. By pinning and sticking fabric and moving small furniture items and one-off finds together, you get to see the effect in real time.

Find a corner of your home that you're happy to play in. Paint a section of the wall, hang something unexpected, stick samples or swatches against each other, and analyze the effect. This way you can see what tickles your fancy before committing to an entire scheme.

In an otherwise "dead space" of this house, left, we set up a mini-installation to test out a scheme. Seek out wallpaper prints that trick the eye with photo-realistic textures—the paper here replicates washed-out timber boards in driftwood tones. Why not use a chair as a side table? And place a rope reel in the scheme to see what its natural texture and tone add to the overall look. Notice how the warmth of the copper ship in the artwork pulls out the red tones in the wood of the classic bentwood chair? We hung an enamel tin pendant light low into the space—by having such lightbulb cords dropped low in each room you can easily unscrew your shade and try another, without even reaching for a ladder. A glass float adds the final nautical touch, balancing the ship iconography of the artwork. A vintage desk fan mixes in another era and metallic sheen, adding a sense of playfulness and movement.

Foundations of style

DISCOVERING YOUR *VISUAL VOCABULARY*

As you turn the pages of this book you'll discover it reads as a visual narrative, a running commentary on styling ideas and set-ups.

Inspired by the images, I invite you to imagine the impetus behind each styled scenario . . . How did the setting come to exist? What does it say to you? Does it conjure up memories? There are no wrong or right answers.

As my interpretations unfold, you'll discover that you too have a vocabulary to tap into. Listen to the first reaction you have to an image and you'll notice what language develops. Write down your instinctive thoughts, if that helps. From here, you'll be able to share what inspires you with friends and, even more importantly, with the homewares salesperson or paint specialist who will help you to create your own look.

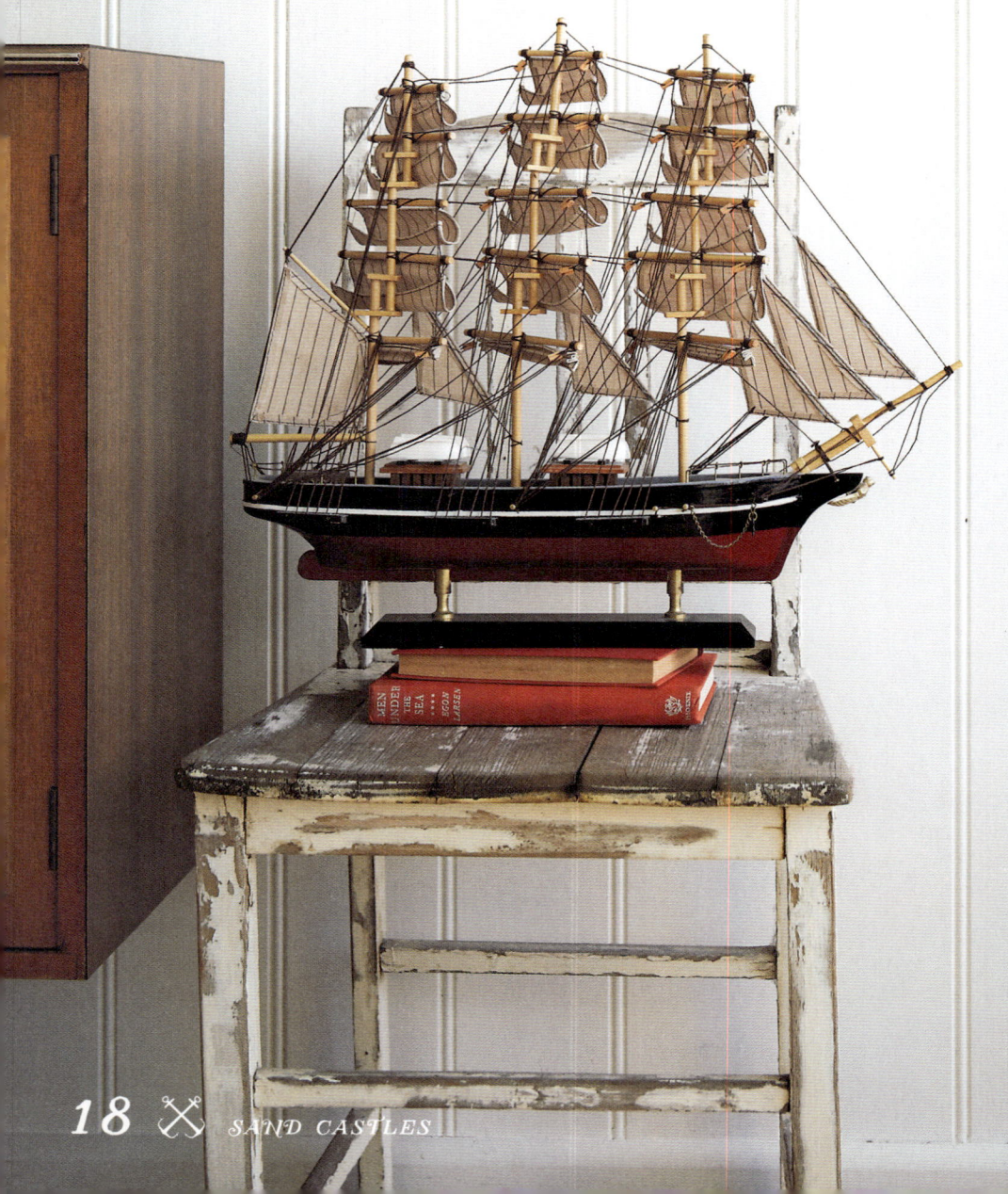

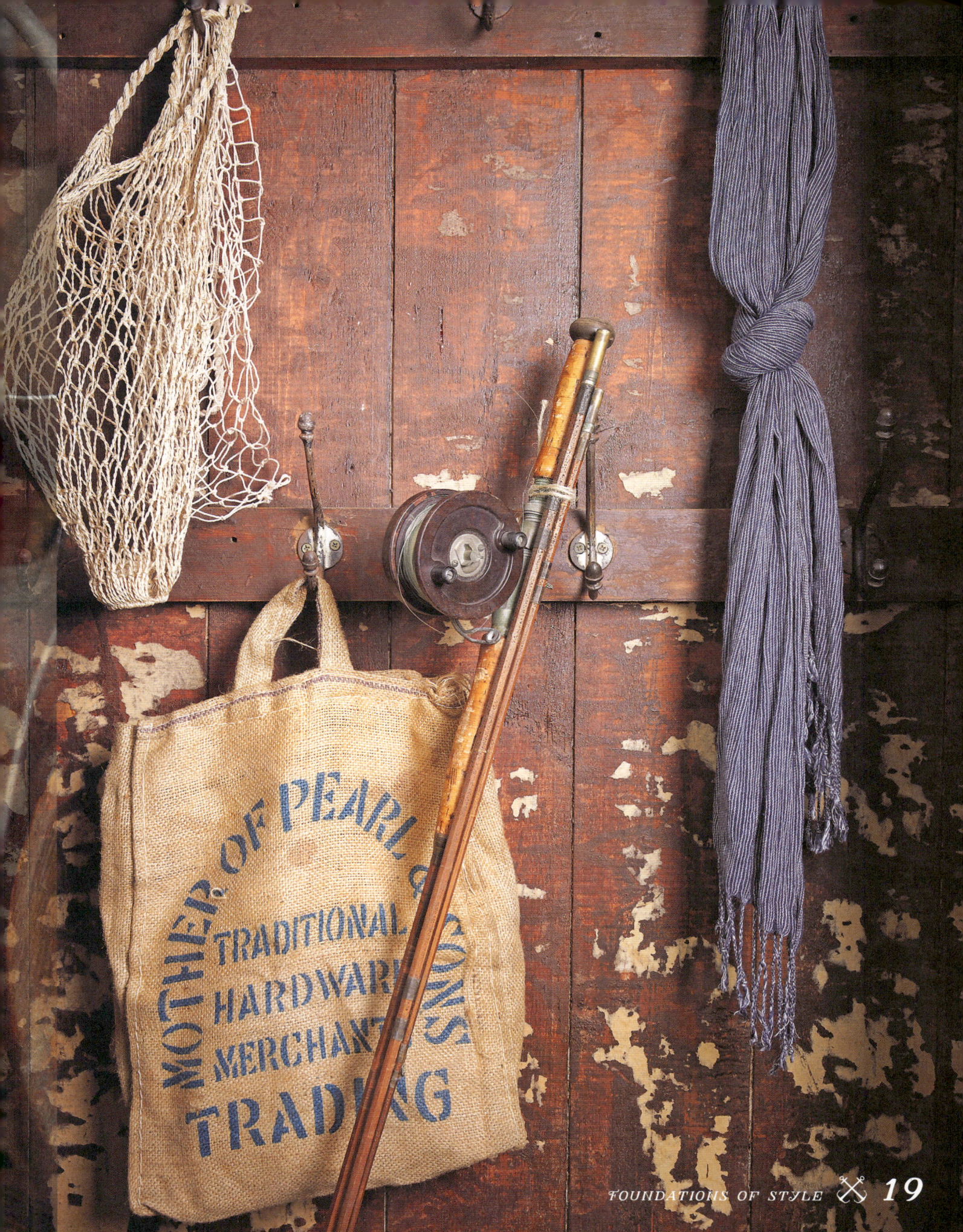

Foundations of style

FINDING INSPIRATION IN YOUR SURROUNDINGS

What holds inspiration for you?

If there's one thing I'm adamant about, it's that for modern coastal styling to be truly authentic, the inspiration has to come from the source. In contrast, by simply looking at editorial shots in magazines and imitating the décor, all we end up with is a diluted variation on the initial theme.

So, if you're lucky enough to be close by, take a walk along the ocean shoreline. What do you find that can be collected as inspiration? These lengths of sand are prime spots to discover free textural swatches for your home: the pearly oyster tones of a washed-up shell; the sea- and sun-battered patina of driftwood; the spiky organic forms of sea life; the corroded rock faces bubbling into new forms.

Inspiration can come from anywhere, and can be both natural and constructed: consider the primary-colored nautical iconography at a marina, or weathered signage of a lifeguard station. How could each of these be reinterpreted in your home? In thinking about this, you'll come up with a unique styling solution that resonates honestly and far more strongly than a decorative item straight off the shelf of a shop.

If you don't have a nearby shoreline to explore, pull out photos and postcards from your favorite coastal getaways. What fond memories do these conjure up for you? And, once again, how could you use those elements that stand out for you to create a vibe of natural escape in your home?

In this book, hopefully you'll find textural inspiration, perhaps in the close-ups of nautical pass-me-bys which, when examined, reveal much more than first met the eye.

For me, a constant source of inspiration is my daily swim in the ocean baths (you end up with less sand in your Speedos than at the beach). The Art Deco façade of Newcastle Ocean Baths turns every visit into an occasion. In my everyday styling work I seek to capture the fresh essence of the cool, crisp ocean waters, especially as the seasons change. There is nothing that clears my mind better than a breath of coastal air or a dip in the sea.

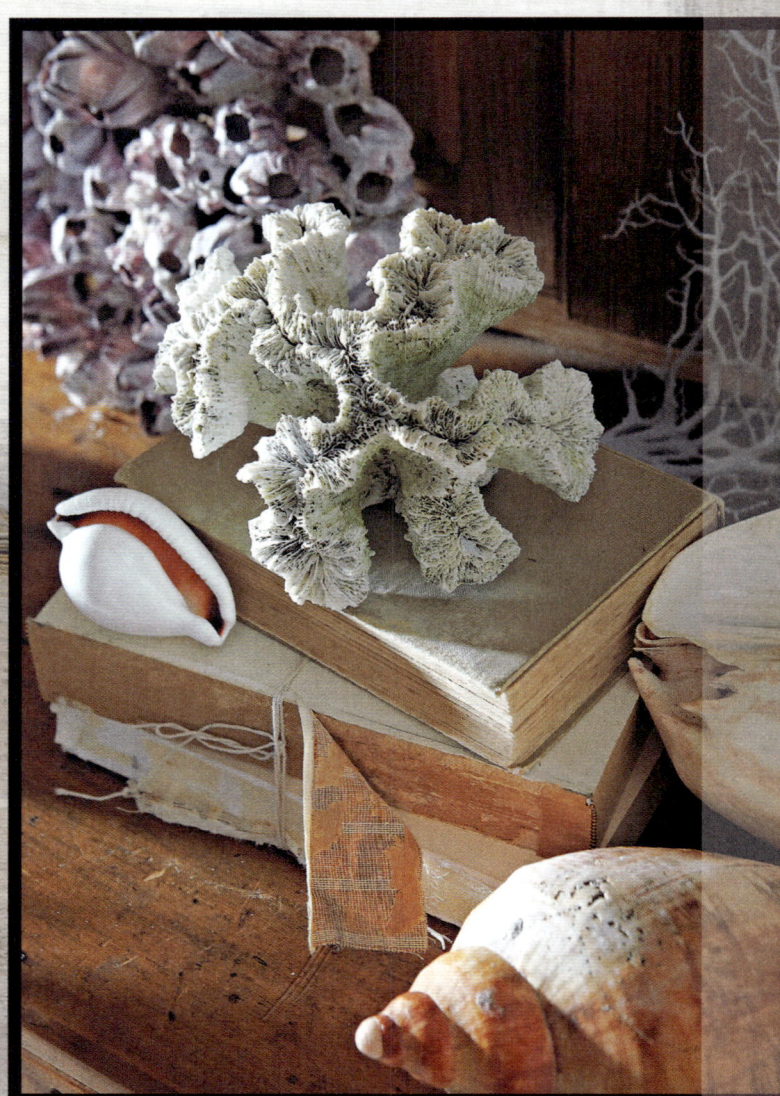

20 SAND CASTLES

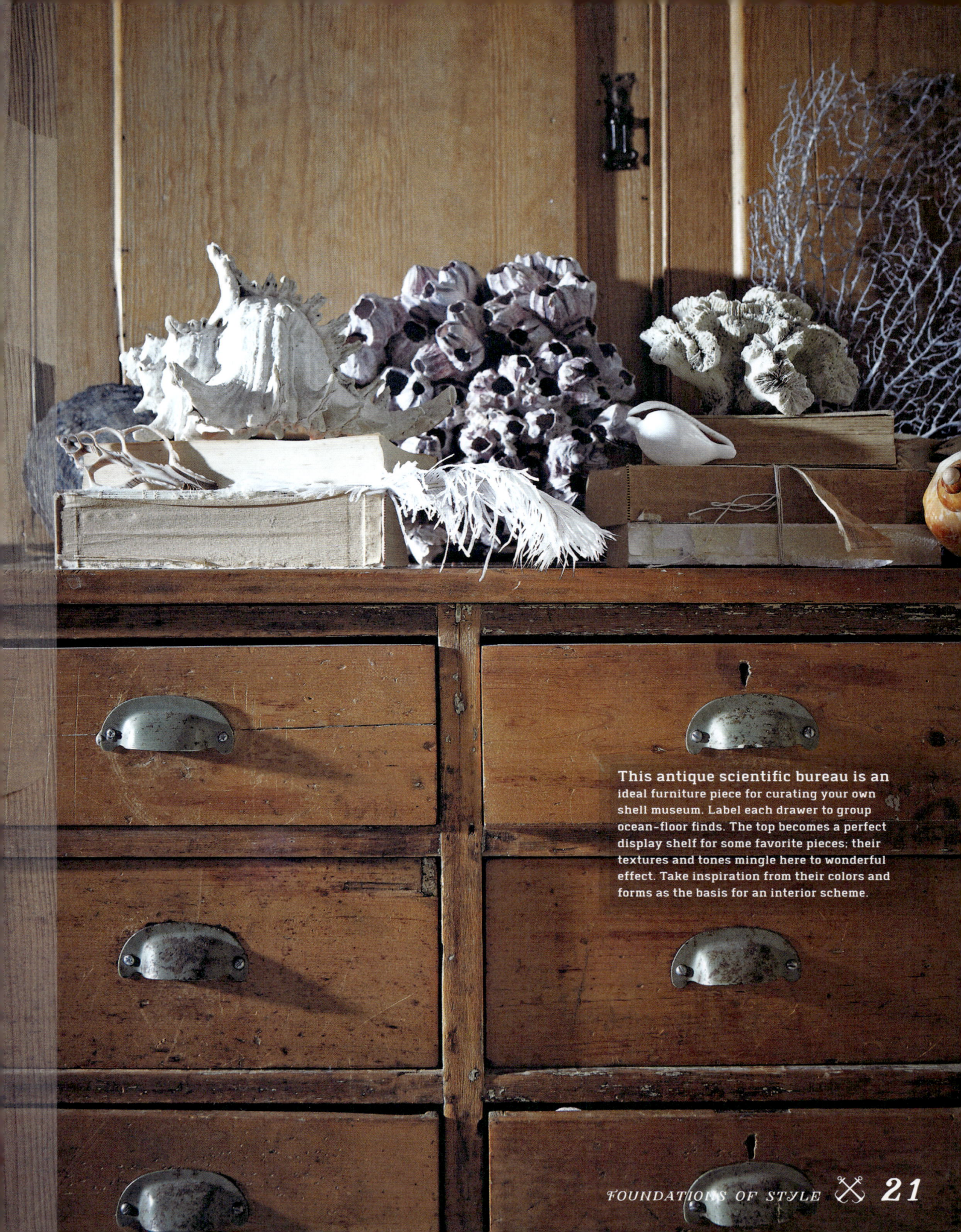

This antique scientific bureau is an ideal furniture piece for curating your own shell museum. Label each drawer to group ocean-floor finds. The top becomes a perfect display shelf for some favorite pieces; their textures and tones mingle here to wonderful effect. Take inspiration from their colors and forms as the basis for an interior scheme.

FOUNDATIONS OF STYLE 21

Foundations of style

MOOD BOARDS & COLOR PALETTES

At the opening of each chapter in this book you'll find a textured mood board that visually communicates the scheme ahead. This "cut and paste" process is a common building block of design, no matter what medium the artist works in. Ask any interior stylist how they begin the design process and they will invariably answer that the first vital tool is always the mood board.

This visual blueprint can be referred to throughout the design process—the success of a mood board lies in its magical ability to subliminally unveil your own taste and style.

Start by collecting visual scraps that appeal to you. These will often be clippings from magazines and photographs of other homes; but you can go a step further and become a bowerbird, gathering finds from nature and your everyday travels. Small objects that hold precious memories of your life journey will also reveal something personal. The real intrigue of a mood board is in the texture: this three-dimensional manifestation of a concept or collection is instantly appealing.

Your pieces can be curated in any form. Allocate a pin board in your home or office that you're likely to glance at often. Or use a journal that you can carry around and stick ideas into.

Don't be too precious. Collage pieces alongside each other because they appeal to you, hold memories for you, or perhaps because they clash yet charm, even though you don't know why!

Sometimes you might notice that, although you were drawn to some clippings and offcuts, they don't work together as you had hoped. That's OK: simply start a new pile and watch as a secondary board develops. That's exactly what happens in a couple of the chapters that follow: we found that one styling genre actually resulted in a few different looks.

Now, stand back and examine your mood board. What are the strongest elements? Are there any recurring features in your collection? Is there a particular color that emerges as a constant? Look closely at the textures of your elements. What you'll uncover is an overall insight into what visually appeals to you. A successful mood board will also reveal what works in terms of a color palette and the groupings that emerge from randomly collected images and items.

Patterns might appear through repetition of shapes. As in nature, like attracts like. When we begin to look for this visual significance in the random, thrown-together pile of "things we like," we begin to understand what truly inspires us.

If it helps, as words pop into your mind when you look at your mood board, don't be afraid to scrawl these into the scheme, too. In this way you begin to articulate your style and create that design vocabulary, helping to verbalize what you're seeking.

Once you've identified your own personal trends, the next step is to imagine how these might translate into reality. Trawl the internet, searching the keywords you've unveiled through your board, and see what furniture pieces match your brief.

Visit hardware and decorator stores and start matching paint swatches and fabric samples to the colors, tones, and textures of your collection. Add these to the board.

Something else to try: when you've bought sample pots to match your swatches, shake the cans well to make sure the pigment is thoroughly mixed, then take off all the lids, arrange them next to each other, paint-side-up, and take a snap. Your photograph will reveal your palette in a more appealing (and more color-accurate) format than the store swatches.

Most importantly, as you shop and then create your interior, refer back to the mood board to confirm that each choice reflects the personal esthetic you formed as your styling foundation.

As I put together the mood boards for this book, I realized that mine work best as table-top creations. They are simply too heavy to hang! Rather than images from magazines and paper paint swatches, I'm drawn to one-off objects and random three-dimensional pieces that I find on my travels. I combine these to see what emerges. There is no wrong or right method here, and you might find your mood boards are image based, and so lighter, and can be hung up on the wall to look at.

Notice how the baseboard (the board that a mood board is created on) often creates a solid background. The mood board grows layer by layer but always lets the background breathe by never fully covering it. The lesson here is to always start with an inspiring blank canvas, whether that is cork, wood, linen, hessian . . . I'm usually drawn to a natural-colored, tactile basecloth, much like the sand that forms the backdrop of most coastal locations.

After the mood board in each chapter, a color palette demonstrates tones that go together to make up a similar scheme. How you reinterpret that is up to you: by using it alongside fabric swatches, or matching paint pigments, or reworking a piece of furniture, or creating a feature wall.

When you look at an image that appeals to you, notice how many colors make up the whole. By isolating a segment of each color and pulling it out as a swatch, you can build a coherent palette. For the technically minded, you can use the eyedropper tool in Photoshop to select a pure pixel of color from an image. The final collection will be your preferred palette and explain the appeal of the image you were drawn to in the first place.

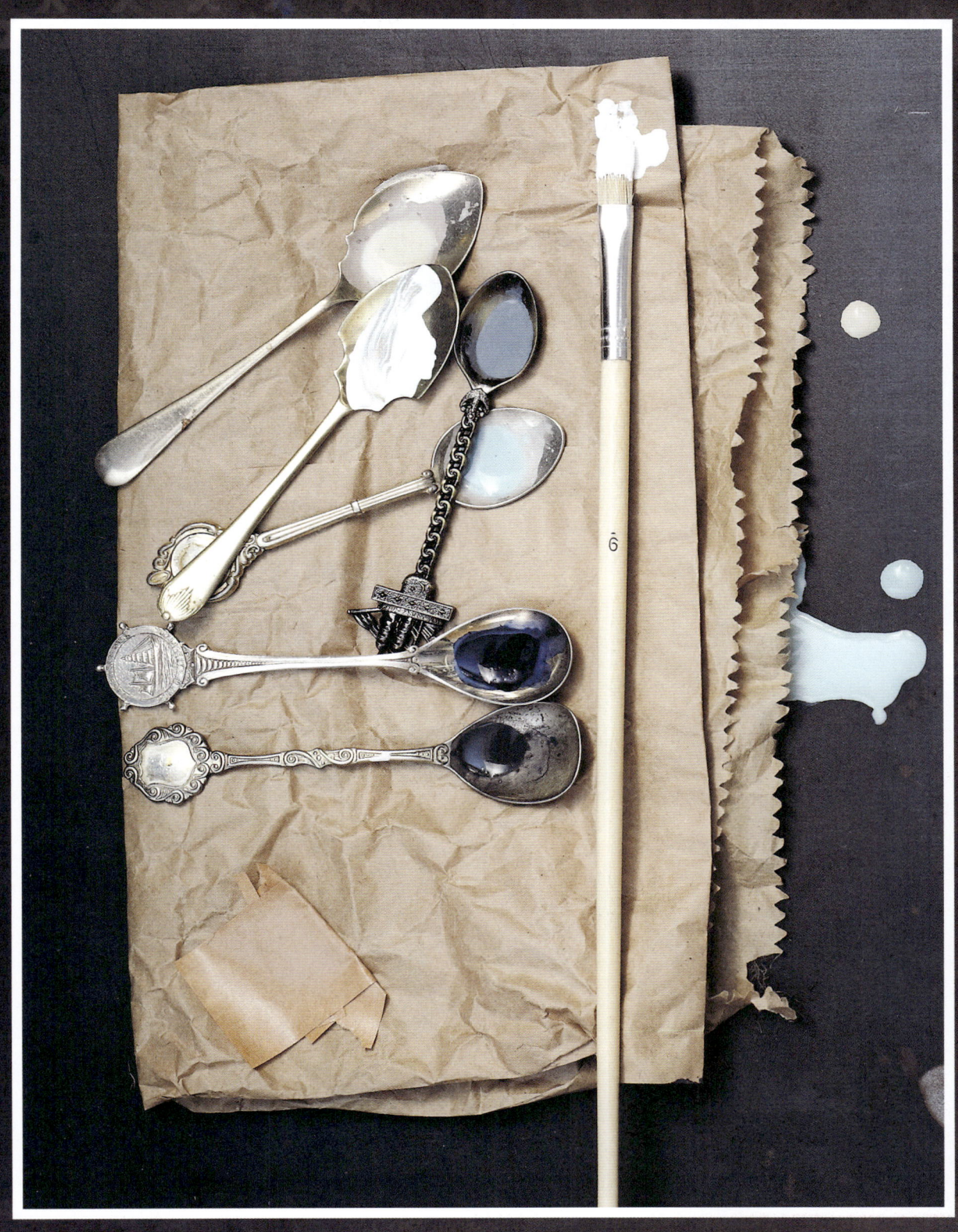

FOUNDATIONS OF STYLE 23

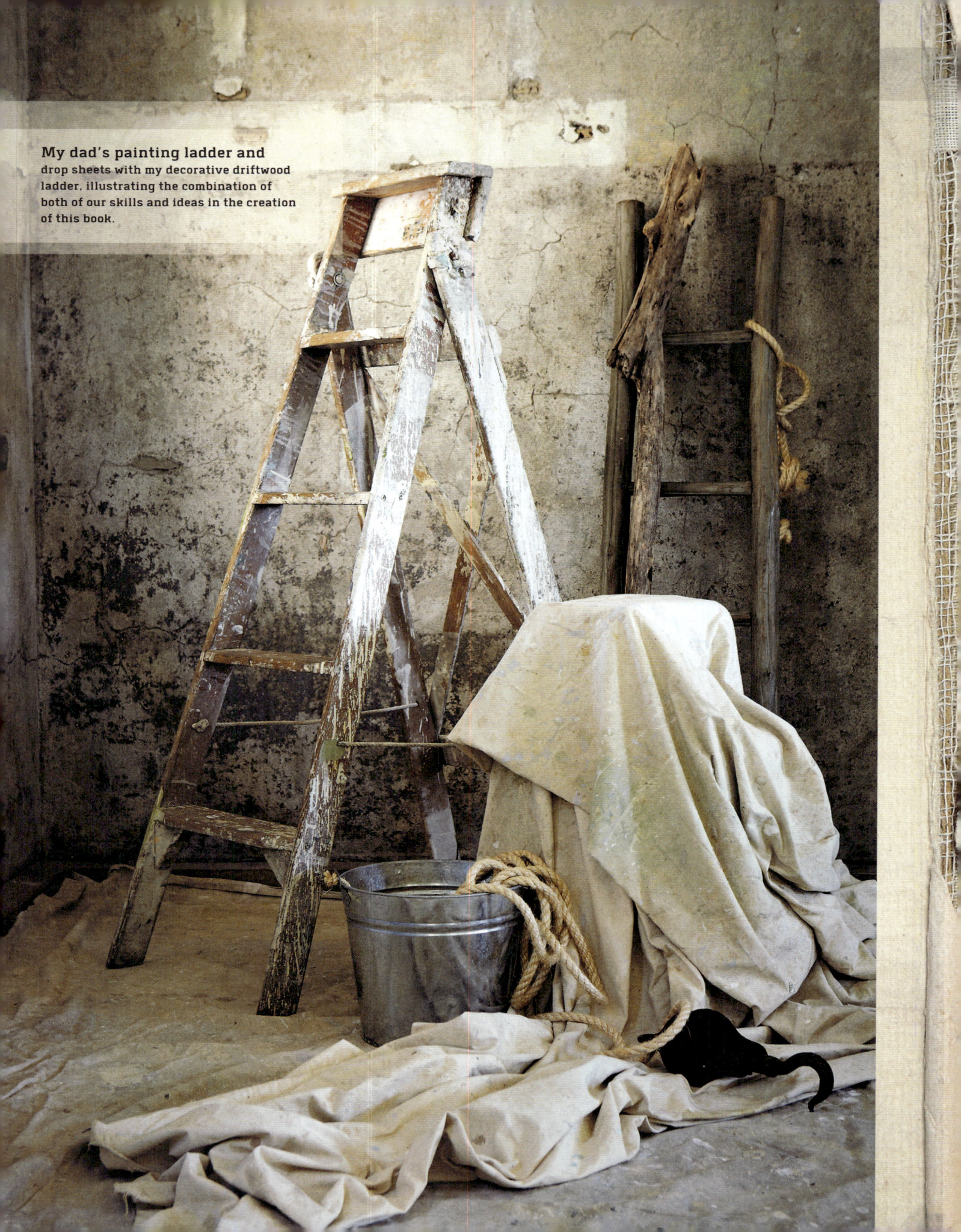

My dad's painting ladder and drop sheets with my decorative driftwood ladder, illustrating the combination of both of our skills and ideas in the creation of this book.

Dedication

Stephen Neve, 1955–2013

I was introduced to the wondrous effects of paint at a young age by my dad, Stephen. He was a professional house painter and ran a successful business for many decades. When I was a child, he came home from work every day splattered from head to toe, with dried paint in his hair and down his arms. The garage was always piled up with brushes, cans of paints, and drop sheets.

If I try hard enough, I might even remember the first time he showed me a fan deck of paint swatch cards, splitting open the pages to reveal the rainbow of color choices that even just one company could offer.

My bedroom as a one-year-old might well have set my destiny. My mum, Rhonda, convinced Dad to buy a simple, untreated pine single bed and chest of drawers, but then he painted them vivid, glossy fire engine red. What a vision. It was proof of the ability of paint to create something completely unique and unlike any other piece of furniture in the world, just with a simple coat (or preferably two!) of paint.

I would never again have a simple bedroom set. As I grew up I was creating my own unique look on a constantly revolving basis. I consider this the best experimental training ever, and I thank my parents for giving me the freedom to do whatever I wanted, no matter how wild the idea. As a fourteen-year-old I explained to my local newspaper: "I love art and hope to become an interior decorator. I practice this skill on my bedroom. I usually change it around every week. In the past month it has gone from modern silver to tribal African." I guess it was no surprise that I would one day do the same professionally for other people.

Sadly, my father retired early due to illness, which recently claimed his life at a devastatingly young age. I have inherited the garage full of brushes, cans of paint, and drop sheets, and they have been used wisely in the process of creating this book.

Whenever I pick up a paintbrush I will think of my father, and the passion for paint he has passed down to me as the next generation of our family.

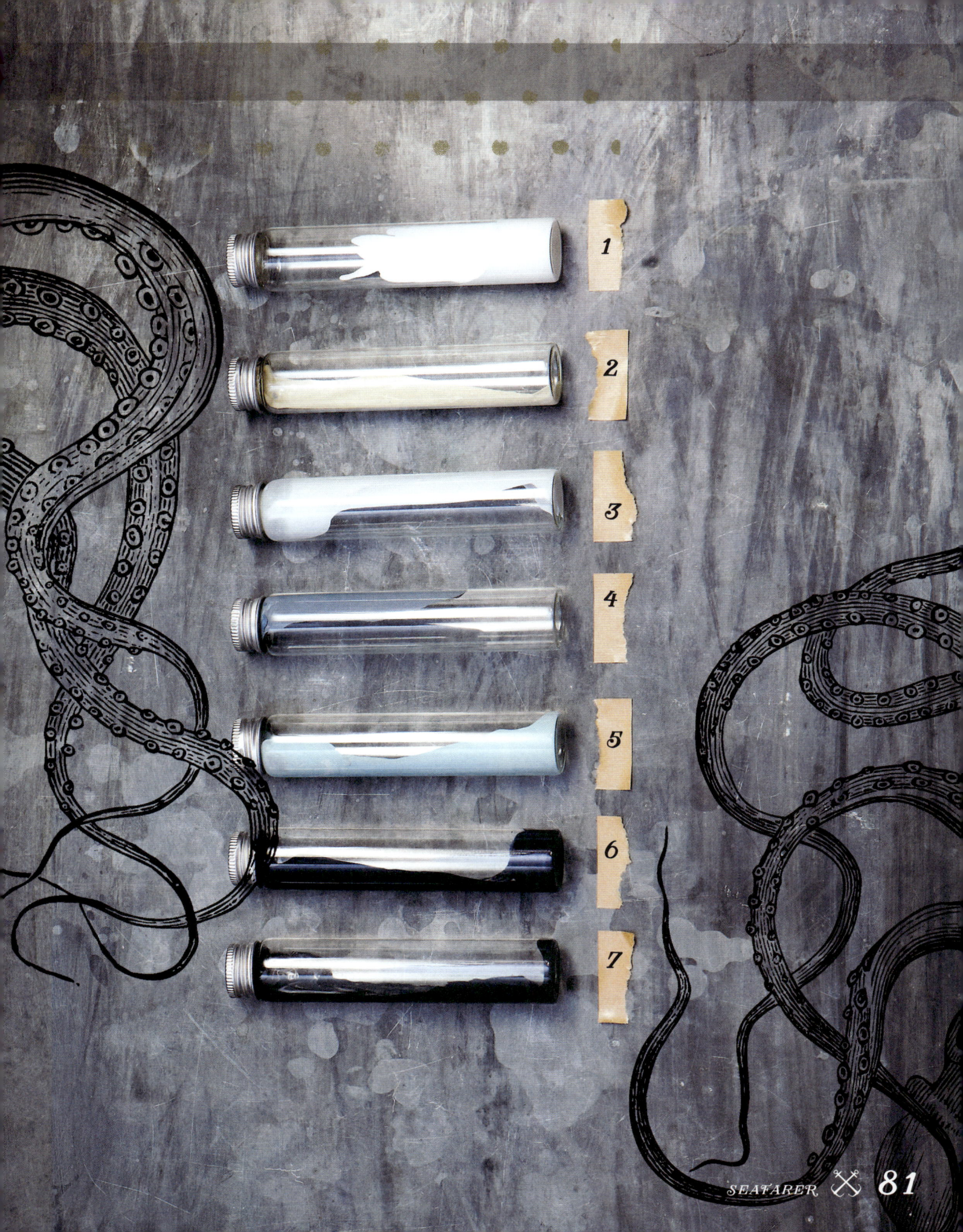

MAN AGAINST THE SEA

I thought I would sail about a little and see the watery part of the world. Whenever I find myself growing grim about the mouth; whenever it is a damp, drizzly November in my soul...then, I account it high time to get to sea as soon as I can. There is magic in it. Yes, as every one knows, meditation and water are wedded for ever.

Why upon your first voyage as a passenger, did you yourself feel such a mystical vibration, when first told that you and your ship were now out of sight of land? Why did the old Persians hold the sea holy? Why did the Greeks give it a separate deity, and own brother of Jove? Surely all this is not without meaning.

—*Moby Dick*, by Herman Melville, 1851

It seems mankind has always been fascinated by the sea: the scale of it; the unpredictability of it. This love–hate relationship with our greatest natural wonder has been much explored in both literature and film.

A plethora of titles tackles the tension between mankind and the sea. But one aspect is constant: a recurring, universal, and timeless theme of man made small against its wonder. A plotline that continually emerges is one in which man (and it usually is a man, rather than a woman) is left to battle out his individual psychological drama against the wide open space of the ocean. There's no other place where, as the introduction to *Moby Dick* suggests, such a mirror is held up to our inner selves. Perhaps this is why so many of us long for an ocean escape, to sit by the water for even a moment, to gather our thoughts in the fresh sea air.

SAND CASTLES

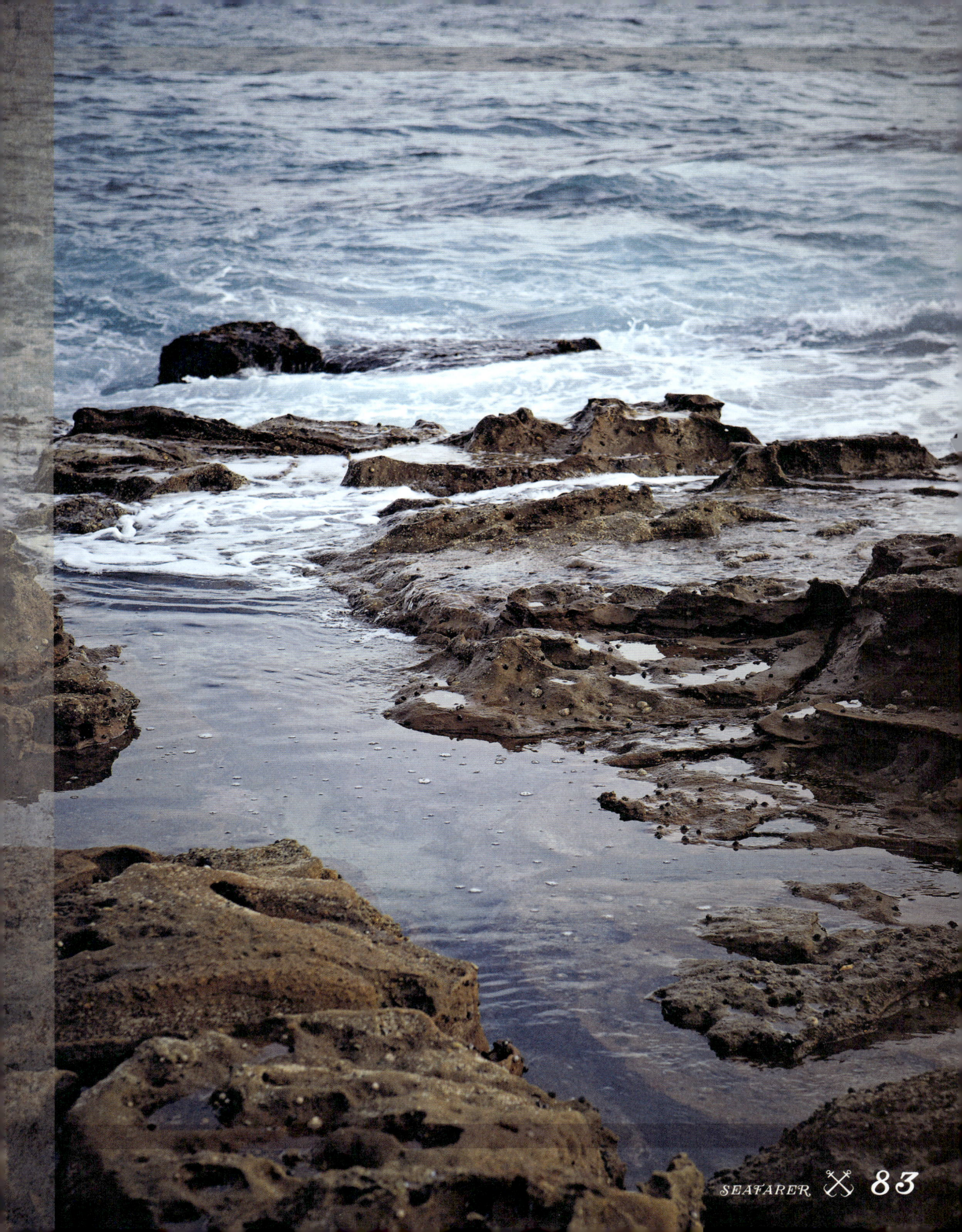

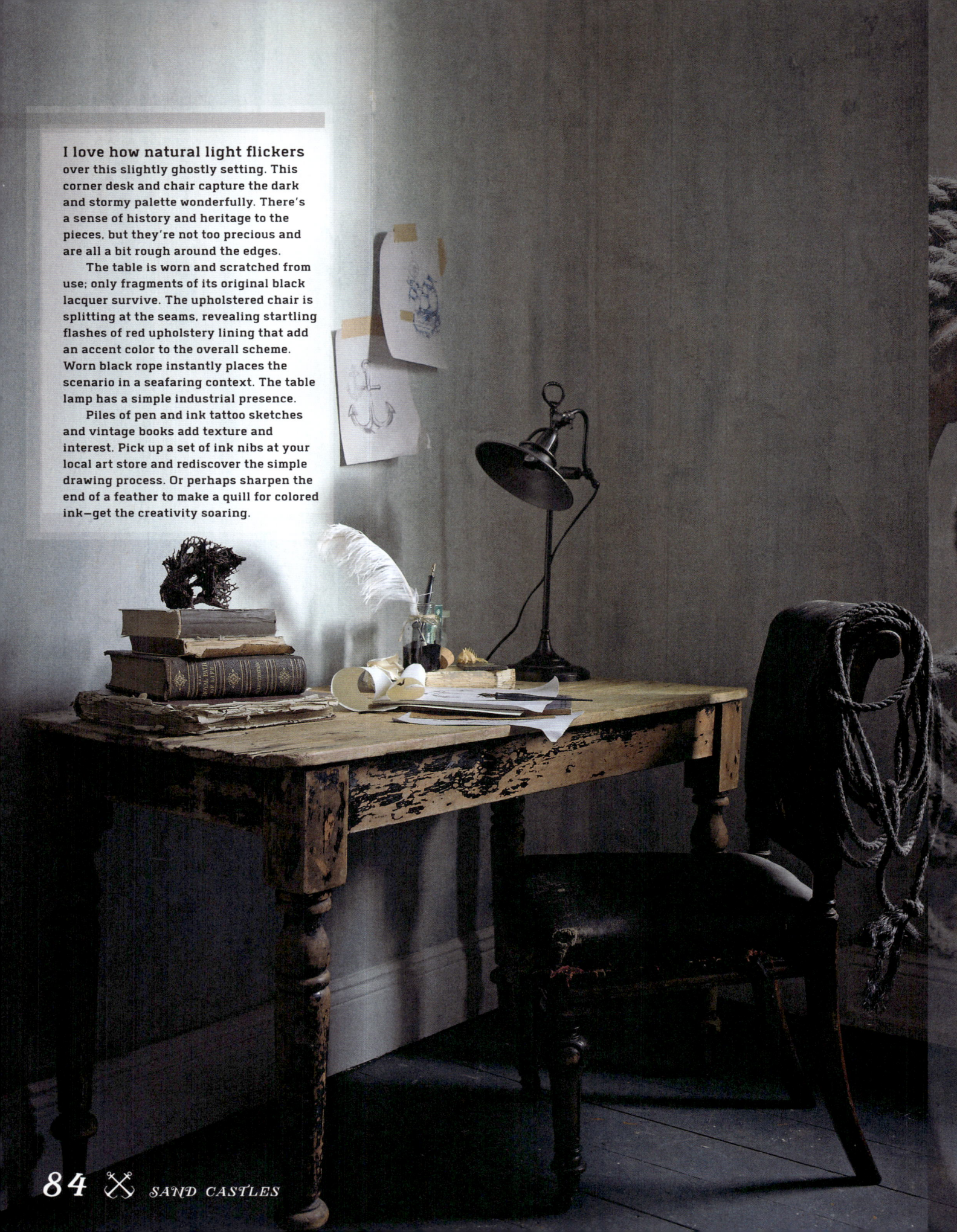

I love how natural light flickers over this slightly ghostly setting. This corner desk and chair capture the dark and stormy palette wonderfully. There's a sense of history and heritage to the pieces, but they're not too precious and are all a bit rough around the edges.

The table is worn and scratched from use; only fragments of its original black lacquer survive. The upholstered chair is splitting at the seams, revealing startling flashes of red upholstery lining that add an accent color to the overall scheme. Worn black rope instantly places the scenario in a seafaring context. The table lamp has a simple industrial presence.

Piles of pen and ink tattoo sketches and vintage books add texture and interest. Pick up a set of ink nibs at your local art store and rediscover the simple drawing process. Or perhaps sharpen the end of a feather to make a quill for colored ink—get the creativity soaring.

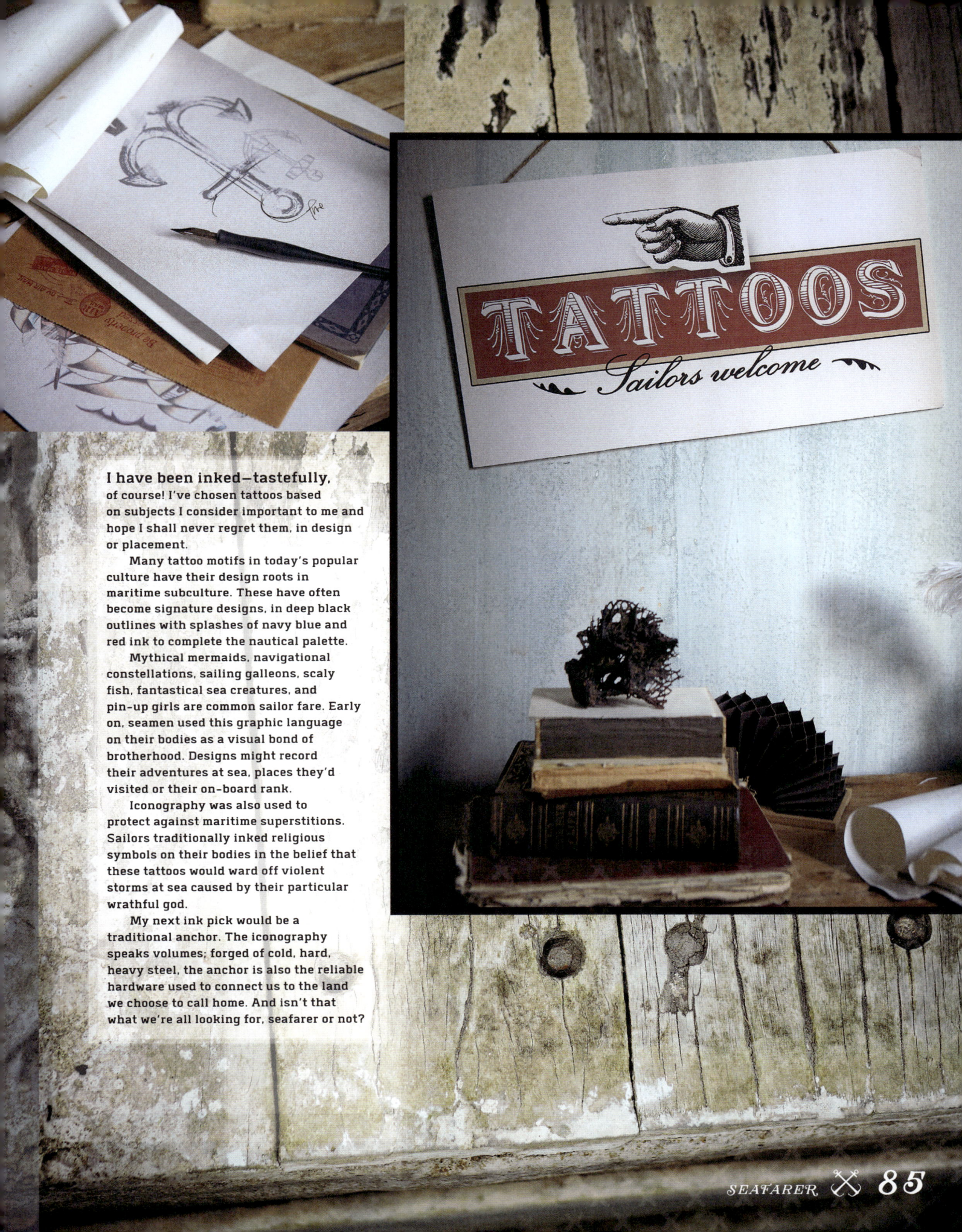

TATTOOS
Sailors welcome

I have been inked—tastefully, of course! I've chosen tattoos based on subjects I consider important to me and hope I shall never regret them, in design or placement.

Many tattoo motifs in today's popular culture have their design roots in maritime subculture. These have often become signature designs, in deep black outlines with splashes of navy blue and red ink to complete the nautical palette.

Mythical mermaids, navigational constellations, sailing galleons, scaly fish, fantastical sea creatures, and pin-up girls are common sailor fare. Early on, seamen used this graphic language on their bodies as a visual bond of brotherhood. Designs might record their adventures at sea, places they'd visited or their on-board rank.

Iconography was also used to protect against maritime superstitions. Sailors traditionally inked religious symbols on their bodies in the belief that these tattoos would ward off violent storms at sea caused by their particular wrathful god.

My next ink pick would be a traditional anchor. The iconography speaks volumes; forged of cold, hard, heavy steel, the anchor is also the reliable hardware used to connect us to the land we choose to call home. And isn't that what we're all looking for, seafarer or not?

Opt for a wrought iron bed, a classic design that will never date. There are some great reproduction versions on the market now in pop colors and shiny metallics. If you're lucky enough to find an original, chances are the bedhead will be intact but the wire base long gone. If so, use timber battens to remake the base as a slat bed and strengthen the overall frame. Depending on the condition of the frame, you might leave the enamel coating flaking off in parts, but if it's running to rust, seek out a professional to scrape back the tube to raw material and respray it.

A stack of vintage suitcases makes a unique bedside table, while also providing ample storage for spare bed linen.

The color palette in this room is a serene scheme of soft grays, barely-there neutrals, and washed-out blues.

Mix and match different bed linen to interesting effect. Here, felt army blankets with a contrasting stripe are thrown over an embroidered bedcover and mismatched sheeting. But the interesting choice is the vintage linen sack, repurposed (and stuffed with two, side-by-side, duck-feather pillows) to become a lengthy statement bolster.

Blue ticking fabric stretched over the mattress is a classic option. Seek out this stripe in linens and soft fabrics wherever you can, so that you always have a stash handy.

If you can't have ocean views, find a panoramic image of the sea and hang it low over your bedhead, like a porthole to an imaginary horizon. The artwork here was an op shop find, bought for a few dollars, and its aging yellow tarnish adds to the sense of history in the room's scheme.

A zinc-caged lamp introduces a lovely metallic sheen to the room without looking showy. Hung low at the bedside, it adds to the atmosphere of sailors' sleeping quarters in some great ship. Just one lamp is fine—adding a second pendant to the other side of the bed would look far too matchy-matchy in this understated scheme.

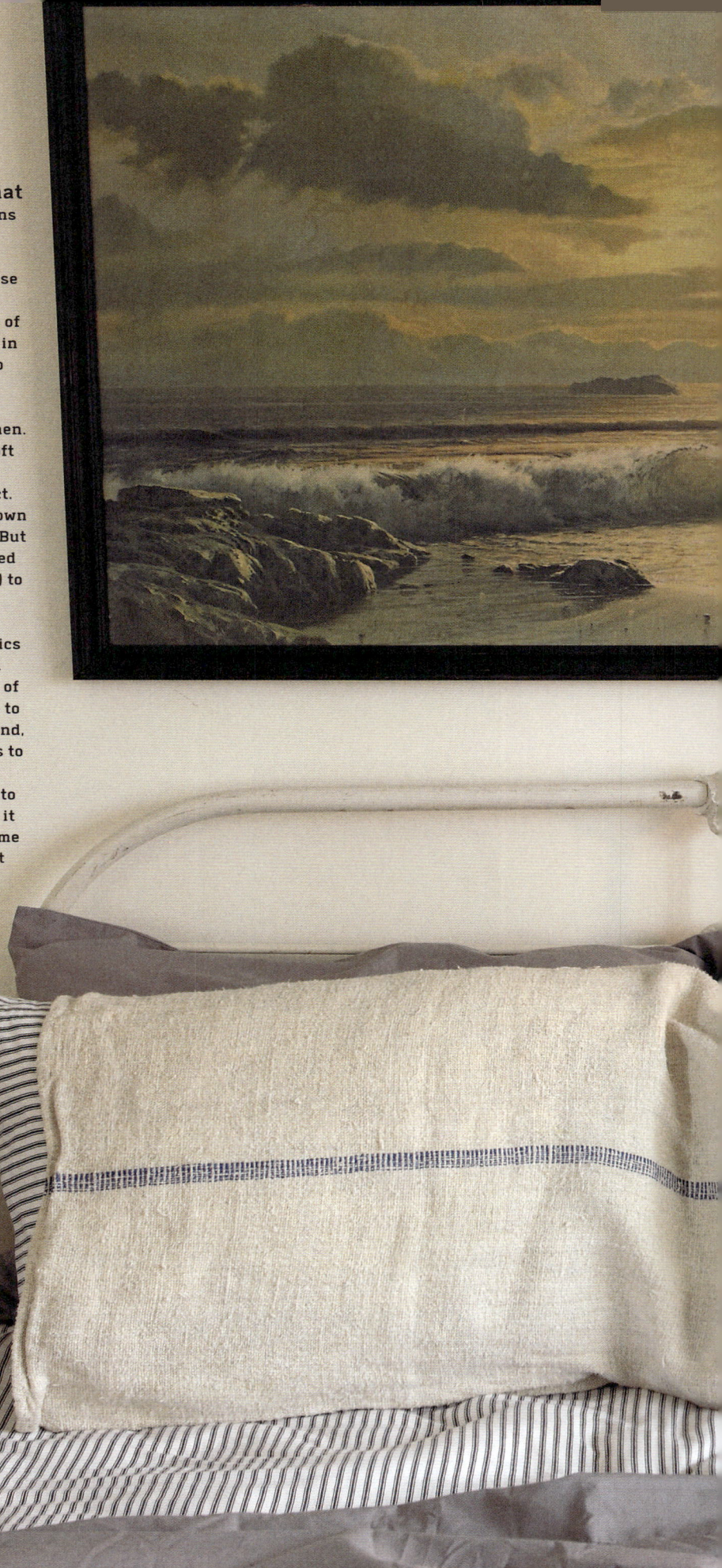

SAND CASTLES

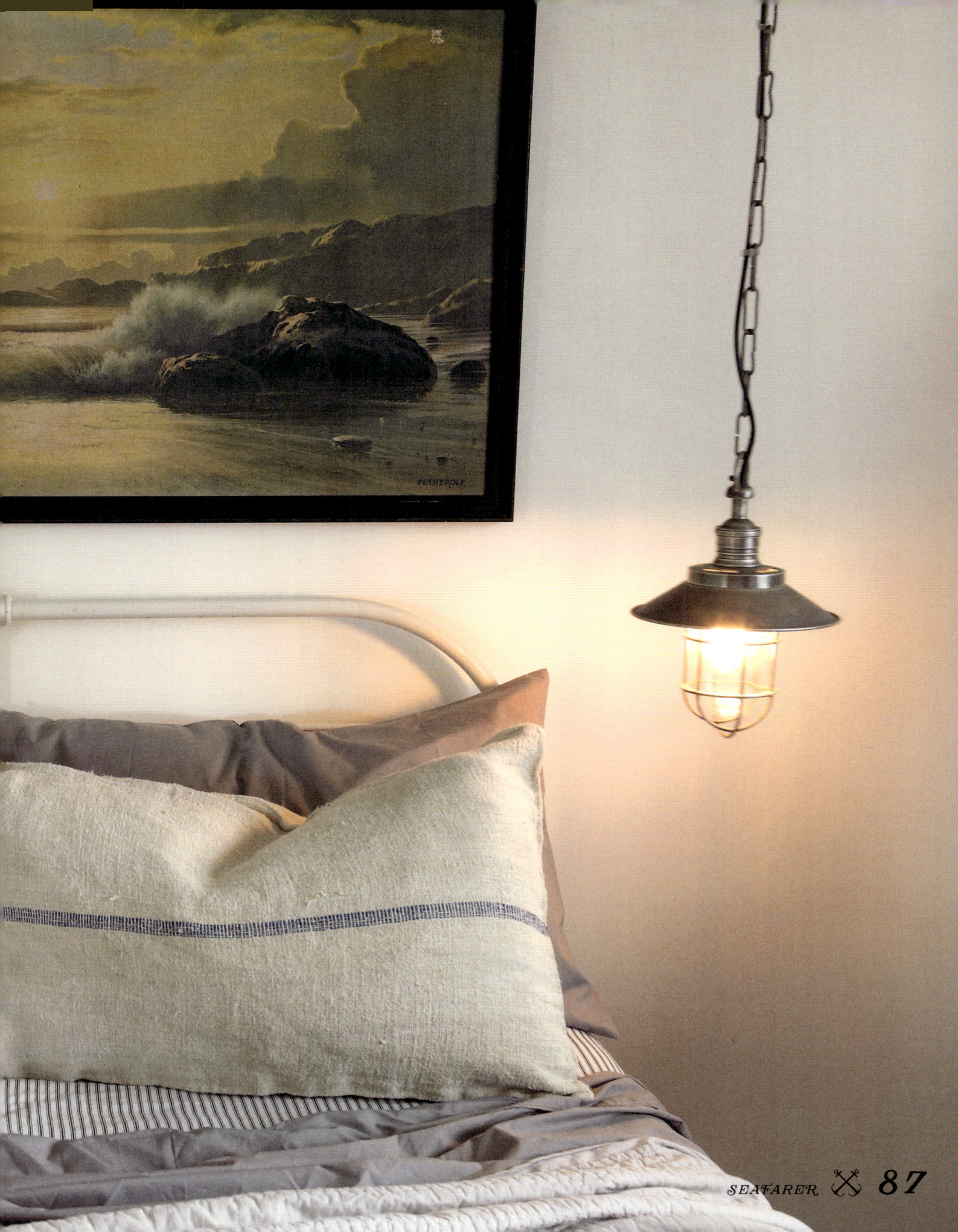

88 SAND CASTLES

When building a vignette, keep your color palette as simple as possible. Place the largest items into the composition first, incorporating the smaller pieces to complete the look. Odd numbers and groups of three are always magic combinations. Don't ask me why —the eye just loves them.

Overlap items and play with distance and "air" between each one, creating clusters within the overall group. Soften objects with a drape of ribbon or rope to break hard edges and lines. Tie a decorative cord around a bottle neck and let the cord fall where it wants to—this looks more natural than contrived, overstyled curls.

For this nautically inspired vignette, left, a chest of drawers (whose varnish is peeling off in artfully perfect shards) becomes a great display shelf. The white-painted brick wall in the background comes to life when side-lighting captures its bumps and imperfections. White mixes with tarnished brass and royal blue to suggest the maritime theme. See how the aged patina of the caged light base is mirrored in the surface of the wooden drawers?

Notice the repetition of form here: the organic shape of the sea urchin shell is replicated in the curved top of the ship's caged light bulb.

VIGNETTES HAVE BECOME A BUZZ WORD ON SOCIAL MEDIA APPS SUCH AS INSTAGRAM. I'M HIGHLY ADDICTED TO SUCH THINGS —I THINK IT'S A WONDERFUL WAY FOR VISUALLY MINDED FOLK TO SHARE IDEAS.

I love the way the everyday can become art with a quick image-editing device like Instagram. The square format is, of course, deliberately reminiscent of old Polaroid prints, another fond addiction of mine—the framing of an image could be way off, and often more of the background subject matter and negative space were highlighted than was intended.

When I'm creating a vignette, I like to imagine how it might appear in a photograph: what forms, colors, and shadows will emerge. These days I feel I haven't really completed a composition until I've looked through a lens and captured the scene with a quick digital happy snap.

The most magical inclusion in this room for me is the gray fishing net resting over the bedhead. Its placement suggests a maritime-style dreamcatcher. An original caged lightbulb hung low by the bedside is a statement piece, casting wonderful shadows over the space. Notice the wooden crate as a bedside table—the perfect height when placed on its side. Unintentionally, it has a sea reference with "Seal Co" stamped on one surface (sometimes these objects seem to gravitate together to create delightful coincidences).

On the bedside table an original ship's bell doubles as an alarm clock, and vintage books tell classic tales of the sea.

The overall palette is serene, but individual elements are working hard: the scheme is balanced by tiny details such as the muted blue stripe on the bed cover that matches the vintage book spine. Hospital-style blankets give a utilitarian simplicity to the bed while adding comfort and warmth with their layers of waffled texture.

Horizontal wood paneling instantly says "boathouse" in this bathroom. It's a brave choice: abandoning functional tiles for painted timber surfaces to create a homely cocoon for bathing.

Here, too, is a good example of grouping like objects to exaggerate their effect: beveled-edged vintage mirrors each have their own individualistic shapes, but also come together as a like-minded visual family.

A row of black wrought-iron wall hooks are functional but you can add whimsy: the knotted fishing net hung from them drapes onto the floor and also introduces an element of natural texture and color, breaking up the room's otherwise monochromatic scheme. Natural sea sponges are functional but also provide lovely organic forms.

Opt for a claw-foot bathtub for ultimate luxury. In this room it's set center stage, away from all four walls, which gives an overall sense of space and lightness around what is essentially a large and clunky item.

SEAFARER

Roll out a striped rug to add a maritime flavor to any space. The deep indigo stripe in this design is almost the color of squid ink and adds a subtle variation in the overall scheme.

A worn leather tool trunk is stencil-sprayed with a skull and crossbones for a hint of piratical humor.

Nautical iconography is hand-carved into square, ink-stained wood panels that are hung in a simple threesome on the white wall. Notice how practical illustrations of sailing knots have become their own unique art form. Seek out these original diagrams in books and manuals.

The chair seat is reupholstered in a plain neutral linen. Arranged on the chair is a simple vignette of old books and a fisherman's reel, with a primitive-looking handmade lure guaranteed to attract any passing fish!

Create the atmosphere of a sailors' mess for your next dinner party. Tolix chairs—real or replica—in raw aluminum create an instant utilitarian vibe. They appear to be more function than comfort, yet, surprisingly, offer both.

Black, a color I am rarely drawn to, is the featured hue here, inspired by the pirate flag. The look is far from heavy because it's balanced by the neutrals of the rug's stripe and the antique pine table. The table's turned legs might be traditional but the overall look is kept modern by the eclectic styling. The mismatched crockery setting features sea iconography. Fish platters appear to float on a graay, frayed muslin fabric scrap used as an impromptu table runner.

Oversized glossy black enamel industrial shades are mock-hung in a rope and pulley system, anchored to one table leg to create a fun effect at the diners' eye level.

Despite the black shades, only the overhead skylight illuminates this dining space, so the huge, dark-framed mirror resting against the wall is a great way to bounce light around the room.

YO HO HO AND A BOTTLE OF RUM...
Hunt down wicker flagons and cork-topped bottles at markets and garage sales and gather them into a pirate-inspired collection.

94 SAND CASTLES

The battered old chair here doubles as a display surface for a tarnished trophy filled with a collection of cracked and broken shells. The chair's metal patina is echoed in the impressive copper telescope, which suggests a view beyond this window to a horizon of uncharted waters.

Touches of signal red—in the book and the cushion's simple stripes—continue the nautical palette.

A makeshift linen curtain, edged with heavy brass rings and printed with crosshatched illustrations of ships, is strung up with rope from the wooden shutters. Notice how the delicate lines of the ships are mimicked in the delicate spindly sea fan on the chair.

SEAFARER

This bathroom receives a theatrical underwater makeover with the addition of an octopus-covered shower curtain. The illustrated imagery of the sea creature seems fitting with the splash and spray that occur in a bathtub shower. It creates a delightful drama.

Abandon the usual plastic circular clasps and use rope instead to string up the fanciful design. An oversized rope tassel becomes the ultimate "soap on a rope," draped over the side of the gorgeous claw-foot bathtub.

SAND CASTLES

Oh, the tales this steamer trunk could tell...
A classic sailor's blue-and-white striped tunic is draped with a rough-edged linen scarf and herringbone vintage tuxedo vest, decorated with a royal blue and gold medal. A rolled-up treasure map and a battered lantern create an atmosphere of adventure.

I adore the textures of this vintage traveling box with its drawers, compartments, and built-in hanging space. What a wonderful way to travel and treasure your possessions—and what a shame they don't make luggage like this anymore.

A trunk like this could be used as a wardrobe in a small space such as a studio apartment, or set up in a corner as a storage and display home for your favorite pieces. It has plenty of hanging room and compartments for showing off all types of treasures, not just clothes.

SEAFARER

98　⚓　SAND CASTLES

SEAFARER 133

This kitchen, while modern, simple, and very functional, also has a nautical and industrial air. The checked red-and-white splashback is a simple effect evoking nautical precision. The two industrial-look swivel stools turn the island bench into an informal dining area, lit by a classic utilitarian pendant shade. With this style of kitchen, opt for classic hardware such as simple wooden pantry knobs and the porcelain basin with pulley handle taps. The lightly sanded edge of the wooden bench breaks up the overall pristine look. The decorative wicker flagons suggest a ship's galley kitchen.

SEAFARER ⚓ 135

MORE SEAFARER STYLING IDEAS

➤ Get swept away in seafarer style by using large-format maps and charts as wall hangings, or tear up a whole atlas and decoupage the pages as unique wallpaper.

➤ Pile well-traveled luggage, such as sea chests and steamer trunks, to table height to magnify their effect and give them new purpose.

➤ Revamp an old suitcase or leather doctor's bag with a nautical-inspired stencil: skull and crossbones or anchor graphics suit the look.

➤ Metal and enamel industrial lighting suggest a bygone era, when items were built to last. Their hard-edged forms would be at home in a harborside dock battered by the elements, where ships are readied for their next voyage. Mock pulley systems inspire unique ways to stylize hanging pendant lights in the modern home.

➤ Subway tiles suggest a factory of nautical hardware, or the sort of rough-and-ready on-land diner where a fisherman or sailor eats his first home-cooked meal.

➤ Seek out sea art. Seafaring was once the most common form of transportation and, as such, its importance was expressed in art. Immortalized in paintings, the ship became a symbol of progress, fearlessness, and power.

➤ Hunt out blankets and throws woven in a loose cable-knit that, as well as adding functional warmth, have the appearance of nets.

➤ Stack piles of vintage books with worn spines in all shades of blue as a homage to the colors that make up the ocean.

➤ Add sea-worn rope to almost any item to introduce nautical flair. For example, replace the hanging wire of a vintage beveled-edged mirror with hefty rope to create an appealing juxtaposition.

Chapter 3

Islander

A LEAFY, WOODY SCHEME INSPIRED BY THE EARTHY ABUNDANCE OF A TROPICAL ISLAND

*And it was good to be
a part of the world
and a world of its own
all surrounded by
the bright blue sea.*

— THE LITTLE ISLAND, BY MARGARET WISE BROWN, 1946

Palm-fringed shores

→ **A tropical oasis, where the lush jungle forest and swaying palm trees give way to the sea.**

The islander theme takes the concept of a coastal holiday one step further, asking how you would exist if you were to live on a tropical island forever. With plentiful supplies from island plantations, create your hideaway beach hut from what is on offer around you.

DEEP FOREST

FRESH GREENS LEND A SENSE OF VITALITY TO THIS TROPICAL MOOD BOARD. Notice how the mix of textures begins from the baseboard up, each layer adding further contrast and interest. Geometric patterns in a block design have a definite tribal feel, while botanical illustrations offer visual inspiration for fabric designs. Textile edges are left raw and unfinished. Buttons, beads, and carved tribal artifacts have a natural unevenness, offering a tactile experience. Shells reconnect the shore to the sea.

Islander
(noun)

AN INHABITANT OF AN ISLAND.

Island
(noun)

1. A LAND MASS, ESPECIALLY ONE SMALLER THAN A CONTINENT, ENTIRELY SURROUNDED BY WATER.

2. ESPECIALLY IN BEING ISOLATED WITH LITTLE OR NO DIRECT COMMUNICATION TO OTHERS.

ISLANDER COLOR PALETTE

Tropical greens (1, 2) reign supreme against light wood and sandy beige (3) tones; incorporating earthy base colors allows these verdant tones to really "pop." Ground the scheme with the inclusion of muted browns (4) found in textured barks and coconut shells, and the warm tan of well-traveled luggage (5).

SEEK OUT THESE ELEMENTS TO CREATE AN ISLANDER LOOK IN YOUR HOME.

➤ Lush tropical foliage ➤ Natural-texture wallpapers ➤ Pineapples ➤ Bamboo blinds ➤ Hula skirts ➤ Rattan furniture ➤ Hanging chairs ➤ Day beds (or other furniture you can easily lounge upon!) ➤ Shell mobiles ➤ Carved wooden furniture ➤ Leaf-shaped platters and plates ➤ Bamboo-handled cflatware ➤ Muslin lanterns ➤ Mosquito nets ➤ Terrariums (it's easy to make your own) ➤ Bamboo cloches (to repurpose as light shades) ➤ Pressed flowers and botanical illustrations ➤ Tiki masks ➤ Shark's tooth jaw casts ➤ Coconuts ➤ Tribal headdress and neckpieces ➤ Brass binoculars

1

2

3

4

5

ISLANDER 145

CREATING AN EVERYDAY RESORT

As a child I was always confused why, on school photo day, when we were all set up in front of the camera, the photographer would grin at us, abandon the usual "Cheese!," and instead urge us to cheer "Holidays!"

Now, as an adult, I realize why that simple word causes people to smile from ear to ear. The idea of a getaway from our everyday existence conjures up warm and heartfelt memories, instantly lifting the spirit and transporting us to a place where our breathing calms and hearts beat slower.

In Australia we're surrounded by ocean on all sides, so it's no wonder that holidays go hand in hand with bodies of water. We either escape to the edge, as far as we can go, where the land meets the sea, or cross the waters to venture further afield.

Regardless of where you live, how wonderful it would be to create an "everyday resort," capturing the tranquillity of a coastal holiday within the four walls of daily life.

LAND TIME

Sailors were often given "land time" when they arrived at their destination, giving them opportunity to explore the unknown wonders, and perhaps dangers, of the new land before them. As they recovered their "land legs" after what may have been months at sea, many were no doubt happy to simply rediscover the pleasures of the earth. Others, however, as we know from historical letters, drawings, and paintings, were on a voyage of discovery, recording every detail of their temporary new home, including the native flora and wildlife, as well as plant samples and specimens they had picked, trimmed, flattened, and dried.

Imagine the exotic air and the thrill of the foreign for these sailors and seafarers: strange animals, alien languages and customs, and new flowers with intoxicating scents. Now imagine, upon the sailor's return home, his walls proudly displaying island souvenirs and gifts from his travels at sea.

Incorporate functional and decorative elements from your island sojourns into your everyday life, inspired by the natural beauty of the trees and the sea: tribal patterning in monochromatic hues influenced by foliage, feathers, and fur; shells gathered and refashioned into garlands in the manner of island handcrafts; and spiky palm leaves laid flat and dried to create silhouette wall art.

A vintage hula skirt becomes the central inspiration for the palette of rich tropical greens used throughout this chapter. Notice the hessian band detail and the tan stitching as a complementary hue.

146 SAND CASTLES

A simple whitewashed wooden love seat fits neatly into the alcove of this bay window, as though made for it. Layers of tropical green create an inviting setting, with cushions and fabrics in leafy green prints adding comfort. A mosquito net is draped whimsically from above, with simple bamboo lanterns offering another point of interest. A carved-stump side table feels right at home here, with a collection of shells and organic-shaped pottery in similar green tones completing the look. Mock tile wallpaper is rolled out to ground the set-up, its intricate patterning mirroring the tangle of greenery visible through the window.

148 · SAND CASTLES

This table setting is inspired by land time, as if a sailor-turned-botanist has set up his temporary work quarters in a linen tent on the island's shoreline. Here he lays out his latest finds to admire and analyze, using heavy bound books from the mother country to cross-reference his notes.

The linen curtains enclosing the tent are overlapped. Hung low over the circular table, a lantern hand-crafted from bamboo and the lightest of silks takes on an organic form.

On the table, glass domes display shell and plant specimens. Create your own terrariums by simply placing offcuts of succulents and cacti in shells to encase their roots. These hardy, water-wise plants only need a mist of water as a quick drink every now and then to keep them happy.

The island's lush green foliage is replicated in the batik fabric, casually thrown across the table as a landscape of patchwork designs, each inspired by nature itself.

Platters and plates in leaf motifs are reminiscent of botanical illustrations and hark back to a pre-industrial times, when communication came from the skill of hand upon paper.

Complementing the round table, the rattan floor mat is made up of smaller rattan circles, all working with the circular tops of the glass domes to give the setting a pleasing visual continuity.

ISLANDER 149

An army-green enamel pendant shade hung from rope, teamed with a fold-out wooden stool with a simple striped canvas seat, suggests a temporary camp for exploring a new-found tropical island. Wallpaper with a palm tree motif is rolled out as a backdrop, and the kantha blanket, hand-stitched in similar colors and patterns, sits folded and ready to offer warmth to the voyager on their first night on the island.

Can you imagine a more tropical alfresco setting in which to recline and relax? This poolside corner cabana is purpose-built with a raised platform large enough to hold a king-size day bed. The thatched roof provides shelter from the elements, while also adding hand-crafted texture. A carved Balinese window panel, set in one of the sandy rendered walls, offers a glimpse of the forest beyond. Take inspiration from the surrounding lush greenery as the starting point for your textile palette, then balance the hues with a warm tone, introduced here with the spectacularly large seashell.

ISLANDER 151

LOFTY ISLAND TREEHOUSE

Set the table for a tropical feast. What exotic fruits and berries will you discover around your new island home? Take their organic forms as inspiration for your table setting. Here, the food cloches and covers in semi-circular textured shells mimic fruit husks.

Above the striking driftwood chandelier, the vaulted ceiling is painted all-white to emphasize the airy nature of this outdoor room, with the balcony giving canopy views into the lush vista beyond. This open-sided space is a wonderful example of blending interior and exterior architecture.

Maximize the proportions of a lengthy dining table by creating a fabric table runner, here in a geometric green pattern, that flows down its entire length and cascades onto the floor at each end. The hefty proportions of the wooden furniture are counter-balanced by the structure's solid support beams, giving a hand-constructed esthetic, connecting with the magnificent tall trees outside.

Notice how the inclusion of a rug softens this outdoor space, its simple striped hues harmonizing perfectly with the interior and external setting, as well as the mix-and-match cushions. As a fresh final touch, some cut tropical leaves on the table bring the island jungle into the home.

ISLANDER 153

Light woods mix effortlessly with tropical greens. To the right, a vintage German teaching chart demonstrates a variety of ferns and sets the leafy tone, while the collection of seashells emphasizes the coastal connection. On the chair a classic ticking fabric in green (rather than the more usual blue or red) mixes with a lattice-print linen cushion and a tactile ikat throw with worn fringing. All the green tones here—from lime green to bottle green—create a pleasant spectrum, balanced by the gentle wood hues and the vintage-paper tone of the fern wall chart.

Simple everyday kitchen items —such as the vintage milk jug, above, and flatware with molded bamboo-patterned handles—are both practical and decorative, and help turn meal times into magical island moments.

154　SAND CASTLES

Farne

This room just begs you to take an afternoon siesta, don't you think? The light wood tones and vivid yet soothing greens all add to the inviting feel.

A mosquito net centrally draped over the bed creates a heavenly canopy, cascading onto a variety of soft linens gracing the bed.

The bed frame is impressive in scale, and the intricate carved wooden tile feature and whitewashed tone adds to its hand-crafted appearance. Notice how the inclusion of one cushion displaying a palm tree motif instantly transports the dreamy setting to a far-flung island. Taupe linens brought into the scheme balance the brighter colors.

A chandelier of wooden shards floats over the space, as if in homage to sea life. You could imagine it moving in the late afternoon coastal breeze, bringing refreshing coolness to the balmy evening.

The sliding louver doors add to the impressive architecture and continue the appealing symmetry of the space. They are highly functional, creating privacy when closed, while allowing cooling sea breezes in through the panels.

Recalling a traditional fold-out fishing stool, this lightweight bamboo stool can be easily moved around and used as a plinth on which to display found items.

Even piles of aged books can be used as temporary pedestals to display little treasures upon. The more tarnished and yellowed the pages, or threadbare the spine, the better! Match such books in color-coded piles, or group them based on titles to delightful effect.

Who doesn't love the idea of an outdoor shower?
It's the perfect spot to wash the remnants of the day's adventures from sandy feet before entering the home. Exposed plumbing and the simplest of showerheads are all that is needed. With its flaking paint and rusted fixtures, the reclaimed jetty pylon dug into the ground, as though it has always been there, becomes a sculpture referencing the nearby sea. Underfoot, similarly rustic sleepers become a shower platform. A rendered pure white wall shields the bather from the neighbors' eyes.

A bamboo cloche is hung by knotted rope as a temporary bedside pendant. The real purpose of such an item is to cover and protect delicate plant life, so it is ideal in this green-toned scheme.

Seek out vintage books with amusing titles to use as decorative pieces that tell a story. Here, *Voodoo Island* has a cover design that suits the mood and colors of the room and its title strikes an amusing note.

An ornate day bed beckons you to take an afternoon snooze. The carved wooden frame is suggestive of Balinese artisan markets where you might find one-of-a-kind treasures. Notice how the circular design of the cushion, created with stitched-on sticks, mimics the low-hanging pendant.

A bold splash of green on the inside of one shutter door breaks up any formality in the architecture of this building. Shutters help control ventilation and light into the home.

Seek out homewares and furnishings that have an organic influence. Here, a green chevron-stripe pattern and palm-leaf motif add to the feeling of a tropical oasis.

Step up onto this alfresco lounge area, where the wood decking has been left untreated to age gracefully from exposure to the elements. Overhead, a canopy is created from lengths of tree trunk that produce delightful shadows over the space, depending on the time of day and angle of the sun.

UPCYCLING & REPURPOSING

As you may have noticed, I'm not one for sticking to convention, especially when it comes to reimagining furniture pieces and putting them to new use.

There is one rule, however: the item should be the same height as the piece of furniture it is replacing, otherwise it won't be very functional or practical. Side tables and stools are almost interchangeable, along with any item that is around 18 inches (45 cm) tall. Stack crates or suitcases to this height; conveniently, these items also allow for extra storage within.

For a bed, you could layer wooden transport pallets to a height of around 24 inches (60 cm), including the mattress, to make it a suitable height.

Wooden cable reels are perfect for dining on if they're large enough—up to 30 inches (75 cm) tall should allow for comfortable seating. A cable reel that is around 16 inches (40 cm) high makes a unique coffee table.

TIKI TIME!

In Maori mythology, Tiki was the name of the first man. The term evolved to refer to any large wooden or stone carvings made in a human-like shape, which were used to signify the entrance to sacred sites on the Polynesian islands.

162 SAND CASTLES

Create a display of the finds from your tropical expedition. A large carved wooden mask in classic tiki style complements the smaller sculpture of a female villager. The leaf-patterned fabric draped as a wall covering introduces tan into the color palette, reminiscent of languid sunsets, or the worn leather of a seasoned traveler's luggage. Mixed cushion coverings add tactile interest. A hand-carved wooden stool, organic in tone, doubles as a side table for a pile of books chronicling island adventures.

This kitchen exudes artisan workmanship. Designed and created by a crafter, the flaws in the wood are left exposed, even highlighted—note how the deep cracks contrast against the vivid green paint. The island bench has an impressive, heavy tone, as if carved from one massive tree.

The bench top is dressed with carved vessels with a similarly organic tone, displaying island fruits. The bouquet of mini pineapples makes a unique floral arrangement that is bound to draw attention. Befriend your local florist and ask them to keep an eye out for such rarities at the early-morning flower markets.

On the wall, a simple yet appealing pattern is stamped out in a soft-green pigment. A souvenir tablecloth looks far from kitsch here as its colors and motifs blend perfectly into the scheme. If you have a discerning eye and can weed out the tacky, you never know what you might find in souvenir shops. Vintage tourist items hold great appeal as they offer an insight into the esthetic of another era, and a nostalgic glimpse into how we chose to spend our leisure time.

This bedroom has the relaxed feel of a tropical plantation-style home, an effect achieved through the white wood paneling and the low louver window, which opens out onto the island greenery beyond.

Inside, rich tropical greens in leaf motifs and stripes delight the eye, accented vividly against the white walls.

I adore pendant shades hung low to the bedside, like this bold green wicker dome. They are functional for individual bedtime reading, and their proportion and scale when placed in this position really work. If you are building or renovating, suggest to your electrician you'd like to wire in similar lights. Even consider making the drop cords extra-long—you can move them around the space by looping them from hooks on the ceiling, for different looks and placements.

166 ✕ *SAND CASTLES*

I love how this setting is so other-worldly. The exotic peacock-style wicker chair has been updated with a coat of vivid tropical-green paint, and rests upon a simple but wonderfully tactile sea-grass mat that has a hand-crafted artisan feel. A side table is modeled from a raw wood trunk; upon it, a large shell holds whispers of the sea.

A lazy hammock rests on standby against a hand-crafted basket, ready to be strung up for an island siesta.

SEA-GRASS MATTING

The manufacturer of this sea-grass matting, so popular in the 1970s, once carried over twenty styles and designs. Nowadays there's just one variety on offer, but it makes for a cost-effective floor solution you can simply cut with garden shears and lay yourself. The texture isn't exactly plush, but it is perfectly practical for a beach shack, where sandy feet are the only ones that come through the door.

This simple table setting mixes many impressive elements to tell a unique story. Underfoot, a geometric, tribal pattern is stamped out in striking green and white, a color theme that continues in the massive pendant, hung low above the table and strung up by rope; a simple stripe of green paint has been applied to suggest a tropical air. The industrial-looking chairs were formerly school chairs, imported from the Philippines. The untouched wall has an arresting patina in natural tones, an effect softened by the makeshift muslin blind, with bamboo rods at each end. The raffia tasseled beach umbrella suggests many sundrenched days of seaside pleasure, every ounce of color stripped dry by the sun, wind, salt, and sea spray. It rests here against the wall, waiting to be put to use.

ISLANDER 169

Along this wood-paneled wall, the homeowner found just the right spot to mount a handsome panel salvaged from a previous renovation. It's a unique piece asking to be hung and displayed with treasured mementos. The hessian covering the wall panel earths the tropical palette, the greens in the leaves, botanical illustrations, and treasure maps playing delightfully against it. The jute floor mat adds further textural interest.

The shell curtain that divides the spaces has a lovely hand-crafted feel, while the brown bamboo chair with winged armrests invites repose.

I SAW A SHIP A SAILING...

**This collection tells a story of tropical discovery:
brass binoculars on the look-out across the horizon;
a small boat ornately carved from wood and poised for adventure, resting upon tomes that retell stories of adventures;
a palm drawing posted to the wall documenting a new tropical find...**

ISLANDER 171

NATURALLY EXOTICA

Don't make a noise or they will dart away . . . revered for their exquisite beauty, the elegant egrets and flamingos immortalized in these paintings evoke images of an unspoilt island paradise. The delicate pinks of the flamingo feathers and lotus flowers are a perfect foil for the lush green tropical foliage, creating a fresh palette to draw ideas from.

Inspired by the bird paintings opposite, this setting brings all their delicate hues to life. A vibrant rendered wall makes a lovely backdrop for the verdant tropical foliage; the monstera leaves from the garden help to blend the man-made setting with its natural surrounds. A whitewashed timber table is casually strewn with green linen ticking as a make-do runner. But the hero pieces are the vintage pineapple-back patio chairs, left to rust into a weathered patina; the seats are upholstered in old hessian sacks, adding another earthy touch. Sea-grass matting is rolled out to help ground the indoor–outdoor sensory mix-up.

HUNTING & GATHERING

Ebony black gives this scheme a tribal edge, the monochromatic hue suiting hand-crafted block patterns. Feathers, shells, and coconut-husk buttons all add layers of interest.

In times gone by, the fine feathers of majestic island birds were valued for their intrinsic beauty and used for personal adornment, as the neckpiece mounted on a delicate stand shows. With its cut-shell and beaded collar, it displays a wonderful symphony of natural textures. Such previously hard-to-find pieces are now more readily available as decorative homewares (you might even choose to wear them on occasion).

The formality of the flock wallpaper hanging against the wall falls away when you identify the subject matter, and becomes instead a quirky homage to the most tropical of fruits, the pineapple.

The earthy palette maintains interest through the mingling of textures and tones. The grain of the wall, constructed from a stack of wooden sleepers, becomes a textured backdrop, while the bolted-on cladding balances the scale and weight of the solid wooden chair, softened by a black cushion embellished with coconut-shell buttons.

ISLANDER 175

A sea-battered wooden sleeper becomes a shelf built into the architecture of this home. Upon it, a still life celebrates hunting and island crafts—an ebony-stained decorative mask resting next to a shark's jaw, the teeth still pointy enough to cause injury. A small chandelier hand-crafted from shells further connects this island home to the sea.

Layered textures bring to life this striking black and wood scheme. A woven rug creates the base texture, which continues in the seat cushion of the high-backed chair, covered simply in a stamped hessian sack—using similar colors and textures develops the subtle palette. A carved wooden side table holds a gloss-black pineapple sculpture for a touch of whimsy, along with a trio of fan-like leaves that have been dried out and sprayed black.

Overhead, a spiky round wicker pendant has a wonderfully organic look—a prime example of how to take your cue from the textures and forms found in seaside nature and incorporate them into a timeless design. With raw edges that spin into an urchin-like protective armor, this pendant looks thoroughly modern and individual.

MORE ISLANDER STYLING IDEAS

➻ Indoor palms create a green oasis. Add hanging planter pots with delicate ferns, or wall-mounted staghorns, to create your own indoor rain forest. Or hang palm fronds above your dining table as a simple yet eye-catching centerpiece.

➻ Work pineapples and other tropical fruits into floral displays. Long gymea lily leaves, birds of paradise, and flat tropical leaves create a lush mini-rain forest in a vase. A simple stylist's secret: a squirt of hairspray adds extra sheen to plant foliage.

➻ Seek out Hawaiian broadcloth and hessian base fabrics in neutral hues and strong open weaves. The stiffness of these textiles suggests a hardy, island-ready purpose.

➻ Sea-grass wallpapers are reeds woven into beautiful tactile papers, every bit unique—no two sections are the same, unlike mass-produced decorative patterns. A thin line is visible between each loom; it's an effect you would try hard to avoid when using normal wallpaper, but sea grass proudly displays its mismatched joins, saying "I'm unique! No two parts of me are ever the same." Just as in nature.

➻ Use tribal-inspired headpieces and necklaces as décor items. The most elaborate is the juju hat, a circular creation consisting of hundreds or more feathers. It can be found in every color of the spectrum, from natural white to vivid hues. When hung flat, it transforms into a striking wall piece.

➻ If you are planning a new home, draw inspiration from island nations. Interconnecting pavilion-style pods, popular in Indonesia for example, offer laid-back coastal living.

In Turkish and Mongolian, "yurt" simply translates to "home." Its tepee-like design was developed as a portable dwelling by nomads of Central Asia thousands of years ago. The circular form is not only appealing but symbolic, leading the eye to a central crown pattern overhead; this center emblem would be passed down through generations, even though the yurt itself may have been rebuilt over time. Layers of insulating sheep wool traditionally covered the self-supporting tent structure.

Some gypsetters have adopted the yurt as a modern-day portable abode; it makes perfect temporary accommodation for a music festival, for example. You can easily create your own mobile retreat—capture the mood by decking out a yurt or tent with all forms of plush comforts, referencing a medley of styles, from the vibrant fabrics of the original gypsies to a relaxed beach look of beaded shell curtains.

The structural circular wooden latticework provides an interesting backdrop for the bedroom setting in this modern cloth-covered yurt. The floor is piled with Turkish rugs in warm tones, providing an inviting passage underfoot. The bed is strewn with linens in contrasting plum and orange tones, the artisan patterns mixing to wonderful effect, and the orange hues adding an almost Buddhist-like serenity. An eye-catching trio of elaborate umbrellas filters the natural light from the skylight above, giving the space a warm glow.

A small wooden dressing table is set up with folksy items and adornments, ready to add the finishing touches to your outfit.

BOHEMIAN

This table setting reminds me of an underwater dive to a colorful coral reef: clusters of spiky coral and bubbled barnacles in blushing hues, its palette of faded pinks and azure blue, all brought further to life with a sprinkle of tarnished gold.

The fan is a feminine motif that offers a visual link back to the flamenco gypsies who pioneered bohemian style. The vintage crocheted tablecloth, on which are laid an assortment of linens that have been over-dyed in brilliant hues, adds a further sense of femininity to the setting.

Tea-light candleholders and embellished Moroccan tea glasses suggest the far-off and exotic. Don't be afraid to use a mix and mismatch of crockery and flatware to create a similarly relaxed, rummaged gypsy appeal. Platters and plates often have an ornate appearance, but in a setting such as this they are far from formal.

BOHEMIAN 217

This patchwork floor of elegantly patterned tiles has a hypnotic effect that sums up the bohemian esthetic of mixing old and new, feminine and rustic.

The amazing mosaic flooring, and the entrancing texture of the hammock—strung up like a fishing net, resplendent in the marine hues of some mythical sea creature—set the space for the seashell-encrusted pedestal. It glistens and glows in pearly sheens of pinks and aquas, all playing against each other as though plucked from an underwater wonderland. Perched on the pedestal, a rustic sphere is a sculptural focal piece, proudly supported by an upturned fish.

Like altars to the sea, these unique shell-craft creations are superbly displayed against the clean white wall. Each shell has aged over time, retaining just a remnant of its original pearly gleam; their muted aspect blends well with the darkened timber doors of the carved Indian buffet underneath. The bouquet of pink and golden flowers, crafted from individual shells, adds a soft, feminine appeal to an otherwise woody scheme, balancing the bright pompom garland that drapes onto the richly hued Aztec rug.

BOHEMIAN 219

The lavish engravings on this wooden console find a subtle echo in the textures of the shell-covered lighthouse table lamp, a loving tribute to seashore life. A dark-stained Eastern icon and bright tropical blooms suggest gypsetter travels to coastal islands and back.

SAND CASTLES

A day bed is casually covered in mismatched cushions, setting off the random patterns in the distressed wood paneling behind. Small paper lanterns add a festive touch to the everyday setting.

222 SAND CASTLES

A fantastical rattan bedhead fits into the "peacock" family of furniture, so-called because of their resemblance to a peacock's display of feathered beauty. Spreading over the bed, a patchwork of folk prints is stitched together, complemented by richly patterned cushions, and a lotus-shaped table lamp on the wooden side table.

At the end of the bed a beautiful carved bench seat holds a collection of folksy painted boxes and trinkets that suggest a gypsetter's favorite pastime: travel. Open a box to find hand-collected shells, which can be made into original and individual jewelry pieces; the sea often creates the perfect opening to thread such pieces together into unique designs.

MORE BOHEMIAN STYLING IDEAS

➤ Drape scarves and tasseled shawls over furniture ends: a true sign of a bohemian's blend of fashion and interiors.

➤ Take this a step further and pin a large sari to the wall as a delicate bedhead. Ornately carved decorative screens suit a similar purpose and exude a feminine flair.

➤ Wicker and rattan sculpted into unique furniture finds such as high-back peacock chairs are perfect for the bohemian look. Bring them up to date with a coat of paint, rustically whitewashed, or with a pop-colored hue.

➤ The almost-forgotten crafts of macramé and beading are rediscovered by a new generation. Seek out hanging planter pots and decorative wall hangings—vintage finds, if you are lucky, or modern creations in fashionable colored threads.

➤ The bohemian existence is a creative one, but also a leisurely one. The most enriching or expressive ideas may come from an afternoon siesta on a crocheted hammock hanging beside a beachside abode, so source relaxed furniture pieces that inspire artistic thought-time.

➤ Lay a wall in mismatched Turkish tiles, each one handcrafted and painted so no two are the same. Such a mosaic is a graphic example of the individual spirit of this esthetic.

BOHEMIAN 225

Chapter 5

Endless summer

**COLORFUL STYLING
DRAWING UPON
NOSTALGIC SEASIDE
HOLIDAY MEMORIES**

*A VACATION IS
HAVING NOTHING TO DO*
AND ALL DAY TO DO IT IN.

— ROBERT ORBEN

Sunny shores

➤ The most colorful of the coastal decorating schemes, this style recalls those long, carefree days of youth and warm, golden summers from days gone by.

Patterns and palettes once considered kitsch find fresh new forms, tugging on the heartstrings and harkening to a simpler time.

FADED
GLORIES

THE MOST VIBRANTLY JEWELED OF THE COASTAL MOOD BOARDS... BUT NOTICE HOW EACH HUE IS A FADED VERSION OF ITS ORIGINAL LUSTROUS SELF. Over time, worn by the elements, layers of paint have flaked and paled. Holiday souvenirs, postcards, happy snaps, and mementos are all joyously collaged here. Seductively colored lures and other fishing paraphernalia please the eyes of both landlubbers and fish. Coral pieces hand-painted with food dyes re-establish an underwater wonderworld on land.

Endless summer
(slang)

1. A SEEMINGLY EXTENDED DURATION OF THE WARMEST SEASON, WHEN REMINISCING AT A LATER DATE.
2. THE TITLE OF A CLASSIC SURF MOVIE.

ENDLESS SUMMER
COLOR PALETTE

The sizzling tones of this palette recall trips to the beach kiosk and the kaleidoscope of sorbets and lollipops on offer. Flamingo pink (1), canary yellow (5), mint green (4), a coral hue (2), and ocean blue (3) fit the licorice-stripe scheme. However, all are presented in a slightly faded hue, like that of a once-vibrant holiday postcard. It is the washed-out tones that tie the seemingly contrasting colors together so successfully.

To visually communicate a concept through a color palette, try something outside the square: dip vintage tourist spoons into sample paint pots and lay them side by side for a unique vision of how the different tints will look next to each other and the story their combination has to tell.

SEEK OUT THESE ELEMENTS TO CREATE YOUR OWN TAKE ON AN ENDLESS SUMMER LOOK IN YOUR HOME.

- Vintage postcards
- Felt tourist flags
- 1960s patio furniture
- Striped canvas
- Colorful fishing lures
- Retro beach towels
- Surfboards
- Striped umbrellas
- Paper umbrellas
- Vintage vinyl (for the covers as much as their tunes)
- Deck chairs
- Plastic strip door curtains
- Souvenir-shop salt and pepper shakers
- Original ice-box coolers and cordial bottles
- Garden ornaments, such as flamingos
- Don't forget the garden sprinkler, essential on a hot afternoon!

1

2

3

4

5

ENDLESS SUMMER 233

HOLIDAY CHARMS

So many of us have fond memories of childhood family holidays, packed into a car alongside siblings. It seemed like a never-ending road trip to get to the seaside destination, punctuated with cries of, "Are we there yet?"

This chapter's esthetic has its tongue firmly planted in its cheek. The aim is to entice a sense of thoughtful nostalgia and amusement at the way we once spent our leisure time.

I still love getting out on the open road with the stereo pumping. Passing sleepy little coastal towns full of unchanged charm and character, I sometimes find it hard to keep my eyes on the road, drawn in by the breathtaking rural scenery, roadside fruit stands, and, my personal favorite, the country motels. Next time you're driving to a remote seaside town, where a caravan park or camping spot beckons, notice the pastel-hued motor inns dotting the freeways. Their kitsch esthetics never fail to delight. It's almost as though there's a competition among motel owners as to who can display the brightest plumage of colors on their painted brick façades, and who can light up their neon "Vacancy" sign in the gaudiest retro font with the most fanciful sea mascot. The names themselves often sound like exotic cocktails.

In Australia any long journey is often broken by the bizarre sights of our peculiar obsession with enormous iconic sculptures: the "big Merino sheep," or the "big prawn," the "big banana," or even the "big beer can." We like it larger than life, molded in fiberglass, and impaled on a stick—preferably in the middle of nowhere. I guess it breaks up the never-ending road trip into smaller chunks of enjoyment. I imagine it's a similar effect to the scale signage at Las Vegas, Times Square, or Piccadilly Circus . . . except our landmarks are spaced hundreds of miles apart.

Imagine a travel brochure from yesteryear come to life as an interior setting in your home. But it's not merely a retro re-creation presented here—each styled scenario mixes both the vintage holiday with the new. The contrast presents a fanciful way of spending those long summer days.

Objects from the past are offered up in weathered tones, preventing the kitschiness from looking too overblown, and casting the past in a soft and sympathetic light.

Some holiday items remain timeless and perenially appealing, no matter what generation reinterprets them as their own; a striped umbrella, a colorful bodyboard, or melting ice creams all play a part in our collective summer vocabulary.

ENDLESS SUMMER 235

ENDLESS SUMMER 237

WORLD OF WALL ART

Against plain white wall paneling, an ever-growing and changing artwork emerges in this home. By simply sticking and pinning vintage holiday postcards in a random group, it is easy to create an appealing collection that works as a mass artwork because of the common shapes and colors.

238 SAND CASTLES

ENDLESS SUMMER ⚓ *239*

240 SAND CASTLES

A pair of old wooden deck chairs, in what would once have been rich red and sunny yellow, are testament to many days of enjoyment in the summery outdoors. Resting alongside, fishing rods await their next outing. Reminiscent of a canvas from a caravan, or a kitchen from an earlier era, a tartan pattern is rolled out in pastel tones. A blue enamel fan sitting on one of the chairs speaks of warm summer days, while a vintage wall thermometer charts the rise in mercury. The pineapple print cushion in canary yellow adds a contemporary burst of color.

ENDLESS SUMMER

SHADES OF SUMMER

Pull up an original patio chair, updated with a spray of teal, and join the backyard party. A record player pumps out tunes from another era; seek out vintage record sleeves for their retro cover artwork. The striped beach towels mimic the canvas on the impressive umbrella, which provides much-needed shade. Plastic strip door curtaining adds color and movement, keeping unwanted flying insects outdoors.

Make yourself a mocktail in retro glassware —complete with a paper umbrella, of course. The cockatoo garden ornament looks right at home in this scheme.

This original fibro-cement beach shack has been invigorated by being painted a fresh green all over, with contrasting white trims, and a fuchsia pink roofline, paying homage to the era in which it was built. It certainly is noticeable from the street! But the bold color choice seems an appropriate one here, holding its own against the clear blue summery sky.

Nothing typifies Endless Summer more than a wall of surfboards, lined up in sorbet colors against a mint-green privacy screen. Wooden decking and outdoor furniture are left to weather gracefully through exposure to the elements; the fresh colors of the sunny cushion and striped towel seem even brighter by contrast. A classic black and white awning completes the quintessential beachside cottage look.

ENDLESS SUMMER 243

This sunny bedroom scheme tells a summer story. The golden walls provide the backdrop for a holiday-inspired collection. A much-loved surfboard is assembled as a bedhead, the scale of a board perfect for such use. The bed is dressed with simple striped linen, its fringed edge reminiscent of a beach umbrella. The original 1950s cooler box is an unusual round shape, but makes a great bedside table. A cockatoo lamp is an eye-catching piece, especially when lit. On the wall, a felt tourist flag evidences holidays from times past.

Canary yellow, sky blue, and crisp white create a classic coastal palette, one that is also a popular choice for brightening beachside bathing boxes. These colors immediately transport me back to childhood days spent at the local public swimming pool. Many of these pools remain unchanged since the 1960s, with stenciled diving blocks and cement grandstands, their sun-washed, pastel-colored hues complementing the ripples of the crystal-clear blue water, like a David Hockney painting of Hollywood sun and sky against a summer patio landscape.

 The mosaic floor tiles in this beach shack remind me of those on the bottom of a swimming pool, often spelling out words or the number of the swimming lane.

 A pineapple-print wallpaper evokes a simpler time, with the motif manifesting again in the base of the vintage table lamp. The old tasseled shade is updated with a lick of paint, the yellow stripes resembling a bright kiosk awning.

 Blue is an unexpected choice for a pineapple, but therein lies the whimsy of this set-up. Do you remember how, to make food appealing to children, it was often re-created in a fanciful color? Consider the variety on offer at the pool kiosk: rainbow popsicles, and other brightly colored ice creams that left a blue stain on your tongue well after the initial enjoyment.

 Borrow slogans from a poolside kiosk for your next informal gathering; make a sign pointing to your drinks station or finger-food table, heralding "Icy Cold Drinks" and the like. While you're at it, consider serving up mini ice-cream cones as a novel dessert.

 Wrap a circular side table in colorful nylon rope to resemble a wharf-side reel of rope. Imagine the same idea executed with a sea-worn rope; this would create an entirely different effect.

ENDLESS SUMMER 245

assist verb (assists, assisting, assisted)
To assist someone means to help them.

assistant noun (plural **assistants**)
1 someone whose job is to help an important person
2 someone who serves customers in a shop

assorted adjective
Assorted things are things of lots of different types. ▶ *We bought a bag of assorted sweets.*

asthma noun (pronounced **ass**-ma)
Someone who has asthma sometimes finds it difficult to breathe.

astonish verb (astonishes, astonishing, astonished)
If something astonishes you, it surprises you a lot.
ℹ When you feel very surprised, you are **astonished**. **Astonishment** is a feeling of great surprise.

astronaut noun (plural **astronauts**)
someone who travels in space

at preposition
1 in a place ▶ *Tom is at home.*
2 when it is a particular time ▶ *I'll meet you at two o'clock.*

ate verb SEE **eat**

athletics noun
sports in which people run, jump, and throw things
ℹ Someone who does athletics is an **athlete**.

atlas noun (plural **atlases**)
a book of maps

atmosphere noun (pronounced **at-moss-fere**)
the air around the Earth

atom noun (plural **atoms**)
one of the very tiny parts that everything is made up of

attach verb (attaches, attaching, attached)
If you attach things together, you join or fasten them together. ▶ *We attached a string to the kite.*

attack verb (attacks, attacking, attacked)
To attack someone means to fight them and hurt them.

attempt verb (attempts, attempting, attempted)
When you attempt to do something, you try to do it. ▶ *The prisoner attempted to escape.*

attend verb (attends, attending, attended)
If you attend school, you go to school. If you attend an event, you go to watch it.

attention noun
1 When you pay attention, you listen carefully to what someone is saying, or watch what they are doing.
2 When soldiers stand to attention, they stand with their feet together and their arms by their sides.

attic noun (plural **attics**)
a room inside the roof of a house

attitude noun (plural **attitudes**)
Your attitude to something is what you think about it. ▶ *You have a very good attitude towards your work.*

attract verb (attracts, attracting, attracted)
1 If something attracts you, you feel interested in it. ▶ *The toy attracted the baby's attention and he stopped crying.*
2 To attract something means to make it come nearer. ▶ *A magnet will attract some types of metal but not others.*

attractive adjective
An attractive thing is pleasant to look at. An attractive person is beautiful or handsome.

auction

auction *noun* (*plural* **auctions**)
a sale when things are sold to the people who offer the most money

audience *noun* (*plural* **audiences**)
all the people who have come to a place to see or hear something

August *noun*
the eighth month of the year

aunt, **aunty** *noun* (*plural* **aunts** *or* **aunties**)
Your aunt is the sister of your mother or father, or your uncle's wife.

author *noun* (*plural* **authors**)
someone who writes books or stories

authority *noun*
If someone has authority, they have the power to make other people do things. ▶ *The police have the authority to arrest people.*

autism *noun*
Someone who has autism finds it difficult to communicate with other people.
ⓘ Someone who has autism is **autistic**.

autobiography *noun* (*plural* **autobiographies**) (*pronounced* or-toe-by-**og**-ra-fee)
a book that tells the story of the writer's own life

autograph *noun* (*plural* **autographs**) (*pronounced* **or**-toe-graf)
When a famous person gives you their autograph, they write their name down for you to keep.

automatic *adjective*
Something that is automatic works on its own, without a person controlling it. ▶ *We have an automatic washing machine.*

autumn *noun*
the time of the year when leaves fall off the trees and it gets colder

available *adjective*
If something is available, it is there for you to use or buy. ▶ *The new toys are not yet available in the shops.*

avalanche *noun* (*plural* **avalanches**)
a large amount of snow or rock that slides suddenly down a mountain

avenue *noun* (*plural* **avenues**)
a wide road in a town or city

average *adjective*
ordinary or usual ▶ *What's the average weight of an elephant?*

avocado *noun* (*plural* **avocados**) (*pronounced* av-o-**car**-do)
a fruit with a dark green skin, green flesh, and a large stone in the middle

avoid *verb* (**avoids, avoiding, avoided**)
If you avoid something, you keep away from it. ▶ *Try to avoid main roads when you are cycling.*

awake *adjective*
When you are awake, you are not sleeping.

award *noun* (*plural* **awards**)
a prize ▶ *Tom got an award for his bravery.*

aware *adjective*
If you are aware of something, you know about it. ▶ *I was aware of somebody watching me.*

away *adverb*
1 not here ▶ *Ali is away today.*
2 to another place ▶ *The boy ran away.* ▶ *Put your books away now.*

awful *adjective*
Something that is awful is horrible or very bad. ▶ *What an awful smell!*

awkward *adjective*
1 Something that is awkward is difficult to do or difficult to use. ▶ *This big box is awkward to carry.*
2 If you feel awkward, you feel embarrassed.

axe *noun* (*plural* **axes**)
a sharp tool for chopping wood

Bb

baby *noun* (*plural* **babies**)
a very young child

back *noun* (*plural* **backs**)
1 Your back is the part of your body that is behind you, between your neck and your bottom.
2 An animal's back is the long part of its body between its head and its tail.
3 The back of something is the part opposite the front. ▶ *We sat in the back of the car.*

back *adverb*
If you go back to a place, you go there again. ▶ *He ran back home.*

background *noun*
The background in a picture is everything that you can see behind the main thing in the picture.

backpack *noun* (*plural* **backpacks**)
a bag that you carry on your back

backwards
1 towards the place that is behind you ▶ *Can you skate backwards?*
2 in the opposite way to usual ▶ *Can you count backwards?*

bacon *noun*
thin slices of meat from a pig, which have been dried or soaked in salt

bad *adjective* (**worse**, **worst**)
1 Something that is bad is nasty or horrible. ▶ *The football match was cancelled because of the bad weather.*
2 A bad person does things that are against the law. ▶ *The police always catch the bad guys in the end.*

badge *noun* (*plural* **badges**)
a small thing that you pin or sew onto your clothes, to show which school or club you belong to

badger *noun* (*plural* **badgers**)
an animal that digs holes in the ground. It has a white face with black stripes on it.

badly *adverb*
1 If you do something badly, you do not do it very well. ▶ *Our team played very badly today.*
2 If you are badly hurt or upset, you are hurt or upset a lot.

badminton *noun*
a game in which people use a racket to hit a very light shuttlecock over a high net

bag *noun* (*plural* **bags**)
something that you use for carrying things in

baggy *adjective* (**baggier**, **baggiest**)
Baggy clothes are loose and not tight on your body.

Baisakhi *noun*
a Sikh festival which takes place in April

bait *noun*
food that you put on a hook or in a trap to catch animals

bake *verb* (**bakes, baking, baked**)
When you bake food, you cook it in an oven. ▶ *I baked a cake.*

baker *noun* (*plural* **bakers**)
someone whose job is to make or sell bread and cakes
❶ The place where a baker makes or sells bread and cakes is a **bakery**.

balance *noun* (*plural* **balances**)
1 A balance is a pair of scales that you use for weighing things.
2 If you have good balance, you can hold your body steady and not fall over.

balance

balance *verb* (balances, balancing, balanced)
1 When you balance, you hold your body steady and do not fall over. ▶ *Can you balance on a tightrope?*
2 If you balance something, you put it somewhere carefully so that it does not fall. ▶ *He balanced a coin on the end of his finger.*

balcony *noun* (*plural* **balconies**)
1 a small platform outside an upstairs window of a building, where people can stand or sit
2 the seats upstairs in a cinema or theatre

bald *adjective*
Someone who is bald has no hair on their head.

ball *noun* (*plural* **balls**)
1 a round object that you hit, kick, or throw in games ▶ *Try and catch the ball when I throw it to you.*
2 a big party where people wear very smart clothes and dance with each other

ballerina *noun* (*plural* **ballerinas**)
a woman who dances in ballets

ballet *noun* (*plural* **ballets**)
a type of dancing in which women dance on the very tips of their toes

balloon *noun* (*plural* **balloons**)
1 a small, colourful rubber bag that you can fill with air and use for playing with or to decorate a room for a party
2 a very big bag that is filled with hot air or gas so that it floats in the sky. People can stand in a basket underneath the balloon.

bamboo *noun*
a tall, tropical plant with stiff, hollow stems. The stems are used to make furniture.

ban *verb* (bans, banning, banned)
If you ban something, you say that people are not allowed to do it. ▶ *They have banned skateboarding in the playground.*

banana *noun* (*plural* **bananas**)
a long yellow fruit that grows in hot countries

band *noun* (*plural* **bands**)
1 a group of people who do something together ▶ *They were attacked by a band of robbers.*
2 a group of people who play music together
3 a thin strip of material ▶ *We wore name bands round our wrists.*

bandage *noun* (*plural* **bandages**)
a strip of material that you wrap round part of your body if you have hurt it

bandit *noun* (*plural* **bandits**)
a person who attacks and robs people

bang *noun* (*plural* **bangs**)
a sudden very loud noise ▶ *The balloon burst with a bang.*

bang *verb* (bangs, banging, banged)
1 When you bang something, you hit it hard. ▶ *He banged on the window.*
2 When something bangs, it makes a sudden loud noise. ▶ *The door banged shut.*

banish *verb* (banishes, banishing, banished)
To banish someone means to send them away from a place as a punishment.

banisters *noun*
the rail that you can hold on to at the side of a staircase

banjo *noun* (*plural* **banjos**)
a musical instrument that you play by pulling on the strings with your fingers

bank *noun* (*plural* **banks**)
1 a place where people can keep their money safely. Banks also lend money to people.
2 the ground near the edge of a river or lake ▶ *We walked along the bank of the river.*

banner noun (plural **banners**)
a long, thin flag with words written on it ▶ *They hung up a banner with 'Welcome Home' written on it.*

banquet noun (plural **banquets**)
a large special meal for a lot of people

baptize verb (**baptizes, baptizing, baptized**)
When someone is baptized, they are accepted as a Christian in a special ceremony.
ⓘ A **baptism** is a ceremony in which someone is baptized.

bar noun (plural **bars**)
1 a long piece of wood or metal ▶ *There were bars on the windows to stop people from escaping.*
2 a block of chocolate or soap
3 a place that serves food and drinks at a counter ▶ *Is there a coffee bar at the museum?*

barbecue noun (plural **barbecues**)
1 a party where people sit outside and cook food over a fire
2 a metal frame that you put food on to cook it over a fire outside

barbed wire noun
wire with a lot of sharp spikes in it which is used for making fences

barber noun (plural **barbers**)
a hairdresser for men and boys

bar chart noun (plural **bar charts**)
a graph that uses bars of different lengths to show different amounts of things

bare adjective (**barer, barest**)
1 If a part of your body is bare, it has nothing covering it. ▶ *Don't go outside with bare feet.*
2 If something is bare, it has nothing on it or in it. ▶ *The walls of her bedroom were bare.*

barely adverb
only just ▶ *I was so tired that I could barely walk.*

bargain noun (plural **bargains**)
something that you buy very cheaply, for much less than its usual price ▶ *You can usually find some bargains at the market.*

barge noun (plural **barges**)
a long boat with a flat bottom. Barges are used on canals.

barge verb (**barges, barging, barged**)
If you barge into someone, you bump into them by accident.

bark noun
the hard covering round the trunk and branches of a tree

bark verb (**barks, barking, barked**)
When a dog barks, it makes a loud, rough sound.

barley noun
a plant that farmers grow. Its seed is used for making food and beer.

bar mitzvah noun (plural **bar mitzvahs**)
a celebration for a Jewish boy when he reaches the age of 13

barn noun (plural **barns**)
a large building on a farm, where a farmer keeps animals, hay, or grain

barnacle noun (plural **barnacles**)
a small sea creature. Barnacles stick to rocks and the bottoms of ships.

barrel noun (plural **barrels**)
1 a round, wooden container that beer, wine, or water is kept in
2 The barrel of a gun is the tube that the bullet comes out of.

barrier noun (plural **barriers**)
a fence or wall that stops you getting past a place

barrow noun (plural **barrows**)
a small cart that you push along

base noun (plural **bases**)
1 The base of an object is the part at the bottom, which it stands on.
2 Someone's base is the main place where they live or work.

baseball

baseball *noun*
a game in which two teams hit a ball with a long bat and run round a square in order to score points

basement *noun* (*plural* **basements**)
the rooms in a building that are below the ground

bash *verb* (**bashes, bashing, bashed**)
If you bash something, you hit it very hard.

basic *adjective*
Basic things are simple but very important. ▶ *You need to learn the basic skills first.*

basically *adverb*
really ▶ *Basically, if you don't have enough food you will die.*

basin *noun* (*plural* **basins**)
a large bowl

basket *noun* (*plural* **baskets**)
a container that you carry things in. A basket is made of thin strips of straw, plastic, or metal that are twisted or woven together.

basketball *noun*
a game in which two teams try to score points by bouncing a ball and throwing it into a high net

bat *noun* (*plural* **bats**)
1 a small animal with wings that flies and hunts for food at night and hangs upside down during the day
2 a piece of wood that you use for hitting a ball in a game

bat *verb* (**bats, batting, batted**)
When you bat in a game, you try to hit the ball with a bat.

bath *noun* (*plural* **baths**) (rhymes with *path*)
a large container which you can fill with water to sit in and wash yourself all over

bathe *verb* (**bathes, bathing, bathed**) (rhymes with *save*)
1 When you bathe, you go swimming in the sea or a river. ▶ *They bathed in the pool.*
2 If you bathe a part of your body, you wash it gently because it hurts. ▶ *He bathed his cut finger.*

bathroom *noun* (*plural* **bathrooms**)
a room with a bath, washbasin, and toilet

baton *noun* (*plural* **batons**)
1 a stick that a conductor of an orchestra uses to show the musicians how fast to play
2 a stick that a runner in a relay race passes to the next person in the team

batsman *noun* (*plural* **batsmen**)
the person who is holding a bat and trying to hit the ball in a game of cricket or rounders

batter *noun*
a mixture of flour, eggs, and milk that you use to make pancakes

batter *verb* (**batters, battering, battered**)
If you batter something, you hit it hard again and again.

battery *noun* (*plural* **batteries**)
an object that contains a store of electricity. You put batteries inside torches and radios to make them work.

battle *noun* (*plural* **battles**)
a big fight between two groups of people

battlements *noun*
the top part of a castle wall, which has gaps through which people could fire at the enemy

bawl *verb* (**bawls, bawling, bawled**)
When you bawl, you shout or cry very loudly.

bay *noun* (*plural* **bays**)
a place on the coast where the land bends inwards and sea fills the space ▶ *The ship took shelter in the bay.*

beach noun (plural **beaches**)
an area of sand or pebbles by the edge of the sea

bead noun (plural **beads**)
a small piece of wood, glass, or plastic with a hole through the middle. You thread beads on a string to make a necklace.

beady adjective
Beady eyes are small and bright.

beak noun (plural **beaks**)
A bird's beak is its mouth, which is hard and pointed.

beaker noun (plural **beakers**)
a tall cup

beam noun (plural **beams**)
1 A wooden beam is a long strong piece of wood that supports the floor or roof of a building.
2 A beam of light is a ray of light that shines onto something.

beam verb (**beams, beaming, beamed**)
When you beam, you smile happily.

bean noun (plural **beans**)
Beans are the seeds of some plants which you can eat. Sometimes you eat just the seeds, and sometimes you eat the seeds and the pod that they grow in. ▶ *We had baked beans on toast for tea.*

bear noun (plural **bears**)
a large wild animal with thick fur and sharp teeth and claws

bear verb (**bears, bearing, bore, borne**)
1 If something will bear your weight, it will support your weight and so you can stand on it safely.
2 If you cannot bear something, you hate it.

beard noun (plural **beards**)
hair growing on a man's chin ▶ *He had white hair and a long, grey beard.*

beast noun (plural **beasts**)
1 a big, fierce animal
2 a horrible person

beastly adjective
If someone is beastly, they are unkind.

beat verb (**beats, beating, beaten**)
1 To beat someone means to hit them hard a lot of times. ▶ *It's cruel to beat animals.*
2 If you beat someone, you win a game against them. ▶ *Joshua always beats me at tennis.*
3 When you beat a mixture, you stir it hard. ▶ *Dad beat some eggs to make an omelette.*

beat noun
the regular rhythm in a piece of music ▶ *I like dancing to music with a strong beat.*

beautiful adjective
1 Something that is beautiful is very nice to look at, hear, or smell. ▶ *What a beautiful picture!*
2 Someone who is beautiful has a lovely face. ▶ *He longed to marry the beautiful princess.*
❶ If you do something **beautifully**, you do it very nicely. If something has **beauty**, it is beautiful.

beaver noun (plural **beavers**)
a furry animal with a long flat tail. Beavers live near rivers and build dams made of mud and sticks.

became verb SEE **become**

because conjunction
for the reason that ▶ *He was angry because I was late.*

beckon verb (**beckons, beckoning, beckoned**)
If you beckon to someone, you move your hand to show them that you want them to come nearer.

become verb (**becomes, becoming, became, become**)
to start to be ▶ *He became angry when I told him about the broken window.*

bed

bed noun (plural **beds**)
1 a piece of furniture that you sleep on
2 a piece of ground that you grow flowers or vegetables in ► *Please don't walk on the flower beds.*
3 the bottom of the sea or a river ► *The old ship was now resting on the sea bed.*

bee noun (plural **bees**)
an insect that can fly and sting you. Bees use nectar from flowers to make honey.

beech noun (plural **beeches**)
a large tree

beef noun
meat from a cow

beefburger noun (plural **beefburgers**)
a piece of minced beef that has been made into a round flat cake and cooked

beer noun (plural **beers**)
a type of alcoholic drink

beetle noun (plural **beetles**)
an insect with hard, shiny wings

beetroot noun (plural **the plural is the same**)
a round, dark red vegetable

before adverb, conjunction, preposition
1 earlier than ► *We usually do maths before lunch.*
2 already ► *Have you been here before?*
3 in front of ► *The girl vanished before my eyes.*

beg verb (**begs, begging, begged**)
If you beg someone to do something, you ask them very strongly to do it. ► *We begged him to come with us.*

began verb SEE **begin**

beggar noun (plural **beggars**)
someone who is very poor and lives by asking other people for money

begin verb (**begins, beginning, began, begun**)
To begin means to start.
❶ The **beginning** of something is when it starts.

begun verb SEE **begin**

behave verb (**behaves, behaving, behaved**)
1 The way you behave is the way you speak and do things. ► *He was behaving very strangely.*
2 If you behave yourself, you are polite and do not do anything that is rude or naughty.
❶ Your **behaviour** is the way you behave.

behind adverb, preposition
at the back of ► *He hid behind the wall.*

being noun (plural **beings**)
a living creature ► *They looked like beings from another planet.*

believe verb (**believes, believing, believed**)
If you believe something, you feel sure that it is true. ► *I don't believe you – I think you're lying!*
❶ Your **beliefs** are the things that you believe are true.

bell noun (plural **bells**)
a metal object that rings when something hits it

bellow verb (**bellows, bellowing, bellowed**)
If you bellow, you shout very loudly.

belong verb (**belongs, belonging, belonged**)
1 If something belongs to you, it is yours. ► *That pen belongs to me.*
2 If something belongs in a place, it goes there.
❶ Your **belongings** are the things which belong to you.

below preposition
1 underneath ► *Can you swim below the surface of the water?*
2 less than ► *The temperature was below freezing last night.*

belt noun (plural **belts**)
a band of leather or other material that you wear round your waist

bench noun (plural **benches**)
a long wooden or stone seat for more than one person

bend verb (**bends, bending, bent**)
1 When you bend something, you make it curved and not straight. ▶ *She carefully bent the wire into the correct shape.*
2 When you bend down, you lean forward so that your head is nearer to the ground.

bend noun (plural **bends**)
a part of a road or river that curves round ▶ *She drove carefully round the bend.*

beneath preposition
underneath ▶ *The ship disappeared beneath the waves.*

bent verb SEE **bend**

berry noun (plural **berries**)
a small round fruit with seeds in it ▶ *You can eat some berries, but others are poisonous.*

beside preposition
at the side of ▶ *She was standing beside her brother.*

besides preposition
as well as ▶ *Ten people besides me also won prizes.*

best adjective
The best person or thing is the one that is better than any other. ▶ *Katy is the best swimmer in the school.*

bet verb (**bets, betting, bet**)
When you bet with someone, you agree that they will pay you money if you are right about something, but you will pay them money if you are wrong.

betray verb (**betrays, betraying, betrayed**)
If someone betrays you, they do something unkind to you when you had trusted them and thought they were your friend.

better adjective
1 If one thing is better than another, it is more interesting, more useful, or more exciting.
2 If you are better than someone else, you are able to do something more quickly or more successfully. ▶ *She's better at swimming than I am.*
3 When you are better, you are well again after an illness.

between preposition
1 in the middle of two people or things ▶ *I sat between Mum and Dad.*
2 among ▶ *Share the money between you.*

beware verb
If you tell someone to beware, you are warning them to be careful.

bewildered adjective
If you are bewildered, you feel confused because you do not understand something.

bewitched adjective
Someone who is bewitched is under a magic spell.

beyond preposition
further than ▶ *Don't go beyond the end of the road.*

biased adjective (pronounced **bi-ast**)
If someone is biased, they unfairly help one person or team more than another. ▶ *The referee was biased.*

Bible noun (plural **Bibles**)
the holy book of the Christian religion
❶ A **biblical** story or character is one that is in the Bible.

bicycle noun (plural **bicycles**)
something with two wheels, which you sit on and ride along by pushing pedals round with your feet

big

big *adjective* (**bigger**, **biggest**)
Something that is big is large.
▶ *London is a very big city.*

bike *noun* (*plural* **bikes**)
a bicycle

bikini *noun* (*plural* **bikinis**)
a two-piece swimming costume for women and girls

bill *noun* (*plural* **bills**)
1 a piece of paper that tells you how much money you owe someone
2 a bird's beak

billion *noun* (*plural* **billions**)
1,000,000,000; one thousand million

bin *noun* (*plural* **bins**)
a container for putting rubbish in

bind *verb* (**binds**, **binding**, **bound**)
If you bind things together, you tie them together tightly.

bingo *noun*
a game in which each player has a card with numbers on it. Someone chooses numbers and calls them out, and the first player whose numbers are all called out is the winner.

binoculars *noun*
two tubes that you hold to your eyes like a pair of glasses and look through to make things that are far away seem bigger and nearer

biodegradable *adjective*
(*pronounced* bye-oh-dee-**grade**-a-bul)
Things that are biodegradable will rot away naturally after you have used them.

biography *noun* (*plural* **biographies**)
a book that tells the true story of a person's life

biology *noun*
the study of animals and plants

bird *noun* (*plural* **birds**)
any animal with feathers, wings, and a beak

Biro *noun* (*plural* **Biros**)
(*trademark*) a type of pen

birth *noun*
The birth of a baby is when it leaves its mother's body and is born.

birthday *noun* (*plural* **birthdays**)
the day each year when you remember and celebrate the day you were born

biscuit *noun* (*plural* **biscuits**)
a kind of small, crisp cake

bishop *noun* (*plural* **bishops**)
an important priest in the Christian church

bit *noun* (*plural* **bits**)
a small amount of something
▶ *Would you like a bit of chocolate?*

bit *verb* SEE **bite**

bitch *noun* (*plural* **bitches**)
a female dog

bite *verb* (**bites**, **biting**, **bit**, **bitten**)
When you bite something, you use your teeth to cut it. ▶ *Be careful that dog doesn't bite you.*

bitter *adjective*
If something tastes bitter, it has a nasty sour taste.

black *adjective*
1 Something that is black is the colour of the sky on a very dark night.
2 Someone who is black has a skin that is naturally dark in colour.

blackberry *noun* (*plural* **blackberries**)
a small, sweet, black berry that grows on prickly bushes

blackbird *noun* (*plural* **blackbirds**)
a bird. The male is black with an orange beak, but the female is brown.

blackboard *noun* (*plural* **blackboards**)
a smooth, dark board that you can write on with chalk

blacksmith noun (plural **blacksmiths**)
someone who makes horseshoes and other things out of iron

blade noun (plural **blades**)
1 The blade of a knife or sword is the long, sharp part of it.
2 A blade of grass is one piece of grass.

blame verb (**blames, blaming, blamed**)
When you blame someone, you say that it is their fault that something bad has happened. ▶ *Simon blamed me for losing his money.*

blank adjective
A blank piece of paper has nothing written or drawn on it.

blanket noun (plural **blankets**)
a thick warm cover that you put on a bed

blast noun (plural **blasts**)
a sudden rush of wind or air ▶ *I felt a blast of cold air as I opened the door.*

blast-off noun
the time when a rocket leaves the ground and goes up into space

blaze noun (plural **blazes**)
a large, strong fire

blaze verb (**blazes, blazing, blazed**)
When a fire is blazing, it is burning brightly.

blazer noun (plural **blazers**)
a type of jacket, especially one that children wear to school as part of their school uniform

bleach noun
a chemical that you use to kill germs and make things clean

bleach verb (**bleaches, bleaching, bleached**)
To bleach something means to make it white, or lighter in colour. ▶ *The sun had bleached her hair.*

bleak adjective (**bleaker, bleakest**)
A bleak place is cold and miserable.

bleat verb (**bleats, bleating, bleated**)
When a sheep bleats, it makes a long sound.

bleed verb (**bleeds, bleeding, bled**)
If a part of your body is bleeding, blood is coming out of it.

bleep verb (**bleeps, bleeping, bleeped**)
If a machine bleeps, it makes a short, high sound.

blend verb (**blends, blending, blended**)
When you blend things, you mix them together.

bless verb (**blesses, blessing, blessed**)
1 To bless something means to make it holy by saying a prayer over it.
2 You say **bless you** when someone sneezes.

blew verb SEE **blow**

blind adjective
Someone who is blind cannot see

blind noun (plural **blinds**)
a piece of material that you pull down to cover a window

blindfold noun (plural **blindfolds**)
a piece of cloth that you tie over someone's eyes so that they cannot see

blink verb (**blinks, blinking, blinked**)
When you blink, you close your eyes and then open them again quickly.

blister noun (plural **blisters**)
a sore place on your skin that is caused by something rubbing against it. A blister looks like a small lump and has liquid inside it.

blizzard noun (plural **blizzards**)
a storm with a lot of snow and wind

blob noun (plural **blobs**)
a small lump or drop of something ▶ *There was a blob of jam on the table.*

block

block noun (plural **blocks**)
1 a thick piece of stone or wood
2 a tall building with lots of flats or offices inside ▶ *She lives in a block of flats near the city centre.*

block verb (**blocks, blocking, blocked**)
If something is blocking a road or pipe, it is in the way and nothing can get past it. ▶ *Some parked cars were blocking the road.*

block graph noun (plural **block graphs**)
a graph that uses stacks of blocks to show different amounts of things

blond, blonde adjective
Someone who is blond has fair or light-coloured hair.
❶ Usually we use the spelling **blond** for boys and men, and the spelling **blonde** for women and girls.

blood noun
the red liquid that is pumped round inside your body

bloom verb (**blooms, blooming, bloomed**)
When a plant blooms, it has flowers on it. ▶ *Roses bloom in the summer.*

blossom noun (plural **blossoms**)
the flowers on a tree

blot noun (plural **blots**)
a spot of liquid that has been spilt on something ▶ *His exercise book was covered in ink blots.*

blouse noun (plural **blouses**)
a shirt that a woman or girl wears

blow noun (plural **blows**)
If you receive a blow, someone hits you hard.

blow verb (**blows, blowing, blew, blown**)
1 When you blow, you make air come out of your mouth.
2 When the wind blows, it moves along.

blue adjective
Something that is blue is the colour of the sky on a fine day.

bluebell noun (plural **bluebells**)
a small, blue wild flower

bluff verb (**bluffs, bluffing, bluffed**)
When you bluff, you pretend that you are going to do something when really you are not. ▶ *He said he was going to tell the teacher, but I knew he was only bluffing.*

blunt adjective (**blunter, bluntest**)
Something that is blunt is not sharp. ▶ *This knife is too blunt to cut anything.*

blurb noun
a short piece of writing about a book, which tells you what the book is about and why it is good

blush verb (**blushes, blushing, blushed**)
When you blush, your face goes red because you feel shy or guilty.

boar noun (plural **boars**)
1 a male pig
2 a wild pig

board noun (plural **boards**)
a flat piece of wood

board verb (**boards, boarding, boarded**)
When you board an aeroplane, bus, ship, or train, you get onto it.

boarding school noun (plural **boarding schools**)
a school where children live during the term

boast verb (**boasts, boasting, boasted**)
If you boast, you talk about how clever you are or how well you can do things. ▶ *He boasted about how good he was at football.*

boat noun (plural **boats**)
something that floats on water and can carry people and goods over water

body *noun* (*plural* **bodies**)
1 Your body is every part of you that you can see and touch.
2 A body is a dead person.
▶ *The police found a man's body in the river.*

bodyguard *noun* (*plural* **bodyguards**)
someone who guards and protects an important person

bog *noun* (*plural* **bogs**)
a piece of soft, wet ground

boil *verb* (**boils, boiling, boiled**)
1 When water boils, it bubbles and gives off steam because it is very hot.
▶ *Is the water boiling yet?*
2 When you boil something, you cook it in boiling water. ▶ *We boiled the potatoes.*
ⓘ The temperature at which water boils is called the **boiling point**.

bold *adjective* (**bolder, boldest**)
1 Someone who is bold is brave and not afraid.
2 Bold writing is large and easy to see.

bolt *noun* (*plural* **bolts**)
1 a piece of metal that you slide across to lock a door
2 a thick metal pin that looks like a screw with a blunt end. You screw a bolt into a nut to fasten something.

bolt *verb* (**bolts, bolting, bolted**)
1 When you bolt a door or window, you lock it with a bolt. ▶ *Remember to bolt the back door.*
2 If you bolt, you run away suddenly. ▶ *The horse bolted when it saw the fire.*
3 If you bolt food, you eat it very quickly.

bomb *noun* (*plural* **bombs**)
a weapon that explodes and hurts people or damages things

bone *noun* (*plural* **bones**)
Your bones are the hard white parts inside your body. Your skeleton is made of bones.

bonfire *noun* (*plural* **bonfires**)
a large fire that you make outside, especially to burn rubbish

bongo *noun* (*plural* **bongos**)
a type of drum that you play with your hands

bonnet *noun* (*plural* **bonnets**)
the part of a car that covers the engine

boo *verb* (**boos, booing, booed**)
When people boo, they show that they do not like someone or something by shouting 'boo'.

book *noun* (*plural* **books**)
a set of pages that are joined together inside a cover
ⓘ A **bookcase** is a piece of furniture that you keep books on. A **bookmark** is a strip of paper or cloth that you keep inside a book to mark a place.

book *verb* (**books, booking, booked**)
When you book something, you arrange for it to be reserved for you.
▶ *Dad booked seats for the pantomime.*

boom *verb* (**booms, booming, boomed**)
When something booms, it makes a long, loud, deep sound. ▶ *The thunder boomed overhead.*

boomerang *noun* (*plural* **boomerangs**)
a curved stick that comes back to the person who throws it

boot *noun* (*plural* **boots**)
1 a type of shoe that also covers your ankle and part of your leg
2 the part of a car that you carry luggage in

border

border noun (plural **borders**)
1 the place where two countries meet ▶ *You need a passport to cross the border.*
2 a narrow strip along the edge of something ▶ *On the table was a white tablecloth with a blue border.*

bore verb (**bores, boring, bored**)
1 If something bores you, you find it dull and not interesting. ▶ *These silly games bore me to death!*
2 If you bore a hole in something, you make a hole.
3 SEE **bear** verb
ℹ Something that you find dull and not interesting is **boring**. If you are **bored**, you are fed up because what you are doing is not interesting.

born adjective
When a baby is born, it comes out of its mother's body and starts to live.

borne verb SEE **bear**

borrow verb (**borrows, borrowing, borrowed**)
When you borrow something, you take it and use it for a while and then give it back. ▶ *Can I borrow your pen?*

boss noun (plural **bosses**)
the person who is in charge

bossy adjective
Someone who is bossy likes to tell other people what to do.

both adjective, pronoun
the two of them ▶ *Hold the camera in both hands.*

bother verb (**bothers, bothering, bothered**)
1 If something bothers you, it worries you or annoys you. ▶ *Is the loud music bothering you?*
2 If you do not bother to do something, you do not do it because it would take too much effort. ▶ *He never bothers to tidy his room.*

bottle noun (plural **bottles**)
a tall glass or plastic container that you keep liquids in

bottom noun (plural **bottoms**)
1 The bottom of something is the lowest part of it. ▶ *Suraya waited for us at the bottom of the hill.*
2 Your bottom is the part of your body that you sit on.

bough noun (plural **boughs**) (rhymes with *now*)
a large branch of a tree

bought verb SEE **buy**

boulder noun (plural **boulders**) (*pronounced* **bole**-der)
a large rock

bounce verb (**bounces, bouncing, bounced**)
When something bounces, it springs back into the air when it hits something hard. ▶ *The ball bounced off the wall.*

bound verb (**bounds, bounding, bounded**)
When you bound, you run and jump. ▶ *The dog bounded over the gate.*

bound adjective
If something is bound to happen, it will definitely happen. ▶ *We've got the best team, so we're bound to win.*

bound verb SEE **bind**

boundary noun (plural **boundaries**)
a line that marks the edge of a piece of land

bouquet noun (plural **bouquets**) (*pronounced* boo-**kay**)
a bunch of flowers

bow noun (plural **bows**) (rhymes with *go*)
1 a knot with large loops ▶ *She tied the ribbon into a bow.*
2 a weapon that you use for shooting arrows ▶ *The men were armed with bows and arrows.*

bow verb (**bows, bowing, bowed**)
(rhymes with *cow*)
When you bow, you bend forwards to show respect to someone or to thank people for clapping.

bowl noun (*plural* **bowls**)
a round dish that you serve food in

bowl verb (**bowls, bowling, bowled**)
When you bowl in a game of cricket or rounders, you throw the ball for someone else to hit.

bowling noun
a game in which you roll a heavy ball towards a set of tall sticks and try to knock them over

box noun (*plural* **boxes**)
a container with straight sides, made of cardboard or plastic

box verb (**boxes, boxing, boxed**)
When people box, they fight by hitting each other with their fists.
ⓘ Someone who boxes as a sport is a **boxer**.

boy noun (*plural* **boys**)
a male child

boyfriend noun (*plural* **boyfriends**)
A girl's boyfriend is the boy she is going out with.

brace noun (*plural* **braces**)
a piece of wire that you wear across your teeth to straighten them

bracelet noun (*plural* **bracelets**)
a piece of jewellery that you wear round your wrist

braces noun
a set of straps that you wear over your shoulders to keep your trousers up

bracket noun (*plural* **brackets**)
Brackets are marks like these () that you use in writing.

brag verb (**brags, bragging, bragged**)
When you brag about something, you boast about it.

braille noun
a way of writing that uses a pattern of raised dots on paper. Blind people can read braille by touching the dots with their fingers.

brain noun (*plural* **brains**)
Your brain is the part inside your head that controls your body and allows you to think and remember things.
ⓘ Someone who has a good brain and is clever is **brainy**.

brake noun (*plural* **brakes**)
the part of a car or bicycle that makes it slow down and stop

bramble noun (*plural* **brambles**)
a prickly bush that blackberries grow on

bran noun
the outside part of the seeds of grain which is usually left when the grain is made into flour

branch noun (*plural* **branches**)
a part that grows out from the trunk of a tree

brand noun (*plural* **brands**)
the name of something that you buy, which shows who made it ▶ *He always wants to buy expensive brands of trainers.*

brass noun
a yellow metal. Brass is used for making some musical instruments such as trumpets and trombones.

brave adjective (**braver, bravest**)
Someone who is brave is willing to do dangerous things. ▶ *Are you brave enough to come with me on this adventure?*
ⓘ If you do something in a brave way, you do it **bravely**. **Bravery** is being brave.

bray

bray verb (brays, braying, brayed)
When a donkey brays, it makes a loud, harsh sound.

bread noun
a food that is made from flour and water, and baked in the oven

breadth noun
The breadth of something is how wide it is. ▶ *We measured the length and breadth of the garden.*

break verb (breaks, breaking, broke, broken)
1 If you break something, you smash it into several pieces.
2 If you break something, you damage it so that it no longer works. ▶ *Joshua's broken my CD player.*
3 If you break a law or a promise, you do something that goes against it. ▶ *You should never break a promise.*
4 If something breaks down, it stops working. ▶ *Our car broke down on the motorway.*

break noun (plural breaks)
1 a gap in something ▶ *We managed to escape through a break in the hedge.*
2 a short rest ▶ *We'll have a short break before we continue.*

breakfast noun (plural breakfasts)
the first meal of the day, which you eat in the morning

breast noun (plural breasts)
1 A woman's breasts are the parts on the front of her body that can produce milk to feed a baby.
2 The breast on a chicken or other bird is its chest.

breath noun (plural breaths)
the air that you take into your body and then blow out again ▶ *Ali took a deep breath and dived into the water.*

breathe verb (breathes, breathing, breathed)
When you breathe, you take air into your lungs through your nose or mouth and then blow it out again.

breed verb (breeds, breeding, bred)
When animals breed, they produce babies.

breed noun (plural breeds)
a particular type of animal ▶ *A labrador is a very popular breed of dog.*

breeze noun (plural breezes)
a gentle wind

bribe noun (plural bribes)
something that you offer to someone to persuade them to do something

bribe verb (bribes, bribing, bribed)
If you bribe someone, you offer them something to persuade them to do something.

brick noun (plural bricks)
a small block made from baked clay. People use bricks for building houses.

bride noun (plural brides)
a woman who is getting married

bridegroom noun (plural bridegrooms)
a man who is getting married

bridesmaid noun (plural bridesmaids)
a girl or woman who walks behind the bride at her wedding

bridge noun (plural bridges)
something that is built over a river, railway, or road so that people can go across it

bridle noun (plural bridles)
the leather straps that you put over a horse's head and use to control it

brief adjective (briefer, briefest)
Something that is brief is short and does not last very long. ▶ *We only had time for a brief visit.*

briefcase noun (plural briefcases)
a small case that you carry books and papers in

briefs noun
pants

bright *adjective* (**brighter, brightest**)
1 A bright light shines with a lot of light.
2 A bright colour is strong and not dull. ▶ *Grace was wearing a bright red jumper.*
3 A bright day is sunny. ▶ *It was a lovely bright, sunny day.*
4 Someone who is bright is clever and learns things quickly.

brilliant *adjective*
1 Someone who is brilliant is very clever. ▶ *He is a brilliant scientist.*
2 Something that is brilliant is very good. ▶ *We saw a brilliant film yesterday.*

brim *noun* (*plural* **brims**)
1 the edge round the top of a container ▶ *Her cup was filled to the brim.*
2 the part of a hat that sticks out round the bottom edge

bring *verb* (**brings, bringing, brought**)
1 If you bring something with you, you carry it with you. ▶ *Don't forget to bring your swimming costume.*
2 If you bring someone with you, they come with you. ▶ *Can I bring my friend with me?*

brisk *adjective* (**brisker, briskest**)
A brisk way of walking is quick and lively. ▶ *We went for a brisk walk after lunch.*

bristle *noun* (*plural* **bristles**)
Bristles are short, stiff hairs like the hairs on a brush.

brittle *adjective*
Something that is brittle is hard and dry and will break easily. ▶ *We picked up some dry, brittle twigs.*

broad *adjective* (**broader, broadest**)
Something that is broad is wide.
▶ *We came to a broad river.*

broadcast *noun* (*plural* **broadcasts**)
a television or radio programme

broadcast *verb* (**broadcasts, broadcasting, broadcast**)
To broadcast something means to send it out as a television or radio programme. ▶ *The match will be broadcast live on television.*

broccoli *noun*
a dark green vegetable

brochure *noun* (*plural* **brochures**)
(*pronounced* **broh**-shoor)
a small book that gives you information about something

broke, broken *verb* SEE **break** *verb*

bronchitis *noun* (*pronounced* bron-**kye**-tus)
an illness that gives you a very bad cough

bronze *noun*
a hard, brown, shiny metal

brooch *noun* (*plural* **brooches**)
(*pronounced* **broach**)
a piece of jewellery that you pin to your clothes

broom *noun* (*plural* **brooms**)
a brush with a long handle that you use for sweeping floors

broth *noun*
a thin soup made from meat and vegetables

brother *noun* (*plural* **brothers**)
Your brother is a boy who has the same parents as you.

brought *verb* SEE **bring**

brow *noun* (*plural* **brows**)
1 Your brow is your forehead. ▶ *He wiped the sweat from his brow.*
2 The brow of a hill is the top of it.

brown *adjective*
1 Something that is brown is the colour of soil.
2 Brown bread is made with the whole wheat grain, not just the white part.

browse

browse verb (**browses, browsing, browsed**)
1 When you browse in a shop, you look around to see if there is anything you like.
2 When you browse on a computer, you look for information on the Internet.

bruise noun (plural **bruises**)
a dark mark on your skin that you get when you have been hit

brush noun (plural **brushes**)
an object with short, stiff hairs on the end of a handle. You use a brush for cleaning things, and you also use a brush for painting.

brush verb (**brushes, brushing, brushed**)
When you brush something, you clean it using a brush.

bubble noun (plural **bubbles**)
Bubbles are small balls of air or gas inside a liquid, for example like the ones you find in fizzy drinks.

bubble verb (**bubbles, bubbling, bubbled**)
When a liquid bubbles, it makes bubbles. ▶ *When water boils, it bubbles.*

bucket noun (plural **buckets**)
a container with a handle that you use for carrying water

buckle noun (plural **buckles**)
the part of a belt that you use to fasten the two ends together

bud noun (plural **buds**)
a small lump on a plant that will later open into a flower or leaf

Buddhist noun (plural **Buddhists**)
someone who follows the Buddhist religion and follows the teachings of the Buddha
❶ The religion that Buddhists follow is **Buddhism**.

budge verb (**budges, budging, budged**)
When you budge, you move slightly.

budgerigar noun (plural **budgerigars**)
a small, brightly coloured bird that some people keep as a pet

buffet noun (plural **buffets**) (pronounced **boof**-ay)
1 a meal where a lot of different cold foods are put onto a table and you help yourself to the food that you want
2 a place where you can buy drinks and snacks on a train

bug noun (plural **bugs**)
1 an insect
2 a germ that gets into your body and makes you ill ▶ *He's got a stomach bug.*
3 a problem in a computer program that makes it go wrong

buggy noun (plural **buggies**)
a chair on wheels that you can push a small child in

build verb (**builds, building, built**)
When you build something, you make it by joining or fixing different parts together. ▶ *It took nearly three years to build this bridge.*
❶ A **builder** is someone who builds houses and other buildings.

building noun (plural **buildings**)
a structure like a house, school, shop, or church

built verb SEE **build**

bulb noun (plural **bulbs**)
1 the part of an electric lamp that gives out light
2 a part of a plant that grows under the ground and looks like an onion. Daffodils and tulips grow from bulbs.

bulge verb (**bulges, bulging, bulged**)
If something bulges, it sticks out because it is so full. ▶ *His pockets were bulging with sweets.*

bull noun (plural **bulls**)
a male cow, elephant, or whale

bulldozer *noun* (*plural* **bulldozers**)
a heavy machine that moves earth and makes land flat

bullet *noun* (*plural* **bullets**)
a small piece of metal that is fired from a gun

bull's-eye *noun* (*plural* **bull's-eyes**)
the centre of a target

bully *verb* (**bullies, bullying, bullied**)
To bully someone means to hurt them or be unkind to them.

bully *noun* (*plural* **bullies**)
someone who hurts other people or is unkind to them

bump *verb* (**bumps, bumping, bumped**)
If you bump something, you knock it or hit it. ▶ *I bumped my head on the door.*

bump *noun* (*plural* **bumps**)
1 the noise that something makes when it falls to the ground ▶ *He fell to the ground with a bump.*
2 a small lump on your skin that you get when you have knocked it

bumper *noun* (*plural* **bumpers**)
a bar along the front or back of a car. The bumper protects the car if it hits something.

bumpy *adjective* (**bumpier, bumpiest**)
A bumpy road has a lot of lumps and holes in it.

bun *noun* (*plural* **buns**)
1 a small, round cake
2 a round piece of bread that you eat a burger in

bunch *noun* (*plural* **bunches**)
a group of things that are tied together ▶ *The children bought me a bunch of flowers.*

bundle *noun* (*plural* **bundles**)
a group of things that are tied together ▶ *She was carrying a bundle of old clothes.*

bungalow *noun* (*plural* **bungalows**)
a house without any upstairs rooms

bungee jumping *noun*
the sport of jumping off a high place attached to a very long piece of elastic, which stops you just before you hit the ground

bungle *verb* (**bungles, bungling, bungled**)
If you bungle something, you do it very badly.

bunk *noun* (*plural* **bunks**)
a bed that has another bed above or below it ▶ *Can I sleep in the top bunk?*
❶ Two beds that are joined together, one above the other, are called **bunk beds**.

buoy *noun* (*plural* **buoys**) (rhymes with *boy*)
an object that floats in the sea to warn ships about danger

burden *noun* (*plural* **burdens**)
something heavy that you have to carry

burger *noun* (*plural* **burgers**)
a piece of minced meat that has been made into a round, flat cake and cooked

burglar *noun* (*plural* **burglars**)
someone who goes into a building and steals things

burial *noun* (*plural* **burials**)
When there is a burial, a dead person is buried.

burn *verb* (**burns, burning, burned** or **burnt**)
1 When something burns, it catches fire. ▶ *Paper burns easily.*
2 If you burn something, you damage it or destroy it using fire or heat. ▶ *We burnt all our rubbish on a bonfire.*
3 If you burn yourself, you hurt your skin with fire or heat. ▶ *If you go out in the hot sun your skin will burn.*

burrow *noun* (*plural* **burrows**)
a hole in the ground that an animal lives in

burst

burst *verb* (**bursts, bursting, burst**)
if something bursts, it suddenly breaks open ▶ *He kept blowing the balloon up until it burst.*

bury *verb* (**buries, burying, buried**)
(rhymes with *merry*)
1 When you bury something, you put it in a hole in the ground and cover it over.
2 When a dead person is buried, their body is put into the ground.

bus *noun* (*plural* **buses**)
something that a lot of people can travel in on a road

bush *noun* (*plural* **bushes**)
a plant that looks like a small tree

business *noun* (*plural* **businesses**)
(*pronounced* **bizz**-niss)
1 When people do business, they buy and sell things.
2 a shop or company that makes or sells things ▶ *Salim wants to run his own business when he grows up.*

bustle *verb* (**bustles, bustling, bustled**)
When you bustle about, you move around and do things quickly. ▶ *She bustled about, tidying the house.*

busy *adjective* (**busier, busiest**)
1 If you are busy, you have a lot of things to do. ▶ *We were busy working all morning.*
2 A busy place has a lot of people and traffic in it.

but *conjunction*
however ▶ *We wanted to play tennis, but we couldn't because it was raining.*

butcher *noun* (*plural* **butchers**)
someone who cuts up meat and sells it in a shop

butter *noun*
a yellow food that is made from milk. You spread butter on bread.

buttercup *noun* (*plural* **buttercups**)
a small, yellow wild flower

butterfly *noun* (*plural* **butterflies**)
an insect with large colourful wings

button *noun* (*plural* **buttons**)
1 a small round thing that you use to fasten clothes by pushing it through a small hole in the clothes
2 a part of a machine that you press to switch it on or off

buy *verb* (**buys, buying, bought**)
When you buy something, you get it by giving someone money for it.

buzz *verb* (**buzzes, buzzing, buzzed**)
When something buzzes, it makes a sound like a bee.

by *preposition*
1 near ▶ *You can leave your bag by the front door.*
2 travelling in ▶ *We're going by train.*

bypass *noun* (*plural* **bypasses**)
a main road which goes round a town, not through it

byte *noun* (*plural* **bytes**)
You measure a computer's memory by saying how many bytes it has.
❶ A **megabyte** is one million bytes. A **gigabyte** is one thousand million bytes.

Cc

cab *noun* (*plural* **cabs**)
1 a taxi
2 the part at the front of a lorry, bus, or train where the driver sits

cabbage *noun* (*plural* **cabbages**)
a round, green vegetable with a lot of leaves that are wrapped tightly round each other

cabin *noun* (*plural* **cabins**)
1 a room for passengers in a ship or aeroplane
2 a small hut ▶ *They lived in a log cabin in the woods.*

cabinet *noun* (*plural* **cabinets**)
a cupboard that you keep or store things in

cable *noun* (*plural* **cables**)
1 strong, thick wire or rope
2 a bundle of wires that are held together in a plastic covering. They carry electricity or television signals.

cactus *noun* (*plural* **cacti**)
a plant with a thick green stem that has no leaves but is covered in prickles. Cacti grow in hot, dry places and do not need much water.

cafe *noun* (*plural* **cafes**) (*pronounced* **kaff**-ay)
a place where you can buy a drink or food and sit down to eat or drink it

cafeteria *noun* (*plural* **cafeterias**)
a place in a school or other building where you can buy food and eat it

cage *noun* (*plural* **cages**)
a box or small room with bars across it for keeping animals or birds in

cake *noun* (*plural* **cakes**)
a sweet food that you make with flour, fat, eggs, and sugar and bake in the oven

calamity *noun* (*plural* **calamities**)
something very bad that happens suddenly

calcium *noun*
Calcium is found in some foods and is used by your body to make bones and teeth.

calculate *verb* (**calculates, calculating, calculated**)
When you calculate an amount, you do a sum and work out how many or how much it is. ▶ *Can you calculate how much six ice creams will cost?*
ℹ When you calculate something, you do a **calculation**.

calculator *noun* (*plural* **calculators**)
a machine that you use to do sums

calendar *noun* (*plural* **calendars**)
a list of all the days, weeks, and months in a year. You can write on a calendar things that you are going to do each day.

calf *noun* (*plural* **calves**)
1 a young cow, elephant, or whale
2 Your calf is the back part of your leg between your knee and your ankle.

call *verb* (**calls, calling, called**)
1 When you call to someone, you speak loudly so that they can hear you. ▶ *'Look out!' he called.*
2 When you call someone, you tell them to come to you. ▶ *Mum called us in for tea.*
3 When you call someone a name, you give them that name. ▶ *We decided to call the puppy Patch.*
4 When you call someone, you telephone them. ▶ *I'll call you when I get home.*

calm *adjective* (**calmer, calmest**)
1 If the sea or the weather is calm, it is still and not stormy. ▶ *It was a lovely calm day.*
2 If you are calm, you are quiet and not noisy or excited. ▶ *He told the children to keep calm.*

calorie *noun* (*plural* **calories**)
a way of measuring the amount of energy that food gives you. Food that has a lot of calories gives you a lot of energy.

camcorder *noun* (*plural* **camcorders**)
a camera that you use for taking video pictures

came *verb* SEE **come**

camel *noun* (*plural* **camels**)
a big animal with one or two humps on its back. Camels are used to carry people and goods in deserts, because they can travel for a long time without eating or drinking.

camera *noun* (*plural* **cameras**)
a machine that you use for taking photographs

camouflage

camouflage *verb* (**camouflages, camouflaging, camouflaged**)
If something is camouflaged, it is hidden because it looks very like the things around it.

camp *noun* (*plural* **camps**)
a place where people stay for a short time in tents or small huts

camp *verb* (**camps, camping, camped**)
When you camp, you sleep in a tent. ▶ *We went camping last summer.*

can *noun* (*plural* **cans**)
a tin with food or drink in

can *verb* (**could**)
If you can do something, you are able to do it. ▶ *Can you swim?*

canal *noun* (*plural* **canals**)
a river that people have made for boats to travel on

canary *noun* (*plural* **canaries**)
a small yellow bird that some people keep as a pet

cancel *verb* (**cancels, cancelling, cancelled**)
When you cancel something that was arranged, you say that it will not happen. ▶ *My piano lesson was cancelled.*

cancer *noun* (*plural* **cancers**)
a serious disease in which cells in one part of your body begin to grow in an unusual way

candle *noun* (*plural* **candles**)
a stick of wax with string through the centre. You light the string and it burns slowly to give you light.

cane *noun* (*plural* **canes**)
a long, thin stick made of wood or bamboo

cannibal *noun* (*plural* **cannibals**)
a person who eats human flesh

cannon *noun* (*plural* **cannons**)
a big gun that was used in the past and fired heavy metal balls

cannot *verb*
can not ▶ *I cannot understand this.*

canoe *noun* (*plural* **canoes**)
a light, narrow boat that you move by using a paddle

can't *verb*
can not ▶ *I can't read your writing.*

canteen *noun* (*plural* **canteens**)
a place where people can go to buy and eat food in a school or factory

canter *verb* (**canters, cantering, cantered**)
When a horse canters, it gallops slowly.

canvas *noun*
a type of strong cloth that is used for making tents and sails

cap *noun* (*plural* **caps**)
1 a soft hat with a stiff part that sticks out at the front, over your eyes
2 a lid for a bottle or other container ▶ *Put the cap back on the toothpaste.*

capable *adjective*
If you are capable of doing something, you can do it. ▶ *You're capable of better work.*

capacity *noun* (*plural* **capacities**)
The capacity of a container is the amount that it can hold.

cape *noun* (*plural* **capes**)
a cloak

capital *noun* (*plural* **capitals**)
A country's capital is its most important city. ▶ *London is the capital of England.*

capital letter *noun* (*plural* **capital letters**)
Capital letters are the big letters you put at the beginning of names and sentences. A, B, C, D, and so on are capital letters.

captain *noun* (*plural* **captains**)
1 The captain of a ship or aeroplane is the person in charge of it.
2 The captain of a team is the person in charge of it, who tells the others what to do. ▶ *William is the captain of the school football team.*

caption *noun* (*plural* **captions**)
words that are printed next to a picture and tell you what the picture is about

captive *noun* (*plural* **captives**)
a prisoner
❶ Someone who is being kept a prisoner is being held in **captivity**.

capture *verb* (**captures, capturing, captured**)
To capture someone means to catch them. ▶ *The police captured the thieves.*

car *noun* (*plural* **cars**)
something that you can drive along in on roads

caravan *noun* (*plural* **caravans**)
a small house on wheels that can be pulled by a car from place to place

card *noun* (*plural* **cards**)
1 Card is thick, stiff paper.
2 A card is a piece of card with a picture and a message on it. You send cards to people at special times like their birthday or Christmas.
3 Cards are small pieces of card with numbers or pictures on them, that you use to play games. ▶ *Shall we play cards?*

cardboard *noun*
very thick, strong paper

cardigan *noun* (*plural* **cardigans**)
a knitted jumper that has buttons down the front

care *noun* (*plural* **cares**)
1 If you take care when you are doing something, you do it carefully. ▶ *You should take more care with your schoolwork.*
2 If you take care of someone, you look after them.

care *verb* (**cares, caring, cared**)
1 If you care about something, it is important to you. ▶ *Tom doesn't care who wins the game.*
2 If you care for someone, you look after them.

careful *adjective*
If you are careful, you make sure that you do things safely and well so that you do not have an accident. ▶ *Be careful when you cross the road.*
❶ If you do something in a careful way, you do it **carefully**.

careless *adjective*
If you are careless, you are not careful and so you make mistakes or have an accident.
❶ If you do something in a careless way, you do it **carelessly**.

carer *noun* (*plural* **carers**)
someone who looks after another person who is ill or very old

caretaker *noun* (*plural* **caretakers**)
someone whose job is to look after a building

cargo *noun* (*plural* **cargoes**)
the goods that are taken in a ship or aeroplane from one place to another

caring *adjective*
A caring person cares about other people and tries not to upset them.

carnation *noun* (*plural* **carnations**)
a red, white, or pink flower

carnival *noun* (*plural* **carnivals**)
a large party that takes place in the streets. People dress up in fancy dress and there is music and dancing.

carnivore *noun* (*plural* **carnivores**)
an animal that eats meat
❶ An animal that is a carnivore is **carnivorous**.

carol *noun* (*plural* **carols**)
a special song that people sing at Christmas

carpenter *noun* (*plural* **carpenters**)
someone whose job is to make things out of wood

carpet *noun* (*plural* **carpets**)
a thick, soft material that is put on a floor to cover it

carriage

carriage *noun* (*plural* **carriages**)
1 The carriages on a train are the parts where people sit.
2 something that is pulled by horses for people to travel in

carried *verb* SEE **carry**

carrier bag *noun* (*plural* **carrier bags**)
a plastic bag that you can carry things in

carrot *noun* (*plural* **carrots**)
a long, thin, orange vegetable

carry *verb* (**carries, carrying, carried**)
1 When you carry something, you hold it in your hands or arms and take it somewhere. ▶ *He carried the drinks into the classroom.*
2 If you carry on doing something, you keep doing it. ▶ *The children carried on talking.*

cart *noun* (*plural* **carts**)
Something with wheels that you can put things in to take them somewhere. Some carts are pulled by horses, and others are pushed along by people.

carton *noun* (*plural* **cartons**)
a small plastic or cardboard box in which food or drink is sold

cartoon *noun* (*plural* **cartoons**)
1 a funny drawing that makes people laugh
2 a film that has drawings instead of real people

cartridge *noun* (*plural* **cartridges**)
a small tube with ink in that you put into a pen or computer printer

cartwheel *noun* (*plural* **cartwheels**)
When you do a cartwheel, you put your hands on the ground and swing your legs into the air in a circle.

carve *verb* (**carves, carving, carved**)
1 When you carve something, you make it by cutting wood or stone into the right shape.
2 When you carve meat, you cut slices from it.

case *noun* (*plural* **cases**)
1 a box for keeping things in
2 a suitcase

cash *noun*
money

cassette *noun* (*plural* **cassettes**)
a small flat box with a tape inside it for recording or playing music or films

cast *verb* (**casts, casting, cast**)
1 To cast something means to throw it. ▶ *He cast the ring into the water.*
2 To cast a spell on someone means to say a spell that will affect them.

cast *noun* (*plural* **casts**)
The cast of a play is all the actors who are in it.

castle *noun* (*plural* **castles**)
a large, strong building with thick, stone walls

casual *adjective*
Casual clothes are clothes that you wear when you are relaxing.

casualty *noun* (*plural* **casualties**)
1 a person who is killed or injured in an accident or in a war
2 the part of a hospital where people are taken if they are injured or become ill suddenly

cat *noun* (*plural* **cats**)
a furry animal that people often keep as a pet. Lions, tigers, and leopards are large, wild cats.

catalogue *noun* (*plural* **catalogues**)
a list of all the things that you can buy from a place, sometimes with pictures of the things

catapult *noun* (*plural* **catapults**)
a weapon that you can use for firing small stones

catastrophe *noun* (*plural* **catastrophes**)
something very bad that happens by accident

catch verb (catches, catching, caught)
1 If you catch something that is moving through the air, you get hold of it. ▶ *Try to catch the ball.*
2 To catch someone means to find them and take them prisoner. ▶ *The police finally caught the bank robbers.*
3 If you catch an illness, you get it.
4 When you catch a bus or train, you get on it.

catching adjective
If an illness is catching, it passes easily from one person to another.

caterpillar noun (plural caterpillars)
a small animal that looks like a worm and will turn into a butterfly or moth

cathedral noun (plural cathedrals)
a big, important church

catkin noun (plural catkins)
Catkins are the flowers of some trees, which hang down from the branches in the spring.

cattle noun
cows and bulls

caught verb SEE **catch**

cauldron noun (plural cauldrons)
a large pot that was used in the past for cooking

cauliflower noun (plural cauliflowers)
a large, round, white vegetable

cause noun (plural causes)
The cause of something is the thing that makes it happen. ▶ *We do not know the cause of the explosion.*

cause verb (causes, causing, caused)
To cause something to happen means to make it happen. ▶ *The wind caused the door to slam.*

cautious adjective (pronounced **kor-shuss**)
If you are cautious, you are very careful not to do anything that might be dangerous.

cavalry noun
The cavalry is the part of an army that fights on horses.

cave noun (plural caves)
a big hole in the rock under the ground or inside a mountain

cavern noun (plural caverns)
a big cave

CD noun (plural CDs)
a round, flat disc on which music or computer information can be stored. CD is short for **compact disc**.

CD-ROM noun (plural CD-ROMs)
a round, flat disc on which computer information is stored. CD-ROM is short for **compact disc read-only memory**.

cease verb (ceases, ceasing, ceased)
If something ceases, it stops happening.

ceiling noun (plural ceilings) (pronounced **see-** ling)
the part of a room above your head

celebrate verb (celebrates, celebrating, celebrated)
When you celebrate, you do something special because it is an important day. ▶ *What shall we do to celebrate your birthday?*
❶ A **celebration** is a special event to celebrate something.

celery noun
a vegetable with long white stalks that you can eat raw

cell noun (plural cells)
1 a small room in which a prisoner is kept in a prison
2 Cells are the tiny parts that all living things are made of.

cellar noun (plural cellars)
a room underneath a building

cello noun (plural cellos) (c- in this word sounds like **ch-**)
a musical instrument like a big violin. You sit down and hold it between your knees to play it.

cellphone

cellphone noun (plural **cellphones**)
a telephone that you can carry around with you

Celsius adjective
We can measure temperature in degrees Celsius. Water boils at 100 degrees Celsius.

cement noun
the substance that builders use to hold bricks together

cemetery noun (plural **cemeteries**)
a place where dead people are buried

centigrade adjective
We can measure temperature in degrees centigrade. Water boils at 100 degrees centigrade.

centimetre noun (plural **centimetres**)
We can measure length in centimetres. There are 100 centimetres in one metre.

centipede noun (plural **centipedes**)
a long, creeping creature with a lot of tiny legs

centre noun (plural **centres**)
1 The centre of something is the part in the middle of it. ▶ *He was standing in the centre of the room.*
2 a place where you go to do certain things ▶ *Have you been to the new sports centre yet?*

century noun (plural **centuries**)
a hundred years

cereal noun (plural **cereals**)
1 Cereals are plants such as wheat and corn that are grown by farmers for their seeds.
2 A breakfast cereal is a food that you eat at breakfast. Cereals are often made from wheat, oats, or rice, and you eat them with milk.

cerebral palsy noun
Someone who has cerebral palsy has difficulties moving some parts of their body because their brain was damaged when they were born.

ceremony noun (plural **ceremonies**)
an event at which something important is announced to people. There is usually a ceremony when people get married, or when someone has died.

certain adjective
1 If you are certain about something, you are sure that it is true. ▶ *Are you certain it was Jessica that you saw?*
2 A certain person or thing is one in particular. ▶ *A certain person is going to be very angry about this.*
❶ If you are certain that something is true, you can say that it is **certainly** true.

certificate noun (plural **certificates**)
a piece of paper that says you have achieved something

chain noun (plural **chains**)
a metal rope that is made of a line of metal rings fastened together

chair noun (plural **chairs**)
a seat for one person to sit on

chalk noun (plural **chalks**)
1 a type of soft white rock ▶ *We could see the white chalk cliffs in the distance.*
2 a white or coloured stick that you use for writing on a blackboard

challenge verb (**challenges, challenging, challenged**)
If you challenge someone to a race or competition, you ask them to take part in it.

champagne noun
a type of wine that people often drink to celebrate something

champion noun (plural **champions**)
the person who has won a game or competition and shown that they are the best ▶ *Anita is now the 100 metres champion in our school.*

chance noun (plural **chances**)
1 A chance to do something is a time when it is possible for you to do it. ▶ *This is our last chance to escape.*
2 When something happens by chance, it just happens, with no one planning or organizing it.

change verb (**changes, changing, changed**)
1 When you change something, you make it different. ▶ *I'm going to change my room around.*
2 When something changes, it becomes different. ▶ *Caterpillars change into butterflies or moths.*
3 When you change something, you give it to someone or get rid of it, and get a different one instead. ▶ *I'm going to take these trousers back to the shop to change them.*

change noun
1 Change is the money you get back when you give too much money to pay for something. ▶ *The shopkeeper gave me my change.*
2 (plural **changes**) When there is a change, something becomes different.

channel noun (plural **channels**)
1 a narrow area of sea ▶ *It doesn't take long to cross the English Channel.*
2 a television station ▶ *Which channel is the football on?*

chant verb (**chants, chanting, chanted**)
When people chant, they say or sing the same words over and over again.

chaos noun (pronounced **kay**-oss)
When there is chaos, everything is very confused and no one knows what is happening.

chapel noun (plural **chapels**)
1 a small church
2 a room inside a church or other building where people can pray

chapter noun (plural **chapters**)
one part of a book ▶ *I read three chapters of my book last night.*

character noun (plural **characters**)
1 a person in a story ▶ *Who is your favourite character in the book?*
2 Your character is the sort of person you are. ▶ *The twins look the same, but they have very different characters.*

charcoal noun
a black substance that is made of wood that has been burnt very slowly. You can use it for drawing, or as a fuel in a barbecue.

charge noun (plural **charges**)
A charge is the amount of money that you have to pay for something.
in charge If you are in charge of something, you have the job of organizing it or looking after it. ▶ *Mum left me in charge of the washing-up.*

charge verb (**charges, charging, charged**)
1 If you charge money for something, you ask for money.
2 If you charge at someone, you rush at them suddenly. ▶ *The bull charged at us.*

chariot noun (plural **chariots**)
a small cart with two wheels that was used in the past for racing and fighting. It was pulled by horses, and a person stood up in it.

charity noun (plural **charities**)
an organization that raises money and uses it to help people who are poor or need help

charm noun (plural **charms**)
1 If someone has charm, they are pleasant and polite and so people like them.
2 a magic spell
3 a small ornament that you wear to bring good luck

charming adjective
1 Something that is charming is pretty and lovely.
2 Someone who is charming is pleasant and polite.

chart

chart *noun* (*plural* **charts**)
1 a big map
2 a sheet of paper that has rows of numbers or dates on it
the charts a list of the pop songs that are most popular each week

chase *verb* (**chases, chasing, chased**)
To chase someone means to run after them and try to catch them. ▶ *They chased each other round the playground.*

chat *verb* (**chats, chatting, chatted**)
When people chat, they talk in a friendly way.

chatter *verb* (**chatters, chattering, chattered**)
1 If you chatter, you talk a lot about things that are not very important.
2 When your teeth chatter, they bang together because you are cold.

cheap *adjective* (**cheaper, cheapest**)
Something that is cheap does not cost very much money.

cheat *verb* (**cheats, cheating, cheated**)
1 If you cheat in a game or test, you break the rules so that you can do well.
2 If you cheat someone, you get something from them by tricking them.

cheat *noun* (*plural* **cheats**)
someone who cheats in a game or test

check *verb* (**checks, checking, checked**)
If you check something, you look at it carefully to make sure that it is right. ▶ *Remember to check your spellings.*

checkout *noun* (*plural* **checkouts**)
the place in a shop where you pay for things

check-up *noun* (*plural* **check-ups**)
When you have a check-up, a doctor or dentist looks at you to check that there are no problems.

cheek *noun* (*plural* **cheeks**)
1 Your cheeks are the sides of your face. ▶ *She had lovely rosy cheeks.*
2 Cheek is talking or behaving in a rude way towards someone.

cheeky *adjective* (**cheekier, cheekiest**)
If you are cheeky, you are rude to someone and do not show that you respect them.

cheer *verb* (**cheers, cheering, cheered**)
When you cheer, you shout to show that you are pleased or that you want your team to win.

cheerful *adjective*
If you are cheerful, you are happy.

cheese *noun* (*plural* **cheeses**)
a type of food that is made from milk and has a strong, salty taste

cheetah *noun* (*plural* **cheetahs**)
a wild animal that is a member of the cat family. Cheetahs have black spots on their body, and can run very fast.

chef *noun* (*plural* **chefs**)
someone who cooks the food in a hotel or restaurant

chemical *noun* (*plural* **chemicals**)
a substance that is found in nature or made in a science laboratory. Some chemicals are dangerous and can harm you.
❶ **Chemistry** is the subject in which you study chemicals.

chemist *noun* (*plural* **chemists**)
someone who makes or sells medicines

cheque *noun* (*plural* **cheques**)
a special piece of paper that a person can sign and use instead of money

cherry *noun* (*plural* **cherries**)
a small round red fruit with a stone in the middle

chess *noun*
a game in which two people move special pieces across a black and white board

chest *noun* (*plural* **chests**)
1 a big, strong box
2 Your chest is the front part of your body between your neck and your waist.

chestnut *noun* (*plural* **chestnuts**)
1 a large tree
2 a nut that grows on a chestnut tree

chew *verb* (**chews, chewing, chewed**)
When you chew food, you keep biting on it in your mouth before you swallow it.

chewing gum *noun*
a type of sweet that you keep chewing and do not swallow

chick *noun* (*plural* **chicks**)
a baby bird

chicken *noun* (*plural* **chickens**)
a bird that is kept on farms for its meat and eggs

chickenpox *noun*
an illness that gives you red itchy spots on your body

chief *noun* (*plural* **chiefs**)
a leader who is in charge of other people

child *noun* (*plural* **children**)
1 a young boy or girl
2 Someone's child is their son or daughter.
❶ Your **childhood** is the time when you are a child. Someone who is **childish** behaves in a silly way, like a child.

childminder *noun* (*plural* **childminders**)
a person who looks after children during the day while their parents are at work

chill *noun* (*plural* **chills**)
If you catch a chill, you catch a cold.

chill *verb* (**chills, chilling, chilled**)
To chill something means to make it cold.

chilli *noun* (*plural* **chillis**)
a small red or green pepper that has a very hot taste and is added to food to give it a strong, hot flavour

chilly *adjective* (**chillier, chilliest**)
If you are chilly, you are slightly cold. If the weather is chilly, it is quite cold.

chime *verb* (**chimes, chiming, chimed**)
When a clock or bell chimes, it makes a ringing sound.

chimney *noun* (*plural* **chimneys**)
a tall pipe that takes smoke away from a fire inside a building

chimpanzee *noun* (*plural* **chimpanzees**)
an African ape. Chimpanzees look like large monkeys and have long arms and no tail.

chin *noun* (*plural* **chins**)
Your chin is the part at the bottom of your face, under your mouth.

china *noun*
cups, saucers, and plates that are made of pottery

chip *noun* (*plural* **chips**)
1 Chips are small pieces of fried potato.
2 If there is a chip in something, a small piece of it has broken off.
▶ *There's a chip in this mug.*
3 A computer chip is the small electronic part inside it that makes it work.

chip *verb* (**chips, chipping, chipped**)
If you chip something, you break a small piece off it.

chirp *verb* (**chirps, chirping, chirped**)
When birds chirp, they sing.

chocolate *noun* (*plural* **chocolates**)
a sweet food that is made from cocoa and sugar

choice

choice noun (plural **choices**)
1 When you make a choice, you choose something. ▶ *You can have first choice.*
2 If there is a choice, there are several different things to choose from. ▶ *There's a choice of vanilla, chocolate, or strawberry ice cream.*

choir noun (plural **choirs**) (*pronounced* **kwire**)
a group of people who sing together

choke verb (**chokes, choking, choked**)
When you choke, you cannot breathe properly. ▶ *The smoke made me choke.*

chomp verb (**chomps, chomping, chomped**)
If you chomp on something, you chew it.

choose verb (**chooses, choosing, chose, chosen**)
When you choose something, you decide that it is the one you want.

chop verb (**chops, chopping, chopped**)
When you chop something, you cut it with a knife or axe.

chop noun (plural **chops**)
a thick slice of pork or lamb with a bone still attached to it

chopsticks noun
a pair of thin sticks that you hold in one hand and use to eat food

chore noun (plural **chores**)
Chores are small jobs that you need to do every day around the house.

chorus noun (plural **choruses**) (ch- in this word sounds like **k**-)
The chorus is the part of a song or poem that you repeat after each verse.

chose, chosen verb SEE **choose**

christen verb (**christens, christening, christened**)
When a baby is christened, it is given its name at a Christian ceremony in church.
❶ A **christening** is a ceremony at which a baby is christened.

Christian noun (plural **Christians**)
someone who follows the Christian religion and believes in Jesus Christ
❶ The religion that Christians follow is **Christianity**.

Christmas noun (plural **Christmases**)
December 25th, when Christians celebrate the birth of Jesus Christ

chrysalis noun (plural **chrysalises**) (*pronounced* **kriss**-a-liss)
the hard cover that a caterpillar makes round itself before it changes into a butterfly or moth

chubby adjective
Someone who is chubby is slightly fat.

chuck verb (**chucks, chucking, chucked**)
To chuck something means to throw it hard.

chuckle verb (**chuckles, chuckling, chuckled**)
When you chuckle, you laugh quietly to yourself.

chug verb (**chugs, chugging, chugged**)
When a train or lorry chugs along, it moves along slowly.

chunk noun (plural **chunks**)
A chunk of something is a large piece or lump of it.

church noun (plural **churches**)
a building where Christians pray and worship

cigar noun (plural **cigars**)
a roll of tobacco leaves that some people smoke

cigarette noun (plural **cigarettes**)
a thin tube of paper with tobacco inside that some people smoke

cinders noun
small pieces of burnt wood or coal that are left after a fire has gone out

cinema noun (plural **cinemas**)
a place where people go to watch films

circle noun (plural **circles**)
a round shape like a ring or a wheel
❶ Something that is round like a circle is **circular**.

circle verb (**circles, circling, circled**)
To circle means to go round in a circle. ▶ *Birds circled around above us.*

circuit noun (plural **circuits**)
a path that electricity flows around. If there is a break in a circuit, the electricity cannot flow.

circumference noun (plural **circumferences**)
The circumference of a circle is how much it measures round its edge.

circumstances noun
The circumstances of an event are the things that are happening around it and might affect it. ▶ *The police need to know the circumstances surrounding the accident.*

circus noun (plural **circuses**)
a show in which clowns, acrobats, and sometimes animals perform in a large tent

citizen noun (plural **citizens**)
a person who lives in a town, city, or country

citrus adjective
Citrus fruits are fruits such as oranges, lemons, and grapefruits.

city noun (plural **cities**)
a big town

civil adjective
If you are civil, you are polite.

civilization noun (plural **civilizations**)
the way of life of a particular group of people ▶ *We're doing a project on the ancient Greek civilization.*

claim verb (**claims, claiming, claimed**)
1 When you claim something, you say that you want it because it is yours.
2 If you claim that something is true, you say that it is true.

clamber verb (**clambers, clambering, clambered**)
When you clamber over things, you climb over them.

clang verb (**clangs, clanging, clanged**)
When something clangs, it makes a loud, ringing sound.

clank verb (**clanks, clanking, clanked**)
When things clank, they make a sound like the sound of heavy pieces of metal banging together.

clap verb (**claps, clapping, clapped**)
When you clap, you bang your hands together to make a noise.

clash verb (**clashes, clashing, clashed**)
When things clash, they make a loud sound like the sound of two metal objects banging together.

clasp verb (**clasps, clasping, clasped**)
If you clasp something, you hold it tightly.

class noun (plural **classes**)
a group of children who learn things together

classroom noun (plural **classrooms**)
a room where children have lessons

clatter noun
a loud rattling or banging noise ▶ *I heard the clatter of horses' hooves on the road.*

clatter

clatter verb (**clatters, clattering, clattered**)
When things clatter, they make a loud rattling or banging noise.

clause noun (plural **clauses**)
a group of words that contains a verb and makes up one part of a sentence

claw noun (plural **claws**)
An animal's claws are its sharp nails. ▶ *Polar bears have huge, sharp claws.*

clay noun
a type of sticky mud that becomes very hard when it dries out. Clay is used for making pots and pottery.

clean adjective (**cleaner, cleanest**)
Something that is clean has no dirt on it. ▶ *She put on some clean clothes.*

clean verb (**cleans, cleaning, cleaned**)
To clean something means to take the dirt off it so that it is clean.

clear adjective (**clearer, clearest**)
1 If water or glass is clear, it is not dirty and you can see through it.
2 If a picture or sound is clear, you can see it or hear it easily. ▶ *Please speak in a nice, clear voice.*
3 If something is clear, you can understand it. ▶ *All this mess has to be tidied up. Is that clear?*
4 If a place is clear, there is nothing blocking it or getting in the way. ▶ *The road is clear now.*
❶ You can say that you see, hear, or understand something **clearly**.

clear verb (**clears, clearing, cleared**)
To clear a place means to get rid of things that are in the way. ▶ *Will you help me clear the table, please?*

clench verb (**clenches, clenching, clenched**)
When you clench your teeth or fists, you close them tightly.

clerk noun (plural **clerks**) (rhymes with *park*)
someone who works in an office

clever adjective (**cleverer, cleverest**)
Someone who is clever learns things quickly and easily.

click verb (**clicks, clicking, clicked**)
1 When something clicks, it makes a short sound like the sound a light switch makes.
2 When you click on something on a computer, you move the mark on the screen so that it is on that thing and then you press the button on the mouse.

cliff noun (plural **cliffs**)
a steep hill made of rock next to the sea

climate noun (plural **climates**)
The climate that a place has is the sort of weather that it has. ▶ *India has a very hot climate.*

climb verb (**climbs, climbing, climbed**)
1 To climb means to go upwards. ▶ *She climbed the stairs slowly.*
2 When you climb, you use your hands and feet to move over things. ▶ *They climbed over the rocks.*

cling verb (**clings, clinging, clung**)
When you cling to something, you hold on to it very tightly.

clinic noun (plural **clinics**)
a place where you can go to see a doctor or nurse

clip noun (plural **clips**)
a fastener that you use for keeping things in place ▶ *You hold pieces of paper together with paper clips.*

clip verb (**clips, clipping, clipped**)
To clip something means to cut it with scissors or shears.

cloak noun (plural **cloaks**)
a piece of clothing that you wrap around your shoulders and fasten round your neck

cloakroom noun (plural **cloakrooms**)
the room where you can hang your coat

clock noun (plural **clocks**)
a machine that shows you the time

clockwise adverb
If something moves clockwise, it moves round in a circle in the same direction as the hands of a clock.
▶ *Turn the handle clockwise.*

clockwork adjective
A clockwork toy is worked by a spring which you have to wind up.

clog verb (**clogs, clogging, clogged**)
If something gets clogged with things, it gets blocked up.

close adjective (**closer, closest**) (rhymes with *dose*)
1 If you are close to something, you are near it. ▶ *Don't get too close to the fire.*
2 If you take a close look at something, or keep a close watch on something, you do it very carefully.
❶ You can say that you look at something or watch something **closely**.

close verb (**closes, closing, closed**) (rhymes with *doze*)
1 To close something means to shut it. ▶ *Please close the door when you go out.*
2 When a shop closes, it is no longer open and people cannot go there. ▶ *The shop closes at half past five.*

cloth noun
material for making things like clothes and curtains

clothes, clothing noun
the things that you wear to cover your body

cloud noun (plural **clouds**)
Clouds are the large grey or white things that sometimes float high in the sky. Clouds are made of drops of water that often fall as rain.
❶ When there are clouds in the sky, the weather is **cloudy**. A **cloudless** sky has no clouds in it.

clover noun
a small plant that has leaves like three small leaves joined together

clown noun (plural **clowns**)
someone in a circus who wears funny clothes and make-up and does silly things to make people laugh

club noun (plural **clubs**)
1 a group of people who get together because they are interested in doing the same thing ▶ *We have got a chess club at school.*
2 a thick stick that is used as a weapon

cluck verb (**clucks, clucking, clucked**)
When a hen clucks, it makes a soft sound in its throat.

clue noun (plural **clues**)
something that helps you to find the answer to a puzzle

clump noun (plural **clumps**)
A clump of trees or bushes is a group of them growing close together.

clumsy adjective (**clumsier, clumsiest**)
If you are clumsy, you are not careful and so are likely to knock things over or drop things.

clung verb SEE **cling**

cluster noun (plural **clusters**)
A cluster of things is a group of them very close together.

clutch verb (**clutches, clutching, clutched**)
When you clutch something, you hold on to it very tightly. ▶ *She was clutching her teddy bear.*

clutter

clutter *noun*
a lot of things in an untidy mess
❶ A place that is **cluttered** is very messy and untidy.

coach *noun* (*plural* **coaches**)
1 a bus that takes people on long journeys
2 The coaches on a train are the carriages where people sit.
3 someone who trains people in a sport ▶ *You should always listen to your football coach.*

coal *noun*
a type of hard, black rock that people burn on fires. Coal is found under the ground.

coarse *adjective* (**coarser**, **coarsest**)
Something that is coarse is rough or hard. ▶ *His clothes were made of coarse cloth.*

coast *noun* (*plural* **coasts**)
the land that is right next to the sea ▶ *We went to the coast last Sunday.*

coat *noun* (*plural* **coats**)
1 a piece of clothing with sleeves that you wear on top of other clothes to keep warm
2 An animal's coat is the hair or fur that covers its body.
3 A coat of paint is a layer of paint. ▶ *Your model will look better if you give it two coats of paint.*

cobbler *noun* (*plural* **cobblers**)
someone whose job is to mend shoes

cobbles *noun*
round stones that people used in the past for making roads

cobra *noun* (*plural* **cobras**)
a poisonous snake. A cobra can lift the front part of its body off the ground and spread the skin on its neck so that it looks like a hood.

cobweb *noun* (*plural* **cobwebs**)
a thin, sticky net that a spider spins to trap insects

cockerel *noun* (*plural* **cockerels**)
a male chicken

cocoa *noun*
a brown powder that tastes of chocolate. It is used for making a hot chocolate drink and also for making chocolate cakes and biscuits.

coconut *noun* (*plural* **coconuts**)
a big, round, hard nut that grows on palm trees. It is brown and hairy on the outside and it has sweet, white flesh inside that you can eat.

cocoon *noun* (*plural* **cocoons**)
a covering that some insects spin from silky threads to protect themselves while they are changing into their adult form

cod *noun* (the plural is the same)
a sea fish that you can eat

code *noun* (*plural* **codes**)
a set of signs or letters that you use for sending messages secretly

coffee *noun* (*plural* **coffees**)
a hot drink that is made by adding hot water to roasted coffee beans that have been ground into a powder

coffin *noun* (*plural* **coffins**)
the long box in which a dead person's body is put

coil *verb* (**coils**, **coiling**, **coiled**)
To coil something means to wind it round and round in the shape of a lot of circles. ▶ *The snake was coiled round a branch.*

coin *noun* (*plural* **coins**)
a piece of metal money

cold *adjective* (**colder**, **coldest**)
Something that is cold is not hot. ▶ *This soup is cold!*

cold *noun* (*plural* **colds**)
an illness that makes you sneeze and gives you a runny nose

collage noun (plural **collages**) (pronounced **coll**-arj)
a picture that you make by gluing small pieces of paper and material

collapse verb (**collapses, collapsing, collapsed**)
1 If something collapses, it falls down. ▶ *Several buildings collapsed after the earthquake.*
2 If someone collapses, they fall over because they are ill.

collar noun (plural **collars**)
1 The collar on a piece of clothing is the part that goes round your neck.
2 a thin band of leather or material that goes round an animal's neck

collect verb (**collects, collecting, collected**)
1 If you collect things, you get them and keep them together. ▶ *A lot of people collect stamps.*
2 When you collect someone, you go to a place and get them. ▶ *She collected the children from school.*
❶ A set of things that someone has collected is a **collection**.

collective noun noun (plural **collective nouns**)
a noun that is the name of a group of things, people, or animals. *Flock* and *herd* are collective nouns.

college noun (plural **colleges**)
a place where you can go to study after you have left school

collide verb (**collides, colliding, collided**)
To collide with something means to bump into it. ▶ *The lorry collided with a bus.*

colon noun (plural **colons**)
a mark like this : that you use in writing

colour noun (plural **colours**)
Red, green, blue, and yellow are different colours.
❶ Something that has a lot of bright colours is **colourful**.

colour verb (**colours, colouring, coloured**)
When you colour something, you use paint or pencils to put colour on it.

column noun (plural **columns**)
1 a thick stone post that supports or decorates a building
2 a line of numbers or words one below the other

comb noun (plural **combs**)
Something you use to make your hair tidy. It is a strip of plastic or metal with a row of thin teeth along it.

combine verb (**combines, combining, combined**)
When you combine things, you join or mix them together.
❶ A **combination** is a set of things that have been joined or mixed together.

combine harvester noun (plural **combine harvesters**)
a machine that cuts down corn and separates the seeds from the stalks

come verb (**comes, coming, came, come**)
1 To come to a place means to move towards it. ▶ *Would you like to come to my house for tea?*
2 When something comes, it arrives in a place. ▶ *Has the letter come yet?*

comedian noun (plural **comedians**)
someone who entertains people by making them laugh

comedy noun (plural **comedies**)
a play, film, or TV programme that is funny and makes you laugh

comet noun (plural **comets**)
an object that moves around the sun and looks like a bright star with a tail

comfort

comfort *verb* (**comforts, comforting, comforted**)
When you comfort someone, you are kind to them and try to make them feel better when they are hurt or upset.

comfortable *adjective*
1 If something is comfortable, it is pleasant to use or to wear and does not hurt you at all. ▶ *This chair is very comfortable.*
2 If you are comfortable, you are relaxed and are not in any pain. ▶ *Are you comfortable?*
❶ If you are sitting or standing **comfortably**, you are sitting or standing so that you feel comfortable.

comic *adjective*
Something that is comic is funny and makes you laugh.
❶ **Comical** means the same as comic.

comic *noun* (*plural* **comics**)
1 a magazine for children that has stories told in pictures
2 a person who does funny things to make people laugh

comma *noun* (*plural* **commas**)
a mark like this , that you use in writing

command *verb* (**commands, commanding, commanded**)
If you command someone to do something, you tell them to do it.

commemorate *verb* (**commemorates, commemorating, commemorated**)
When you commemorate an event, you do something special so that people will remember it.

comment *noun* (*plural* **comments**)
something that you say about a person or thing ▶ *You shouldn't make rude comments about someone's appearance.*

commentary *noun* (*plural* **commentaries**)
a description of something that is happening, for example a race or game
❶ To **commentate** means to describe something that is being broadcast on TV or radio. A **commentator** is someone who does this.

commercial *noun* (*plural* **commercials**)
an advertisement on TV or radio

commit *verb* (**commits, committing, committed**)
To commit a crime means to do it. ▶ *He had committed murder.*

committee *noun* (*plural* **committees**)
a group of people who meet to talk about things and decide what to do

common *adjective* (**commoner, commonest**)
Something that is common is normal and ordinary.

common noun *noun* (*plural* **common nouns**)
a noun that is the name of a thing. For example, *hat*, *dog*, and *teacher* are all common nouns.

commotion *noun*
When there is a commotion, a lot of people are making a noise and moving about all at once.

communicate *verb* (**communicates, communicating, communicated**)
When people communicate, they talk or write to each other.
❶ **Communication** happens when people talk or write to each other.

community *noun* (*plural* **communities**)
all the people who live in a place

commuter *noun* (*plural* **commuters**)
a person who travels to work every day in a car or train

compact *adjective*
Something that is compact is small and neat.

compact disc *noun* (*plural* **compact discs**)
a CD

companion *noun* (*plural* **companions**)
a friend who is with you

company *noun* (*plural* **companies**)
1 A company is a group of people who make and sell things, or do things together.
2 If you have company, you are not alone.

comparative *adjective*
The comparative form of an adjective is the part that means 'more', for example 'bigger' is the comparative form of 'big'.

compare *verb* (**compares, comparing, compared**)
When you compare things, you try to see how they are the same and how they are different.
❶ When you compare things, you make a **comparison** between them.

compass *noun* (*plural* **compasses**)
1 an instrument with a needle that always points north ▶ *The walkers used a compass to find their way home.*
2 an instrument that you use for drawing circles. It is also called a **pair of compasses**.

compatible *adjective*
Things that are compatible will work well together.

competition *noun* (*plural* **competitions**)
a game or race that people take part in and try to win
❶ When you **compete**, you take part in a competition and try to win.

complain *verb* (**complains, complaining, complained**)
If you complain, you say that you are not happy about something or do not like something. ▶ *We all complained about the terrible food.*
❶ When you complain, you can also say that you make a **complaint**.

complete *adjective*
1 Something that is complete has all its parts and has nothing missing. ▶ *This is not a complete chess set.*
2 If something is complete, it is finished. ▶ *After three days the work was complete.*
3 Complete means in every way. ▶ *Winning the game was a complete surprise.*
❶ When something happens **completely**, it happens totally. ▶ *The building was completely destroyed.*

complete *verb* (**completes, completing, completed**)
When you complete something, you finish it. ▶ *You can play when you have completed your work.*

complicated *adjective*
Something that is complicated is difficult to understand or do. ▶ *The instructions are very complicated.*

compliment *noun* (*plural* **compliments**)
If someone gives you a compliment, they say something nice about you.

composer *noun* (*plural* **composers**)
someone who writes music
❶ to **compose** music means to write it

composition *noun* (*plural* **compositions**)
1 a piece of music that someone has written
2 a story you have written

compound

compound noun (plural **compounds**)
a word that is made up of two words joined together. *Bedroom* and *blackboard* are compounds.

comprehensive school noun (plural **comprehensive schools**)
a school all children can go to when they are eleven years old

compulsory adjective
If something is compulsory, you have to do it.

computer noun (plural **computers**)
a machine which can store information and do calculations. You can also play games on computers.

concave adjective
Something that is concave curves inwards in the shape of a bowl.

conceal verb (**conceals, concealing, concealed**)
To conceal something means to hide it.

conceited adjective
If you are conceited, you think that you are very clever or attractive.

concentrate verb (**concentrates, concentrating, concentrated**)
When you concentrate, you think hard about the thing you are doing. ▶ *I'm trying to concentrate on my work!*

concern verb (**concerns, concerning, concerned**)
If something concerns you, it is important to you and you should be interested in it. If something does not concern you, it is nothing to do with you.

concerned adjective
If you are concerned about something, you are worried about it.

concert noun (plural **concerts**)
a show in which people play music for other people to listen to ▶ *I'm playing the recorder in the school concert.*

conclusion noun (plural **conclusions**)
something that you decide is true after you have thought about everything carefully ▶ *I came to the conclusion that my sister must have been lying to me.*

concrete noun
a mixture of cement and sand used for making buildings and paths

condemn verb (**condemns, condemning, condemned**)
1 When you condemn something, you say that it is very bad. ▶ *We all condemn cruelty to animals.*
2 To condemn someone to a punishment means to give them that punishment. ▶ *The robbers were condemned to five years in prison.*

condition noun (plural **conditions**)
1 The condition something is in is how new or clean it is, and how well it works. If it is in good condition, it looks new and works properly. If it is in poor condition, it is old or dirty, or does not work properly.
2 A condition is something you must do before you can do or have something else. ▶ *You can go out to play on condition that you tidy your room first.*

conduct verb (**conducts, conducting, conducted**)
When you conduct music, you stand in front of the musicians and control the way they play.

conductor noun (plural **conductors**)
1 someone who stands in front of an orchestra and controls the way the musicians play
2 someone who sells tickets on a bus

cone noun (plural **cones**)
1 a shape that is round at one end and goes in to a point at the other end, like the shape of a witch's hat
2 a hard, brown fruit that grows on pine trees and fir trees

confectionery *noun*
sweets and chocolates

confess *verb* (**confesses, confessing, confessed**)
If you confess, you admit that you have done something wrong.
ℹ When you confess, you make a **confession**.

confetti *noun*
tiny pieces of coloured paper that people throw over a bride and bridegroom at their wedding

confide *verb* (**confides, confiding, confided**)
If you confide in someone, you tell them a secret.

confident *adjective*
If you are confident, you are brave and not afraid because you know that you can do something well.
▶ *Sam is a very confident swimmer.*
ℹ **Confidence** is the feeling you have when you are confident.

confidential *adjective*
Information that is confidential must be kept secret.

confuse *verb* (**confuses, confusing, confused**)
1 If something confuses you, you cannot understand it.
2 If you confuse things, you get them muddled up in your mind.
ℹ If you feel **confused**, you feel puzzled. If something is **confusing**, it makes you feel puzzled. **Confusion** is the feeling you have when you are puzzled.

congratulate *verb* (**congratulates, congratulating, congratulated**)
If you congratulate someone, you tell them that you are pleased that something special has happened to them. ▶ *I congratulated Salim on winning the race.*
ℹ You say **congratulations** to someone when you want to congratulate them.

conjunction *noun* (*plural* **conjunctions**)
a word that you use to join two parts of a sentence together. *And* and *but* are conjunctions.

conjuror *noun* (*plural* **conjurors**)
someone who entertains people by doing tricks that look like magic

conker *noun* (*plural* **conkers**)
the hard, brown nut that grows on a horse chestnut tree

connect *verb* (**connects, connecting, connected**)
To connect things means to join them together. ▶ *You need to connect the printer to your computer.*
ℹ A **connection** is a place where two things are connected.

connective *noun* (*plural* **connectives**)
a word or phrase that you use to join different sentences or parts of sentences. *However*, *and*, and *meanwhile* are connectives.

conquer *verb* (**conquers, conquering, conquered**)
To conquer people means to beat them in a battle or war.

conscience *noun*
Your conscience is the feeling inside you that tells you what is right and wrong. ▶ *Tom had a guilty conscience about breaking the window.*

conscious *adjective*
When you are conscious, you are awake and able to understand what is happening around you. ▶ *He slowly became conscious again after the operation.*

consequence *noun* (*plural* **consequences**)
something that happens as a result of something else

conservation *noun*
taking good care of the world's air, water, plants, and animals ▶ *Using less paper will help with conservation of the rain forest.*

consider

consider *verb* (**considers, considering, considered**)
When you consider something, you think about it carefully.

considerable *adjective*
A considerable amount is a large amount.

considerate *adjective*
If you are considerate, you think about other people and are kind and thoughtful in the way you behave.

consonant *noun* (*plural* **consonants**)
Consonants are all the letters of the alphabet except **a, e, i, o**, and **u**, which are vowels.

constable *noun* (*plural* **constables**)
a policeman or policewoman

constant *adjective*
Something that is constant goes on all the time.
❶ Something that happens **constantly** happens all the time.

constellation *noun* (*plural* **constellations**)
a group of stars

construct *verb* (**constructs, constructing, constructed**)
To construct something means to build it.

contain *verb* (**contains, containing, contained**)
To contain something means to have it inside. ▶ *The chest contained gold, silver, and precious stones.*

container *noun* (*plural* **containers**)
anything that you can put other things into. Buckets, cups, bags, boxes, and jars are all containers.

contented *adjective*
If you are contented, you are happy.

contents *noun*
The contents of something are the things that are inside it.

contest *noun* (*plural* **contests**)
a competition

continent *noun* (*plural* **continents**)
one of the seven very large areas of land in the world. Asia, Europe, and Africa are all continents.

continual *adjective*
Something that is continual happens again and again, without ever stopping. ▶ *I couldn't get on with my work because there were continual interruptions.*
❶ Something that happens **continually** happens again and again.

continue *verb* (**continues, continuing, continued**)
If you continue doing something, you go on doing it. ▶ *The teacher opened the window and then continued talking.*

continuous *adjective*
Something that is continuous goes on happening and never stops. ▶ *The factory machines made a continuous humming noise.*
❶ Something that happens **continuously** happens without ever stopping.

contraction *noun* (*plural* **contractions**)
a short form of one or more words. *Haven't* is a contraction of *have not*.

contradict *verb* (**contradicts, contradicting, contradicted**)
If you contradict someone, you say that what they have said is wrong.

contribute *verb* (**contributes, contributing, contributed**)
If you contribute money, you give it to help pay for something.
❶ A **contribution** is an amount of money that you give to help pay for something.

control *noun* (*plural* **controls**)
The controls are the switches and buttons that you use to make a machine work.

control *verb* (**controls, controlling, controlled**)
When you control something, you make it do what you want it to do. ▶ *He moved the switches and levers to control the model aeroplane in the air.*

convenient *adjective*
If something is convenient, you can reach it and use it easily.

conversation *noun* (*plural* **conversations**)
When people have a conversation, they talk to each other.

convex *adjective*
Something that is convex curves outwards in the shape of a ball.

convince *verb* (**convinces, convincing, convinced**)
If you convince someone about something, you make them believe it.

cook *verb* (**cooks, cooking, cooked**)
When you cook food, you prepare it and heat it so that it is ready to eat.
❶ A **cooker** is a machine on which you cook food.

cook *noun* (*plural* **cooks**)
someone whose job is to cook

cool *adjective* (**cooler, coolest**)
Something that is cool is slightly cold. ▶ *I'd love a cool drink.*

cope *verb* (**copes, coping, coped**)
If you can cope with something, you can manage to do it.

copper *noun*
a shiny brown metal

copy *verb* (**copies, copying, copied**)
1 When you copy something, you write it down or draw it in the same way as it has already been written or drawn. ▶ *She copied the poem in her best writing.*
2 When you copy someone, you do exactly the same as them.

coral *noun*
a type of rock that is made in the sea from the bodies of tiny creatures

cord *noun* (*plural* **cords**)
a thin rope

core *noun* (*plural* **cores**)
The core of an apple or pear is the hard part in the middle of it.

cork *noun* (*plural* **corks**)
something that is pushed into the top of a bottle of wine to close it

corn *noun*
the seeds of plants such as wheat, which we use as food

corner *noun* (*plural* **corners**)
1 the place where two edges meet ▶ *He was sitting by himself in the corner of the room.*
2 the place where two streets meet ▶ *Our school is just round the corner from the library.*

cornet *noun* (*plural* **cornets**)
1 a biscuit shaped like a cone, for holding ice cream
2 a musical instrument like a small trumpet

corpse *noun* (*plural* **corpses**)
a dead body

correct *adjective*
Something that is correct is right and has no mistakes. ▶ *That is the correct answer.*
❶ If you say or do something **correctly**, you do it in the right way.

correct *verb* (**corrects, correcting, corrected**)
When you correct something, you find the mistakes in it and put them right.
❶ When you correct something, you make a **correction**.

corridor *noun* (*plural* **corridors**)
a passage in a building with rooms leading off it

cost *verb* (**costs, costing, cost**)
The amount that something costs is the amount you have to pay to buy it. ▶ *How much did your new bike cost?*

costly *adjective*
Something that is costly costs a lot of money to buy.

costume

costume *noun* (*plural* **costumes**)
clothes that you wear for acting in a play

cosy *adjective* (**cosier, cosiest**)
A cosy place is warm and comfortable.

cot *noun* (*plural* **cots**)
a bed with sides for a baby

cottage *noun* (*plural* **cottages**)
a small house in the country

cotton *noun*
1 thread that you use for sewing
2 a type of cloth that is used for making clothes

couch *noun* (*plural* **couches**)
a long seat that two or three people can sit on

cough *verb* (**coughs, coughing, coughed**) (rhymes with *off*)
When you cough, you make a rough sound in your throat and push air out through your mouth.

could *verb* SEE **can**

count *verb* (**counts, counting, counted**)
1 When you count things, you use numbers to say how many there are. ▶ *I counted the books.*
2 When you count, you say numbers in order. ▶ *Can you count to 1000?*

counter *noun* (*plural* **counters**)
1 the table where you pay for things in a shop
2 a small, round piece of plastic that you use for playing some games

country *noun* (*plural* **countries**)
1 A country is a land with its own people and laws. England, Australia, and China are all countries.
2 The country is land that is not in a town. ▶ *Do you live in the town or in the country?*

countryside *noun*
The countryside is land with fields, woods, and farms away from towns.

county *noun* (*plural* **counties**)
one of the areas that Britain and Ireland are divided into ▶ *Which county do you live in?*

couple *noun* (*plural* **couples**)
1 two people who are married or going out with each other
2 A couple of things means two of them.

coupon *noun* (*plural* **coupons**)
a special piece of paper which you can use to pay for something

courage *noun*
the feeling you have when you are not afraid, and you dare to do something difficult or dangerous
▶ *Anita showed a lot of courage when she had to go to hospital.*
❶ When you show courage, you are **courageous**.

course *noun* (*plural* **courses**)
1 The course of an aeroplane or a ship is the direction it travels in.
2 a set of lessons
3 a piece of ground where people play golf or run races

court *noun* (*plural* **courts**)
1 a piece of ground that is marked out so that people can play a game such as netball or tennis
2 a building where people decide whether someone is guilty of committing a crime
3 The court of a king or queen is the place where they live and rule the country.

cousin *noun* (*plural* **cousins**)
Your cousin is a child of your aunt or uncle.

cover *verb* (**covers, covering, covered**)
When you cover something, you put something else over it. ▶ *She covered him with a blanket.*

cover *noun* (*plural* **covers**)
a piece of material which goes over or round something

cow *noun* (*plural* **cows**)
a large animal that is kept on farms for its milk and meat

coward *noun* (*plural* **cowards**)
someone who is afraid when they ought to be brave

cowboy *noun* (*plural* **cowboys**)
a man who looks after the cattle on large farms in America

crab *noun* (*plural* **crabs**)
an animal with a hard shell on its back, which lives in the sea. Crabs have ten legs and large, powerful claws for catching food.

crack *noun* (*plural* **cracks**)
1 a thin line on something where it has nearly broken ▶ *There is a crack in this glass.*
2 a sudden loud noise ▶ *We heard a crack of thunder.*

crack *verb* (**cracks, cracking, cracked**)
1 When you crack something, you break it so that it has lines on it but does not break into pieces. ▶ *Be careful not to crack the glass.*
2 When something cracks, it makes a sharp noise like the noise a dry twig makes when you break it.

cracker *noun* (*plural* **crackers**)
1 a paper tube with a toy inside it. When two people pull the tube apart, it bangs and one person wins the toy.
2 a thin biscuit with a salty taste

crackle *verb* (**crackles, crackling, crackled**)
When something crackles, it makes the crackling sounds that burning wood makes.

cradle *noun* (*plural* **cradles**)
a bed with sides for a young baby

crafty *adjective* (**craftier, craftiest**)
Someone who is crafty is clever and very good at getting what they want.

cram *verb* (**crams, cramming, crammed**)
If you cram things into a place, you force them all in.

cramp *noun*
If you get cramp, you get a pain because one of your muscles has suddenly become stiff and tight.

crane *noun* (*plural* **cranes**)
a large machine for lifting heavy things

crash *noun* (*plural* **crashes**)
1 an accident in which a car, lorry, train, or plane hits something
2 the noise of something falling or crashing ▶ *I heard a loud crash as the tree fell.*

crash *verb* (**crashes, crashing, crashed**)
1 If something crashes, it bumps into something else and makes a loud noise.
2 If a computer crashes, it stops working suddenly.

crate *noun* (*plural* **crates**)
a large box

crawl *verb* (**crawls, crawling, crawled**)
1 When you crawl, you move along on your hands and knees. ▶ *We crawled through the tunnel.*
2 When a car or train crawls along, it moves very slowly.

crawl *noun*
a way of swimming in which your arms go over your head one at a time, and your legs kick

crayon *noun* (*plural* **crayons**)
a coloured pencil

craze *noun* (*plural* **crazes**)
something that is fashionable or popular for only a short time

crazy *adjective* (**crazier, craziest**)
Someone who is crazy does very silly or strange things. Something that is crazy is very silly or strange.

creak *verb* (**creaks, creaking, creaked**)
If something creaks, it makes a rough, squeaking noise. ▶ *The door creaked as I opened it.*

cream

cream *noun*
a thick white liquid that is taken from milk. You eat cream with fruit and other sweet foods.

crease *verb* (**creases, creasing, creased**)
When you crease something, you make untidy lines in it by pressing on it. ▶ *Don't sit on my jacket – you will crease it.*

create *verb* (**creates, creating, created**)
When you create something new, you make it.
❶ The **creation** of something is the time when it is first made.

creature *noun* (*plural* **creatures**)
any animal ▶ *You shouldn't harm any creature.*

creep *verb* (**creeps, creeping, crept**)
1 When you creep, you move along with your body very close to the ground. ▶ *We crept through the hole in the hedge.*
2 When you creep, you walk very quietly and secretly. ▶ *We crept away and nobody saw us.*

creep *noun* (*plural* **creeps**)
1 a nasty person
2 If something gives you the creeps, it frightens you.
❶ Something that is **creepy** frightens you.

crept *verb* SEE **creep**

crescent *noun* (*plural* **crescents**)
a curved shape, like the shape of a new moon

crew *noun* (*plural* **crews**)
a group of people who work together on a boat or aeroplane

crib *noun* (*plural* **cribs**)
a cot for a young baby

cricket *noun*
1 a game in which two teams hit a ball with a bat and try to score runs by running between two wickets
2 an insect that makes a shrill chirping sound

cried *verb* SEE **cry**

crime *noun* (*plural* **crimes**)
something bad that a person does, which is against the law

criminal *noun* (*plural* **criminals**)
someone who has done something bad that is against the law

crimson *adjective*
Something that is crimson is a deep red colour.

crinkle *verb* (**crinkles, crinkling, crinkled**)
When you crinkle something, you make small lines on it by creasing it.

crisis *noun* (*plural* **crises**)
a time when bad or dangerous things are happening

crisp *adjective* (**crisper, crispest**)
1 Food that is crisp is dry and breaks easily. ▶ *I would love a nice, crisp piece of toast.*
2 Fruit that is crisp is firm and fresh.

crisp *noun* (*plural* **crisps**)
Crisps are thin, crisp slices of fried potato that you eat as a snack.

criticize *verb* (**criticizes, criticizing, criticized**)
If you criticize someone, you say that they have done something wrong.

croak *verb* (**croaks, croaking, croaked**)
When a frog croaks, it makes a loud, rough sound.

crocodile *noun* (*plural* **crocodiles**)
a large animal that lives in rivers in some hot countries. Crocodiles are reptiles, and have short legs, a long body, and sharp teeth.

crocus *noun* (*plural* **crocuses**)
a small white, yellow, or purple spring flower

crook *noun* (*plural* **crooks**)
1 someone who steals things
2 a shepherd's stick with a curved top

crooked *adjective*
Something that is crooked is not straight.

crop *noun* (*plural* **crops**)
a type of plant which farmers grow as food

cross *adjective* (**crosser, crossest**)
If you are cross, you are angry or in a bad temper.

cross *noun* (*plural* **crosses**)
a mark like x or +

cross *verb* (**crosses, crossing, crossed**)
1 When you cross a road or a river, you go across it. ▶ *Take care when you cross the road.*
2 When you cross your arms or legs, you put one over the other.
3 When you cross out writing, you draw a line through it.

crossroads *noun*
a place where two roads cross

crossword *noun* (*plural* **crosswords**)
a puzzle in which you answer clues and write down words which cross over each other in a square

crouch *verb* (**crouches, crouching, crouched**)
When you crouch, you bend your knees under you so that your bottom is almost touching the ground.

crow *noun* (*plural* **crows**)
a big, black bird

crowd *noun* (*plural* **crowds**)
a large number of people ▶ *There were crowds of people in the streets.*
❶ If a place is **crowded**, it is full of people.

crown *noun* (*plural* **crowns**)
a special hat made of silver or gold which a king or queen wears

cruel *adjective* (**crueller, cruellest**)
If you are cruel to someone, you hurt them or are very unkind to them.
❶ **Cruelty** is behaviour which is cruel.

cruise *noun* (*plural* **cruises**)
a holiday on a big ship that travels to a lot of different places

crumb *noun* (*plural* **crumbs**)
Crumbs are very small pieces of bread or cake.

crumble *verb* (**crumbles, crumbling, crumbled**)
When something crumbles, it breaks into a lot of small pieces. ▶ *The old buildings were beginning to crumble.*

crumple *verb* (**crumples, crumpling, crumpled**)
When you crumple something, you make it very creased. ▶ *My clothes were all crumpled.*

crunch *verb* (**crunches, crunching, crunched**)
When you crunch food, you eat it by breaking it noisily with your teeth.

crush *verb* (**crushes, crushing, crushed**)
When you crush something, you squash it by pressing it hard. ▶ *Mind you don't crush the flowers.*

crust *noun* (*plural* **crusts**)
The hard part around the outside of bread.

crutch *noun* (*plural* **crutches**)
a stick that people who have hurt their legs use to lean on when they are walking

cry *verb* (**cries, crying, cried**)
1 When you cry, tears come out of your eyes.
2 When you cry, you shout something. ▶ *'Look out!' she cried.*

crystal *noun* (*plural* **crystals**)
1 a type of mineral that is found in rock. It is hard and clear like glass.
2 a small, hard, shiny piece of something ▶ *Crystals of ice had formed on the window.*

cub *noun* (*plural* **cubs**)
a young bear, lion, tiger, fox, or wolf

cube

cube *noun* (*plural* **cubes**)
a square shape like the shape of a dice. Cubes have six square sides that are all the same size.

cuckoo *noun* (*plural* **cuckoos**)
a bird that lays its eggs in other birds' nests

cucumber *noun* (*plural* **cucumbers**)
a long, green vegetable that you eat raw in salads

cuddle *verb* (**cuddles, cuddling, cuddled**)
When you cuddle someone, you put your arms round them to show that you love them.
❶ If something is **cuddly**, it looks nice and you want to cuddle it.

cuff *noun* (*plural* **cuffs**)
The cuff on a shirt is the part that goes round your wrist.

culprit *noun* (*plural* **culprits**)
the person who has done something bad or wrong.

cunning *adjective*
someone who is cunning is clever and very good at getting what they want

cup *noun* (*plural* **cups**)
1 a container with a handle, which you use for drinking from
2 a silver cup that is given as a prize to the winner of a competition

cupboard *noun* (*plural* **cupboards**)
a piece of furniture with doors on the front, which you use for keeping things in

cure *verb* (**cures, curing, cured**)
To cure someone means to make them better after they have been ill.

curious *adjective*
1 If you are curious about something, you want to know more about it.
2 Something that is curious is strange or unusual. ▶ *There was a curious smell in the kitchen.*
❶ **Curiosity** is the feeling you have when you are curious about something.

curl *noun* (*plural* **curls**)
a piece of hair that is curved, not straight
❶ **Curly** hair has a lot of curls in it.

curl *verb* (**curls, curling, curled**)
If you curl up, you bend your body into a round shape.

currant *noun* (*plural* **currants**)
a small dried grape

current *noun* (*plural* **currents**)
A current of water, air, or electricity is an amount of it that is moving in one direction. ▶ *The current is very strong in this part of the river.*

curry *noun* (*plural* **curries**)
meat or vegetables cooked in a spicy sauce

curse *noun* (*plural* **curses**)
If someone puts a curse on a person, they say magic words asking for the person to be hurt or killed.

cursor *noun* (*plural* **cursors**)
the mark which shows your position on a computer screen ▶ *Move the cursor to the end of the line.*

curtain *noun* (*plural* **curtains**)
a piece of cloth that you can pull in front of a window to cover it

curtsy *verb* (**curtsies, curtsying, curtsied**)
When a woman or girl curtsies, she puts one foot behind the other and bends her knees. ▶ *She curtsied to the Queen.*

curve *noun* (*plural* **curves**)
a line that is bent smoothly like the letter C
❶ Something that is **curved** is in the shape of a curve.

cushion *noun* (*plural* **cushions**)
a soft object that you put on a chair to sit on or lean against

custom *noun* (*plural* **customs**)
If something is a custom, you do it because people have done it in that way for a long time. ▶ *It is a custom to give presents at Christmas.*

customer noun (plural **customers**)
someone who buys something in a shop

cut verb (**cuts, cutting, cut**)
1 If you cut yourself, you break a part of your skin on something sharp. ▶ *He fell over and cut his knee.*
2 When you cut something, you use a knife or scissors to break it into pieces.

cut noun (plural **cuts**)
If you have a cut on your skin, your skin has been broken by something sharp.

cute adjective (**cuter, cutest**)
If something is cute, it is pretty or nice to look at.

cutlery noun
knives, forks, and spoons

cycle verb (**cycles, cycling, cycled**)
When you cycle, you ride a bicycle.
❶ A **cyclist** is someone who cycles.

cygnet noun (plural **cygnets**)
(pronounced **sig**-net)
a young swan

cylinder noun (plural **cylinders**)
(pronounced **sil**-in-der)
a shape that looks like a tube with flat, round ends

cymbals noun (pronounced **sim**-bals)
two round pieces of metal that you bang together when you are playing music

Dd

dad, **daddy** noun (plural **dads** or **daddies**)
Your dad is your father.

daffodil noun (plural **daffodils**)
a yellow flower that grows in the spring

daft adjective (**dafter, daftest**)
Someone who is daft is silly.

dagger noun (plural **daggers**)
a short knife with two sharp edges, which people use as a weapon

daily adverb
If something happens daily, it happens every day.

dairy noun (plural **dairies**)
a place where people make cheese, butter, and yogurt from milk

daisy noun (plural **daisies**)
a small flower with white petals and a yellow centre

dam noun (plural **dams**)
a wall that is built across a river to hold water back

damage verb (**damages, damaging, damaged**)
To damage something means to break it or spoil it. ▶ *Mind you don't damage any of the paintings.*

damp adjective (**damper, dampest**)
Something that is damp is slightly wet. ▶ *Don't sit on the damp grass.*

dance verb (**dances, dancing, danced**)
When you dance, you move about in time to music.
❶ A **dancer** is someone who dances.

dance noun (plural **dances**)
1 When you do a dance, you move about in time to music.
2 A dance is a party where people dance.

dandelion noun (plural **dandelions**)
a small wild plant which has yellow flowers and balls of white feathery seeds which blow away

danger noun (plural **dangers**)
When there is danger, there is the chance that something horrible might happen and someone might get hurt.

dangerous

dangerous *adjective*
Something that is dangerous might kill or hurt you. ▶ *Parachuting is quite a dangerous sport.*

dangle *verb* (**dangles, dangling, dangled**)
When something dangles down, it hangs down loosely. ▶ *She sat on the fence with her legs dangling.*

dare *verb* (**dares, daring, dared**)
1 If you dare to do something, you are brave enough to do it.
2 If you dare someone to do something, you tell them to do it to show how brave they are. ▶ *I dare you to climb that tree.*
ℹ Someone who is **daring** does difficult or dangerous things.

dark *adjective* (**darker, darkest**)
1 If a place is dark, there is no light in it. ▶ *The streets outside were very dark.*
2 Something that is dark is nearly black in colour.
ℹ When there is **darkness**, there is no light.

darling *noun* (*plural* **darlings**)
You call someone darling if you love them very much.

dart *noun* (*plural* **darts**)
a small arrow that you throw at a board in a game called **darts**

dart *verb* (**darts, darting, darted**)
To dart means to move quickly and suddenly. ▶ *He darted behind a bush.*

dash *verb* (**dashes, dashing, dashed**)
To dash means to run or move very quickly. ▶ *She dashed into the house.*

dash *noun* (*plural* **dashes**)
1 When you make a dash, you run or move quickly. ▶ *He made a dash for the door.*
2 a long mark like this — that you use in writing

data *noun*
information about something

date *noun* (*plural* **dates**)
1 If you say what the date is, you say what day of the month and what year it is. ▶ *What's the date today?*
2 If you have a date with someone, you have arranged to go out with them. ▶ *My sister had a date with her boyfriend last night.*
3 a sweet brown fruit that grows on a palm tree

daughter *noun* (*plural* **daughters**)
Someone's daughter is their female child.

dawdle *verb* (**dawdles, dawdling, dawdled**)
If you dawdle, you walk very slowly. ▶ *Stop dawdling! We're late!*

dawn *noun*
the time of day when the sun rises

day *noun* (*plural* **days**)
1 a period of twenty-four hours ▶ *We'll be leaving in five days.*
2 the part of the day when it is light ▶ *The days are shorter in winter, and the nights are longer.*

dazed *adjective*
If you feel dazed, you feel shocked and confused.

dazzle *verb* (**dazzles, dazzling, dazzled**)
If a bright light dazzles you, you cannot see anything because it is shining in your eyes.

dead *adjective*
Someone who is dead is not alive.

deadly *adjective* (**deadlier, deadliest**)
Something that is deadly can kill you.

deaf *adjective* (**deafer, deafest**)
Someone who is deaf cannot hear.

deal *verb* (**deals, dealing, dealt**)
1 When you deal out cards, you give them to each person at the beginning of a game.
2 When you deal with something, you do the work that needs to be done on it.

dear *adjective* (**dearer, dearest**)
1 If someone is dear to you, you love them a lot.
2 Something you write before someone's name at the start of a letter.
3 Something that is dear costs a lot of money. ▶ *Those trainers are too dear.*

death *noun* (*plural* **deaths**)
Death is the time when someone dies.

decay *verb* (**decays, decaying, decayed**)
When something decays, it goes bad and rots.

deceive *verb* (**deceives, deceiving, deceived**)
When you deceive someone, you make them believe something that is not true.

December *noun*
the twelfth and last month of the year

decent *adjective*
Something that is decent is good.

decide *verb* (**decides, deciding, decided**)
When you decide to do something, you choose to do it. ▶ *We decided to go to the park.*

decimal *adjective*
A decimal system counts in tens.

decimal *noun* (*plural* **decimals**)
a number that has tenths shown as numbers after a dot, for example 2·5

decision *noun* (*plural* **decisions**)
When you make a decision, you decide what you are going to do.

deck *noun* (*plural* **decks**)
a floor in a ship or bus

deckchair *noun* (*plural* **deckchairs**)
a folding chair that you sit on outside in warm weather

declare *verb* (**declares, declaring, declared**)
When you declare something, you say it out loud so that everyone can hear it.

decorate *verb* (**decorates, decorating, decorated**)
1 When you decorate something, you make it look nice or pretty. ▶ *We decorated the Christmas tree.*
2 When you decorate a room, you put paint or wallpaper on the walls. ▶ *I'm helping to decorate my bedroom.*
❶ **Decorations** are things that you put in a room to make it look nice.

decrease *verb* (**decreases, decreasing, decreased**)
When something decreases, it becomes less. ▶ *The temperature decreases at night.*

deed *noun* (*plural* **deeds**)
something special or brave that you do ▶ *I was very proud of my good deed.*

deep *adjective* (**deeper, deepest**)
Something that is deep goes down a long way from the top. ▶ *Be careful, the water's quite deep.*

deer *noun* (the plural is the same)
an animal that eats grass and can run fast. Male deer have long horns called **antlers**.

defeat *verb* (**defeats, defeating, defeated**)
If you defeat someone, you beat them in a game or battle.

defend *verb* (**defends, defending, defended**)
To defend a place means to keep it safe and stop people from attacking it.

definite *adjective*
Something that is definite is certain. ▶ *Is it definite that you can come?*
❶ If something will **definitely** happen, it is certain that it will happen.

definition

definition *noun* (*plural* **definitions**)
a sentence that explains what a word means

defy *verb* (**defies, defying, defied**)
If you defy someone, you refuse to do what they have told you to do. ▶ *She defied her parents and stayed out late.*

degree *noun* (*plural* **degrees**)
We can measure how hot or cold something is in degrees. You can write the number of degrees using the sign °. ▶ *The temperature is 22°C today.*

dejected *adjective*
If you feel dejected, you feel miserable.

delay *verb* (**delays, delaying, delayed**)
1 If you are delayed, something makes you late. ▶ *The train was delayed by heavy snow.*
2 If you delay something, you put off doing it until later. ▶ *We'll delay giving the prizes until everyone is here.*

delete *verb* (**deletes, deleting, deleted**)
When you delete something that you have written, you rub it out or remove it.

deliberate *adjective*
If something is deliberate, someone has done it on purpose.
❶ If you do something **deliberately**, you do it on purpose.

delicate *adjective*
Something that is delicate will break easily.

delicious *adjective*
Something that is delicious tastes very nice. ▶ *That cake looks delicious!*

delight *verb* (**delights, delighting, delighted**)
If something delights you, you like it a lot. ▶ *He delighted the children with his magic tricks.*
❶ If you are **delighted** with something, you like it a lot.

deliver *verb* (**delivers, delivering, delivered**)
When you deliver something, you take it to someone's house.

demand *verb* (**demands, demanding, demanded**)
If you demand something, you ask for it very strongly. ▶ *He demanded his money back.*

democratic *adjective*
In a democratic system everyone has the right to vote to choose things.
❶ A **democracy** is a country that has a democratic system of government.

demolish *verb* (**demolishes, demolishing, demolished**)
When people demolish a building, they knock it down.

demonstrate *verb* (**demonstrates, demonstrating, demonstrated**)
If you demonstrate something to someone, you show them how to do it. ▶ *I will now demonstrate how the machine works.*

demonstration *noun* (*plural* **demonstrations**)
1 If you give someone a demonstration of something, you show them how to do it.
2 When there is a demonstration, a lot of people march through the streets to show that they are angry about something.

den *noun* (*plural* **dens**)
1 a place where a wild animal lives
2 a secret place where you can hide

denim *noun*
a strong cloth that jeans and other clothes are made of

dense *adjective* (**denser, densest**)
Something that is dense is thick. ▶ *We couldn't see because of the dense fog.*

dent *verb* (**dents, denting, dented**)
If you dent something, you bang it and make a hollow in it.

dentist noun (plural **dentists**)
someone whose job is to check and look after people's teeth

deny verb (**denies, denying, denied**)
If you deny something, you say that it is not true. ▶ *She denied breaking the cup.*

deodorant noun (plural **deodorants**)
a perfume that you wear on your body so that you do not smell nasty

depart verb (**departs, departing, departed**)
To depart means to leave a place. ▶ *The train departs from platform 1.*

depend verb (**depends, depending, depended**)
If you depend on someone, you need them to help you. ▶ *The young lions depend on their mother for food.*

depress verb (**depresses, depressing, depressed**)
If something depresses you, it makes you feel unhappy.
❶ If you are **depressed**, you are sad.

depth noun (plural **depths**)
The depth of something is how deep it is. ▶ *Measure the depth of the hole.*

deputy noun (plural **deputies**)
someone who helps a person in their job and does it for them when they are not there

derelict adjective
A derelict building is old and beginning to fall down.

descend verb (**descends, descending, descended**)
To descend means to go down.

describe verb (**describes, describing, described**)
When you describe something, you talk about it and say what it is like. ▶ *Can you describe a tiger?*
❶ When you describe something, you give a **description** of it.

desert noun (plural **deserts**)
dry land where very few plants can grow

deserted adjective
A place that is deserted is empty, with no one in it.

deserve verb (**deserves, deserving, deserved**)
If you deserve a punishment or reward, you should get it. ▶ *He was so brave he deserves a medal.*

design verb (**designs, designing, designed**)
When you design something, you plan it and draw a picture of it.
❶ A **designer** is someone who designs things.

desire verb (**desires, desiring, desired**)
If you desire something, you want it very much.

desk noun (plural **desks**)
a table where you can read, write, and keep books

despair verb (**despairs, despairing, despaired**)
If you despair, you give up hope.

desperate adjective
If you are desperate for something, you want it or need it very much. ▶ *She was desperate for a drink of water.*
❶ If you want something **desperately**, you want it very much.

dessert noun (plural **desserts**)
sweet food that you eat at the end of a meal ▶ *We had ice cream for dessert.*

destination noun (plural **destinations**)
Your destination is the place you are travelling to.

destroy verb (**destroys, destroying, destroyed**)
To destroy something means to break it or spoil it so badly that you cannot use it again. ▶ *The earthquake destroyed several buildings.*

detail

detail noun (plural **details**)
one small part of something, or one small piece of information about it ▶ *Jessica could remember every detail about the house.*

detect verb (**detects, detecting, detected**)
If you detect something, you see it or notice it.

detective noun (plural **detectives**)
someone who looks at clues and tries to find out who committed a crime

detergent noun (plural **detergents**)
a liquid or powder that you use for cleaning or washing things.

determined adjective
If you are determined to do something, you have made up your mind that you want to do it. ▶ *We are determined to win.*
ⓘ **Determination** is the feeling you have when you are determined to do something.

detest verb (**detests, detesting, detested**)
If you detest something, you hate it.

develop verb (**develops, developing, developed**)
When something develops, it changes and grows. ▶ *Acorns develop into oak trees.*

device noun (plural **devices**)
something that has been made to do a particular job ▶ *He had a special device for removing nails.*

devil noun (plural **devils**)
a wicked spirit

devious adjective
If someone is devious, they keep things secret and do not tell you what they are doing.

devoted adjective
If you are devoted to someone, you love them a lot. ▶ *The little boy was devoted to his pet dog.*

devour verb (**devours, devouring, devoured**)
To devour something means to eat it all hungrily.

dew noun
tiny drops of water that form on the ground during the night

diabetic adjective
Someone who is diabetic has to be careful about what foods they eat and sometimes has to have injections to control the amount of sugar in their blood.

diagonal adjective
A diagonal line goes from one corner of something to the opposite corner.

diagram noun (plural **diagrams**)
a picture that shows what something is like or explains how it works

dial noun (plural **dials**)
a circle with numbers round it, like the one on a clock

dial verb (**dials, dialling, dialled**)
When you dial a number, you call that number on a telephone. ▶ *He dialled 999 and asked for an ambulance.*

diameter noun (plural **diameters**)
The diameter of a circle is the distance across the centre of it.

diamond noun (plural **diamonds**)
1 a very hard jewel that looks like clear glass
2 a shape that looks like a square standing on one of its corners

diarrhoea noun (pronounced die-a-ree-a)
an illness which makes you go to the toilet very often and gives you very watery waste

diary noun (plural **diaries**)
a book where you write down the things that you do each day

dice noun (the plural is the same)
a small cube with each side marked with a different number of dots. You use dice in various games.

dictionary *noun* (*plural* **dictionaries**)
a book that explains what words mean and shows you how to spell them

did *verb* SEE **do**

die *verb* (**dies, dying, died**)
When someone dies, they stop living.

diesel *noun* (*plural* **diesels**)
a type of engine which uses oil as fuel, instead of petrol

diet *noun* (*plural* **diets**)
1 Your diet is the kind of food that you eat. ▶ *You should try to eat a healthy diet.*
2 If you go on a diet, you eat less food because you want to become thinner.

different *adjective*
If things or people are different, they are not the same. ▶ *She's very different from her sister.*
❶ A **difference** between things is a way in which they are different.

difficult *adjective*
Something that is difficult is not easy. ▶ *This maths is very difficult.*
❶ A **difficulty** is a difficult problem.

dig *verb* (**digs, digging, dug**)
When you dig, you move soil away and make a hole in the ground.

digest *verb* (**digests, digesting, digested**)
When you digest food, your stomach breaks it down and changes it so that your body can use it.

digital *adjective*
1 A digital watch or clock shows the time with numbers, rather than with hands.
2 A digital camera or television uses a special kind of electronic signal to make pictures.

dignified *adjective*
Someone who is dignified looks proud, serious, and important.

dilemma *noun* (*plural* **dilemmas**)
If you are in a dilemma, you have to make a very difficult choice and you do not know what to do.

dilute *verb* (**dilutes, diluting, diluted**)
To dilute a liquid means to make it weaker by adding water.

dim *adjective* (**dimmer, dimmest**)
A dim light is not very bright.

din *noun*
a very loud, annoying noise

dinghy *noun* (*plural* **dinghies**)
a small sailing boat

dingy *adjective* (**dingier, dingiest**) (*pronounced* **din**-jee)
A dingy room is dark and gloomy.

dining room *noun* (*plural* **dining rooms**)
the room where people have their meals

dinner *noun* (*plural* **dinners**)
the main meal of the day

dinosaur *noun* (*plural* **dinosaurs**)
an animal like a huge lizard that lived millions of years ago

dip *verb* (**dips, dipping, dipped**)
When you dip something into liquid, you put it in and leave it there for only a short time. ▶ *I dipped my toe into the water.*

direct *adjective*
If you go somewhere in a direct way, you go straight there, without going anywhere else first. ▶ *We got on the direct train to London.*
❶ You can also say that you go **directly** to a place if you go straight there.

direct *verb* (**directs, directing, directed**)
1 If you direct someone to a place, you explain to them how to get there. ▶ *Can you direct me to the station?*

direction

2 The person who directs a play or film organizes it and tells everyone what they should do.
ⓘ The person who directs a play or film is the **director**.

direction noun (plural **directions**)
The direction you are going in is the way you are going. ▶ *I went home, but Sam went off in the opposite direction.*

dirt noun
dust or mud

dirty adjective (**dirtier**, **dirtiest**)
Something that is dirty has mud or dirt on it.

disabled adjective
Someone who is disabled finds it hard to do some things because a part of their body does not work properly.
ⓘ Someone who is disabled has a **disability**.

disagree verb (**disagrees**, **disagreeing**, **disagreed**)
If you disagree with someone, you think that they are wrong.
ⓘ When there is a **disagreement**, two people disagree with each other.

disappear verb (**disappears**, **disappearing**, **disappeared**)
When something disappears, it goes away and you cannot see it any more.

disappoint verb (**disappoints**, **disappointing**, **disappointed**)
If something disappoints you, you feel sad because it is not as good as you thought it would be.
ⓘ When something disappoints you, you feel **disappointed**.

disapprove verb (**disapproves**, **disapproving**, **disapproved**)
If you disapprove of something, you do not like it and do not think that it is right.

disaster noun (plural **disasters**)
something very bad that happens
▶ *The train crash was a terrible disaster.*

disc noun (plural **discs**)
1 any round, flat object
2 a round, flat piece of plastic that has music or computer information on it. This is also called a **compact disc**.

disciple noun (plural **disciples**)
a person who follows a religious leader

discipline noun
When there is discipline, people behave well and do the things they are told to do. ▶ *Our teacher likes to have good discipline in the classroom.*

disco noun (plural **discos**)
a party where you dance to pop music

discourage verb (**discourages**, **discouraging**, **discouraged**)
If you discourage someone from doing something, you try to stop them from doing it. ▶ *She discouraged her children from watching too much television.*

discover verb (**discovers**, **discovering**, **discovered**)
When you discover something, you find it, or find out about it. ▶ *Who first discovered electricity?*
ⓘ When you make a **discovery**, you discover something.

discuss verb (**discusses**, **discussing**, **discussed**)
When people discuss something, they talk about it.
ⓘ When you discuss something, you have a **discussion**.

disease noun (plural **diseases**)
an illness

disgraceful adjective
If something is disgraceful, it is very bad and you should be ashamed of it. ▶ *That was disgraceful behaviour!*

disguise verb (disguises, disguising, disguised)
If you disguise yourself, you make yourself look different so that people will not recognize you.

disguise noun (plural **disguises**)
special clothes that you wear so that you will look different and people will not recognize you

disgust verb (disgusts, disgusting, disgusted)
If something disgusts you, it is horrible and you hate it.
❶ Something that is horrible and disgusts you is **disgusting**.

dish noun (plural **dishes**)
1 a bowl in which food is served
2 food that has been prepared and cooked in a particular way

dishonest adjective
Someone who is dishonest is not honest and does not tell the truth.

disk noun (plural **disks**)
a flat piece of plastic on which computer information is stored

dislike verb (dislikes, disliking, disliked)
If you dislike something, you do not like it.

dismal adjective
Something that is dismal is dull and gloomy. ▶ *What horrible, dismal weather!*

dismiss verb (dismisses, dismissing, dismissed)
To dismiss someone means to send them away. ▶ *The teacher dismissed the class at the end of the day.*

disobey verb (disobeys, disobeying, disobeyed)
If you disobey someone, you do not do what they have told you to do.

display verb (displays, displaying, displayed)
When you display things, you put them somewhere so that people can look at them.

display noun (plural **displays**)
a show or exhibition ▶ *We made a display of our paintings.*

disposable adjective
Things that are disposable are meant to be thrown away when you have finished using them.

disqualify verb (disqualifies, disqualifying, disqualified)
If you are disqualified from a competition, you are not allowed to take part in it because you have behaved badly or done something wrong.

dissolve verb (dissolves, dissolving, dissolved)
When something dissolves in water, it mixes with the water so that you can no longer see it. ▶ *Sugar will dissolve in water, but sand will not.*

distance noun (plural **distances**)
The distance between two places is the amount of space between them. ▶ *We measured the distance between the two buildings.*

distant adjective
Something that is distant is far away.

distinct adjective
If something is distinct, you can see it or hear it quite clearly. ▶ *The sound of the cuckoo was quite distinct.*

distinguish verb (distinguishes, distinguishing, distinguished)
If you can distinguish between two things, you can tell the difference between them.

distract verb (distracts, distracting, distracted)
If you distract someone, you talk to them or make a noise so that they cannot concentrate on what they are doing.

distress noun
the feeling you have when you are very sad and upset

district noun (plural **districts**)
part of a town, city, or country

disturb

disturb verb (**disturbs, disturbing, disturbed**)
1 If you disturb someone, you interrupt them and stop them from doing something. ▶ *I'm working, so please don't disturb me.*
2 If something disturbs you, it makes you feel worried.

ditch noun (*plural* **ditches**)
a long, narrow hole in the ground

dive verb (**dives, diving, dived**)
If you dive into water, you jump in head first.
❶ A **diver** is someone who dives into water and swims around under the water, wearing special equipment.

divide verb (**divides, dividing, divided**)
1 When you divide things, you share them out. ▶ *Divide the sweets equally between you.*
2 When you divide something, you split it into smaller parts. ▶ *The cake was divided into eight pieces.*
3 When you divide numbers, you find out how many times one number goes into another. Six divided by two is three, 6 ÷ 2 = 3.
❶ When you divide numbers, you do **division**.

divorce noun (*plural* **divorces**)
When there is a divorce, two people end their marriage.
❶ Someone who is **divorced** is no longer married.

Diwali noun
an important Hindu festival at which lamps are lit. It is held in October or November.

dizzy adjective (**dizzier, dizziest**)
If you feel dizzy, you feel as if everything is spinning round you.

do verb (**does, doing, did, done**)
When you do something, you carry out that action. ▶ *She did a dance in the middle of the room.*

dock noun (*plural* **docks**)
a place where ships and boats can be loaded and unloaded

doctor noun (*plural* **doctors**)
someone whose job is to give people medicines and treatment when they are ill, to help them get better

dodge verb (**dodges, dodging, dodged**)
When you dodge something, you move quickly to get out of its way.

does verb SEE **do**

dog noun (*plural* **dogs**)
an animal people often keep as a pet. Dogs can bark, and you can train them to obey you.

doll noun (*plural* **dolls**)
a toy in the shape of a baby or person

dollar noun (*plural* **dollars**)
an amount of money. Dollars are used in the United States of America, Australia, and some other countries.

dolphin noun (*plural* **dolphins**)
a large animal that swims like a fish and lives in the sea. Dolphins are mammals, and breathe air.

dome noun (*plural* **domes**)
a round roof that is shaped like the top half of a ball

domino noun (*plural* **dominoes**)
Dominoes are small, oblong pieces of wood with spots on them. They are used in the game called **dominoes**.

donate verb (**donates, donating, donated**)
If you donate something, you give it to someone in order to help them.
❶ A **donation** is a present or an amount of money that you give to someone.

done verb SEE **do**

donkey noun (*plural* **donkeys**)
an animal that looks like a small horse with long ears

don't *verb*
do not ▶ *Don't be silly!*

door *noun* (*plural* **doors**)
something that you can open and go through to get into a place ▶ *Don't forget to close the door behind you.*

dose *noun* (*plural* **doses**)
A dose of medicine is the amount that you have to take.

dot *noun* (*plural* **dots**)
a small spot that looks like a full stop

double *adjective*
Something that is double the size of something else is twice as big.

double *verb* (**doubles, doubling, doubled**)
If you double an amount, you make it twice as big.

doubt *noun* (*plural* **doubts**)
If you have doubts about something, you are not sure about it.

doubt *verb* (**doubts, doubting, doubted**)
If you doubt something, you do not believe it. ▶ *I doubt that he will come to the party.*

dough *noun*
a mixture of flour and water that you cook to make bread or cakes

doughnut *noun* (*plural* **doughnuts**)
a small cake that is fried and covered in sugar

dove *noun* (*plural* **doves**)
a bird that looks like a small pigeon

down *adverb, preposition*
towards a lower place ▶ *He ran down the hill.*

down *noun*
very soft feathers

download *verb* (**downloads, downloading, downloaded**)
When you download information, you copy it from the Internet onto your computer.

downward, downwards *adverb*
When something goes downwards, it goes towards a lower place. ▶ *The bird glided slowly downwards.*

doze *verb* (**dozes, dozing, dozed**)
If you are dozing, you are nearly asleep.

dozen *noun* (*plural* **dozens**)
a set of twelve ▶ *I bought a dozen eggs.*

draft *noun* (*plural* **drafts**)
a first copy of a piece of work, which you do not do very neatly

drag *verb* (**drags, dragging, dragged**)
When you drag something heavy, you pull it along the ground.

dragon *noun* (*plural* **dragons**)
a large monster with wings, that you read about in stories

dragonfly *noun* (*plural* **dragonflies**)
a large insect with a brightly coloured body that lives near water

drain *noun* (*plural* **drains**)
a pipe that carries water away under the ground

drain *verb* (**drains, draining, drained**)
When water drains away, it flows away.

drake *noun* (*plural* **drakes**)
a male duck

drama *noun*
acting in a play or story ▶ *Why don't you join a drama club?*

dramatic *adjective*
Something that is dramatic is very exciting.

drank *verb* SEE **drink**

draught *noun* (*plural* **draughts**) (*pronounced* **draft**)
1 cold air that blows into a room
2 Draughts are round pieces of wood or plastic that you move across a board when you are playing a game called **draughts**.

draw

draw verb (draws, drawing, drew, drawn)
1 When you draw a picture, you make a picture with a pen, pencil, or crayon.
2 When you draw curtains, you open them or close them.
3 When two people draw in a game, they have the same score at the end of the game. ▶ *We drew 1–1.*

drawbridge noun (plural **drawbridges**)
a bridge that goes over the water round a castle. It can be pulled up to stop people getting into the castle.

drawer noun (plural **drawers**)
a part of a piece of furniture that you can pull out and use for keeping things in

drawing noun (plural **drawings**)
a picture that someone has drawn

dread noun
great fear ▶ *Cats have a dread of water.*

dreadful adjective
Something that is dreadful is very bad. ▶ *The room was in a dreadful mess.*

dream noun (plural **dreams**)
1 things that you seem to see when you are asleep
2 something that you would like very much ▶ *Her dream was to become a ballet dancer.*

dream verb (dreams, dreaming, dreamed or dreamt)
1 When you dream, you seem to see things in your head when you are asleep.
2 If you dream about something, you think about it because you would like to do it. ▶ *He had always dreamt of being an Olympic champion.*

dreary adjective (drearier, dreariest)
Something that is dreary is dull, gloomy, and miserable. ▶ *It was a dull and dreary winter's day.*

drench verb (drenches, drenching, drenched)
To drench something means to soak it with water.

dress noun (plural **dresses**)
a piece of clothing that a woman or girl wears. It has a skirt, and also covers the top half of her body.

dress verb (dresses, dressing, dressed)
When you dress, you put on clothes. You can also say that you **get dressed**.

dressing gown noun (plural **dressing gowns**)
a piece of clothing that you wear over your pyjamas or nightie to keep warm when you are walking around

drew verb SEE **draw**

dribble verb (dribbles, dribbling, dribbled)
1 If you dribble, water comes out of your mouth. Babies often dribble.
2 When you dribble with a ball, you kick it as you run along, so that it stays close to your feet.

drift verb (drifts, drifting, drifted)
If something drifts along, it is carried along gently by water or air. ▶ *The empty boat drifted along on the sea.*

drill noun (plural **drills**)
a tool that you use for making holes

drink verb (drinks, drinking, drank, drunk)
When you drink, you swallow liquid.

drink noun (plural **drinks**)
a liquid that you take into your mouth and swallow

drip verb (drips, dripping, dripped)
When water drips, it falls in small drops. ▶ *The snow was melting, and water was dripping off the roof.*

drive verb (drives, driving, drove, driven)
1 When you drive, you control a car, bus, train, or lorry. ▶ *My big brother is learning to drive.*
2 When you drive animals, you make them move along. ▶ *We drove the cows into the field.*
ⓘ Someone who drives a car, bus, train, or lorry is a **driver**.

drizzle noun
very light rain

droop verb (droops, drooping, drooped)
When something droops, it hangs down weakly. ▶ *The flowers were drooping because they had no water.*

drop noun (plural **drops**)
A drop of water is a very small amount of it. ▶ *I felt a few drops of rain on my face.*

drop verb (drops, dropping, dropped)
If you drop something, you do not hold it tightly enough and it falls out of your hands.

drove verb SEE **drive**

drown verb (drowns, drowning, drowned)
If you drown, you die because you are under water and cannot breathe.

drowsy adjective
If you feel drowsy, you feel sleepy.

drug noun (plural **drugs**)
1 a medicine that can help you feel better if you are ill or in pain
2 a substance that some people take for pleasure because it changes the way they feel or behave. These drugs are illegal and dangerous.

drum noun (plural **drums**)
a hollow musical instrument that you bang with a stick or with your hands

drunk adjective
Someone who is drunk cannot control what they say or do because they have drunk too much alcohol.

drunk verb SEE **drink**

dry adjective (drier, driest)
Something that is dry is not wet or damp.

duchess noun (plural **duchesses**)
a woman who has a title to show that she is rich and important. The husband of a duchess is a **duke**.

duck noun (plural **ducks**)
a bird that lives near water and swims on the water

duck verb (ducks, ducking, ducked)
If you duck, you bend down quickly so that something will not hit you.

due adjective
The time that something is due is the time you expect it to arrive. ▶ *The train is due at two o'clock.*

duel noun (plural **duels**)
a fight between two people using swords or guns

duet noun (plural **duets**)
a piece of music that two people play or sing together

dug verb SEE **dig**

duke noun (plural **dukes**)
a man who has a title to show that he is rich and important. The wife of a duke is a **duchess**.

dull adjective (duller, dullest)
1 A dull colour is not very bright.
2 Something that is dull is boring and not interesting. ▶ *That was a very dull film!*

dummy noun (plural **dummies**)
1 a piece of rubber that you give to a baby to suck on
2 a model of a person. You often see dummies with clothes on in shop windows.

dump noun (plural **dumps**)
a place where people leave rubbish

dump

dump *verb* (dumps, dumping, dumped)
1 When you dump rubbish, you leave it somewhere because you want to get get rid of it.
2 When you dump something, you put it down carelessly. ▶ *She dumped her school bag on the floor.*

dungeon *noun* (*plural* dungeons)
a prison underneath a castle

during *preposition*
while something else is going on ▶ *I fell asleep during the film.*

dusk *noun*
the dim light at the end of the day, just before it gets dark

dust *noun*
dry dirt that is like powder ▶ *There was dust on all the furniture.*
ⓘ Something that is **dusty** is covered with dust.

dustbin *noun* (*plural* dustbins)
a large container that you use for putting rubbish in

duty *noun* (*plural* duties)
If it is your duty to do something, you have to do it. ▶ *Parents have a duty to look after their children.*

duvet *noun* (*plural* duvets)
a thick, warm cover for a bed

DVD *noun* (*plural* DVDs)
a round, flat disc on which music, pictures, or film can be stored. DVD is short for **digital versatile disc**.

dwarf *noun* (*plural* dwarfs)
a very small person in stories

dwell *verb* (dwells, dwelling, dwelt or dwelled)
The place where you dwell is the place where you live.

dye *verb* (dyes, dyeing, dyed)
When you dye something, you change its colour by putting it in a special coloured liquid.

dying *verb* SEE **die**

dynamite *noun*
something that people use for making explosions and blowing things up

dyslexic *adjective* (*pronounced* dis-**lex**-ic)
Someone who is dyslexic finds it difficult to learn to read and write because their brain muddles up letters and words.

Ee

each *adjective*
every ▶ *She gave each child a present.*

eager *adjective*
If you are eager to do something, you are very keen to do it. ▶ *We were eager to start the game.*

eagle *noun* (*plural* eagles)
a large bird that hunts and eats small animals. Eagles live in mountain areas.

ear *noun* (*plural* ears)
Your ears are the parts of your body that you use for hearing.
ⓘ **Earrings** are jewellery that you wear in your ears.

early *adjective* (earlier, earliest)
1 If you are early, you arrive before people are expecting you. ▶ *We were ten minutes early.*
2 When it is early in the day, it is in the morning, not the afternoon or evening. ▶ *We had to get up very early this morning.*

earn *verb* (earns, earning, earned)
When you earn money, you get it by working for it.

earth *noun*
1 the planet that we all live on
2 the soil in which plants grow

earthquake noun (plural **earthquakes**)
a time when the ground suddenly shakes. Strong earthquakes can destroy buildings.

easel noun (plural **easels**)
a stand that holds a blackboard or a picture so that you can write or paint easily

east noun
East is the direction where the sun rises in the morning.
❶ The **eastern** part of a country is the part in the east.

Easter noun
the day when Christians celebrate Jesus Christ coming back from the dead

easy adjective (**easier**, **easiest**)
If something is easy, you can do it or understand it without any trouble. ▶ *These sums are really easy!*
❶ If you do something without any trouble, you do it **easily**.

eat verb (**eats, eating, ate, eaten**)
When you eat, you put food in your mouth and swallow it.

eavesdrop verb (**eavesdrops, eavesdropping, eavesdropped**)
When you eavesdrop, you listen when other people are talking to each other.

eccentric adjective
Someone who is eccentric behaves in rather strange ways.

echo noun (plural **echoes**)
When you hear an echo, you hear a sound again as it bounces back off something solid. You often hear echoes in caves and tunnels.

eclipse noun (plural **eclipses**)
When there is an eclipse of the sun, the moon moves in front of it and hides it for a short time. When there is an eclipse of the moon, the sun moves in front of it and hides it for a short time.

eczema noun (pronounced **ex**-ma)
If you have eczema, your skin is dry or red and itchy.

edge noun (plural **edges**)
The edge of something is the part along the end or side of it. ▶ *He put his book down on the edge of the table.*

edit verb (**edits, editing, edited**)
1 When you edit something that you have written, you check it and change some parts so that it is better.
2 When people edit a film or television programme, they choose the parts that they want to keep and take some parts out.

educate verb (**educates, educating, educated**)
To educate someone means to teach them things they need to know like reading and writing. ▶ *A teacher's job is to educate children.*
❶ Your **education** is all the things people teach you at school.

eel noun (plural **eels**)
a long fish that looks like a snake

effect noun (plural **effects**)
If something has an effect, it makes something else happen. ▶ *Some chemicals have a harmful effect on the environment.*

effort noun (plural **efforts**)
If you put effort into something, you work hard to do it. ▶ *You should put more effort into your work.*

egg noun (plural **eggs**)
an oval object with a thin shell. Eggs are laid by birds, snakes, and insects. We can cook and eat hens' eggs.

Eid noun
a Muslim festival that marks the end of Ramadan

eight noun (plural **eights**)
the number 8

eighteen noun
the number 18

eighty

eighty *noun*
the number 80

either *adjective*
one or the other ▶ *There are two cakes. You can have either one.*

elastic *noun*
a strip of material that can stretch and then go back to its usual size

elbow *noun* (*plural* **elbows**)
Your elbow is the joint in the middle of your arm, where your arm can bend.

elderly *adjective*
Someone who is elderly is old.

elect *verb* (**elects, electing, elected**)
When people elect someone, they choose them by voting for them. ▶ *We elected a new captain of the football team.*
❶ When there is an **election**, people vote to choose the people who will be in charge of their town or country.

electricity *noun*
the power or energy that is used to give light and heat and to work machines. It comes along wires or from batteries.
❶ An **electric** or **electrical** machine is worked by electricity.

electronic *adjective*
An electronic machine uses electrical signals to control the way it works. TV sets, computers, and automatic washing machines have electronic devices inside them.

elegant *adjective*
Someone who is elegant is beautiful and graceful. Something that is elegant is smart and attractive, and looks expensive.

elephant *noun* (*plural* **elephants**)
a very big grey animal with tusks and a very long nose called a trunk

eleven *noun*
the number 11

elf *noun* (*plural* **elves**)
a small fairy in stories

else *adverb*
different ▶ *Ask someone else.* ▶ *Let's do something else.*

elsewhere *adverb*
in a different place ▶ *They're not here, so they must be elsewhere.*

email *noun* (*plural* **emails**)
a message that you send from your computer to someone else's computer

embarrass *verb* (**embarrasses, embarrassing, embarrassed**)
If something embarrasses you, it makes you feel shy, nervous, or ashamed.
❶ If you feel **embarrassed**, you feel shy, nervous, or ashamed. **Embarrassment** is the feeling you have when you are embarrassed.

embrace *verb* (**embraces, embracing, embraced**)
When you embrace someone, you put your arms round them to show that you love them.

embroidery *noun*
pretty sewing that decorates something

emerald *noun* (*plural* **emeralds**)
a green jewel or precious stone

emerge *verb* (**emerges, emerging, emerged**)
When something emerges, it comes out of a place and you can see it. ▶ *The mouse emerged from its hole.*

emergency *noun* (*plural* **emergencies**)
When there is an emergency, something very dangerous suddenly happens and people must act quickly so that no one gets hurt. ▶ *Call the doctor, it's an emergency.*

emotion *noun* (*plural* **emotions**)
Your emotions are your feelings.

empire *noun* (*plural* **empires**)
a group of countries that are ruled over by one person
ⓘ An **emperor** is a man who rules an empire. An **empress** is a woman who rules an empire.

employ *verb* (**employs, employing, employed**)
To employ someone means to pay them to work for you.
ⓘ If you are **employed**, you have a job and work for someone.

empty *adjective*
Something that is empty has nothing in it. ▶ *I looked in the box, but it was empty.*

empty *verb* (**empties, emptying, emptied**)
When you empty something, you take everything out of it. ▶ *He emptied his pocket.*

enchanted *adjective* (*plural* **enchantments**)
Something that is enchanted is under a magic spell.

encourage *verb* (**encourages, encouraging, encouraged**)
When you encourage someone, you tell them to do something and make them feel brave enough to do it. ▶ *He encouraged me to try again.*
ⓘ When you encourage someone, you give them **encouragement**.

encyclopedia *noun* (*plural* **encyclopedias**) (*pronounced* en-sye-clo-**pee**-dee-a)
a book that gives you information about a lot of different things

end *noun* (*plural* **ends**)
The end of something is the place or time where it stops. ▶ *We walked on to the end of the lane.*
ⓘ The **ending** of a film or book is the way in which it ends.

end *verb* (**ends, ending, ended**)
When something ends, it stops.

endangered *adjective*
An animal or plant that is endangered may soon not exist anymore.

enemy *noun* (*plural* **enemies**)
1 someone who wants to hurt you
2 the people fighting against you

energy *noun*
1 If you have energy, you feel strong and fit.
2 Energy is the power that comes from coal, electricity, and gas. Energy makes machines work and gives us heat and light.
ⓘ When you have a lot of energy, you feel **energetic**.

engaged *adjective*
If you are engaged, you have promised that you will marry someone.

engine *noun* (*plural* **engines**)
a machine that can make things move

engineer *noun* (*plural* **engineers**)
someone who makes machines, or plans the building of roads and bridges

enjoy *verb* (**enjoys, enjoying, enjoyed**)
If you enjoy something, you like doing it or watching it. ▶ *Do you enjoy playing tennis?*
ⓘ If something is **enjoyable**, you enjoy doing it. **Enjoyment** is the feeling you have when you are enjoying something.

enormous *adjective*
Something that is enormous is very big.

enough *adjective*
If you have enough of something, you have as much as you need. ▶ *I haven't got enough money to buy an ice cream.*

enter

enter verb (enters, entering, entered)
1 When you enter a place, you go into it. ▶ *He knocked on the door and entered the room.*
2 If you enter a race or competition, you take part in it.

entertain verb (entertains, entertaining, entertained)
To entertain people means to do things that they enjoy watching, or things that make them laugh. ▶ *The clown entertained the children.*
ⓘ **Entertainment** is anything that people watch for pleasure.

enthusiastic adjective
If you are enthusiastic about something, you are very keen on it and want to do it.

entire adjective
whole ▶ *The entire class was ill.*

entirely adverb
completely ▶ *She was covered entirely in mud.*

entrance noun (plural entrances)
the way into a place ▶ *We couldn't find the entrance to the secret cave.*

entry noun (plural entries)
a way into a place ▶ *We couldn't go in because there was a sign on the door saying 'No Entry'.*

envelope noun (plural envelopes)
a paper cover that you put a letter in before you send it

envious adjective
If you feel envious, you want something that someone else has. ▶ *I'm envious because my brother has got a new bike.*

environment noun (plural environments)
the world we live in, especially the plants, animals, and things around us ▶ *Planting more trees will improve our environment.*

envy noun
the feeling you have when you would like to have something that someone else has

episode noun (plural episodes)
one programme in a radio or TV serial ▶ *We must wait until next week to see the next episode.*

equal adjective
If two things are equal, they are the same size or worth the same amount. ▶ *Everyone had an equal share of the cake.*
ⓘ If you share things **equally**, you share them into equal amounts.

equator noun
an imaginary line round the middle of the earth. Countries near the equator are very hot.

equipment noun
the things that you need for doing something ▶ *If you want to play ice hockey, you will have to buy a lot of expensive equipment.*

errand noun (plural errands)
a short journey to take a message or fetch something for someone

error noun (plural errors)
a mistake

erupt verb (erupts, erupting, erupted)
When a volcano erupts, hot, liquid rock comes up out of it.

escalator noun (plural escalators)
a moving staircase

escape verb (escapes, escaping, escaped)
1 If you escape, you get away from a place and become free. ▶ *A lion escaped from the zoo.*
2 If you escape from something, you get away from it. ▶ *They escaped from the rain by going into a cafe.*

especially adverb
more than anything else ▶ *I love fruit, especially apples.*

estate noun (plural **estates**)
an area of land with a lot of houses on it

estimate verb (**estimates, estimating, estimated**)
When you estimate an amount, you guess how much it will be. ▶ *Can you estimate how long it would take to walk twenty miles?*

euro noun (plural **euros**)
an amount of money. Euros are used in several countries in Europe.

evaporate verb (**evaporates, evaporating, evaporated**)
When water evaporates, it changes into a gas and so disappears.

eve noun (plural **eves**)
the day or night before a special day ▶ *We stay up late on Christmas Eve.*

even adjective
1 Something that is even is smooth and level. ▶ *You need an even surface to work on.*
2 Amounts that are even are equal. ▶ *The scores were even at half time.*
3 An even number is a number that you can divide by two. 4, 6, and 8 are even numbers.
❶ If you share something **evenly**, you share it equally.

evening noun (plural **evenings**)
the time at the end of the day before people go to bed

event noun (plural **events**)
something important that happens ▶ *Your birthday is a big event.*

eventually adverb
in the end ▶ *We got home eventually.*

ever adverb
at any time ▶ *Have you ever been to America?*
for ever always.

evergreen noun (plural **evergreens**)
a tree that keeps its green leaves all through the year

every adjective
each ▶ *I go swimming every week.*

everybody, everyone
every person ▶ *Everybody cheered when he scored a goal.*

everything pronoun
all things ▶ *Put everything away in the cupboard.*

everywhere adverb
in all places ▶ *We've looked everywhere for the ball.*

evidence noun
anything that proves that something is true, or that something happened ▶ *These footprints are evidence that someone has been in the garden.*

evil adjective
Something that is evil is wicked.

ewe noun (plural **ewes**) (sounds like *you*)
a female sheep

exact adjective
just right ▶ *Add the exact amount of water.*
❶ Something that is just right is **exactly** right.

exaggerate verb (**exaggerates, exaggerating, exaggerated**)
If you exaggerate, you say that something is bigger or better than it really is.

exam, examination noun (plural **exams** or **examinations**)
an important test

examine verb (**examines, examining, examined**)
When you examine something, you look at it very carefully.

example noun (plural **examples**)
1 one thing that shows what all the others are like ▶ *Can you show me an example of your handwriting?*
2 Someone who sets an example behaves well and shows other people how they should behave.

excellent adjective
Something that is excellent is very good.

except

except *preposition*
apart from ▶ *Everyone got a prize except me.*

exchange *verb* (**exchanges, exchanging, exchanged**)
If you exchange something, you give it to someone and get something else in return.

excite *verb* (**excites, exciting, excited**)
If something excites you, it makes you feel happy, interested, and keen to do something.
❶ If you feel **excited**, you feel happy, interested, and keen to do something. Something that is **exciting** makes you feel this way. **Excitement** is an excited feeling.

exclaim *verb* (**exclaims, exclaiming, exclaimed**)
When you exclaim, you shout something suddenly because you are surprised or excited. ▶ *'I don't believe it!' she exclaimed.*

exclamation mark *noun* (*plural* **exclamation marks**)
a mark like this ! that you use in writing. You put an exclamation mark after words to show that they have been shouted.

excuse *noun* (*plural* **excuses**) (rhymes with *goose*)
a reason you give to try to explain why you have done wrong so that you will not get into trouble ▶ *Her excuse for being late was that she had missed the bus.*

excuse *verb* (**excuses, excusing, excused**) (rhymes with *choose*)
1 If you excuse someone, you forgive them. ▶ *I'm sorry for interrupting you. Please excuse me.*
2 If you are excused from doing something, you do not have to do it. ▶ *I was excused from swimming because I had a cold.*

execute *verb* (**executes, executing, executed**)
To execute someone means to kill them as a punishment.

exercise *noun* (*plural* **exercises**)
1 When you do exercise, you run around or move your body to make your body healthy and strong. ▶ *You should do more exercise.*
2 a piece of work that you do to make yourself better at something ▶ *The teacher gave us some spelling exercises.*

exhausted *adjective*
If you are exhausted, you are very tired.

exhibition *noun* (*plural* **exhibitions**)
a collection of things that are put on show so that people can come to see them ▶ *We went to see an exhibition of paintings by young artists.*

exist *verb* (**exists, existing, existed**)
Things that exist are real, not imaginary. ▶ *Fairies don't really exist.*

exit *noun* (*plural* **exits**)
the way out of a place

expand *verb* (**expands, expanding, expanded**)
When something expands, it gets bigger. ▶ *I blew air into the balloon and watched it expand.*

expect *verb* (**expects, expecting, expected**)
If you expect that something will happen, you think that it will happen. ▶ *It is so cold I expect it will snow.*

expedition *noun* (*plural* **expeditions**)
a long, difficult journey to a place far away ▶ *They went on an expedition to the North Pole.*

expel *verb* (**expels, expelling, expelled**)
When someone is expelled from a place, they are told that they must leave.

expensive *adjective*
Something that is expensive costs a lot of money.

experience noun (plural **experiences**)
1 If you have experience of something, you have done it before and so know what it is like. ▶ *He's frightened of animals because he hasn't had any experience of them before.*
2 An experience is something very good or bad that happens to you. ▶ *Being stuck in the tunnel was a very frightening experience.*
ℹ Someone who is **experienced** has done something before and so knows what it is like.

experiment noun (plural **experiments**)
a test that you do to find out whether an idea works ▶ *We did an experiment to see which things dissolve in water.*

expert noun (plural **experts**)
someone who does something very well or knows a lot about something

explain verb (**explains, explaining, explained**)
When you explain something, you talk about it so that other people understand it. ▶ *The teacher explained how the machine worked.*

explode verb (**explodes, exploding, exploded**)
When something explodes, it bursts or blows up with a loud bang.

explore verb (**explores, exploring, explored**)
When you explore a place, you look around it carefully to find out what it is like. ▶ *Let's explore the cave.*
ℹ An **explorer** is someone who explores new places in different countries.

explosion noun (plural **explosions**)
a loud bang that is made when something bursts or blows up

express verb (**expresses, expressing, expressed**)
When you express your ideas or feelings, you talk about them or show them to other people.

expression noun (plural **expressions**)
1 Your expression is the look on your face. ▶ *He had a sad expression on his face.*
2 An expression is a word or phrase.

extinct adjective
Animals that are extinct no longer exist because they are all dead. ▶ *Dinosaurs are extinct.*

extinguish verb (**extinguishes, extinguishing, extinguished**)
When you extinguish a fire, you put it out.

extra adjective
Something extra is something more than you would usually have or do. ▶ *Bring some extra food in case we get hungry.*

extraordinary adjective
Something that is extraordinary is very unusual. ▶ *The camel is an extraordinary animal. It stores water in its hump.*

extravagant adjective
Someone who is extravagant spends more money than they need to.

extreme adjective
1 Extreme means very great. ▶ *No plants can grow in the extreme heat of the desert.*
2 The extreme part of a place is the part that is furthest away. ▶ *These animals only live in the extreme north of the country.*

extremely adverb
very ▶ *My parents were extremely angry with me.*

eye noun (plural **eyes**)
1 Your eyes are the parts of your body that you use for seeing.
2 the small hole in the top of a needle
ℹ Your **eyebrows** are the curved lines of hair that you have above each eye. Your **eyelashes** are the short hairs that grow around the edges of each eye.

fable

fable noun (plural **fables**)
a story that teaches you something, for example one that teaches you not to be selfish or greedy. Fables often have animals as their main characters.

fabric noun (plural **fabrics**)
cloth or material

fabulous adjective
Something that is fabulous is wonderful. ▶ *What a fabulous picture!*

face noun (plural **faces**)
1 Your face is the front part of your head, which has your eyes, nose, and mouth on it.
2 The face of a clock or watch is the front part of it, which shows the time.

face verb (**faces, facing, faced**)
The direction that you are facing is the direction in which you are looking.

facility noun (plural **facilities**)
something that you can use and enjoy ▶ *Our school has very good sports facilities.*

fact noun (plural **facts**)
something that we know is true ▶ *It's a fact that the earth travels around the sun.*

factory noun (plural **factories**)
a large building where people make things with machines

fade verb (**fades, fading, faded**)
1 When a colour or light fades, it becomes less bright.
2 When a sound fades, it becomes less loud.

fail verb (**fails, failing, failed**)
If you fail a test, you do not pass it.
▶ *I hope I don't fail my piano exam.*

failure noun (plural **failures**)
1 someone who has failed a test, or has not managed to do something very well
2 something that does not work well or is not successful

faint adjective (**fainter, faintest**)
1 A faint sound is not very loud and you cannot hear it very well.
2 A faint colour, mark, or light is not very bright or clear.
3 If you feel faint, you feel dizzy.

faint verb (**faints, fainting, fainted**)
If you faint, you feel dizzy and become unconscious for a short time.

fair adjective (**fairer, fairest**)
1 Something that is fair treats everyone in the same way so that everyone is equal. ▶ *It's not fair if she gets more sweets than me.*
2 Fair hair is light in colour.
❶ If you treat people equally, in a fair way, you treat them **fairly**.

fair noun (plural **fairs**)
a place with a lot of rides and stalls, where you can go to enjoy yourself by going on the rides and trying to win things at the stalls

fairly adverb
quite ▶ *It's fairly warm today.*

fairy noun (plural **fairies**)
a small, magical person in a story

faith noun
If you have faith in something, you trust it or believe in it.

faithful adjective
If you are faithful to someone, you always help them and support them.
▶ *Joshua was his faithful friend.*

fake noun (plural **fakes**)
something that has been made to look like a valuable thing, but is not real ▶ *It looked like a real Roman coin, but it was a fake.*

fall verb (falls, falling, fell, fallen)
1 To fall means to drop down towards the ground. ▶ *Katy tripped and fell.*
2 When you fall asleep, you start sleeping.

false adjective
1 Something that is false is not real. ▶ *The money was hidden in a suitcase with a false bottom.*
2 Something that is false is not true. ▶ *He gave a false name to the police.*

familiar adjective
If something is familiar to you, you recognize it or know about it. ▶ *His face was familiar - where had I seen him before?*

family noun (plural **families**)
1 Your family is all the people who are related to you, for example your parents, brothers and sisters, aunts and uncles.
2 A family of animals or plants is a group of them that are closely related. ▶ *Lions, tigers, and leopards all belong to the cat family.*

famine noun (plural **famines**)
If there is a famine, there is not enough food for people.

famous adjective
Someone or something famous is very well known. ▶ *She hopes that one day she might be a famous pop star.*
❶ **Fame** is being famous.

fan noun (plural **fans**)
1 a machine that blows air about to cool a place
2 something that you hold in your hand and wave in front of your face to cool your face
3 someone who supports a famous person or a sports team ▶ *Salim is a Manchester United fan.*

fancy adjective
Something that is fancy is decorated in a pretty way.

fancy verb (**fancies, fancying, fancied**)
If you fancy someone, you like them and would like to go out with them.

fancy dress noun
clothes that you wear when you want to dress up for a party or for fun

fang noun (plural **fangs**)
Fangs are the long, sharp teeth that some animals have.

fantastic adjective
Something that is fantastic is wonderful.

fantasy noun (plural **fantasies**)
A fantasy is something that is magical and cannot happen in real life. ▶ *I like reading fantasy stories.*

far adverb (**farther, further, farthest, furthest**)
Something that is far away is a long way away. ▶ *Edinburgh is quite far away from London.*

fare noun (plural **fares**)
the amount of money that you have to pay to travel on a train, bus, boat, or aeroplane

farewell interjection
goodbye

farm noun (plural **farms**)
a piece of land where someone grows crops and keeps animals for food.
❶ A **farmer** is someone who has a farm.

farther, farthest adverb SEE **far**

fascinate verb (**fascinates, fascinating, fascinated**)
If something fascinates you, you are very interested in it. ▶ *Old coins fascinate me.*

fashion noun (plural **fashions**)
a style of clothes that is popular for a short time. Clothes that are **in fashion** are popular now. Clothes that are **out of fashion** are not popular.
❶ Clothes that are popular now are **fashionable**.

fast

fast adjective (**faster**, **fastest**)
1 Something that is fast moves quickly. ▶ *We're going to London on the fast train.*
2 If a clock or watch is fast, it shows a time that is later than the right time. ▶ *My watch is ten minutes fast.*

fast verb (**fasts**, **fasting**, **fasted**)
When you fast, you do not eat any food for a period of time. ▶ *During the month of Ramadan, Muslims fast every day from dawn until sunset.*

fasten verb (**fastens**, **fastening**, **fastened**)
1 When you fasten something, you close it or do it up. ▶ *Don't forget to fasten your seat belt.*
2 If you fasten two things together, you tie or join them together.

fat noun
1 the white, greasy part of meat
2 a substance such as butter or margarine that people use when they are cooking or preparing food ▶ *You should try not to eat too much fat.*

fat adjective (**fatter**, **fattest**)
Someone who is fat has a big, round body. ▶ *My sister worries because she thinks she's too fat.*

fatal adjective
A fatal accident is one in which someone dies.

fate noun
If you say that something happens by fate, you mean that you think it has happened because a magical power has made it happen.

father noun (*plural* **fathers**)
Your father is your male parent.

fault noun (*plural* **faults**)
1 If there is a fault in something, there is something wrong with it. ▶ *I think there is a fault in the computer program.*
2 If something is your fault, you made it happen. ▶ *It was your fault that the dog got out!*

favour noun (*plural* **favours**)
If you do someone a favour, you do something for them. ▶ *Please do me a favour and post those letters for me.*

favourite adjective
Your favourite thing is the one that you like the most. ▶ *Cats are my favourite animals.*

fax noun (*plural* **faxes**)
a copy of a letter or a picture that you send to someone using telephone lines and a machine called a **fax machine**

fax verb (**faxes**, **faxing**, **faxed**)
When you fax something to someone, you send it to them using a fax machine.

fear noun (*plural* **fears**)
the feeling you get when you are frightened because you think something bad is going to happen
❶ Someone who is **fearless** is brave and does not feel any fear.

fear verb (**fears**, **fearing**, **feared**)
If you fear something, you are afraid of it. ▶ *There is no need to fear the dark.*

feast noun (*plural* **feasts**)
a special big meal for a lot of people

feat noun (*plural* **feats**)
something very brave or difficult that someone does ▶ *Climbing Mount Everest was an amazing feat.*

feather noun (*plural* **feathers**)
A bird's feathers are the light, soft things that it has all over its body.

February noun
the second month of the year

fed verb SEE **feed**

fed up adjective
If you feel fed up, you feel tired, miserable, and bored.

feeble *adjective* (**feebler**, **feeblest**)
Someone who is feeble is very weak.

feed *verb* (**feeds**, **feeding**, **fed**)
To feed a person or an animal means to give them food. ▶ *Don't forget to feed your guinea pig.*

feel *verb* (**feels**, **feeling**, **felt**)
1 When you feel something, you touch it to find out what it is like.
2 When you feel an emotion such as anger, fear, or happiness, you have that emotion. ▶ *We were all feeling very miserable.*

feeling *noun* (*plural* **feelings**)
something that you feel inside yourself, like anger or love.

feet *noun* SEE **foot**

fell *verb* SEE **fall**

felt *noun*
a type of thick cloth

felt *verb* SEE **feel**

female *adjective*
A female animal or person can become a mother.

feminine *adjective*
Something that is feminine looks as if it is suitable for girls and women, not boys and men.

fence *noun* (*plural* **fences**)
a kind of wall made from wood or wire. Fences are put round gardens and fields.

fern *noun* (*plural* **ferns**)
a plant with thin, delicate leaves

ferocious *adjective* (*pronounced* fer-oh-shuss)
A ferocious animal is fierce and dangerous.

ferry *noun* (*plural* **ferries**)
a boat that takes people across a river or short stretch of water

fertilizer *noun* (*plural* **fertilizers**)
something you add to the soil to feed plants and make them grow better

festival *noun* (*plural* **festivals**)
a special time when people celebrate something
❶ A **festive** time is a special time when people are celebrating something. **Festivities** are special things that people do when they are celebrating something.

fetch *verb* (**fetches**, **fetching**, **fetched**)
When you fetch something, you go and get it. ▶ *Could you fetch my coat for me?*

fête *noun* (*plural* **fêtes**) (*pronounced* **fate**)
an event outside with games and competitions, and a lot of stalls selling different things

fever *noun* (*plural* **fevers**)
If you have a fever, you have a high temperature and your body feels very hot. You sometimes have a fever when there is a germ in your body that is making you ill.

few *adjective*, *pronoun*
A few means a small number.
▶ *There were only a few people there.*

fib *noun* (*plural* **fibs**)
If you tell a fib, you tell a small lie.

fibre *noun* (*plural* **fibres**)
1 a thin thread
2 a substance in some foods which we need to help our body digest things properly

fiction *noun*
books and stories that are made up, not true
❶ A **fictional** character is one in a story.

fiddle *verb* (**fiddles**, **fiddling**, **fiddled**)
If you fiddle with something, you keep touching it or moving it about.
▶ *Please don't fiddle with the controls.*

fidget

fidget *verb* (**fidgets, fidgeting, fidgeted**)
When you fidget, you keep moving about and touching things in an annoying way. ▶ *Please don't fidget!*

field *noun* (*plural* **fields**)
a piece of ground with crops or grass growing on it ▶ *We had to walk through a field with cows in.*

fierce *adjective* (**fiercer, fiercest**)
A fierce animal is dangerous because it might bite you or attack you. ▶ *Tigers are very fierce animals.*

fifteen *noun*
the number 15

fifth *adjective* SEE **five**

fifty *noun*
the number 50

fight *verb* (**fights, fighting, fought**)
When people fight, they hit each other or attack each other.

figure *noun* (*plural* **figures**)
1 a number, such as 1, 2 or 3
2 Your figure is the shape of your body. ▶ *You shouldn't worry so much about your figure.*

file *noun* (*plural* **files**)
1 a book or box that you keep pieces of paper in
2 You store information in files on a computer.
3 a tool that you rub against things to make them smooth
4 If people walk in single file, they walk in a line, with one person behind the other.

fill *verb* (**fills, filling, filled**)
1 When you fill something, you put so much in it that it is full. ▶ *Rebecca filled the jug with milk.*
2 If food fills you up, it makes you feel full.

film *noun* (*plural* **films**)
1 a roll of plastic you put in a camera for taking photographs
2 a moving picture that you watch on a screen at the cinema or on television

filthy *adjective* (**filthier, filthiest**)
Something that is filthy is very dirty.

fin *noun* (*plural* **fins**)
The fins on a fish are the parts on its sides that it uses to help it swim.

final *adjective*
The final thing is the one that comes last. ▶ *This will be the final song in our concert.*
🛈 Something that happens **finally** happens last, after a lot of other things have happened.

final *noun* (*plural* **finals**)
the last game in a competition, which will decide who has won ▶ *Are you going to watch the World Cup final?*

find *verb* (**finds, finding, found**)
When you find something, you see it. ▶ *I found 50 pence on the ground.*

fine *adjective* (**finer, finest**)
1 Something that is fine is thin and light. ▶ *I've got very fine hair.*
2 If the weather is fine, it is sunny.
3 If you feel fine, you feel well and happy.

fine *noun* (*plural* **fines**)
an amount of money that you have to pay because you have done something wrong ▶ *If you do not take your library books back on time, you may have to pay a fine.*

finger *noun* (*plural* **fingers**)
Your fingers are the parts of your body on the ends of your hands.
🛈 Your **fingernails** are the nails on your fingers. Your **fingerprints** are the marks that your fingers leave on something after you have touched it.

finish verb (finishes, finishing, finished)
1 When you finish something, you come to the end of it. ▶ *Have you finished your maths yet?*
2 When something finishes, it ends. ▶ *What time does the film finish?*

fir noun (plural firs)
a tall tree that has cones, and long, thin leaves shaped like needles

fire noun (plural fires)
1 When there is a fire, something is burning. ▶ *We all had to leave the building because there was a fire.*
2 A fire is a machine that gives out heat.

fire verb (fires, firing, fired)
When you fire a gun, you make it shoot.

fire brigade noun (plural fire brigades)
a team of firefighters

fire engine noun (plural fire engines)
a large truck that carries firefighters and the equipment that they need to put out fires

fire extinguisher noun (plural fire extinguishers)
a special container with water or foam in it, which you can use to put out a fire

firefighter noun (plural firefighters)
a person whose job is to put out fires

fireman noun (plural firemen)
a person whose job is to put out fires

firework noun (plural fireworks)
something that explodes with coloured lights and loud bangs

firm adjective (firmer, firmest)
1 Something that is firm is hard and does not move easily when you pull it or press on it. ▶ *That shelf is not very firm so don't put too many books on it.*
2 Someone who is firm is quite strict and will not change their mind.

first adjective
The first thing is the one that comes before all the others. ▶ *A is the first letter of the alphabet.*

first aid noun
help that you give to a person who is hurt, before a doctor comes

first person noun
When you use the first person, you use the words 'I' and 'me' to write about yourself in a story.

fish noun (plural fishes or fish)
an animal that swims and lives in water. Fish have fins to help them swim and scales on their bodies.

fish verb (fishes, fishing, fished)
When you fish, you try to catch fish.

fisherman noun (plural fishermen)
a person who catches fish

fist noun (plural fists)
When you make a fist, you close your hand tightly.

fit adjective (fitter, fittest)
1 If you are fit, your body is healthy and strong. ▶ *Swimming helps to keep you fit.*
2 If something is fit to use or eat, it is good enough. ▶ *This food is not fit to eat!*

fit verb (fits, fitting, fitted)
1 If something fits you, it is the right size for you to wear.
2 If something fits into a place, it is the right size to go there.

five noun (plural fives)
the number 5
❶ The **fifth** thing is the one that is number 5.

fix verb (fixes, fixing, fixed)
1 When you fix one thing onto another, you join it on firmly. ▶ *My dad fixed the shelf onto the wall.*
2 When you fix something, you mend it. ▶ *She fixed the broken toy.*

fizzy adjective (fizzier, fizziest)
A fizzy drink has a lot of tiny bubbles of gas in it.

flag

flag noun (plural **flags**)
a piece of cloth with a special design on, which is fixed to a pole ▶ *Do you know the colours of the French flag?*

flake noun (plural **flakes**)
a small piece of something ▶ *A few flakes of snow were beginning to fall.*

flame noun (plural **flames**)
Flames are the orange, pointed parts that come up out of a fire.

flannel noun (plural **flannels**)
a small piece of cloth that you use for washing yourself

flap noun (plural **flaps**)
a part of something that hangs down and can move about ▶ *You need a hat with flaps that come down over your ears.*

flap verb (**flaps, flapping, flapped**)
When something flaps, it moves up and down or from side to side. ▶ *The huge bird flapped its wings and flew off.*

flash noun (plural **flashes**)
a sudden bright light ▶ *We saw a flash of lightning.*

flash verb (**flashes, flashing, flashed**)
When a light flashes, it shines brightly and then stops shining again. ▶ *The lights flashed on and off.*

flashy adjective (**flashier, flashiest**)
Something that is flashy looks very expensive. ▶ *He drives a flashy car.*

flask noun (plural **flasks**)
a container that keeps hot drinks hot and cold drinks cold

flat adjective (**flatter, flattest**)
1 Something that is flat is smooth and level, and has no bumps on it. ▶ *You need a nice flat surface for rollerblading.*
2 A flat battery has no more power in it.
3 A flat tyre or ball does not have enough air in it.
❶ When you **flatten** something, you make it smooth and flat.

flat noun (plural **flats**)
a set of rooms that you can live in inside a large building ▶ *We live in a flat on the top floor.*

flatter verb (**flatters, flattering, flattered**)
If you flatter someone, you praise them and say nice things to them.

flavour noun (plural **flavours**)
The flavour of something is the taste that it has when you eat it or drink it. ▶ *This ice cream has got a delicious flavour.*
❶ A **flavouring** is something that you add to food to give it a nice taste.

flea noun (plural **fleas**)
a small jumping insect that lives on larger animals and sucks their blood

flee verb (**flees, fleeing, fled**)
When you flee, you run away.

fleece noun (plural **fleeces**)
1 A sheep's fleece is the wool on its body.
2 A fleece is a type of warm coat or jacket made of thick material.

fleet noun (plural **fleets**)
a group of ships sailing together

flesh noun
Your flesh is the soft part of your body between your bones and your skin.

flew verb SEE **fly**

flick verb (**flicks, flicking, flicked**)
When you flick something, you knock it with your finger so that it flies through the air. ▶ *Ali flicked a piece of paper at me.*

flicker verb (**flickers, flickering, flickered**)
When a flame or light flickers, it shines on and off.

flight noun (plural **flights**)
1 a journey in an aeroplane ▶ *We went on a flight from London to New York.*
2 A flight of stairs is a set of stairs.

flimsy *adjective* (flimsier, flimsiest)
Something that is flimsy is not very thick or strong and will break easily.

fling *verb* (flings, flinging, flung)
When you fling something, you throw it as hard as you can. ► *He flung the book down onto the floor.*

flip *verb* (flips, flipping, flipped)
When you flip something over, you turn it over quickly.

flipper *noun* (*plural* flippers)
1 The flippers on a seal or a penguin are the parts on the sides of its body that it uses for swimming.
2 Flippers are large, flat shoes that you wear on your feet to help you swim.

flirt *verb* (flirts, flirting, flirted)
When you flirt with someone, you are nice to them and show them that you like them and want to go out with them.

float *verb* (floats, floating, floated)
When something floats, it does not sink but stays on the surface of water.

flock *noun* (*plural* flocks)
A flock of sheep or birds is a large group of them.

flood *noun* (*plural* floods)
When there is a flood, a lot of water spreads over the land.

flood *verb* (floods, flooding, flooded)
When a river floods, it becomes too full and spills out over the land.

floodlight *noun* (*plural* floodlights)
Floodlights are large, bright lights that are used to light up a building or a sports pitch at night.

floor *noun* (*plural* floors)
1 The floor in a building is the part that you walk on.
2 A floor in a tall building is one of the levels in it. ► *The toy department is on the third floor.*

flop *verb* (flops, flopping, flopped)
1 If you flop down, you sit or lie down suddenly because you are very tired. ► *She flopped down into a chair.*
2 If something flops about, it hangs and moves about loosely. ► *My hair keeps flopping into my eyes.*

floppy disk *noun* (*plural* floppy disks)
a flat, square piece of plastic that stores information for a computer

flour *noun*
a powder that is made from crushed wheat. You use flour for making bread, pastry, and cakes.

flow *verb* (flows, flowing, flowed)
When water flows, it moves along like a river.

flow chart *noun* (*plural* flow charts)
a diagram that shows the different stages of how something happens

flower *noun* (*plural* flowers)
the brightly-coloured part of a plant ► *There were lots of beautiful flowers in the garden.*

flown *verb* SEE **fly**

flu *noun*
an illness that gives you a bad cold and makes you ache all over and feel very hot. Flu is short for **influenza**.

fluff *noun*
light, soft wool or feathers ► *The chicks looked like little yellow balls of fluff.*
❶ Something that is **fluffy** looks soft and light, like fluff.

fluid *noun* (*plural* fluids)
a liquid

fluke *noun* (*plural* flukes)
If something is a fluke, it has happened once by chance but will probably not happen again.

flung *verb* SEE **fling**

fluorescent

fluorescent *adjective* (*pronounced* floor-**ess**-ent)
A fluorescent colour is very bright and seems to shine in the dark.

fluoride *noun*
a substance which is added to toothpaste because people think it helps to keep your teeth healthy

flush *verb* (**flushes, flushing, flushed**)
1 When you flush, your face goes red because you feel shy or guilty.
2 When you flush a toilet, you clean it by making water rush through it.

flute *noun* (*plural* **flutes**)
a musical instrument which you hold sideways across your mouth and play by blowing across a hole in it

flutter *verb* (**flutters, fluttering, fluttered**)
When something flutters, it flaps gently. ▶ *The flags fluttered in the breeze.*

fly *noun* (*plural* **flies**)
a small insect with wings

fly *verb* (**flies, flying, flew, flown**)
When something flies, it moves along through the air.

foal *noun* (*plural* **foals**)
a young horse

foam *noun*
1 a thick mass of small bubbles on the top of a liquid
2 a soft, light substance that is used for making furniture

focus *verb* (**focuses, focusing, focused**)
When you focus a camera or telescope, you move the controls so that you get a clear picture.

fog *noun*
When there is fog, there is thick cloud just above the ground, which makes it difficult to see. ▶ *It is difficult to drive in thick fog.*
❶ When there is fog, the weather is **foggy**.

foil *noun*
a sheet of very thin metal, which you use for wrapping food or covering it when you cook it

fold *verb* (**folds, folding, folded**)
When you fold something, you bend one part of it over another part.
▶ *Please fold your clothes neatly.*

folder *noun* (*plural* **folders**)
a thin cardboard case that you keep pieces of paper in

folk *noun*
people ▶ *I know most of the folk who live round here.*

folk tale *noun* (*plural* **folk tales**)
a traditional story that has been passed down for many years

follow *verb* (**follows, following, followed**)
1 If you follow someone, you go after them. ▶ *I decided to follow Emily to see where she went.*
2 If you follow a road or path, you go along it. ▶ *Follow this path until you come to a river.*
3 If you follow instructions, you do what they tell you to do.

fond *adjective* (**fonder, fondest**)
If you are fond of something, you like it a lot. If you are fond of someone, you like them a lot.

food *noun* (*plural* **foods**)
anything that you eat to help you grow and be healthy

fool *noun* (*plural* **fools**)
someone who is very silly
❶ Someone who is very silly is **foolish**.

foot *noun* (*plural* **feet**)
1 Your feet are the parts of your body that you stand on.
2 We can measure length in feet. One foot is about 30 centimetres.
❶ A **footprint** is a mark on the ground left by someone's foot. A **footstep** is the sound of someone walking along.

football *noun*
1 a game in which two teams try to score goals by kicking a ball into a net
2 a ball that you use for playing football
ℹ A **footballer** is someone who plays football.

for *preposition*
1 If something is for a person, you are going to give it to that person. ▶ *This present is for Ameena.*
2 If you say what something is for, you are saying how you use it. ▶ *You need a sharp knife for cutting bread.*

forbid *verb* (**forbids, forbidding, forbade, forbidden**)
To forbid someone to do something means to tell them that they must not do it. If something is forbidden, you are not allowed to do it.

force *noun* (*plural* **forces**)
1 If you use force to do something, you use your strength. ▶ *They had to use force to open the door.*
2 A force is something that pushes or pulls an object.
3 A police force is all the police who work together in one town or area.

force *verb* (**forces, forcing, forced**)
1 If you force someone to do something, you make them do it. ▶ *He forced me to give him the money.*
2 If you force something open, you use your strength to open it.

forecast *noun* (*plural* **forecasts**)
When you give a forecast, you say what you think is going to happen.

forehead *noun* (*plural* **foreheads**)
Your forehead is the part of your head that is above your eyes.

foreign *adjective*
Things that are foreign come from other countries or are to do with other countries. ▶ *I wish I could speak a foreign language.*
ℹ A **foreigner** is someone who comes from another country.

forest *noun* (*plural* **forests**)
an area of land where a lot of trees grow close together

forge *verb* (**forges, forging, forged**)
If you forge something, you copy it because you want to trick people. ▶ *Someone had forged my signature.*
ℹ A **forgery** is something that has been forged. ▶ *I think some of these banknotes may be forgeries.*

forget *verb* (**forgets, forgetting, forgot, forgotten**)
If you forget something, you do not remember it. ▶ *I forgot to do my homework.*

forgive *verb* (**forgives, forgiving, forgave, forgiven**)
If you forgive someone, you stop being angry with them.

forgot, forgotten *verb* SEE **forget**

fork *noun* (*plural* **forks**)
1 a tool with three sharp points called prongs. You use a fork for eating food, and you use a large fork for digging in the ground.
2 A fork in a road is a place where the road splits, and two roads go off in different directions.

forked *adjective*
Something that is forked divides into two parts near the end. ▶ *Some snakes have a forked tongue.*

form *noun* (*plural* **forms**)
1 a piece of paper that has writing on it and spaces where you must fill in your name and other information
2 a class in a school ▶ *Which form are you in?*
3 a type ▶ *A bicycle is a form of transport.*

form *verb* (**forms, forming, formed**)
When something forms, it is made. ▶ *These rocks formed millions of years ago.*

formal

formal *adjective*
1 Formal events or clothes are very smart and not relaxed.
2 Formal language is language that you write down, not language you use when you are talking to friends.

fort *noun* (*plural* **forts**)
a strong building that looks like a castle

fortnight *noun* (*plural* **fortnights**)
A fortnight is two weeks.

fortress *noun* (*plural* **fortresses**)
a big fort

fortunate *adjective*
If you are fortunate, you are lucky.
▶ *We are very fortunate to live in such a nice town.*
❶ **Fortunately** means luckily.

fortune *noun* (*plural* **fortunes**)
A fortune is a very large amount of money.

forty *noun*
the number 40

forwards, **forward**
1 towards the place that is in front of you ▶ *The train moved slowly forwards.*
2 If you are looking forward to something, you are excited because it is going to happen.

fossil *noun* (*plural* **fossils**)
part of a dead plant or animal that has been in the ground for millions of years and has gradually turned to stone

foster *verb* (**fosters, fostering, fostered**)
When people foster a child, they look after it in their home as if it was their own child.

fought *verb* SEE **fight**

foul *adjective* (**fouler, foulest**)
Something that is foul is dirty and nasty. ▶ *There was a foul smell outside.*

foul *noun* (*plural* **fouls**)
If you commit a foul in a game such as football, you push or kick another player.

found *verb* SEE **find**

fountain *noun* (*plural* **fountains**)
a jet of water that shoots up into the air

four *noun* (*plural* **fours**)
the number 4
❶ The **fourth** thing is the one that is number 4.

fourteen *noun*
the number 14

fox *noun* (*plural* **foxes**)
a wild animal that looks like a dog and has red fur and a long, furry tail

fraction *noun* (*plural* **fractions**)
a number that is not a whole number. $\frac{1}{2}$, $\frac{3}{5}$, and $\frac{1}{4}$ are fractions

fracture *noun* (*plural* **fractures**)
a place where a bone is cracked or broken

fragile *adjective*
Something that is fragile will break easily if you drop it.

fragment *noun* (*plural* **fragments**)
a small piece that has broken off something ▶ *There were a few fragments of glass on the ground.*

frail *adjective* (**frailer, frailest**)
Someone who is frail is not strong or healthy.

frame *noun* (*plural* **frames**)
1 the part round the outside of a picture or a pair of glasses ▶ *On the wall was a picture in a silver frame.*
2 the part that supports an object ▶ *You need a tent with a strong frame to camp in the mountains.*

frantic *adjective*
If you do things in a frantic way, you do them very quickly because you are in a hurry.

fraud noun (plural **frauds**)
1 something that is not real, but has been made to trick people ▶ *I knew that the letter was a fraud.*
2 someone who is not really the person they are pretending to be ▶ *I don't believe that he's a policeman – I think he's a fraud.*

freckle noun (plural **freckles**)
Freckles are the small brown spots that some people have on their skin, especially when they have been in the sun.

free adjective (**freer**, **freest**)
1 If you are free, you can go where you want and do what you want to do. ▶ *After fifteen years in prison he was finally free.*
2 If something is free, you do not have to pay for it. ▶ *Entry to the museum is free.*
ⓘ **Freedom** is being able to go where you want and do what you want to do.

free verb (**frees**, **freeing**, **freed**)
To free someone means to let them go after they have been locked up.

freeze verb (**freezes**, **freezing**, **froze**, **frozen**)
1 When something freezes, it becomes very cold and hard and changes into ice. ▶ *The lake froze over last winter.*
2 If you are freezing or frozen, you are very cold.

freezer noun (plural **freezers**)
a large, very cold container in which you can store frozen food for a long time

frequent adjective
Something that is frequent happens quite often. ▶ *We make frequent visits to our grandparents.*
ⓘ Something that happens quite often happens **frequently**.

fresh adjective (**fresher**, **freshest**)
1 Something that is fresh is clean and new. ▶ *We changed into some fresh clothes.*
2 Fresh food has been made or picked only a short time ago.
3 Fresh air is clean and cool.
4 Fresh water is not salty.
5 If you feel fresh, you do not feel tired.
ⓘ Food that is **freshly** made was made only a short time ago.

Friday noun (plural **Fridays**)
the day after Thursday

fridge noun (plural **fridges**)
a large cool container that you keep food in so that it does not go bad. Fridge is short for **refrigerator**.

friend noun (plural **friends**)
Your friends are the people you like and know well.
ⓘ Someone who is **friendly** behaves in a kind way, like a friend. **Friendship** is kind behaviour between friends.

fright noun (plural **frights**)
a sudden feeling of fear ▶ *That loud noise gave me a fright.*

frighten verb (**frightens**, **frightening**, **frightened**)
If something frightens you, it makes you feel scared. ▶ *The sudden noise frightened me.*
ⓘ If you are **frightened** of something, you are afraid of it. Something that is **frightening** makes you feel afraid.

frill noun (plural **frills**)
a strip of material with a lot of folds in it, which is stitched to the edge of a piece of clothing to make it look nice

fringe noun (plural **fringes**)
short hair that hangs down over your forehead

frog noun (plural **frogs**)
a small animal with a smooth, wet skin and long back legs. Frogs live near water and can jump by using their strong back legs.

from

from *preposition*
1 When you go away from a place, you leave that place. ▶ *We flew from London to Paris.*
2 If a present is from a person, that person gave it to you. ▶ *I got a lovely present from my aunt.*

front *noun* (*plural* **fronts**)
The front of something is the part that faces forwards. ▶ *She spilled some juice down the front of her dress.*

frost *noun* (*plural* **frosts**)
ice that looks like powder and covers the ground when the weather is cold

froth *noun*
a mass of small bubbles on the top of a liquid

frown *verb* (**frowns, frowning, frowned**)
When you frown, you have lines on your forehead because you are angry or worried.

froze, frozen *verb* SEE **freeze**

fruit *noun* (*plural* **fruits** *or* **fruit**)
the part of a plant which contains seeds. A lot of fruits taste sweet and are good to eat. Apples, oranges, and bananas are all types of fruit.

frustrate *verb* (**frustrates, frustrating, frustrated**)
If something frustrates you, it makes you feel cross.

fry *verb* (**fries, frying, fried**)
When you fry food, you cook it in hot fat.

fuel *noun* (*plural* **fuels**)
anything that people burn to make heat ▶ *Coal is a fuel.*

full *adjective* (**fuller, fullest**)
If something is full, it has as much inside it as it can hold. ▶ *Her pockets were full of sweets.* ▶ *The room was full of people.*

full stop *noun* (*plural* **full stops**)
a dot which you put at the end of every sentence

fumble *verb* (**fumbles, fumbling, fumbled**)
If you fumble with something, you hold it in a clumsy way.

fumes *noun*
gases and smoke which smell nasty

fun *noun*
When you have fun, you enjoy yourself. ▶ *We had great fun on the beach.*

fund *noun* (*plural* **funds**)
an amount of money that people have collected so that they can use it for something special ▶ *Our school is raising funds to buy a new computer.*

funeral *noun* (*plural* **funerals**)
the ceremony that takes place when a dead person is buried or burned

funnel *noun* (*plural* **funnels**)
a chimney on a ship or steam engine

funny *adjective* (**funnier, funniest**)
1 Something that is funny makes you laugh or smile. ▶ *Tom told us some very funny jokes.*
2 Something that is funny is strange or surprising. ▶ *There was a funny smell in the classroom.*

fur *noun* (*plural* **furs**)
the soft hair that covers some animals

furious *adjective*
If you are furious, you are very angry.

furniture *noun*
things such as beds and tables that you need inside a house

furry *adjective* (**furrier, furriest**)
A furry animal is covered in fur.

further *adverb* SEE **far**

fuse *noun* (*plural* **fuses**)
1 a safety device in an electrical machine that stops the machine from working if there is a problem
2 The fuse on a bomb or firework is the part that you light. When the fuse has burnt away, the bomb or firework will explode.

fuss verb (fusses, fussing, fussed)
If you fuss about something, you worry about it too much.

fussy adjective (fussier, fussiest)
Someone who is fussy only likes certain things and so is difficult to please. ► *Some children are very fussy with their food.*

future noun
The future is the time that will come. ► *Nobody knows what will happen in the future.*

fuzzy adjective (fuzzier, fuzziest)
A picture or sound that is fuzzy is not very clear.

Gg

gadget noun (plural gadgets)
a small, useful tool

gain verb (gains, gaining, gained)
If you gain something, you get something good or useful. ► *I got the answer right and gained two points for my team.*

gala noun (plural galas)
A swimming gala is a swimming competition.

galaxy noun (plural galaxies)
a large group of stars and planets. The Milky Way is a galaxy.

gale noun (plural gales)
a very strong wind

gallery noun (plural galleries)
a building or large room where there are paintings on the walls for people to look at

gallon noun (plural gallons)
We can measure liquids in gallons. A gallon is about $4\frac{1}{2}$ litres.

gallop verb (gallops, galloping, galloped)
When a horse gallops, it runs as fast as it can.

gamble verb (gambles, gambling, gambled)
If you gamble, you try to win money by playing a game.

game noun (plural games)
something that you play for fun ► *Shall we have a game of tennis?*

gander noun (plural ganders)
a male goose

gang noun (plural gangs)
a group of people who spend time together and do things together ► *Do you want to join our gang?*

gangster noun (plural gangsters)
someone who belongs to a gang that robs and kills people

gaol noun (plural gaols) (pronounced jail)
a prison

gap noun (plural gaps)
a hole, or an empty space between two things ► *We climbed through a gap in the fence.*

gape verb (gapes, gaping, gaped)
1 If you gape at something, you stand and look at it with your mouth open, because you are so surprised. ► *Our friends just gaped at us when we told them we'd won.*
2 Something that is gaping is wide open. ► *He fell down a big gaping hole in the ground.*

garage noun (plural garages)
1 a building in which people keep a car or bus
2 a place that sells petrol and mends cars

garbage noun
things that you have thrown away because you do not want them any more

garden noun (plural gardens)
a piece of ground where people grow flowers, fruit, or vegetables

gargle

gargle verb (gargles, gargling, gargled)
When you gargle, you move a liquid around at the back of your throat but do not swallow it. You often gargle when you have a sore throat.

garlic noun
a plant like an onion with a very strong smell and taste

gas noun (plural gases)
any substance that is like air, and is not a solid or a liquid. We can burn some types of gas to give heat to cook with or heat our homes. ▶ *Oxygen is a gas.*

gash noun (plural gashes)
a deep cut in your skin ▶ *She fell over and got a nasty gash on her forehead.*

gasp verb (gasps, gasping, gasped)
When you gasp, you breathe in quickly and noisily because you are surprised, or because you have been running. ▶ *'I can't run any further,' he gasped.*

gate noun (plural gates)
a door in a wall or fence

gateau noun (plural gateaus or gateaux) (pronounced gat-oh)
a large, rich cake with cream or fruit in it

gather verb (gathers, gathering, gathered)
1 When people gather, they come together. ▶ *A crowd gathered to watch the fight.*
2 When you gather things, you collect them and bring them together. ▶ *We gathered nuts from the bushes.* ▶ *I need to gather some information for my project.*

gave verb SEE **give**

gaze verb (gazes, gazing, gazed)
If you gaze at something, you look at it for a long time. ▶ *She lay in the garden and gazed up at the sky.*

gear noun (plural gears)
1 The gears on a bicycle or car help to control how fast you go by changing the speed at which the wheels go round.
2 Your gear is all the things that you need to play a game or do a job. ▶ *Don't forget to bring your tennis gear.*

gel noun
a thick, sticky liquid that you put on your hair to hold it in place

general adjective
1 Something that is general includes most people. ▶ *The general opinion in our class is that school is fun.*
2 Something that is general does not go into details. ▶ *We had a general discussion about what life was like in Roman times.*

general noun (plural generals)
an important officer in the army

generally adverb
usually ▶ *It is generally cold here in the winter.*

generation noun (plural generations)
all the people who are the same age ▶ *This film will be popular with the older and younger generations.*

generous adjective
Someone who is generous is kind and always ready to give or share the things that they have.

genius noun (plural geniuses)
someone who is extremely clever

gentle adjective (gentler, gentlest)
If you are gentle, you touch something in a kind, careful way and are not rough. ▶ *You must be gentle with the kitten.*
❶ If you touch something in a gentle way, you touch it **gently**.

gentleman noun (plural gentlemen)
a polite name for a man

genuine adjective (pronounced jen-yoo-in)
Something that is genuine is real.
▶ *Do you think this is genuine gold?*

geography noun (pronounced jee-og-ra-fee)
the subject in which you learn about the earth, with its mountains, rivers, countries, and the people who live in them

geology noun
the subject in which you learn about rocks and fossils

gerbil noun (plural **gerbils**)
a small, brown animal with long back legs and a long tail. People sometimes keep gerbils as pets.

germ noun (plural **germs**)
a tiny living thing, that is too small to see. Germs sometimes make you ill if they get inside your body.

gesture noun (plural **gestures**)
a sign that you make with your hands to tell someone something

get verb (**gets, getting, got**)
1 When you get something, you receive it, buy it, or earn it, and it becomes yours. ▶ *What did you get for your birthday?*
2 To get means to become. ▶ *Are you getting tired yet?*

ghastly adjective
Something that is ghastly is horrible.
▶ *What a ghastly colour!*

ghost noun (plural **ghosts**)
the shape of a dead person that some people think they can see

giant noun (plural **giants**)
a very big person, especially in stories

giddy adjective (**giddier, giddiest**)
If you feel giddy, you feel dizzy.

gift noun (plural **gifts**)
a present

gigantic adjective
Something that is gigantic is very big.
▶ *I've never seen such a gigantic bar of chocolate.*

giggle verb (**giggles, giggling, giggled**)
If you giggle, you laugh in a silly way.

gill noun (plural **gills**)
The gills on a fish are the parts on its sides that it breathes through.

ginger noun
a spice with a strong, hot taste

ginger adjective
Ginger hair is a reddish-orange colour.

gingerbread noun
a kind of cake or biscuit that has ginger in to give it a strong taste

gingerly adverb
If you do something gingerly, you do it very carefully.

giraffe noun (plural **giraffes**)
a very tall African animal with a very long neck. Giraffes are the tallest animals in the world, and they use their long necks to reach up and eat leaves off trees.

girl noun (plural **girls**)
a female child

girlfriend noun (plural **girlfriends**)
A boy's girlfriend is the girl he is going out with.

give verb (**gives, giving, gave, given**)
If you give something to someone, you let them have it. ▶ *Ali gave me a lovely present for my birthday.*

glad adjective
If you are glad about something, you are happy about it.
ⓘ If you do something **gladly**, you are happy and willing to do it.

gladiator noun (plural **gladiators**)
someone in ancient Rome who took part in public fights that people watched

glamorous

glamorous *adjective*
Someone who is glamorous looks elegant, rich, and beautiful.

glance *verb* (**glances, glancing, glanced**)
If you glance at something, you look at it quickly.

glare *verb* (**glares, glaring, glared**)
1 If you glare at someone, you look at them angrily. ▶ *The teacher glared at the two boys.*
2 If a light glares, it shines with a very bright light that hurts your eyes.

glass *noun* (*plural* **glasses**)
1 the hard, clear substance that windows are made of
2 a cup made of glass, which you drink out of

glasses *noun*
two round pieces of glass in a frame, which some people wear over their eyes to help them to see better

gleam *verb* (**gleams, gleaming, gleamed**)
If something gleams, it shines. ▶ *The cat's eyes gleamed in the dark.*

glee *noun*
a feeling of great happiness

glide *verb* (**glides, gliding, glided**)
When something glides along, it moves along very smoothly. ▶ *The skaters glided over the ice.*

glider *noun* (*plural* **gliders**)
a type of aeroplane without an engine

glimmer *verb* (**glimmers, glimmering, glimmered**)
If something glimmers, it shines with a faint light.

glimpse *verb* (**glimpses, glimpsing, glimpsed**)
If you glimpse something, you see it for only a few seconds. ▶ *I glimpsed an animal in the bushes.*

glint *verb* (**glints, glinting, glinted**)
If something glints, it shines or sparkles. ▶ *The water was glinting in the moonlight.*

glisten *verb* (**glistens, glistening, glistened**)
If something glistens, it shines and sparkles because it is wet. ▶ *The grass glistened with dew.*

glitter *verb* (**glitters, glittering, glittered**)
If something glitters, it shines and sparkles brightly. ▶ *We could see the glittering lights of the palace.*

gloat *verb* (**gloats, gloating, gloated**)
If you gloat, you show that you are pleased because you have done well and someone else has done badly.

globe *noun* (*plural* **globes**)
a ball with the map of the whole world on it
❶ Something that is **global** happens all over the world.

gloomy *adjective* (**gloomier, gloomiest**)
1 A gloomy place is dark.
2 If you feel gloomy, you feel sad.

glorious *adjective*
Something that is glorious is beautiful or magnificent. ▶ *It was a glorious summer's day.*

glory *noun*
If you win glory, you do very well and become famous.

glossary *noun* (*plural* **glossaries**)
a list at the back of a book, which explains the meanings of difficult words that are used in the book

glossy *adjective* (**glossier, glossiest**)
Something that is glossy is smooth and shiny.

glove *noun* (*plural* **gloves**)
something that you wear on your hands in cold weather. Gloves have separate parts for your thumb and each finger.

glow *verb* (**glows, glowing, glowed**)
1 If something glows, it shines with a warm, gentle light.
2 When your cheeks glow, they are pink because you are cold or have been running around.

glue *noun* (*plural* **glues**)
a sticky substance that you use for sticking things together

glum *adjective*
If you feel glum, you feel sad.

gnarled *adjective* (**gn-** in this word sounds like **n-**)
Something that is gnarled is bent and twisted because it is very old. ▶ *We sat on the gnarled old tree trunk.*

gnash *verb* (**gnashes, gnashing, gnashed**) (**gn-** in this word sounds like **n-**)
If you gnash your teeth, you grind them together because you are angry.

gnaw *verb* (**gnaws, gnawing, gnawed**) (**gn-** in this word sounds like **n-**)
When an animal gnaws on something, it keeps biting it. ▶ *The dog was outside, gnawing on a bone.*

gnome *noun* (*plural* **gnomes**) (**gn-** in this word sounds like **n-**)
a small, ugly fairy in stories

go *verb* (**goes, going, went, gone**)
1 When you go somewhere, you move or travel so that you are there. ▶ *Where are you going?*
2 If a machine is going, it is working.
3 To go means to become. ▶ *Clay goes hard when you bake it.*

goal *noun* (*plural* **goals**)
1 the net where you must kick or throw the ball to score a point in a game such as football or netball
2 something that you want to achieve ▶ *Her goal in life is to become a professional singer.*

goat *noun* (*plural* **goats**)
an animal with horns that is kept on farms for its milk

gobble *verb* (**gobbles, gobbling, gobbled**)
If you gobble something, you eat it quickly and greedily.

goblin *noun* (*plural* **goblins**)
a bad, ugly fairy in stories

god *noun* (*plural* **gods**)
a person or thing that people worship
❶ A **goddess** is a female god.

goggles *noun*
special thick glasses that you wear to protect your eyes, for example when you are swimming

go-kart *noun* (*plural* **go-karts**)
a type of small car that people use for racing

gold *noun*
a shiny, yellow metal that is very valuable
❶ Something that is **golden** is made of gold or the colour of gold.

goldfish *noun* (*plural* **goldfishes** or **goldfish**)
a small orange fish that people sometimes keep as a pet

golf *noun*
a game that you play by hitting small, white balls with sticks called golf clubs. You have to hit the balls into holes in the ground.

gone *verb* SEE **go**

good

good *adjective* (**better, best**)
1 Something that is good is nice, pleasant, or enjoyable. ▶ *Have you had a good day at school?*
2 Someone who is good is kind and honest. ▶ *You have been a very good friend to me.*
3 When you are good, you behave well and do not do anything naughty. ▶ *The children have all been very good today.*
4 If you are good at something, you can do it well. ▶ *I'm not very good at swimming.*

goodbye *interjection*
the word you say to someone when you are leaving them

goods *noun*
Goods are things that people buy and sell.

goose *noun* (*plural* **geese**)
a large bird that is kept on farms for its meat and eggs. A male goose is called a **gander**.

gooseberry *noun* (*plural* **gooseberries**)
a green berry that grows on a prickly bush

goose pimples *noun*
Goose pimples are small bumps that you get on your skin when you are cold or frightened. They are sometimes called **goose bumps**.

gorgeous *adjective*
Something that is gorgeous is very nice indeed. ▶ *This chocolate ice cream is gorgeous!*

gorilla *noun* (*plural* **gorillas**)
an African animal like a very large monkey with long arms and no tail. A gorilla is a type of ape.

gossip *verb* (**gossips, gossiping, gossiped**)
If you gossip, you talk about other people, sometimes in an unkind way.

got *verb* SEE **get**

government *noun* (*plural* **governments**)
The government is the group of people who are in charge of a country.

gown *noun* (*plural* **gowns**)
a long dress

grab *verb* (**grabs, grabbing, grabbed**)
If you grab something, you take hold of it quickly or roughly. ▶ *The thief grabbed my purse and ran off.*

graceful *adjective*
Someone who is graceful moves in a smooth, gentle way. ▶ *She is a very graceful dancer.*

grade *noun* (*plural* **grades**)
a mark that you get for a piece of work, which shows how good your work is

gradual *adjective*
Something that is gradual happens slowly, bit by bit, not all at once.
ℹ Something that happens in a gradual way happens **gradually**.

graffiti *noun*
writing and pictures that people have scribbled or scratched onto walls

grain *noun* (*plural* **grains**)
1 Grain is the seeds of plants like corn and wheat.
2 A grain of salt or sand is one tiny bit of it.

gram *noun* (*plural* **grams**)
We can measure weight in grams. There are 1000 grams in one kilogram.

grammar *noun*
Grammar is all the rules of a language, which tell us how to put the words together correctly.

grand *adjective* (**grander, grandest**)
Something that is grand is very big and important.

grandchild noun (plural **grandchildren**)
Someone's grandchild is a child of their son or daughter. A grandchild can also be called a **granddaughter**, or a **grandson**.

grandparent noun (plural **grandparents**)
Your grandparents are the parents of your father or mother. You can also call your grandparents your **grandmother** and **grandfather**. A grandmother is often called **grandma** or **granny**. A grandfather is often called **grandpa** or **grandad**.

grant verb (**grants, granting, granted**)
To grant something means to give it to someone. ▶ *The fairy granted her three wishes.*

grape noun (plural **grapes**)
a small, soft green or purple fruit that grows in bunches

grapefruit noun (plural **grapefruits**)
a large, sour-tasting fruit that has thick yellow skin

graph noun (plural **graphs**)
a diagram that shows information about something ▶ *We drew a graph showing how tall each child is.*

graphics noun
pictures or designs, especially pictures that are made on a computer ▶ *Some of the new computer games have got brilliant graphics.*

grasp verb (**grasps, grasping, grasped**)
If you grasp something, you get hold of it and hold it tightly. ▶ *She grasped my arm to stop herself from falling.*

grass noun (plural **grasses**)
a green plant that covers the ground and is used for lawns and parks

grasshopper noun (plural **grasshoppers**)
an insect that has long back legs and can jump a long way

grate verb (**grates, grating, grated**)
When you grate food, you cut it into very small pieces by rubbing it against a rough tool. ▶ *Sprinkle the grated cheese over the top of the pizza.*

grateful adjective
If you are grateful for something, you are glad that you have it. ▶ *We are very grateful for all your help.*

grave noun (plural **graves**)
a place where a dead person is buried in the ground

grave adjective (**graver, gravest**)
Something that is grave is very serious and worrying.

gravel noun
tiny stones that are used to make paths ▶ *Her feet crunched over the gravel.*

gravity noun
the force that pulls things towards the earth

gravy noun
a hot, brown sauce that you eat with meat

graze verb (**grazes, grazing, grazed**)
1 If you graze a part of your body, you hurt it by scraping it against something and making it bleed. ▶ *She fell over and grazed her knee.*
2 When animals graze, they eat grass. ▶ *The sheep were grazing in the field.*

grease noun
a thick, oily substance

great adjective (**greater, greatest**)
1 Something that is great is very big and impressive. ▶ *They were led into the great hall of the palace.*
2 A great person is very clever and important. ▶ *He was a great musician.*
3 Something that is great is very good. ▶ *It's a great film!*

greedy

greedy *adjective* (**greedier, greediest**)
Someone who is greedy wants more food or money than they need.

green *adjective*
Something that is green is the colour of grass.

greengrocer *noun* (*plural* **greengrocers**)
someone who sells fruit and vegetables in a shop

greenhouse *noun* (*plural* **greenhouses**)
a glass building that people use for growing plants in

greet *verb* (**greets, greeting, greeted**)
When you greet someone, you welcome them and say hello to them.
❶ A **greeting** is something that you say when you greet someone.

grew *verb* SEE **grow**

grey *adjective*
Something that is grey is the colour of the sky on a cloudy day.

grid *noun* (*plural* **grids**)
a pattern of straight lines that cross over each other to make squares

grief *noun*
a feeling you have when you are very sad and upset

grill *verb* (**grills, grilling, grilled**)
When you grill food, you cook it on metal bars either under or over heat. ▶ *We grilled some sausages for tea.*

grimace *noun* (*plural* **grimaces**)
When you make a grimace, you twist your face because something is shocking, horrible, or painful.

grin *verb* (**grins, grinning, grinned**)
When you grin, you smile in a cheerful way.

grind *verb* (**grinds, grinding, ground**)
When you grind something, you crush it into tiny bits. ▶ *The wheat was ground into flour.*

grip *verb* (**grips, gripping, gripped**)
When you grip something, you hold on to it tightly.

gripping *adjective*
A book or film that is gripping is very exciting.

gristle *noun*
tough bits in meat that are hard to chew

grit *noun*
tiny bits of stone or sand

groan *verb* (**groans, groaning, groaned**)
When you groan, you make a low sound because you are in pain or are disappointed about something.

grocer *noun* (*plural* **grocers**)
someone who sells tea, sugar, jam, and other kinds of food in a shop

groom *noun* (*plural* **grooms**)
1 a person who looks after horses
2 another word for a bridegroom

groom *verb* (**grooms, grooming, groomed**)
When you groom an animal, you clean it and brush it.

groove *noun* (*plural* **grooves**)
a long, narrow cut in something

grope *verb* (**gropes, groping, groped**)
If you grope around, you try to find something by feeling for it with your hands because you cannot see. ▶ *I groped for the door in the dark.*

grotesque *adjective* (*pronounced* grow-**tesk**)
Something that is grotesque looks horrible and unnatural.

grotto *noun* (*plural* **grottoes**)
a small cave

ground *noun* (*plural* **grounds**)
1 The ground is the earth.
2 A sports ground is a piece of land that people play sport on.

ground *verb* SEE **grind**

grounds *noun*
the land that belongs to a large house

group noun (plural **groups**)
1 a number of people, animals, or things that are together or belong together ► *There was a group of children standing by the ice cream stall.*
2 a number of people who play music together ► *What's your favourite pop group?*

grow verb (**grows, growing, grew, grown**)
1 To grow means to become bigger. ► *Nadim has really grown this year.*
2 When you grow plants, you put them in the ground and look after them.
3 To grow means to become. ► *Everyone was beginning to grow tired.*

growl verb (**growls, growling, growled**)
When an animal growls, it makes a deep, angry sound in its throat.

grown-up noun (plural **grown-ups**)
a man or woman who is not a child any more

growth noun
the way in which something grows and gets bigger ► *We measured the growth of the plants.*

grub noun (plural **grubs**)
1 an animal that looks like a small worm and will become an insect when it is an adult
2 food

grubby adjective (**grubbier, grubbiest**)
Something that is grubby is dirty.

grudge noun (plural **grudges**)
If you have a grudge against someone, you are still cross with them for a long time because they did something nasty to you.

gruff adjective (**gruffer, gruffest**)
A gruff voice is deep and rough.

grumble verb (**grumbles, grumbling, grumbled**)
If you grumble about something, you complain about it.

grumpy adjective (**grumpier, grumpiest**)
Someone who is grumpy is bad-tempered.

grunt verb (**grunts, grunting, grunted**)
When a pig grunts, it makes a rough sound.

guarantee noun (plural **guarantees**) (**gu-** in this word sounds like **g-**)
a promise that something you have bought will be mended or replaced free if it goes wrong

guard verb (**guards, guarding, guarded**)
1 When you guard a place, you watch it to keep it safe from other people. ► *The dog was guarding the house.*
2 When you guard a person, you watch them to keep them safe or to stop them from escaping.

guard noun (plural **guards**)
someone who protects a place or watches a person to keep them safe or stop them from escaping

guardian noun (plural **guardians**)
a person who looks after a child instead of the child's real parents

guess verb (**guesses, guessing, guessed**)
When you guess, you say what you think the answer to a question is when you do not really know. ► *Can you guess how many soft toys I have got?*

guest noun (plural **guests**)
a person who is invited to a party or is invited to stay in someone else's home for a short time

guide noun (plural **guides**)
1 a person who shows you around a place
2 a book that gives you information about something

guide

guide *verb* (**guides, guiding, guided**)
If you guide someone to a place, you lead them or take them there.

guilty *adjective* (**guiltier, guiltiest**)
1 If you are guilty, you have done something wrong. ▶ *The prisoner was found guilty of murder.*
2 If you feel guilty, you feel bad because you have done something wrong.

guinea pig *noun* (*plural* **guinea pigs**)
a small furry animal with no tail. People sometimes keep guinea pigs as pets.

guitar *noun* (*plural* **guitars**)
a musical instrument with strings across it. You hold a guitar in front of your body and play it by pulling on the strings with your fingers.

gulf *noun* (*plural* **gulfs**)
an area of the sea that stretches a long way into the land

gull *noun* (*plural* **gulls**)
a sea bird. A gull is also called a **seagull**.

gulp *verb* (**gulps, gulping, gulped**)
When you gulp food or drink, you swallow it very quickly.

gum *noun* (*plural* **gums**)
1 Your gums are the hard pink parts of your mouth that are around your teeth.
2 Gum is a sweet that you chew but do not swallow.

gun *noun* (*plural* **guns**)
a weapon that fires bullets from a metal tube

gunpowder *noun*
a black powder that explodes

gurdwara *noun* (*plural* **gurdwaras**)
a Sikh temple

gurgle *verb* (**gurgles, gurgling, gurgled**)
1 When water gurgles, it makes a bubbling sound.
2 When a baby gurgles, it makes a happy, laughing sound.

guru *noun* (*plural* **gurus**)
a Hindu religious leader

gush *verb* (**gushes, gushing, gushed**)
When water gushes, it moves very fast.

gust *noun* (*plural* **gusts**)
A gust of wind is a sudden rush of wind.

gutter *noun* (*plural* **gutters**)
1 a place at the side of a road where water collects and flows away when it rains
2 a pipe that goes along the edge of a roof and collects water from the roof when it rains

guzzle *verb* (**guzzles, guzzling, guzzled**)
If you guzzle food, you eat it quickly.

gym *noun* (*plural* **gyms**) (*pronounced* **jim**)
a large room with special equipment in for doing exercises. A gym is also called a **gymnasium**.

gymnastics *plural noun*
special exercises that you do to make your body strong and to show how well you can bend, stretch, and twist your body

gypsy *noun* (*plural* **gypsies**)
Gypsies are people who travel from place to place in caravans.

Hh

habit *noun* (*plural* **habits**)
If something that you do is a habit, you do it without thinking, because you have done it so often before.

habitat *noun* (*plural* **habitats**)
The habitat of an animal or plant is the place where it usually lives or grows. ▶ *These flowers grow in a woodland habitat.*

hack verb (hacks, hacking, hacked)
1 To hack something means to cut it roughly. ▶ *They hacked their way through the jungle.*
2 To hack into a computer means to get into it and use it illegally.

had verb SEE **have**

haddock noun (the plural is the same)
a sea fish that you can eat

haiku noun (plural **haikus** or **haiku**) (pronounced **hye**-koo)
a short poem with three lines. A haiku has a fixed number of syllables.

hail noun
small pieces of ice that fall from the sky like rain.

hair noun (plural **hairs**)
Your hair is the long, soft stuff that grows on your head. An animal's hair is the soft stuff that grows all over its body.
❶ A **hairdresser** is someone who cuts people's hair. A **hairstyle** is a style in which your hair is cut or arranged.

hairy adjective (hairier, hairiest)
Something that is hairy is covered with hair. A person who is hairy has a lot of hair on their body.

half noun (plural **halves**)
One half of something is one of two equal parts that the thing is divided into. It can also be written as $\frac{1}{2}$.
▶ *The front half of the room was empty.*

halfway adverb
in the middle ▶ *I'll meet you halfway between my house and your house.*

hall noun (plural **halls**)
1 the part of a house that is just inside the front door
2 a very big room ▶ *The concert will take place in the school hall.*
3 a large, important building

hallo, **hello** interjection
the word you say to someone when you meet them

Hallowe'en noun
the 31st October, when some people think that witches and ghosts appear

halt verb (halts, halting, halted)
When something halts, it stops.

halter noun (plural **halters**)
a rope or strap that you put around an animal's head or neck so that you can lead it along

halve verb (halves, halving, halved)
To halve something means to cut it into two equal parts.

ham noun
meat from a pig's leg that has been salted or smoked

hamburger noun (plural **hamburgers**)
a round flat piece of minced beef. You usually eat a hamburger in a bread roll.

hammer noun (plural **hammers**)
a heavy tool that you use for hitting nails

hammock noun (plural **hammocks**)
a large piece of cloth that you hang between two posts and use as a bed

hamster noun (plural **hamsters**)
a small brown animal that has smooth fur and a very short tail. Some people keep hamsters as pets. Hamsters can store food in special pouches in their cheeks.

hand noun (plural **hands**)
Your hands are the parts of your body at the ends of your arms.
❶ A **handful** of something is an amount that you can hold in your hand.

handbag noun (plural **handbags**)
a small bag in which women carry money and other things

handcuffs noun
a pair of metal rings that the police lock over someone's wrists to stop them from escaping

handicap

handicap noun (plural **handicaps**)
Someone who has a handicap finds it hard to do some things because a part of their body does not work properly.
ⓘ Someone who has a handicap is **handicapped**.

handkerchief noun (plural **handkerchiefs**)
a piece of material you use for blowing your nose

handle noun (plural **handles**)
the part of something that you hold in your hand

handle verb (**handles, handling, handled**)
When you handle something, you pick it up and hold it in your hands. ▶ *You must handle kittens very gently.*

handlebars noun
The handlebars on a bicycle are the parts that you hold with your hands while you are riding it.

handsome adjective
A handsome man or boy is attractive to look at.

hands-on adjective
If something is hands-on, you can touch it and use it yourself, rather than just looking at it.

handstand noun (plural **handstands**)
When you do a handstand, you put your hands on the ground and swing your legs up into the air.

handwriting noun
Your handwriting is the way in which you write. ▶ *Try to make your handwriting as neat as possible.*

handy adjective (**handier, handiest**)
Something that is handy is useful and easy to use.

hang verb (**hangs, hanging, hung**)
When you hang something up, you put it on a hook or nail. ▶ *You can hang your coat up in the hall.*

hangar noun (plural **hangars**)
a big shed for keeping an aeroplane in

hanger noun (plural **hangers**)
a piece of wood or metal that you hang clothes on

hang-glider noun (plural **hang-gliders**)
a frame that looks like a very small aeroplane. A person hangs down below the frame and can glide through the air.

Hanukkah noun (pronounced hah-noo-ka)
the Jewish festival of lights, which lasts for eight days and begins in December

happen verb (**happens, happening, happened**)
1 When something happens, it takes place. ▶ *The accident happened just after four o'clock.*
2 If you happen to do something, you do it by chance, without planning to do it.

happy adjective (**happier, happiest**)
When you are happy, you feel pleased and you are enjoying yourself.
ⓘ **Happiness** is the feeling you have when you are happy.

harbour noun (plural **harbours**)
a place where people can tie up boats and leave them

hard adjective (**harder, hardest**)
1 Something that is hard is not soft. ▶ *In winter the ground is often hard and frozen.*
2 Something that is hard is difficult. ▶ *The teacher gave us some very hard sums to do.*

hard adverb
When you work hard, you work a lot and with a lot of effort.

hard disk noun (plural **hard disks**)
the part inside a computer where information is stored

hardly adverb
If you can hardly do something, you can only just do it. ► *I was so tired that I could hardly walk.*

hardware noun
1 tools, nails, and other things made of metal
2 A computer's hardware is the parts that you can see, and the parts inside that make it work. The **software** is the programs you put into it.

hare noun (plural **hares**)
an animal that looks like a big rabbit with very long ears. Hares have strong back legs and can run very fast.

harm verb (**harms, harming, harmed**)
To harm something means to damage it or spoil it in some way. To harm someone means to hurt them.
❶ Something that is **harmful** can hurt you or can damage something. Something that is **harmless** cannot hurt you or cannot do any damage to anything.

harmony noun (plural **harmonies**)
a group of musical notes that sound nice together

harness noun (plural **harnesses**)
1 a set of straps that you wear round your body to keep you safe ► *You must wear a safety harness when you are rock climbing.*
2 a set of straps that you put over a horse's head and round its neck so that you can control it

harp noun (plural **harps**)
a musical instrument. It has a large frame with strings stretched across it, and you play it by pulling on the strings with your fingers.

harsh adjective (**harsher, harshest**)
1 Something that is harsh is not soft or gentle. ► *His violin made a harsh, unpleasant sound.*
2 Someone who is harsh is very strict and sometimes unkind. ► *Sometimes our teacher can be very harsh with us.*

harvest noun (plural **harvests**)
the time when farmers gather in the crops that they have grown

hat noun (plural **hats**)
something that you wear on your head

hatch verb (**hatches, hatching, hatched**)
When a baby bird or animal hatches, it comes out of an egg and is born.

hate verb (**hates, hating, hated**)
If you hate something, you do not like it at all. If you hate someone, you do not like them at all.
❶ **Hatred** is the feeling you have when you do not like someone at all.

haul verb (**hauls, hauling, hauled**)
To haul something means to pull it along. ► *They hauled the boat out of the river.*

haunted adjective
A haunted place has ghosts in it.

have verb (**has, having, had**)
1 If you have something, you own it. ► *I don't have a computer at home.*
2 If you have an illness, you are suffering from it. ► *Tom has chickenpox so he can't go to school.*
3 If you have to do something, you must do it. ► *We have to finish our work before we can go out to play.*

hawk noun (plural **hawks**)
a bird that hunts and eats small animals and birds

hay noun
dry grass that people use to feed animals

hay fever *noun*
If you have hay fever, some types of flowers, trees, or grass make you sneeze in the summer.

hazard *noun* (*plural* **hazards**)
something that is dangerous and could hurt you

hazelnut *noun* (*plural* **hazelnuts**)
a nut that you can eat

head *noun* (*plural* **heads**)
1 Your head is the part at the top of your body that contains your brain, eyes, and mouth.
2 The head is the person in charge of something.

headache *noun* (*plural* **headaches**)
If you have a headache, your head hurts.

heading *noun* (*plural* **headings**)
words you write as a title at the top of a piece of writing

headlice *noun*
very small insects that can live on your head and make your head itch

headlight *noun* (*plural* **headlights**)
The headlights on a car are the lights that you use at night so that you can see where you are going.

headline *noun* (*plural* **headlines**)
the words in large print at the top of a piece of writing in a newspaper

headquarters *noun*
the place where an organization is based, and where the people in charge of it work

headteacher *noun* (*plural* **headteachers**)
the person in charge of all the teachers and children in a school. A headteacher is also called a **headmaster** or **headmistress**.

heal *verb* (**heals, healing, healed**)
When a cut or broken bone heals, it gets better. ▶ *It usually takes about six weeks for a broken bone to heal.*

health *noun*
Your health is how well you are.

healthy *adjective* (**healthier, healthiest**)
1 When you are healthy, you are not ill.
2 Things that are healthy are good for you and keep you fit and well.

heap *noun* (*plural* **heaps**)
an untidy pile of things ▶ *He left all his dirty clothes in a heap on the floor!*

hear *verb* (**hears, hearing, heard**)
When you hear something, you notice it through your ears. ▶ *I heard you shout so I came.*

heart *noun* (*plural* **hearts**)
1 Your heart is the part of your body in your chest that pumps blood all round your body.
2 A heart is a curved shape that looks like the shape of a heart and is used to represent love.

heat *noun*
the hot feeling you get from a fire or from the sun

heat *verb* (**heats, heating, heated**)
When you heat something, you make it warm or hot.

heather *noun* (*plural* **heathers**)
a low bush with small purple, pink, or white flowers

heave *verb* (**heaves, heaving, heaved**)
When you heave something that is heavy, you lift it or pull it along. ▶ *We heaved the box of books onto the table.*

heaven *noun*
the place where some people believe that a god lives. Some people believe that good people go to heaven when they die.

heavy *adjective* (**heavier, heaviest**)
Something that is heavy weighs a lot and is hard to lift.

hedge *noun* (*plural* **hedges**)
a line of bushes that are growing very close together and make a sort of wall round a garden or field

hedgehog noun (plural **hedgehogs**)
a small animal that is covered with spines like sharp needles

heel noun (plural **heels**)
Your heel is the back part of your foot.

height noun (plural **heights**)
The height of something is how high it is. The height of a person is how tall they are. ▶ *We measured the height of the door.*

heir noun (plural **heirs**) (pronounced **air**)
the person who will get something when someone else dies ▶ *The princess was heir to the throne.*

held verb SEE **hold**

helicopter noun (plural **helicopters**)
a flying machine with a big propeller that spins round on its roof

hell noun
a place where some people believe bad people are punished after they die

hello, **hallo** interjection
the word you say to someone when you meet them

helmet noun (plural **helmets**)
a strong hat that you wear to protect your head

help verb (**helps**, **helping**, **helped**)
1 When you help someone, you do something for them that makes things easier for them.
2 When you help yourself to something, you take it. ▶ *Please help yourselves to cakes.*
ⓘ Someone who helps another person is a **helper**. If you do something **helpful**, you do something that helps another person.

helping noun (plural **helpings**)
A helping of food is an amount that you give to one person. ▶ *She gave me a huge helping of pudding.*

helpless adjective
If you are helpless, you cannot look after yourself.

hem noun (plural **hems**)
The hem on a piece of clothing is the part at the bottom that is turned under and sewn in place.

hemisphere noun (plural **hemispheres**) (pronounced **hem**-iss-fere)
one half of the earth ▶ *Britain is in the northern hemisphere.*

hen noun (plural **hens**)
a bird that is kept on farms for the eggs that it lays

herb noun (plural **herbs**)
a plant that people add to food when they are cooking to make it taste nice. Parsley and mint are herbs.

herbivore noun (plural **herbivores**)
an animal that eats grass or plants
ⓘ An animal that is a herbivore is **herbivorous**.

herd noun (plural **herds**)
A herd of animals is a group of animals that live and feed together.

here adverb
in this place ▶ *Please wait here until I get back.*

hero noun (plural **heroes**)
1 a boy or man who has done something very brave
2 The hero of a story is the man or boy who is the main character.

heroine noun (plural **heroines**)
1 a girl or woman who has done something very brave
2 The heroine of a story is the woman or girl who is the main character.

heron noun (plural **herons**)
a bird with very long legs that lives near water and eats fish

herring noun (plural **herrings** or **herring**)
a sea fish that you can eat

hesitate

hesitate *verb* (hesitates, hesitating, hesitated)
If you hesitate, you wait for a little while before you do something because you are not sure what you should do.

hexagon *noun* (*plural* hexagons)
a shape with six straight sides

hibernate *verb* (hibernates, hibernating, hibernated)
When animals hibernate, they spend the winter in a special kind of deep sleep. Bats, tortoises, and hedgehogs all hibernate.

hiccup *verb* (hiccups, hiccuping, hiccuped)
When you hiccup, you make a sudden, sharp gulping sound which you cannot stop. You sometimes hiccup when you eat or drink too quickly.

hide *verb* (hides, hiding, hid, hidden)
1 When you hide, you go to a place where people cannot see you.
2 If you hide something, you put it in a secret place so that people cannot find it. ▶ *The pirates hid the treasure.*

hideous *adjective*
Something that is hideous is very ugly and horrible to look at.

hieroglyphics *noun* (*pronounced* hye-ro-**glif**-iks)
the writing that was used by the ancient Egyptians. It was made up of small pictures and symbols.

high *adjective* (higher, highest)
1 Something that is high is very tall. ▶ *There was a high wall around the garden.*
2 Something that is high up is a long way above the ground. ▶ *We could see an aeroplane high up in the sky.*
3 A high voice or sound is not deep or low.

highly *adverb*
very ▶ *Electricity is highly dangerous.*

highwayman *noun* (*plural* highwaymen)
a man on a horse, who stopped people on the roads in past times and robbed them

hijack *verb* (hijacks, hijacking, hijacked)
To hijack a car, lorry, or aeroplane means to take control of it and make it go somewhere else.

hilarious *adjective*
Something that is hilarious is very funny.

hill *noun* (*plural* hills)
a bit of ground that is higher than the ground around it

hind *adjective*
An animal's hind legs are its back legs.

Hindu *noun* (*plural* Hindus)
someone who follows the religion of **Hinduism**, which is an Indian religion with many gods

hinge *noun* (*plural* hinges)
a piece of metal that is fixed to a door and to the wall. A hinge can move so that you can open and shut the door.

hint *verb* (hints, hinting, hinted)
When you hint, you suggest something without saying exactly what you mean. ▶ *Salim hinted that he would like a piece of cake.*

hip *noun* (*plural* hips)
Your hips are the parts of your body where your legs join the rest of your body.

hippopotamus *noun* (*plural* hippopotamuses)
a very large, heavy, African animal that lives near water. It is sometimes called a **hippo** for short.

hire *verb* (hires, hiring, hired)
When you hire something, you pay to use it for a short time. ▶ *You can hire skates at the ice rink.*

hiss *verb* (hisses, hissing, hissed)
When a snake hisses, it makes a long sss sound.

history *noun*
the subject in which you learn about things that happened in the past

hit *verb* (hits, hitting, hit)
To hit something means to bang against it. To hit someone means to knock them or slap them.

hi-tech *adjective*
Hi-tech equipment is very modern and uses the latest computer technology.

hive *noun* (*plural* **hives**)
a special box that bees live in. It is designed so that people can collect the honey that the bees make.

hoard *noun* (*plural* **hoards**)
a secret store of money or other things

hoarse *adjective*
A hoarse voice sounds rough and deep.

hobble *verb* (hobbles, hobbling, hobbled)
When you hobble, you walk slowly because your feet or legs are hurting.

hobby *noun* (*plural* **hobbies**)
something that you do for fun in your spare time

hockey *noun*
a game in which two teams try to score goals by hitting a ball into a net with a special stick

hold *verb* (holds, holding, held)
1 When you hold something, you have it in your hands. ▶ *Please can I hold the puppy?*
2 The amount that something holds is the amount that you can put inside it. ▶ *This pencil case will hold sixteen pencils.*

hole *noun* (*plural* **holes**)
a gap or an empty space in something ▶ *Oh, no! There's a hole in my shoe!*

Holi *noun*
a Hindu festival that happens in the spring

holiday *noun* (*plural* **holidays**)
a time when you do not have to go to school or work

hollow *adjective*
Something that is hollow has an empty space inside it. ▶ *Owls often make their nests in hollow trees.*

holly *noun* (*plural* **hollies**)
a tree that has shiny, prickly leaves and red berries in the winter

holy *adjective* (holier, holiest)
Something that is holy is special because it has something to do with a god or religion.

home *noun* (*plural* **homes**)
Your home is the place where you live.

home page *noun* (*plural* **home pages**)
the main page on a Website, which you can look at by using the Internet

homework *noun*
school work that you do at home, in the evenings or at the weekend

homograph *noun* (*plural* **homographs**)
Homographs are words that have the same spelling but different meanings.

homonym *noun* (*plural* **homonyms**)
Homonyms are words that have the same spelling, or sound the same, but have different meanings.

homophone *noun* (*plural* **homophones**)
Homophones are words that sound the same but have different meanings and sometimes different spellings. For example, **night** and **knight** are homophones.

honest

honest *adjective*
Someone who is honest does not steal or cheat or tell lies.
❶ **Honesty** is behaviour in which you are honest.

honey *noun*
a sweet, sticky food that is made by bees

hood *noun* (*plural* **hoods**)
the part of a coat that you put over your head when it is cold or raining

hoof *noun* (*plural* **hoofs** or **hooves**)
An animal's hooves are the hard parts on its feet.

hook *noun* (*plural* **hooks**)
a curved piece of metal that you use for hanging things on or catching things with ▶ *Please hang your coats on the hooks in the cloakroom.*

hooligan *noun* (*plural* **hooligans**)
a young person who fights with other people and breaks things

hoop *noun* (*plural* **hoops**)
a big wooden or plastic ring that you use in games ▶ *If you manage to throw a hoop over a plastic duck, you win a prize.*

hooray *interjection*
a word you shout when you are very pleased about something

hoot *verb* (**hoots, hooting, hooted**)
To hoot means to make a sound like an owl or the horn of a car. ▶ *I nearly stepped out into the road, but a car hooted at me.*

hop *verb* (**hops, hopping, hopped**)
1 When you hop, you jump on one foot.
2 When animals hop, they jump with two feet together. ▶ *The blackbird hopped across the lawn.*

hope *verb* (**hopes, hoping, hoped**)
If you hope that something will happen, you want it to happen. ▶ *I hope I get a new bike for my birthday.*

hopeful *adjective*
If you are hopeful, you think that something you want to happen will happen.
❶ You say that **hopefully** something will happen when you want it to happen. ▶ *Hopefully I'll be allowed to go to the cinema with you.*

hopeless *adjective*
1 You say that something is hopeless when you think that it is never going to work. ▶ *I tried to open the door again, but it was hopeless.*
2 If you are hopeless at something, you are very bad at it. ▶ *He was hopeless at swimming.*

horizon *noun*
the line in the distance where the sky and the land or sea seem to meet ▶ *I can see a ship on the horizon.*

horizontal *adjective*
Something that is horizontal is flat and level.

horn *noun* (*plural* **horns**)
1 The horns on some animals are the hard, pointed parts that grow on their heads.
2 A horn is a musical instrument made of brass. You play it by blowing into it.
3 The horn on a car is the part that makes a loud noise to warn people when there is danger.

horrible *adjective*
Something that is horrible is very nasty or frightening. ▶ *The medicine tasted horrible.*

horrid *adjective*
Something that is horrid is very nasty. Someone who is horrid is very unkind. ▶ *Why are you being so horrid to me?*

horrify *verb* (**horrifies, horrifying, horrified**)
If something horrifies you, it shocks and upsets you a lot.

horror *noun*
a feeling of very great fear

horse *noun* (*plural* **horses**)
a big animal that people can ride on or use to pull carts

horse chestnut *noun* (*plural* **horse chestnuts**)
a tree that conkers grow on

horseshoe *noun* (*plural* **horseshoes**)
a curved piece of metal that is fitted onto the bottom of a horse's hoof

hosepipe *noun* (*plural* **hosepipes**)
a long plastic or rubber tube that water can go through

hospital *noun* (*plural* **hospitals**)
a place where people who are ill or hurt are looked after until they are better

hostage *noun* (*plural* **hostages**)
a person who is kept as a prisoner until people pay money so that they can be released

hot *adjective* (**hotter, hottest**)
1 Something that is hot is very warm. ▶ *It was a lovely hot summer's day.*
2 Hot food has a strong, spicy taste.

hot dog *noun* (*plural* **hot dogs**)
a sausage that you eat in a long bread roll

hotel *noun* (*plural* **hotels**)
a building where you can pay to stay the night and to have meals

hound *noun* (*plural* **hounds**)
a big dog that people use for hunting

hour *noun* (*plural* **hours**)
We measure time in hours. There are sixty minutes in one hour, and 24 hours in one day.

house *noun* (*plural* **houses**)
a building where people live

hover *verb* (**hovers, hovering, hovered**)
When something hovers in the air, it stays in one place in the air. ▶ *The helicopter hovered overhead.*

hovercraft *noun* (the plural is the same)
a type of boat that travels on a cushion of air just above the surface of the water

how *adverb*
1 a word that you use to ask questions ▶ *How old are you?*
2 a word you use to explain the way something works or happens ▶ *The teacher explained how a camera works.*

however *adverb*
1 no matter how much ▶ *You'll never catch him, however fast you run.*
2 in spite of this ▶ *We were losing 3-0 at half time. However, we still kept trying.*

howl *verb* (**howls, howling, howled**)
To howl means to give a long, loud cry.

huddle *verb* (**huddles, huddling, huddled**)
When people huddle together, they stay very close to each other because they are cold or frightened.

huff *noun* (*plural* **huffs**)
If you are in a huff, you are cross and sulking.

hug *verb* (**hugs, hugging, hugged**)
When you hug someone, you hold them in your arms to show you love them.

huge *adjective*
Something that is huge is very big. ▶ *There was a huge spider in the bath!*

hum *verb* (**hums, humming, hummed**)
When you hum, you sing a tune with your lips closed.

human *noun* (*plural* **humans**)
A human is a man, woman, or child. A human is also called a **human being**.

humble *adjective*
Someone who is humble does not boast or show off.

humiliate

humiliate *verb* (**humiliates, humiliating, humiliated**)
To humiliate someone means to make them seem very silly or stupid.

humour *noun*
1 If you have a sense of humour, you enjoy laughing at things.
2 If you are in a good humour, you are in a good mood.
❶ Something that is **humorous** is funny and makes you laugh.

hump *noun* (*plural* **humps**)
a round bump on a camel's back

hunch *noun* (*plural* **hunches**)
If you have a hunch about something, you have an idea that you think might be right.

hundred *noun* (*plural* **hundreds**)
the number 100

hung *verb* SEE **hang**

hungry *adjective* (**hungrier, hungriest**)
If you are hungry, you feel that you need food.
❶ **Hunger** is the feeling you have when you are hungry. If you eat something **hungrily**, you eat it quickly because you are hungry.

hunt *verb* (**hunts, hunting, hunted**)
1 To hunt means to chase and kill animals for food or as a sport. ▶ *Young lions have to learn to hunt.*
2 When you hunt for something, you look for it in a lot of different places.

hurl *verb* (**hurls, hurling, hurled**)
When you hurl something, you throw it as hard as you can or as far as you can.

hurrah, **hurray** *interjection*
a word you shout when you are very pleased about something

hurricane *noun* (*plural* **hurricanes**)
a storm with a very strong wind

hurry *verb* (**hurries, hurrying, hurried**)
When you hurry, you walk or run quickly, or try to do something quickly.

hurt *verb* (**hurts, hurting, hurt**)
1 To hurt someone means to make them feel pain. ▶ *You shouldn't ever hurt animals.*
2 If a part of your body hurts, it feels sore. ▶ *My leg hurts.*

hurtle *verb* (**hurtles, hurtling, hurtled**)
To hurtle means to move very quickly. ▶ *The rocket hurtled through space.*

husband *noun* (*plural* **husbands**)
A woman's husband is the man she is married to.

hush *interjection*
a word you say to someone to tell them to be quiet ▶ *Hush now, children.*

hut *noun* (*plural* **huts**)
a small building made of wood

hutch *noun* (*plural* **hutches**)
a small box or cage that you keep a pet rabbit in

hymn *noun* (*plural* **hymns**) (sounds like **him**)
a Christian song that praises God

hypermarket *noun* (*plural* **hypermarkets**)
a very big supermarket

hyphen *noun* (*plural* **hyphens**) (*pronounced* **hye**-fen)
a mark like this - that you use in writing to join parts of words together. The word 'grown-up' has a hyphen.

hypnotize *verb* (**hypnotizes, hypnotizing, hypnotized**)
To hypnotize someone means to send them into a deep sleep, so that you can control what they do.

Ii

ice *noun*
water that has frozen hard

iceberg *noun* (*plural* **icebergs**)
a very big piece of ice floating in the sea

ice cream *noun* (*plural* **ice creams**)
a very cold, frozen food that is made from milk or cream and flavoured with sugar and fruit or chocolate

ice hockey *noun*
a game in which two teams skate on ice and try to score goals by hitting a flat disc into a net using special sticks

icicle *noun* (*plural* **icicles**)
a thin, pointed piece of ice hanging down from a high place

icing *noun*
a sweet mixture that you spread over cakes to decorate them ▶ *We put chocolate icing on the cake.*

icy *adjective* (**icier**, **iciest**)
1 Something that is icy is very cold.
2 When the road is icy, it is slippery because it is covered with ice.

idea *noun* (*plural* **ideas**)
1 When you have an idea, you think of something that you could do.
▶ *I've got an idea. Let's go to the beach.*
2 If you have an idea about something, you have a picture of it in your mind. ▶ *The film gave us an idea about what life was like in ancient Rome.*

ideal *adjective*
Something that is ideal is perfect.
▶ *It was ideal weather for a picnic.*

identical *adjective*
Things that are identical are exactly the same.

identify *verb* (**identifies, identifying, identified**)
To identify someone means to recognize them and say who they are.

idiot *noun* (*plural* **idiots**)
a very stupid person

idle *adjective* (**idler, idlest**)
Someone who is idle is lazy.

idol *noun* (*plural* **idols**)
a famous person that a lot of people love ▶ *Would you like to be a pop idol?*

igloo *noun* (*plural* **igloos**)
a small, round house that is made of blocks of hard snow

ignorant *adjective*
If you are ignorant about something, you do not know anything about it.

ignore *verb* (**ignores, ignoring, ignored**)
If you ignore someone, you refuse to speak to them or take any notice of them. ▶ *I said hello to her, but she ignored me.*

ill *adjective*
If you are ill, you are not very well.
▶ *I feel too ill to go to school.*

illegal *adjective*
Something that is illegal is against the law, and you are not allowed to do it.

illness *noun* (*plural* **illnesses**)
something that makes people ill. Measles, chickenpox, and colds are illnesses.

illustrate *verb* (**illustrates, illustrating, illustrated**)
To illustrate a book or story means to add pictures to it.
❶ An **illustrated** book has pictures in it. An **illustration** is a picture that is added to a book or story.

image *noun* (*plural* **images**)
a picture

imaginary

imaginary *adjective*
Something that is imaginary does not really exist, but is only in your mind or in a story. ▶ *Dragons are imaginary animals.*

imagine *verb* (**imagines, imagining, imagined**)
When you imagine something, you make a picture of it in your mind. ▶ *I closed my eyes and tried to imagine I was on the beach.*
❶ When you use your **imagination**, you imagine things.

Imam *noun* (*plural* **Imams**)
a Muslim religious leader

imitate *verb* (**imitates, imitating, imitated**)
To imitate someone means to copy the way they speak or behave. ▶ *He imitated the teacher's voice.*

imitation *noun* (*plural* **imitations**)
something that has been made to look like something valuable ▶ *It's not a real diamond, it's only a glass imitation.*

immaculate *adjective*
Something that is immaculate is perfectly clean and has nothing wrong with it.

immediate *adjective*
Something that is immediate happens straight away.
❶ If you do something **immediately**, you do it straight away. ▶ *Come here immediately!*

immense *adjective*
Something that is immense is very big. ▶ *They were on the edge of an immense forest.*

immigrate *verb* (**immigrates, immigrating, immigrated**)
When people immigrate, they come and live in a country.
❶ **Immigration** is when people come to live in a country. An **immigrant** is someone who has come to live in a country.

immortal *adjective*
Someone who is immortal will live for ever and never die.

immunize *verb* (**immunizes, immunizing, immunized**)
To immunize someone means to give them an injection so that they are protected against an illness.

impatient *adjective*
Someone who is impatient gets bored and angry if they have to wait for something. ▶ *Don't be so impatient! It's your turn next.*

impersonate *verb* (**impersonates, impersonating, impersonated**)
To impersonate someone means to pretend to be them.

impertinent *adjective*
If you are impertinent, you are rude or cheeky. ▶ *Don't be so impertinent!*

impolite *adjective*
If you are impolite, you are rude and not polite. ▶ *It is impolite to talk with your mouth full.*

important *adjective*
1 If something is important, you must think about it carefully and seriously. ▶ *This is a very important test.*
2 An important person is special and well known.
❶ The **importance** of something is how important it is.

impossible *adjective*
If something is impossible, no one can do it. ▶ *It's impossible to undo this knot.*

impress *verb* (**impresses, impressing, impressed**)
If something impresses you, you think it is very good.

impression *noun* (*plural* **impressions**)
If you have an impression about something, you have a vague idea or feeling about it. ▶ *I get the impression he doesn't like us.*

imprison verb (imprisons, imprisoning, imprisoned)
To imprison someone means to put them in prison.

improve verb (improves, improving, improved)
1 To improve something means to make it better. ▶ *He improved his handwriting.*
2 When something improves, it gets better. ▶ *Your maths is improving.*
❶ An **improvement** is a change that makes something better. ▶ *There has been a great improvement in your reading this year.*

improvise verb (improvises, improvising, improvised)
When you improvise, you play music and make up the tune as you are playing.

in preposition
1 inside ▶ *My pencil case is in my bag.*
2 wearing ▶ *All the children were in school uniform.*

inch noun (plural **inches**)
We can measure length in inches. One inch is about $2\frac{1}{2}$ centimetres.

include verb (includes, including, included)
If you include something you put it with other things and make it part of the set or group. If you include someone, you let them join a group.

income noun (plural **incomes**)
Someone's income is the amount of money that they earn.

inconvenient adjective
If something is inconvenient, it causes problems for you.
▶ *Sometimes my friends call round at an inconvenient time.*

incorrect adjective
Something that is incorrect is wrong and not correct. ▶ *She gave an incorrect answer.*

increase verb (increases, increasing, increased)
When an amount increases, it gets bigger. ▶ *The number of children in my class has increased from 30 to 32.*

incredible adjective
Something that is incredible seems too strange or amazing to believe.

indeed adverb
really ▶ *He's very rich indeed.*

independent adjective
Someone who is independent can do things for themselves and does not need help from other people.

index noun (plural **indexes**)
a list at the back of a book, which tells you what things are in the book and where to find them

indignant adjective
If you are indignant, you feel angry because someone has said or done something unfair.

individual adjective
Something that is individual is for just one person. ▶ *He had individual lessons to help him to read.*

individual noun (plural **individuals**)
one person

indoors adverb
inside a building

industry noun (plural **industries**)
An industry is all the factories and companies that make one particular thing. ▶ *Japan has a big car industry.*
❶ An **industrial** place has a lot of factories.

infant noun (plural **infants**)
a very young child

infection noun (plural **infections**)
If you have an infection, you have a germ in your body which is making you ill. ▶ *She has an ear infection.*

infectious adjective
An infectious illness can be spread from one person to other people.

infinity

infinity noun
Infinity is a time, place, or amount that has no end or limit.

inflate verb (inflates, inflating, inflated)
To inflate something means to put air into it. ▶ *The tyres on your bicycle are flat, so you must inflate them.*

influence verb (influences, influencing, influenced)
If you influence someone, you change the way that they think or behave.

inform verb (informs, informing, informed)
When you inform someone about something, you tell them about it. ▶ *You should inform your teacher if you feel ill.*

informal adjective
1 Informal events or clothes are relaxed and not too smart.
2 Informal language is language that you use when you are talking to friends, not language you would write down.

information noun
facts about something ▶ *We are collecting information about rain forests.*

infuriate verb (infuriates, infuriating, infuriated)
If something infuriates you, it makes you very angry. ▶ *Sometimes my little sister infuriates me!*

ingenious adjective
An ingenious idea is new and very clever.

ingredient noun (plural ingredients)
Ingredients are the things that you mix together when you are cooking something. ▶ *Sugar, flour, eggs, and butter are the main ingredients of the cake.*

inhabit verb (inhabits, inhabiting, inhabited)
To inhabit a place means to live in it.
❶ The **inhabitants** of a place are the people who live in it.

inhaler noun (plural inhalers)
a small tube with medicine in for people who have asthma. When you need it, you squirt some of the medicine into your mouth and breathe it in.

inherit verb (inherits, inheriting, inherited)
If you inherit something, you get it from someone when they die.

initial noun (plural initials)
Your initials are the first letters of each of your names.

injection noun (plural injections)
When you have an injection, a doctor puts a needle into your arm to put medicine into your body.

injure verb (injures, injuring, injured)
To injure someone means to hurt them.
❶ If you are hurt, you are **injured**, or you have an **injury**.

ink noun (plural inks)
the coloured liquid inside a pen, which comes out onto the paper when you write

inn noun (plural inns)
a small hotel

innocent adjective
If you are innocent, you have not done anything wrong.

input noun
The input is the information that you put into a computer. The information that you get out is the **output**.

inquiry noun (plural inquiries)
If you make inquiries about something, you ask questions about it so that you can find out about it.

inquisitive *adjective*
Someone who is inquisitive asks a lot of questions and wants to know about things.

insane *adjective*
Someone who is insane is mad.

inscription *noun* (*plural* **inscriptions**)
words that are written or carved somewhere for people to see, like the words carved on a monument

insect *noun* (*plural* **insects**)
a small creature with six legs. Flies, ants, butterflies, and bees are all different types of insect.

insert *verb* (**inserts, inserting, inserted**)
When you insert something, you put it into a hole or a slot. ▶ *He inserted a disk into the computer.*

inside *noun* (*plural* **insides**)
The inside of something is the part in the middle of it.

inside *adverb, preposition*
in something ▶ *She opened the box and put the book inside.* ▶ *Come inside, it's raining.*

insist *verb* (**insists, insisting, insisted**)
If you insist on something, you say very firmly that you want to do it. ▶ *He insisted on coming with us.*

insolent *adjective*
If you are insolent, you are very rude or cheeky.

inspect *verb* (**inspects, inspecting, inspected**)
When you inspect something, you look at it very carefully to check that it is all right.
ⓘ When you do an **inspection**, you inspect something.

inspector *noun* (*plural* **inspectors**)
1 someone whose job is to check that things are done properly
2 an important policeman

instalment *noun* (*plural* **instalments**)
one part of a story that is told in parts ▶ *I can't wait for next week's instalment!*

instant *adjective*
1 Something that is instant happens immediately.
2 Instant food is food that you can make very quickly.
ⓘ Something that happens **instantly** happens immediately.

instead *adverb*
in place of something else ▶ *They gave us water instead of lemonade.*

instinct *noun* (*plural* **instincts**)
something that an animal or person does naturally, without thinking about it ▶ *Spiders spin webs by instinct.*

instruct *verb* (**instructs, instructing, instructed**)
1 To instruct someone means to tell them them how to do something.
2 If you instruct someone to do something, you order them to do it.
ⓘ When you give someone **instructions**, you tell them how to do something.

instrument *noun* (*plural* **instruments**)
1 something that you use for playing music ▶ *Violins and flutes are musical instruments.*
2 a tool or machine that you use for doing a job ▶ *A microscope is an instrument for looking at very tiny things.*

insult *verb* (**insults, insulting, insulted**)
To insult someone means to upset them by saying rude or nasty things to them. ▶ *She insulted me by saying I was stupid.*

intelligent

intelligent *adjective*
Someone who is intelligent is clever and can learn things quickly.
❶ Someone who is intelligent has a lot of **intelligence**.

intend *verb* (intends, intending, intended)
If you intend to do something, you plan to do it.

intentional *adjective*
If something was intentional, you did it on purpose.

interactive *adjective*
An interactive computer program is one in which you can change and control things.

interest *verb* (interests, interesting, interested)
If something interests you, you think it is exciting and you want to see it or learn about it. ▶ *Ancient buildings interest me a lot.*
❶ If something interests you, you can say that you are **interested** in it, or that you find it **interesting**.

interfere *verb* (interferes, interfering, interfered)
If you interfere, you get involved with something that has nothing to do with you.

interjection *noun* (*plural* interjections)
a word that you say or shout on its own, not as part of a sentence. *Hello* and *hooray* are interjections.

international *adjective*
Something that is international involves people from different countries. ▶ *We're going to watch an international football match.*

Internet *noun*
a system that allows computers all over the world to get information and send messages to each other

interrupt *verb* (interrupts, interrupting, interrupted)
If you interrupt someone, you disturb them while they are talking or working, and make them stop.

interval *noun* (*plural* intervals)
a short break in the middle of a play or concert

interview *verb* (interviews, interviewing, interviewed)
To interview someone means to ask someone questions to find out what they are like, or what they think, or what they know.

into *preposition*
in ▶ *He threw a stone into the water.*

introduce *verb* (introduces, introducing, introduced)
When you introduce people, you bring them together and let them meet each other. ▶ *Suraya introduced me to her friend.*

introduction *noun* (*plural* introductions)
a short part at the beginning of a book or piece of music

invade *verb* (invades, invading, invaded)
When people invade a country, they attack it. ▶ *The Romans invaded Britain.*
❶ An **invasion** is when people invade a country.

invalid *noun* (*plural* invalids)
someone who is ill and weak

invent *verb* (invents, inventing, invented)
If you invent something new, you are the first person to make it or think of it. ▶ *Do you know the name of the man who invented the computer?*
❶ An **invention** is something new that someone has invented.

inverted commas *noun*
the marks like this ' ' or this " " that you use in writing to show what someone has said

investigate verb (investigates, investigating, investigated)
If you investigate something, you try to find out about it.

invisible adjective
If something is invisible, no one can see it.

invite verb (invites, inviting, invited)
When you invite someone, you ask them to come to your house or to go somewhere with you. ▶ *Who have you invited to your party?*
❶ When you invite someone, you give them an **invitation**.

involved adjective
If you are involved in something, you take part in it or help to do it.

iron noun (plural **irons**)
1 a type of strong, heavy metal
2 an object that you use for making clothes smooth and flat. It has a flat piece of metal with a handle, and you heat it before you use it.

irritate verb (irritates, irritating, irritated)
To irritate someone means to make them feel annoyed. ▶ *My little brother keeps irritating me!*

Islam noun
the religion that Muslims follow
❶ Things that are **Islamic** are to do with Islam.

island noun (plural **islands**)
a piece of land with water all round it

italics noun
sloping letters printed *like this*

itch verb (itches, itching, itched)
When your skin itches, it is uncomfortable and feels as if you need to scratch it.

item noun (plural **items**)
one thing in a list or group of things ▶ *The first item on the list is cheese.*

it's
1 it is ▶ *It's raining.*
2 it has ▶ *Look at that dog. It's only got three legs.*

ivory noun
a hard, white substance that people use for making jewellery and ornaments. Ivory comes from the tusks of elephants.

ivy noun (plural **ivies**)
a climbing plant that often grows on old walls and buildings

Jj

jab verb (jabs, jabbing, jabbed)
When you jab something, you poke it roughly with your finger or with something sharp.

jab noun (plural **jabs**)
When you have a jab, a doctor puts a needle into your arm to put medicine into your body.

jacket noun (plural **jackets**)
a short coat

jackpot noun (plural **jackpots**)
If you win the jackpot, you win a very large amount of money in a game or competition.

jagged adjective
Something that is jagged has a sharp, uneven edge. ▶ *We climbed over the jagged rocks.*

jail noun (plural **jails**)
a prison

jam noun (plural **jams**)
1 a thick, sweet, sticky food that is made by cooking fruit and sugar together ▶ *We had bread with raspberry jam.*
2 If there is a traffic jam, there are too many cars on the road and they cannot move forward. ▶ *The bus got stuck in a traffic jam.*

jam

jam *verb* (jams, jamming, jammed)
When something jams, it gets stuck and you cannot move it. ▶ *Our back door keeps getting jammed.*

January *noun*
the first month of the year

jar *noun* (*plural* jars)
a glass container that food is kept in

jaw *noun* (*plural* jaws)
Your jaws are the bones that hold your teeth in place. You move your lower jaw to open your mouth.

jazz *noun*
a type of lively music

jealous *adjective*
If you are jealous of someone, you are unhappy because they have something that you would like, or they can do something better than you can. ▶ *I was very jealous of my brother's new bicycle.*

jeans *noun*
trousers that are made of strong cotton cloth

jeer *verb* (jeers, jeering, jeered)
If you jeer at someone, you laugh at them in a rude, unkind way.

jelly *noun* (*plural* jellies)
a sweet food made from fruit and sugar that shakes when you move it

jellyfish *noun* (the plural is the same)
a sea animal that has a soft, clear body. Some types of jellyfish can sting you.

jerk *verb* (jerks, jerking, jerked)
When something jerks, it moves suddenly and roughly. ▶ *The bus jerked forward.*

jersey *noun* (*plural* jerseys)
a warm piece of clothing with long sleeves

jet *noun* (*plural* jets)
1 A jet of water is a thin stream that comes out of a small hole very quickly.
2 a fast aeroplane

Jew *noun* (*plural* Jews)
someone who follows the religion of Judaism
ⓘ Someone who is a Jew is **Jewish**.

jewel *noun* (*plural* jewels)
a beautiful and valuable stone ▶ *Diamonds and rubies are jewels.*

jewellery *noun*
necklaces, bracelets, and rings

jigsaw puzzle *noun* (*plural* jigsaw puzzles)
a set of small pieces of cardboard or wood that fit together to make a picture

jingle *verb* (jingles, jingling, jingled)
When something jingles, it makes a light, ringing sound. ▶ *The keys jingled as he walked along.*

job *noun* (*plural* jobs)
1 the work that someone does to earn money ▶ *My sister has a job in the supermarket at weekends.*
2 something useful that you have to do ▶ *It's my job to wash up.*

jockey *noun* (*plural* jockeys)
someone who rides horses in races

jodhpurs *noun*
tight trousers that you wear when you are riding a horse

jog *verb* (jogs, jogging, jogged)
1 When you jog, you run slowly.
2 If you jog something, you knock it or bump it. ▶ *He jogged my elbow and I spilled my drink.*

join *verb* (joins, joining, joined)
1 When you join things together, you fasten or tie them together.
2 When you join a club or group, you become a member of it. ▶ *I've joined a swimming club.*

joint *noun* (*plural* joints)
1 Your joints are the parts of your arms and legs that you can bend and turn. Your ankles, elbows, and hip are all joints.
2 a large piece of meat

joke noun (plural **jokes**)
something you say or do to make people laugh ▶ *The teacher sometimes tells us jokes.*

joke verb (**jokes, joking, joked**)
When you joke, you say things to make people laugh.

jolly adjective (**jollier, jolliest**)
If you are jolly, you are happy and cheerful.

jolt verb (**jolts, jolting, jolted**)
1 When something jolts, it moves with sudden and rough movements. ▶ *The old bus jolted along.*
2 If you jolt something, you knock it or bump it.

journalist noun (plural **journalists**)
someone who writes about the news in a newspaper

journey noun (plural **journeys**)
When you go on a journey, you travel somewhere. ▶ *We went on a long train journey from London to Edinburgh.*

joy noun
a feeling of great happiness

joystick noun (plural **joysticks**)
a lever that you move forwards, backwards, or sideways to control a computer game or a machine

Judaism noun
the religion that Jews follow

judge noun (plural **judges**)
1 a person who decides how people should be punished when they have broken the law
2 the person who chooses the winner in a competition

judge verb (**judges, judging, judged**)
When you judge something, you say how good or bad it is.

judo noun
a sport in which people fight with their hands and try to throw each other to the floor

jug noun (plural **jugs**)
a container with a handle that you use for pouring out water and other liquids

juggle verb (**juggles, juggling, juggled**)
When you juggle, you keep throwing several balls or other things into the air and catching them again quickly.

juice noun (plural **juices**)
the liquid that is in fruit and vegetables ▶ *Would you like some orange juice?*
❶ Fruit that is **juicy** has a lot of juice in it.

July noun
the seventh month of the year

jumble noun
A jumble of things is a lot of different things all mixed up together.

jumble sale noun (plural **jumble sales**)
a sale of old clothes and other things that people have given away

jump verb (**jumps, jumping, jumped**)
When you jump, you push yourself up into the air.

jumper noun (plural **jumpers**)
a warm piece of clothing with long sleeves which you wear on the top half of your body

junction noun (plural **junctions**)
a place where two roads or railway lines meet

June noun
the sixth month of the year

jungle noun (plural **jungles**)
a thick forest in a hot country

junior adjective
Junior means for young children. ▶ *He plays for a junior football team.*

junk

junk *noun*
useless things that people do not want any more ▶ *The garage was full of old junk.*

jury *noun* (*plural* **juries**)
the group of people in a court who decide whether a person is guilty or innocent of a crime

just *adjective*
Something that is just is right and fair.

just *adverb*
1 exactly ▶ *This game is just what I wanted.*
2 hardly ▶ *I only just caught the bus.*
3 recently ▶ *She has just left.*
4 only ▶ *I'll just brush my hair and then we can go.*

Kk

kangaroo *noun* (*plural* **kangaroos**)
an Australian animal that jumps along on its strong back legs. Female kangaroos have pouches in which they carry their babies.

karaoke *noun* (*pronounced* ka-ree-**oh**-kee)
When you do karaoke, you hold a microphone and sing along to a music tape.

karate *noun*
a sport in which people fight with their hands and feet

kebab *noun* (*plural* **kebabs**)
pieces of meat and vegetable that you cook on a long spike called a skewer

keen *adjective* (**keener**, **keenest**)
If you are keen on something, you like it. ▶ *I'm not very keen on sport.*

keep *verb* (**keeps, keeping, kept**)
1 If you keep something, you have it for yourself and do not get rid of it or give it to anyone else. ▶ *He kept the money he found.*
2 When you keep something in a certain way, you make it stay that way. ▶ *Try to keep your bedroom tidy.*
3 If you keep doing something, you go on doing it. ▶ *He keeps teasing me!*
4 If you keep animals, you look after them.

kennel *noun* (*plural* **kennels**)
a little hut for a dog to sleep in

kept *verb* SEE **keep**

kerb *noun* (*plural* **kerbs**)
the edge of a pavement, where you step down to go onto the road

ketchup *noun*
a type of thick, cold tomato sauce

kettle *noun* (*plural* **kettles**)
a container that you boil water in

key *noun* (*plural* **keys**)
1 a piece of metal that is shaped so that it fits into a lock
2 The keys on a piano or computer keyboard are the parts that you press to make it work.

keyboard *noun* (*plural* **keyboards**)
The keyboard on a piano or computer is the set of keys that you press to make it work.

kick *verb* (**kicks, kicking, kicked**)
When you kick something, you hit it with your foot.

kid *noun* (*plural* **kids**)
1 a child
2 a young goat

kidnap *verb* (**kidnaps, kidnapping, kidnapped**)
To kidnap someone means to take them away and say that you will only let them go if someone pays you money.

kidney noun (plural **kidneys**)
Your kidneys are the parts inside your body that remove waste substances from your blood.

kill verb (**kills, killing, killed**)
To kill a person or animal means to make them die.

kilogram noun (plural **kilograms**)
We can measure weight in kilograms. There are 1000 grams in one kilogram. A kilogram is also called a **kilo**.

kilometre noun (plural **kilometres**)
We can measure distance in kilometres. There are 1000 metres in one kilometre.

kilt noun (plural **kilts**)
a skirt with pleats at the back. In Scotland, men sometimes wear kilts as part of their traditional costume.

kind noun (plural **kinds**)
a type ▶ *A terrier is a kind of dog.*

kind adjective (**kinder, kindest**)
Someone who is kind is friendly and nice to people. ▶ *It was very kind of you to help us.*
❶ If you do something in a kind way, you do it **kindly**. **Kindness** is behaviour in which you are kind.

king noun (plural **kings**)
a man who rules a country

kingdom noun (plural **kingdoms**)
a land that is ruled by a king or queen

kiss verb (**kisses, kissing, kissed**)
When you kiss someone, you touch them with your lips because you like them or love them.

kit noun (plural **kits**)
1 the clothes and other things that you need to do a sport ▶ *I can't find my football kit.*
2 a set of parts that you fit together to make something ▶ *I got a model aeroplane kit for my birthday.*

kitchen noun (plural **kitchens**)
the room in a house in which people prepare and cook food

kite noun (plural **kites**)
a light frame covered in cloth or paper. You hold a kite at the end of a long string and make it fly in the air.

kitten noun (plural **kittens**)
a young cat

kiwi fruit noun (plural **kiwi fruits**)
a fruit with a brown, hairy skin and green flesh

knee noun (plural **knees**)
Your knee is the part in the middle of your leg, where your leg can bend.

kneel verb (**kneels, kneeling, kneeled**)
When you kneel, you go down onto your knees.

knew verb SEE **know**

knickers noun
pants that women and girls wear

knife noun (plural **knives**)
a tool with a long, sharp edge that you use for cutting things

knight noun (plural **knights**)
a man who wore armour and rode into battle on a horse, in the past

knit verb (**knits, knitting, knitted**)
When you knit, you make clothes out of wool by twisting the wool over a pair of long needles or using a machine.

knob noun (plural **knobs**)
1 a round handle on a door or drawer
2 a round button that you turn to make a machine work

knock verb (**knocks, knocking, knocked**)
When you knock something, you bang it or hit it.

knot

knot *noun* (*plural* **knots**)
the twisted part where pieces of string or cloth have been tied together ▶ *I can't undo the knot in my shoelaces.*

know *verb* (**knows, knowing, knew, known**)
1 If you know something, you have learnt it and have it in your mind.
2 If you know someone, you have met them before and you recognize them.

knowledge *noun* (*pronounced* **noll**-idge)
all the things that you know and understand ▶ *He has a lot of knowledge about animals.*

knuckle *noun* (*plural* **knuckles**)
Your knuckles are the parts where your fingers bend.

koala *noun* (*plural* **koalas**)
a furry Australian animal that lives in trees and looks like a small bear

Koran *noun*
the holy book of the religion of Islam

Ll

label *noun* (*plural* **labels**)
a piece of paper or cloth that is put on something to show what it is or tell you something about it

laboratory *noun* (*plural* **laboratories**)
a room in which people do scientific experiments

lace *noun* (*plural* **laces**)
1 Lace is a type of thin, pretty material with a pattern of holes in it.
2 Laces are pieces of string that you use to tie up your shoes.

ladder *noun* (*plural* **ladders**)
a tall frame that you can climb up. A ladder has two long poles with short bars between them, which you climb up like steps.

ladle *noun* (*plural* **ladles**)
a big, deep spoon that you use for serving soup

lady *noun* (*plural* **ladies**)
1 a polite name for a woman
2 a title that is given to some important women

ladybird *noun* (*plural* **ladybirds**)
a red or yellow insect with black spots on its back

laid *verb* SEE **lay**

lain *verb* SEE **lie** *verb*

lair *noun* (*plural* **lairs**)
a wild animal's home

lake *noun* (*plural* **lakes**)
a large area of fresh water with land all around it

lamb *noun* (*plural* **lambs**)
a young sheep

lame *adjective*
A lame animal cannot walk properly because it has hurt one of its legs.

lamp *noun* (*plural* **lamps**)
a light, especially one that you can hold or move around. The big lights in a street are called **street lamps**.
▶ *She switched on a lamp in the sitting room.*

land *noun* (*plural* **lands**)
1 Land is the the dry part of the earth where there is no water.
2 A land is a country. ▶ *He has travelled in many foreign lands.*

land *verb* (**lands, landing, landed**)
To land means to arrive on land again after being in the air. ▶ *What time will our plane land?*

landing noun (plural **landings**)
the part of a house that is at the top of the stairs

landlady noun (plural **landladies**)
1 a woman who owns a house or flat and allows other people to live in it if they pay her money
2 a woman who owns a pub

landlord noun (plural **landlords**)
1 a man who owns a house or flat and allows other people to live in it if they pay him money
2 a man who owns a pub

landscape noun
The landscape is everything you can see when you look out over an area of land.

lane noun (plural **lanes**)
1 a narrow road ▶ *We walked along a quiet country lane.*
2 a strip of road that one line of traffic can drive along ▶ *Some motorways have six lanes.*

language noun (plural **languages**)
Your language is the words that you use when you speak or write.

lanky adjective (**lankier, lankiest**)
Someone who is lanky is very tall and thin.

lantern noun (plural **lanterns**)
a candle inside a container

lap noun (plural **laps**)
1 Your lap is the flat part of your legs when you are sitting down. ▶ *Can I sit on your lap?*
2 A lap of a race course is once round it. ▶ *We had to do five laps of the race track.*

lap verb (**laps, lapping, lapped**)
1 When an animal laps, it drinks with its tongue.
2 When water laps, it moves gently backwards and forwards. ▶ *The waves lapped gently against the side of the boat.*

laptop noun (plural **laptops**)
a small computer that you can carry with you and hold on your knees when you are sitting down

larder noun (plural **larders**)
a small room where you can keep food

large adjective (**larger, largest**)
Something that is large is big. ▶ *She gave me a very large portion of chips.*

larva noun
an animal that looks like a small worm and will become an insect when it is an adult

lasagne noun
a type of food made with flat pieces of pasta that are arranged in layers with minced meat and sauce in between

laser noun (plural **lasers**)
a machine that makes a very narrow beam of strong light. Some lasers are used to cut metal, and some are used by doctors in medical operations.

lash verb (**lashes, lashing, lashed**)
1 To lash something means to hit it very hard. ▶ *The rain lashed against the window.*
2 To lash something means to tie it tightly to something else.

lasso noun (plural **lassoes**)
(pronounced lass-oo)
a long rope with a loop at the end. Cowboys use lassoes for catching cattle.

last adjective
The last thing is the one that comes after all the others. ▶ *Z is the last letter of the alphabet.*

last verb (**lasts, lasting, lasted**)
If something lasts for a certain time, it goes on for that amount of time. ▶ *The film lasted two hours.*

latch noun (plural **latches**)
a metal lock or clip that you use for closing a gate or door

late

late *adjective* (**later, latest**)
1 If you are late, you arrive after the time when people are expecting you. ▶ *I was late to school today.*
2 When it is late in the day, it is near the middle or end of the day, not the morning. ▶ *I got up very late today.*

lately *adverb*
not very long ago ▶ *Have you seen Ali lately?*

latest *adjective*
The latest thing is the most modern and most popular. ▶ *She always wears clothes that are the latest fashion.*

lather *noun*
soap bubbles

laugh *verb* (**laughs, laughing, laughed**)
When you laugh, you make sounds that show that you are happy or think something is funny.
❶ **Laughter** is the sound of people laughing.

launch *verb* (**launches, launching, launched**)
1 To launch a boat means to put it into water.
2 To launch a rocket or spaceship means to send it into space.

laundry *noun* (*plural* **laundries**)
dirty clothes that need to be washed

lava *noun*
very hot, liquid rock that comes out of a volcano

lavatory *noun* (*plural* **lavatories**)
a toilet

lavender *noun*
a bush with pale purple flowers that smell very sweet

law *noun* (*plural* **laws**)
The law is all the rules that everyone in a country must obey.

lawn *noun* (*plural* **lawns**)
a piece of ground in a garden that is covered with short grass

lawyer *noun* (*plural* **lawyers**)
a person who has studied the law and who helps people or talks for them in a court of law

lay *verb* (**lays, laying, laid**)
1 When you lay something somewhere, you put it there. ▶ *I laid my clean clothes out on my bed.*
2 When you lay a table, you put knives, forks, and other things on it so that it is ready for a meal.
3 When a bird lays an egg, it produces one.

layer *noun* (*plural* **layers**)
A layer of something is a covering of it on top of something else. ▶ *There was a thick layer of dust on the old book.*

lazy *adjective* (**lazier, laziest**)
Someone who is lazy does not want to work.

lead *verb* (**leads, leading, led**) (rhymes with *seed*)
1 If you lead people, you go in front of them and take them somewhere. ▶ *He led us to the secret cave.*
2 If you lead people, you are in charge of them and tell them what to do. ▶ *Who's going to lead this team?*
3 If you are leading in a game or competition, you are winning.
❶ A **leader** is a person who leads other people.

lead *noun* (*plural* **leads**) (rhymes with *seed*)
1 a long strap that you fasten to a dog's collar so that you can keep hold of it and control it
2 If you are in the lead, you are winning in a race or competition.

lead *noun* (rhymes with *bed*)
a type of heavy, grey metal

leaf *noun* (*plural* **leaves**)
The leaves on a plant are the green parts that grow at the ends of the stems and branches.

leaflet *noun* (*plural* **leaflets**)
a piece of paper that gives you information about something

league *noun* (*plural* **leagues**)
a group of teams that play matches against each other

leak *verb* (**leaks, leaking, leaked**)
If something is leaking, it has a hole or crack in it and liquid can get through. ▶ *The bottle is leaking.*

lean *verb* (**leans, leaning, leaned** or **leant**)
1 If you lean forwards or backwards, you bend your body that way.
2 When you lean against something, you rest against it.

lean *adjective* (**leaner, leanest**)
Lean meat does not have any fat on it.

leap *verb* (**leaps, leaping, leaped** or **leapt**)
To leap means to jump high. ▶ *They leapt into the swimming pool.*

leap year *noun* (*plural* **leap years**)
a year which has 366 days instead of 365. Every four years is a leap year.

learn *verb* (**learns, learning, learned** or **learnt**)
1 When you learn about something, you find out about it. ▶ *We're learning about the Vikings in history.*
2 When you learn to do something, you find out how to do it. ▶ *I learnt to swim last year.*

leash *noun* (*plural* **leashes**)
a dog's lead

least *adjective*
less than all the others ▶ *I chose the least expensive dress.*

leather *noun*
a strong material that is made from the skins of animals. Shoes and bags are often made of leather.

leave *verb* (**leaves, leaving, left**)
1 When you leave a place, you go away from it. ▶ *I leave home every morning at eight o'clock.*
2 When you leave something in a place, you let it stay there and do not take it away. ▶ *I've left my book at home.*

led *verb* SEE **lead** *verb*

ledge *noun* (*plural* **ledges**)
a narrow shelf that sticks out from a wall

leek *noun* (*plural* **leeks**)
a long, white vegetable that has green leaves at one end and tastes like an onion

left *verb* SEE **leave**

left *adjective, adverb*
The left side of something is the side that is opposite the right side. Most people write with their right hand, not their left hand. ▶ *She had a letter in her left hand.* ▶ *Turn left at the traffic lights.*

leg *noun* (*plural* **legs**)
1 Your legs are the parts of your body between your hips and your feet. You use your legs for walking and running.
2 The legs on a table or chair are the parts that it stands on.

legal *adjective*
Something that is legal is not against the law, so you are allowed to do it.

legend *noun* (*plural* **legends**)
an old story that has been handed down from the past ▶ *I like reading old myths and legends.*

leggings *noun*
very tight trousers that women and girls wear

leisure *noun*
Leisure time is time when you can do what you want because you do not have to work.

lemon

lemon *noun* (*plural* **lemons**)
a yellow fruit with a very sour taste

lemonade *noun*
a fizzy drink made from lemons, sugar, and water

lend *verb* (**lends, lending, lent**)
If you lend something to someone, you let them use it for a short time. ▶ *Can you lend me a pencil?*

length *noun*
The length of something is how long it is. ▶ *We measured the length of the playground.*

lens *noun* (*plural* **lenses**)
a curved piece of glass or plastic that makes things look bigger or smaller when you look through it. Glasses and telescopes all have lenses.

lent *verb* SEE **lend** *verb*

leopard *noun* (*plural* **leopards**)
a big wild cat that lives in Africa and Asia. It has yellow fur with black spots on it.

leotard *noun* (*plural* **leotards**)
a tight piece of clothing that people wear when they are dancing

less *adverb*
not as much ▶ *Please make less noise.*

lesson *noun* (*plural* **lessons**)
1 a time when someone is teaching you ▶ *Maths is our first lesson this morning.*
2 something that you have to learn ▶ *Road safety is an important lesson for everyone.*

let *verb* (**lets, letting, let**)
If you let someone do something, you allow them to do it. ▶ *Sam let me ride his bike.*

letter *noun* (*plural* **letters**)
1 Letters are the signs that we use for writing words, such as **a**, **b**, or **c**.
2 A letter is a message that you write down and send to someone.

lettuce *noun* (*plural* **lettuces**)
a vegetable with green leaves that you eat in salads

level *adjective*
1 Something that is level is flat and smooth. ▶ *You need level ground to play tennis on.*
2 If you are level with someone, you are walking or running next to them.
3 If people are level in a game or competition, they have the same number of points.

level *noun* (*plural* **levels**)
If something is at a different level, it is higher or lower.

lever *noun* (*plural* **levers**)
a bar that you pull down to make a machine work

liar *noun* (*plural* **liars**)
someone who tells lies

library *noun* (*plural* **libraries**)
a building or room where a lot of books are kept for people to use or borrow

licence *noun* (*plural* **licences**)
a printed piece of paper that says that you can do something or have something ▶ *You must have a driving licence before you can drive a car.*

lick *verb* (**licks, licking, licked**)
When you lick something, you move your tongue over it.

lid *noun* (*plural* **lids**)
a cover on the top of a box or jar

lie *verb* (**lies, lying, lied**)
When you lie, you say something that you know is not true.

lie *noun* (*plural* **lies**)
something you say that you know is not true ▶ *Don't tell lies.*

lie *verb* (**lies, lying, lay, lain**)
1 When you lie down, you rest with your body spread out on the ground or on a bed.
2 When something lies somewhere, it is there. ▶ *Snow lay on the ground.*

life *noun* (*plural* **lives**)
Your life is the time when you are alive. ▶ *My grandfather had a very exciting life.*

lifeboat *noun* (*plural* **lifeboats**)
a boat that goes out to sea in bad weather to rescue people

life cycle *noun* (*plural* **life cycles**)
The life cycle of an animal is the way in which it is born, grows, has babies, and dies.

lift *verb* (**lifts, lifting, lifted**)
When you lift something, you pick it up or move it upwards. ▶ *I lifted the lid of the box to see what was inside.*

lift *noun* (*plural* **lifts**)
1 a machine that takes people up and down inside a building
2 If someone gives you a lift, they take you somewhere in their car.

lift-off *noun*
the time when a rocket or spaceship leaves the ground and goes up into space

light *noun* (*plural* **lights**)
1 Light is brightness that comes from the sun, the stars, fires, and lamps. Light helps us to see things.
2 A light is a lamp, bulb, or torch that gives out light. ▶ *Please could you switch the light on?*

light *adjective* (**lighter, lightest**)
1 Something that is light is not heavy. ▶ *My suitcase is quite light.*
2 A place that is light is not dark, but has plenty of light in it.
3 A light colour is pale and not very bright. ▶ *She was wearing a light blue jacket.*

light *verb* (**lights, lighting, lit**)
1 To light something means to put light in it so that you can see. ▶ *At Christmas they lit the church with candles.*
2 To light a fire means to make it burn. ▶ *We tried to light the bonfire.*

lighthouse *noun* (*plural* **lighthouses**)
a tower with a bright light that warns ships about rocks or other dangers

lightning *noun*
a bright flash of light that you see in the sky when there is a thunderstorm

light year *noun* (*plural* **light years**)
We can measure very big distances in space in light years. A light year is the distance that light can travel in one year.

like *verb* (**likes, liking, liked**)
If you like something, you think it is nice. If you like someone, you think that they are nice.

like *preposition*
If one thing is like another, it is similar to it. ▶ *It tastes like roast lamb.*

likely *adjective* (**likelier, likeliest**)
If something is likely to happen, it will probably happen. ▶ *It is likely to rain.*

limb *noun* (*plural* **limbs**)
Your limbs are your arms and legs.

limerick *noun* (*plural* **limericks**)
a funny poem with five lines and a strong rhythm

limit *noun* (*plural* **limits**)
an amount or a point which people must not go past ▶ *You must not drive faster than the speed limit.*

limp *verb* (**limps, limping, limped**)
When you limp, you walk with uneven steps because you have hurt one of your legs or feet.

limp *adjective* (**limper, limpest**)
Something that is limp is soft and not stiff. ▶ *The cardboard went limp when it got wet.*

line

line noun (plural **lines**)
1 a long mark like this _____
2 a row of people or things ▶ *There was a long line of people waiting to get into the theatre.*
3 A railway line is the two metal rails a train moves along.
4 A line of writing is the words that are written next to each other on a page. ▶ *I don't know the next line of the poem.*
5 A fishing line is a piece of special thin string that you use for catching fish.

linger verb (**lingers, lingering, lingered**)
If you linger in a place, you stay there when you should really leave.
▶ *Don't linger in the playground after school.*

lining noun (plural **linings**)
a layer that you put inside something to make it thicker or to protect it

link noun (plural **links**)
The links in a chain are the rings that are all joined together to make the chain.

link verb (**links, linking, linked**)
To link two things means to join them together. ▶ *The Channel Tunnel links Britain to France.*

lion noun (plural **lions**)
a big, light brown wild cat that lives in Africa and India. A female lion is called a **lioness**.

lip noun (plural **lips**)
Your lips are the parts round the edges of your mouth.

lipstick noun
colour that people sometimes put on their lips to make them look nice

liquid noun (plural **liquids**)
any substance that is like water, and is not a solid or a gas

lisp verb (**lisps, lisping, lisped**)
If you lisp, you say the sound 's' as if it was 'th'.

list noun (plural **lists**)
a number of words or names that are written down one after the other
▶ *We made a list of all the things we needed to buy.*

listen verb (**listens, listening, listened**)
When you listen, you pay attention so that you can hear something.

lit verb SEE **light** verb

literacy noun
Literacy is being able to read and write.

literature noun
stories, plays, and poetry

litre noun (plural **litres**)
We can measure liquids in litres. There are 100 centilitres in one litre.

litter noun (plural **litters**)
1 Litter is rubbish that people have dropped or left lying about.
2 A litter is all the young animals that are born to the same mother at the same time.

little adjective
1 Something that is little is not very big. ▶ *He's only a little boy.*
2 If you have little of something, you do not have very much. ▶ *I've got very little money.*

live verb (**lives, living, lived**)
1 To live means to be alive.
▶ *Dinosaurs lived millions of years ago.*
2 If you live somewhere, that is where your home is.

live adjective (rhymes with *dive*)
1 A live animal is alive. ▶ *You can see live animals in the zoo.*
2 A live television programme is not recorded, but is broadcast as it is happening.

lively adjective (**livelier, liveliest**)
Someone who is lively has a lot of energy and enjoys having fun.

liver noun (plural **livers**)
Your liver is the part inside your body that keeps your blood clean and healthy.

living noun
When you earn a living, you earn enough money to live.

living room noun (plural **living rooms**)
the room in a house with comfortable chairs, where people sit and talk or watch television

lizard noun (plural **lizards**)
an animal with skin like a snake and four legs. Lizards are reptiles and live in warm countries.

load noun (plural **loads**)
A load of things is an amount that someone is carrying. ▶ *The lorry brought another load of sand.*

load verb (**loads, loading, loaded**)
1 When you load things into a car or lorry, you put them in. ▶ *Load the suitcases into the car boot.*
2 When you load a gun, you put bullets in it.
3 When you load a program onto a computer, you put it on so that you can use it.

loaf noun (plural **loaves**)
A loaf of bread is a large piece of bread that you cut into slices to eat.

loathe verb (**loathes, loathing, loathed**)
If you loathe something, you hate it.

lob verb (**lobs, lobbing, lobbed**)
When you lob something, you throw it high into the air.

lobster noun (plural **lobsters**)
a big sea creature with a shell. Lobsters have two large claws, eight legs, and a tail.

local adjective
Something that is local is near where you live. ▶ *We go to the local school.*

loch noun (plural **lochs**)
a lake in Scotland

lock noun (plural **locks**)
1 The lock on a door, gate, or window is the part that you can open and shut with a key.
2 A lock of hair is a small piece of hair.

lock verb (**locks, locking, locked**)
When you lock something, you shut it and fasten it with a key. ▶ *Don't forget to lock the door when you go out.*

lodger noun (plural **lodgers**)
a person who pays to live in another person's home

loft noun (plural **lofts**)
a room in the roof of a house, where you can store things

log noun (plural **logs**)
a part of a tree that has been chopped down. You can burn logs on a fire.

log verb (**logs, logging, logged**)
When you log in to a computer, you switch it on so that you can use it. When you log out, you shut it down and switch it off.

logical adjective
Something that is logical is sensible or makes sense.

logo noun (plural **logos**)
a small picture that represents a company

lolly noun (plural **lollies**)
a sweet on the end of a stick

lonely adjective (**lonelier, loneliest**)
1 If you feel lonely, you feel sad because you are on your own.
2 A lonely place is far away from people and houses.

loner noun (plural **loners**)
someone who likes spending a lot of time on their own

long

long *adjective* (**longer, longest**)
1 Something that is long measures a lot from one end to the other. ▶ *This piece of string isn't long enough.*
2 Something that is long takes a lot of time. ▶ *I like having a long school holiday in the summer.*

long *verb* (**longs, longing, longed**)
If you long for something, you want it a lot. ▶ *I was longing for a drink.*

loo *noun* (*plural* **loos**)
a toilet

look *verb* (**looks, looking, looked**)
1 When you look at something, you point your eyes at it so that you can see it. ▶ *You must never look directly at the sun.*
2 The way something looks is the way it seems. ▶ *That dog doesn't look very friendly.*
3 When you look for something, you try to find it.
4 When you look after someone, you take care of them.
5 When you look forward to something, you feel excited that it is going to happen.

looking-glass *noun* (*plural* **looking-glasses**)
a mirror

lookout *noun* (*plural* **lookouts**)
someone who watches for danger

loop *noun* (*plural* **loops**)
a ring made in a piece of string or rope

loose *adjective* (**looser, loosest**)
1 Something that is loose is not fixed firmly in place. ▶ *Some of the screws have come loose.*
2 Loose clothes do not fit tightly.
3 If a wild animal is loose, it has escaped and is free.
❶ To **loosen** something means to make it looser.

lord *noun* (*plural* **lords**)
a title that is given to some important men

lorry *noun* (*plural* **lorries**)
a big truck that is used for carrying heavy things by road

lose *verb* (**loses, losing, lost**)
1 When you lose something, you do not have it and do not know where it is. ▶ *I've lost my coat.*
2 When you lose a game, someone else wins. ▶ *Our team lost the match.*

lost *adjective*
If you are lost, you do not know where you are or where you should go. ▶ *Don't get lost in the woods!*

lot *noun* (*plural* **lots**)
A lot means a large number or a large amount. ▶ *I've got lots of friends.*

lotion *noun* (*plural* **lotions**)
a liquid that you put on your skin

lottery *noun* (*plural* **lotteries**)
a competition in which people buy tickets or choose numbers, and win a prize if their tickets or numbers are picked

loud *adjective* (**louder, loudest**)
Something that is loud makes a lot of noise. ▶ *This music is too loud!*

loudspeaker *noun* (*plural* **loudspeakers**)
the part of a TV, radio, or music system that the sound comes from

lounge *noun* (*plural* **lounges**)
a room with comfortable chairs in it, where people can sit and talk or watch television

love *noun*
the strong feeling you have when you like someone very much

love *verb* (**loves, loving, loved**)
1 If you love someone, you like them very much.
2 If you love something, you like it a lot. ▶ *I love chocolate.*

lovely *adjective* (**lovelier, loveliest**)
Something that is lovely is beautiful or very nice. ▶ *What a lovely dress!*

low *adjective* (**lower, lowest**)
1 Something that is low is not high.
▶ *We sat down on a low bench.*
2 A low price is a small price.
3 A low voice or sound is deep.
ℹ To **lower** something means to move it so that it is low. ▶ *We lowered the boat into the water.*

loyal *adjective*
If you are loyal to someone, you always help them and support them.

luck *noun*
Luck is when something happens by chance, without anyone planning it.

lucky *adjective* (**luckier, luckiest**)
If you are lucky, you have good luck.
▶ *We were lucky we got home before the storm started.*

ludicrous *adjective*
Something that is ludicrous is very silly.

luggage *noun*
bags and suitcases that you take with you on a journey

lukewarm *adjective*
Something that is lukewarm is only slightly warm.

lullaby *noun* (*plural* **lullabies**)
a song that you sing to a baby to send it to sleep

luminous *adjective*
Something that is luminous glows in the dark.

lump *noun* (*plural* **lumps**)
1 A lump of something is a piece of it.
▶ *He took some bread and a lump of cheese.*
2 A lump is a bump on your skin that you get when you have knocked it.
▶ *I've got a lump on my head where I hit it.*
ℹ Something that is **lumpy** has hard lumps in it.

lunar *adjective*
Lunar means to do with the moon.
▶ *Have you ever seen a lunar eclipse?*

lunch *noun* (*plural* **lunches**)
a meal that you eat in the middle of the day

lung *noun* (*plural* **lungs**)
Your lungs are the parts inside your chest that you use for breathing.

lunge *verb* (**lunges, lunging, lunged**)
If you lunge, you jump forwards suddenly.

lurch *verb* (**lurches, lurching, lurched**)
If a train or bus lurches, it moves suddenly.

lure *verb* (**lures, luring, lured**)
To lure someone means to lead them into a trap.

lurk *verb* (**lurks, lurking, lurked**)
If you lurk somewhere, you wait there secretly.

luxury *noun* (*plural* **luxuries**)
something expensive that you like but do not really need

lying *verb* SEE **lie** *verb*

Mm

macaroni *noun*
a type of pasta that is shaped like short tubes

machine *noun* (*plural* **machines**)
something that has an engine and moving parts, and can do a job or make things ▶ *Most work in factories is done by machines.*

machine-gun *noun* (*plural* **machine-guns**)
a gun that can keep firing bullets one after the other very quickly

mackintosh

mackintosh noun (plural **mackintoshes**)
a raincoat. A mackintosh is sometimes called a **mac**.

mad adjective (**madder**, **maddest**)
1 Someone who is ill in their mind.
2 If you are mad about something, you like it a lot. ▶ *All the boys in our class are mad about football.*
3 If you are mad, you are very angry. ▶ *My mum was really mad with me.*

made verb SEE **make**

magazine noun (plural **magazines**)
a thin book that is made and sold every week or month with different stories and pictures in it

maggot noun (plural **maggots**)
an animal that looks like a tiny worm and will become a fly when it is an adult

magic noun
In stories, magic is the power that some people have to make impossible and wonderful things happen.
❶ Something that happens by magic is **magical** or happens **magically**.

magician noun (plural **magicians**)
1 a person who does magic tricks to entertain people
2 a person in stories who has the power to use magic

magnet noun (plural **magnets**)
a piece of metal that attracts pieces of iron or steel towards it
❶ Metal that is a magnet is **magnetic**.

magnificent adjective
Something that is magnificent is very good or beautiful. ▶ *The king lived in a magnificent palace.*

magnify verb (**magnifies**, **magnifying**, **magnified**)
To magnify something means to make it look bigger. ▶ *We magnified the insect under the microscope.*

magpie noun (plural **magpies**)
a large black and white bird

maid noun (plural **maids**)
a woman who does cleaning in a hotel or large house

mail noun
letters, cards, and parcels that are sent through the post and delivered to people's houses

main adjective
the main thing is the biggest or most important one ▶ *You shouldn't cycle on the main road.*

main clause noun (plural **main clauses**)
The main clause in a sentence is the most important clause, which could be a sentence on its own.

mainly adverb
almost completely ▶ *Our dog is mainly black, with just a few small patches of white.*

majesty noun
a word you use when you are speaking to a king or queen ▶ *Thank you, Your Majesty.*

major adjective
A major thing is very important or serious. ▶ *There has been a major accident on the motorway.*

majority noun (plural **majorities**)
A majority is most of the people in a group. ▶ *The majority of our class enjoy cooking.*

make verb (**makes**, **making**, **made**)
1 When you make something, you create it. ▶ *Ali made a cake.* ▶ *Please don't make too much mess.*
2 To make something happen means to cause it to happen. ▶ *The horrible smell made me feel sick.*
3 If you make someone do something, you force them to do it. ▶ *Mum made me tidy up my room.*
4 If you make something up, you invent it and it is not true.

make-up *noun*
coloured creams and powders that people put on their faces to make themselves look nice

male *adjective*
A male person or animal can become a father.

mammal *noun* (*plural* **mammals**)
an animal that gives birth to live babies and feeds its young with its own milk. Cats, dogs, whales, lions, and people are all mammals.

man *noun* (*plural* **men**)
a grown-up male person

manage *verb* (**manages, managing, managed**)
1 If you manage to do something difficult, you do it after trying very hard. ▶ *At last I managed to get the door open.*
2 To manage a shop or business means to be in charge of it.
ⓘ The person who manages a shop or business is a **manager**.

mane *noun* (*plural* **manes**)
An animal's mane is the long hair on its neck.

manger *noun* (*plural* **mangers**)
a narrow box that horses and cows can eat hay from

mango *noun* (*plural* **mangoes**)
a fruit with sweet, yellow flesh, which grows in hot countries

maniac *noun* (*plural* **maniacs**)
someone who is mad or very silly

manicure *noun* (*plural* **manicures**)
If you have a manicure, someone cuts your finger nails and makes them look nice.

manner *noun*
The manner in which you do something is the way you do it.

manners *noun*
Your manners are the ways in which you behave when you are talking to people or eating your food. ▶ *It's bad manners to talk with your mouth full.*

manor *noun* (*plural* **manors**)
a big house in the country

mansion *noun* (*plural* **mansions**)
a very big house

mantelpiece *noun* (*plural* **mantelpieces**)
the shelf above a fireplace

many *adjective, pronoun*
Many means a large number. ▶ *He has many friends.*

map *noun* (*plural* **maps**)
a drawing of a town, a country, or the world

marathon *noun* (*plural* **marathons**)
a running race which is about 40 kilometres long

marble *noun* (*plural* **marbles**)
1 a small, glass ball that you use to play games with
2 a type of smooth stone that is used for building or making statues

March *noun*
the third month of the year

march *verb* (**marches, marching, marched**)
When you march, you walk with regular steps like a soldier.

mare *noun* (*plural* **mares**)
a female horse

margarine *noun*
a food that looks and tastes like butter, but is made from vegetable oils, not milk

margin *noun* (*plural* **margins**)
an empty space on the side of a page, where there is no writing

marine *adjective*
Marine animals live in the sea.

mark *noun* (*plural* **marks**)
1 a dirty stain or spot on something ▶ *His hands left dirty marks on the wall.*
2 The mark that you get for a piece of work is the number or letter that shows how well you have done.

mark

mark *verb* (marks, marking, marked)
To mark a piece of work means to give it a number or letter to show how good it is.

market *noun* (*plural* markets)
a group of stalls where people sell food and other things

marmalade *noun*
jam made from oranges or lemons

maroon *verb* (maroons, marooning, marooned)
If someone is marooned, they are left in a wild and lonely place on their own, with no way of escaping.

maroon *adjective*
Something that is maroon is a dark red colour.

marry *verb* (marries, marrying, married)
When you marry someone, you become their husband or wife.
❶ Someone who is **married** has a husband or wife.

marsh *noun* (*plural* marshes)
a piece of very wet, soft ground

marsupial *noun* (*plural* marsupials)
an animal that carries its young in a special pouch on the front of its body. Kangaroos are marsupials.

martial art *noun* (*plural* martial arts)
Martial arts are sports such as judo and karate, in which people fight with each other.

marvellous *adjective*
Something that is marvellous is wonderful.

mascot *noun* (*plural* mascots)
a person or animal that travels with a team to bring them good luck

masculine *adjective*
Something that is masculine looks as if it is suitable for boys and men, not girls and women.

mash *verb* (mashes, mashing, mashed)
When you mash food, you crush it until it is soft and smooth. ▶ *We're having sausages and mashed potatoes for tea.*

mask *noun* (*plural* masks)
something that you wear over your face to hide it or protect it

mass *noun* (*plural* masses)
A mass is a large amount of something, or a large number of things. ▶ *We've got masses of homework!*

massive *adjective*
Something that is massive is very big.

mast *noun* (*plural* masts)
a tall pole that holds up a ship's sails

master *noun* (*plural* masters)
An animal's master is the man or boy who controls it.

masterpiece *noun* (*plural* masterpieces)
a very good piece of work

mat *noun* (*plural* mats)
1 a small carpet
2 a something that you put under a hot plate on a table

match *noun* (*plural* matches)
1 a small, thin stick that makes a flame when you rub it against something rough
2 a game that two people or teams play against each other ▶ *We watched a rugby match on TV.*

match *verb* (matches, matching, matched)
Things that match are the same or go well together. ▶ *This jumper matches your skirt.*

mate *noun* (*plural* mates)
1 A mate is a friend.
2 An animal's mate is the animal that it produces babies with.

mate *verb* (**mates, mating, mated**)
When animals mate, they come together as a pair to produce babies.

material *noun* (*plural* **materials**)
1 A material is something that you use to make things with. ▶ *Wood and stone are building materials.*
2 Material is cloth. ▶ *She was wearing a dress made of very thin material.*

mathematics, **maths** *noun*
the subject in which you learn about numbers, measurement, and shapes

matter *noun* (*plural* **matters**)
1 something that you need to talk about or deal with ▶ *There is an important matter we have to talk about.*
2 When you ask someone what the matter is, you are asking what is wrong.

matter *verb* (**matters, mattering, mattered**)
If something matters, it is important. ▶ *It doesn't matter if you are a bit late.*

mattress *noun* (*plural* **mattresses**)
the soft part of a bed that you lie on

mature *adjective*
Someone who is mature behaves in a grown-up way.

mauve *adjective* (*pronounced* **mowv**)
Something that is mauve is a light purple colour.

May *noun*
the fifth month of the year

may *verb* (**might**)
1 If you may do something, you are allowed to do it. ▶ *May I go out to play?* ▶ *The teacher said we might go out to play.*
2 If something may happen, it is possible that it will happen. ▶ *It may rain later.*

maybe *adverb*
perhaps

mayonnaise *noun*
a cold, white sauce that you eat with salad

mayor *noun* (*plural* **mayors**)
the person in charge of the council of a town or city. A woman who is a mayor can also be called a **mayoress**.

maze *noun* (*plural* **mazes**)
a set of lines or paths that twist and turn so much that it is very easy to lose your way

meadow *noun* (*plural* **meadows**)
a field of grass and flowers

meagre *adjective*
A meagre amount of something is a very small amount.

meal *noun* (*plural* **meals**)
the food that you eat at breakfast, lunch, dinner, tea, or supper

mean *verb* (**means, meaning, meant**)
When you say what a word means, you say what it describes or shows. ▶ *What does the word 'malicious' mean?*

mean *adjective* (**meaner, meanest**)
1 Someone who is mean does not like sharing things.
2 Someone who is mean is unkind. ▶ *That was a really mean thing to do!*

meaning *noun* (*plural* **meanings**)
The meaning of a word is what it means. ▶ *If you don't know the meaning of a word, look it up in the dictionary.*

meanwhile *adverb*
during the time something else is happening ▶ *You go and phone the fire brigade. Meanwhile I'll make sure there's no one left in the building.*

measles *noun*
an illness that gives you red spots all over your body

measure *verb* (**measures, measuring, measured**)
When you measure something, you find out how big it is or how much there is.

meat *noun*
the flesh from animals that we can eat

mechanic *noun* (*plural* **mechanics**)
a person who repairs cars or machines

mechanical *adjective*
Something that is mechanical has parts that move like a machine. ▶ *They used a mechanical digger to make a ditch.*

medal *noun* (*plural* **medals**)
a special piece of metal that is given to someone who has won a competition or done something very brave

meddle *verb* (**meddles, meddling, meddled**)
If you meddle with something, you touch it or interfere with it when it has nothing to do with you.

medicine *noun* (*plural* **medicines**)
a special liquid or tablet that you take when you are ill to make you better

medium *adjective*
Medium means not very big and not very small, but in the middle.

meet *verb* (**meets, meeting, met**)
1 When people meet, they see each other and talk to each other. ▶ *Let's meet at two o'clock.*
2 When two roads or rivers meet, they join together.

meeting *noun* (*plural* **meetings**)
When people have a meeting, they meet to talk about something.

melody *noun* (*plural* **melodies**)
a tune

melon *noun* (*plural* **melons**)
a large, juicy fruit with a lot of small seeds in the middle

melt *verb* (**melts, melting, melted**)
When something melts, it becomes a liquid because it has become warm. ▶ *Ice melts if you take it out of the fridge.*

member *noun* (*plural* **members**)
someone who belongs to a club or group

memory *noun* (*plural* **memories**)
1 Your memory is your ability to remember things. ▶ *Have you got a good memory?*
2 A memory is something that you can remember. ▶ *The old man had happy memories of when he was a boy.*
3 The memory in a computer is the part that stores information.

men *noun* SEE **man**

mend *verb* (**mends, mending, mended**)
When you mend something that is broken, you fix it or put it right so that you can use it again.

meningitis *noun*
an illness which gives you a bad headache and makes you very ill

mental *adjective*
Something that is mental happens in your mind. ▶ *At school we have to do mental arithmetic.*

mention *verb* (**mentions, mentioning, mentioned**)
If you mention something, you talk about it.

menu *noun* (*plural* **menus**)
a list of the different kinds of food you can choose for your meal

mercy *noun*
If you show mercy to someone, you are kind and do not punish them.

meringue *noun* (*plural* **meringues**)
(*pronounced* mer-**ang**)
a crisp cake made from sugar and egg whites

mermaid *noun* (*plural* **mermaids**)
In stories, a mermaid is a sea creature that looks like a woman but has a fish's tail instead of legs.

merry *adjective* (**merrier, merriest**)
Someone who is merry is cheerful and laughing.

mess *noun*
If something is a mess, it is very untidy. ▶ *Don't leave your clothes in a mess.*
ⓘ If something is **messy**, it is untidy.

message *noun* (*plural* **messages**)
words that you write down or record for someone when you cannot see them or speak to them yourself

met *verb* SEE **meet**

metal *noun* (*plural* **metals**)
a hard, strong material. Gold, silver, iron, and tin are all types of metal.

meteor *noun* (*plural* **meteors**)
a piece of rock or metal that flies through space and burns up when it gets near the earth. A piece of rock or metal that falls to earth without burning up is called a **meteorite**.

meter *noun* (*plural* **meters**)
a machine that measures how much of something has been used

method *noun* (*plural* **methods**)
the way in which you do something ▶ *What is the best method of making a bridge?*

metre *noun* (*plural* **metres**)
We can measure length in metres. There are 100 centimetres in a metre.

metric system *noun*
a system for measuring and weighing things that uses units of 10 and 100. Millimetres, centimetres, and metres are part of the metric system.

miaow *verb* (**miaows, miaowing, miaowed**)
When a cat miaows, it makes a long, high sound.

mice *noun* SEE **mouse**

microchip *noun* (*plural* **microchips**)
one of the tiny pieces in a computer that makes it work

microphone *noun* (*plural* **microphones**)
something that you speak into when you want to record your voice or make it sound louder

microscope *noun* (*plural* **microscopes**)
an instrument that makes tiny things look bigger

microwave *noun* (*plural* **microwaves**)
an oven that cooks food very quickly by passing special radio waves through it

midday *noun*
twelve o'clock in the middle of the day

middle *noun* (*plural* **middles**)
1 the part near the centre of something, not at the edges ▶ *There was a puddle in the middle of the playground.*
2 the part that is not near the beginning or end of something ▶ *The phone rang in the middle of the night.*

midnight *noun*
twelve o'clock at night

might *verb* SEE **may**

mighty *adjective* (**mightier, mightiest**)
Something that is mighty is very big or strong.

migrate *verb* (**migrates, migrating, migrated**)
When birds or animals migrate, they travel to another place at the same time each year.

mild *adjective* (**milder, mildest**)
1 Something that is mild is not very strong. ▶ *This soup has a very mild flavour.*
2 Mild weather is quite warm.

mile *noun* (*plural* **miles**)
We can measure distance in miles. One mile is the same as about $1\frac{1}{2}$ kilometres.

military *adjective*
Military things are used by soldiers.

milk *noun*
a white liquid that you can drink. All female mammals make milk to feed their babies. People can drink cows' milk.

mill *noun* (*plural* **mills**)
a place where grain is crushed to make flour

millimetre *noun* (*plural* **millimetres**)
We can measure length in millimetres. There are 1000 millimetres in one metre.

million *noun* (*plural* **millions**)
the number 1,000,000
ℹ A very rich person who has more than a million pounds or dollars is a **millionaire**.

mime *verb* (**mimes, miming, mimed**)
When you mime, you pretend to do something using only actions, not words.

mimic *verb* (**mimics, mimicking, mimicked**)
When you mimic someone, you copy them to make fun of them.

mince *noun*
meat that has been cut into very small pieces

mind *noun* (*plural* **minds**)
Your mind is your ability to think, and all the thoughts, ideas, and memories that you have.

mind *verb* (**minds, minding, minded**)
If you do not mind about something, it does not upset or worry you. ▶ *I don't mind if I have to miss the party.*

mine *noun* (*plural* **mines**)
1 a place where people work to dig coal, metal, or stones out of the ground
2 a bomb that is hidden in the ground or the sea. It explodes when something touches it.

mineral *noun* (*plural* **minerals**)
Minerals are things such as salt that form naturally in the ground.

miniature *adjective*
A miniature thing is very small but looks just the same as a bigger one.

minibus *noun* (*plural* **minibuses**)
a small bus

minister *noun* (*plural* **ministers**)
someone who is in charge of a Christian church

minor *adjective*
A minor thing is not very important or serious. ▶ *He only suffered a minor injury.*

mint *noun* (*plural* **mints**)
1 a green plant that is added to food to give it flavour
2 a sweet that tastes of mint

minus *adjective, preposition*
1 take away ▶ *Six minus two is four,* $6 - 2 = 4$.
2 A minus number is less than 0. ▶ *The temperature outside was minus three.*

minute *noun* (*plural* **minutes**)
(*pronounced* **min**-it)
We measure time in minutes. There are 60 seconds in one minute, and 60 minutes in one hour.

minute *adjective* (*pronounced* my-newt)
Something that is minute is very small.

miracle *noun* (*plural* **miracles**)
something wonderful that has happened, although it did not seem possible ▶ *It's a miracle no one was hurt in the train crash.*

mirage *noun* (*plural* **mirages**)
a trick of the light that makes people see things that are not really there

mirror *noun* (*plural* **mirrors**)
a piece of glass, in which you can see yourself

misbehave *verb* (**misbehaves, misbehaving, misbehaved**)
If you misbehave, you behave in a naughty way.

mischief *noun*
If you get into mischief, you do silly or naughty things.
ℹ Someone who is **mischievous** gets into mischief.

miser noun (plural **misers**)
someone who is mean with money and does not like spending it or giving it to people

miserable adjective
If you are miserable, you are very unhappy.

misfortune noun (plural **misfortunes**)
bad luck

mislay verb (**mislays, mislaying, mislaid**)
If you have mislaid something, you have lost it because you cannot remember where you have put it.

mislead verb (**misleads, misleading, misled**)
If you mislead someone, you tell them something that is not true.

miss verb (**misses, missing, missed**)
1 If you miss something, you do not catch it or hit it. ▶ *I tried to hit the ball but I missed it.*
2 If you miss someone, you feel sad because they are not with you.

missile noun (plural **missiles**)
a weapon which is thrown or fired through the air

missing adjective
Something that is missing is lost. ▶ *We're looking for a missing cat.*

mission noun (plural **missions**)
an important job that someone is sent away to do

mist noun
When there is mist, there is a lot of cloud just above the ground, which makes it difficult to see.

mistake noun (plural **mistakes**)
If you make a mistake, you do something wrong.

mistake verb (**mistakes, mistaking, mistook, mistaken**)
If you mistake someone for another person, you think they are the other person.

mistress noun (plural **mistresses**)
An animal's mistress is the woman or girl who controls it.

misunderstand verb (**misunderstands, misunderstanding, misunderstood**)
If you misunderstand something, you do not understand it correctly.

mitten noun (plural **mittens**)
a glove which does not have a separate part for each finger

mix verb (**mixes, mixing, mixed**)
When you mix things together, you put them together and stir them.

mixture noun (plural **mixtures**)
something that is made of different things mixed together ▶ *Would you like to taste the cake mixture?*

moan verb (**moans, moaning, moaned**)
1 When you moan, you make a low sound because you are in pain.
2 When you moan about something, you complain about it.

moat noun (plural **moats**)
a deep ditch filled with water round a castle

mobile adjective
Something that is mobile can be moved or carried around easily.

mobile noun (plural **mobiles**)
a toy for a baby. It has a lot of colourful things which hang down from the ceiling and move around for the baby to watch.

mobile phone noun (plural **mobile phones**)
a telephone that you can carry around with you. A mobile phone is also called a **mobile**.

mock verb (**mocks, mocking, mocked**)
To mock someone means to make fun of them.

model

model *noun* (*plural* **models**)
1 a small copy of something ▶ *We built a model of a spaceship.*
2 someone who shows new clothes to people by wearing them and walking around in them

moderate *adjective*
A moderate amount is not too big and not too small. ▶ *We were driving along at a moderate speed.*

modern *adjective*
Something that is modern uses new ideas, not old-fashioned ones. ▶ *She likes to wear modern clothes.*

modest *adjective*
1 Someone who is modest does not boast.
2 Someone who is modest is shy.

moist *adjective* (**moister, moistest**)
Something that is moist is slightly wet.

mole *noun* (*plural* **moles**)
1 a small, furry animal that digs holes and tunnels under the ground
2 a small brown mark on your skin

molten *adjective*
Molten rock or metal has melted because it is very hot.

moment *noun* (*plural* **moments**)
a very small amount of time ▶ *Please could you wait a moment?*

monarch *noun* (*plural* **monarchs**)
a king or queen

Monday *noun* (*plural* **Mondays**)
the day after Sunday

money *noun*
the coins and pieces of paper that we use to buy things

mongrel *noun* (*plural* **mongrels**)
a dog that is not one breed, but is a mixture of more than one breed

monitor *noun* (*plural* **monitors**)
a computer screen

monk *noun* (*plural* **monks**)
a man who lives a special religious way of life

monkey *noun* (*plural* **monkeys**)
a furry animal with a long tail. Monkeys are very good at climbing and swinging in trees.

monsoon *noun* (*plural* **monsoons**)
a time of year when it rains a lot in some hot countries

monster *noun* (*plural* **monsters**)
a large, fierce animal in stories

month *noun* (*plural* **months**)
a period of 28, 30, or 31 days. There are twelve months in a year.

monument *noun* (*plural* **monuments**)
a statue that helps people to remember an important person or event.

mood *noun* (*plural* **moods**)
Your mood is the the way you feel, for example whether you are happy or sad. ▶ *Anita's in a very good mood today.*

moody *adjective* (**moodier, moodiest**)
Someone who is moody often feels cross or unhappy.

moon *noun*
the large, round thing that you see shining in the sky at night. The moon travels round the earth in space. ▶ *There is a full moon tonight.*
❶ **Moonlight** is the light from the moon.

moor *noun* (*plural* **moors**)
an area of high land that has bushes but no trees

moor *verb* (**moors, mooring, moored**)
When you moor a boat, you tie it up so that it will not float away.

moose *noun* (the plural is the same)
a large deer with large antlers that lives in North America

mop *noun* (*plural* **mops**)
something that you use for cleaning floors. It has a bundle of loose strings on the end of a long handle.

moral *noun* (*plural* **morals**)
a lesson that a story teaches you about what is right or wrong

more *adjective, adverb*
a bigger number or amount ▶ *You've got more sweets than I have.*

morning *noun* (*plural* **mornings**)
the time from the beginning of the day until the middle of the day

mortal *adjective*
Someone who is mortal will die one day rather than live for ever.

mortar *noun*
a mixture of sand and cement that builders use to stick bricks together when they are building something

mosaic *noun* (*plural* **mosaics**)
a picture made from a lot of small, coloured pieces of glass, or stone

mosque *noun* (*plural* **mosques**)
a building where Muslims pray and worship

mosquito *noun* (*plural* **mosquitoes**)
a small insect that bites people and animals

moss *noun* (*plural* **mosses**)
a plant that forms soft lumps when it grows on the ground or on old walls

most *adjective, adverb*
more than any other ▶ *Which story did you like the most?*

moth *noun* (*plural* **moths**)
an insect like a butterfly, that flies around at night

mother *noun* (*plural* **mothers**)
Your mother is your female parent.

motive *noun* (*plural* **motives**)
Your motive for doing something is your reason for doing it.

motor *noun* (*plural* **motors**)
an engine that makes something move

motor bike, **motor cycle** *noun* (*plural* **motor bikes** *or* **motor cycles**)
a large, heavy bicycle with an engine

motorist *noun* (*plural* **motorists**)
someone who drives a car

motorway *noun* (*plural* **motorways**)
a wide, straight road on which people can drive fast and travel a long way

mould *noun* (*plural* **moulds**) (rhymes with *old*)
1 the grey or green substance that grows on food that has gone bad
2 a container that you use for making liquids set into a particular shape
❶ Something that is **mouldy** has mould growing on it.

mound *noun* (*plural* **mounds**)
a pile of earth

mount *verb* (**mounts, mounting, mounted**)
When you mount a horse or a bicycle, you get onto it so that you can ride it.

mountain *noun* (*plural* **mountains**)
a very high hill

mouse *noun* (*plural* **mice**)
1 a small furry animal with a long tail
2 A computer mouse is the part that you move about on your desk to choose things on the screen.

mousse *noun* (*plural* **mousses**)
a light, creamy pudding made with fruit or chocolate

moustache *noun* (*plural* **moustaches**)
hair that grows on a man's top lip

mouth *noun* (*plural* **mouths**)
1 Your mouth is the part of your face that you can open and use for eating and speaking.
2 The mouth of a river is the place where it flows into the sea.

move

move verb (**moves, moving, moved**)
1 When you move something, you take it from one place and put it in another place.
2 When something moves, it goes from one place to another. ▶ *The dog just sat still and didn't move.*
❶ When there is a **movement**, something moves.

movie noun (*plural* **movies**)
a film that you watch on a screen at the cinema or on television

mow verb (**mows, mowing, mowed, mown**)
When you mow grass, you cut it.

much adjective
a lot ▶ *I haven't got much money.* ▶ *I don't like carrots very much.*

mud noun
wet, sticky soil ▶ *My boots were covered in mud.*
❶ Something that is **muddy** is covered in mud.

muddle verb (**muddles, muddling, muddled**)
When you muddle things up, you mix them up or forget which one is which.

muddle noun (*plural* **muddles**)
If something is in a muddle, it is messy or untidy.

muesli noun (*pronounced* **mooz**-li)
a food that you can eat for breakfast. It is made with cereals, nuts, and dried fruit.

muffled adjective
A muffled sound is not clear, and is hard to hear.

mug noun (*plural* **mugs**)
a big cup

mule noun (*plural* **mules**)
an animal that is a mixture between a horse and a donkey

multiply verb (**multiplies, multiplying, multiplied**)
When you multiply a number, you make it a number of times bigger. Five multiplied by three is fifteen, $5 \times 3 = 15$.
❶ When you multiply numbers you do **multiplication**.

mum, **mummy** noun (*plural* **mums** or **mummies**)
Your mum is your mother.

mumble verb (**mumbles, mumbling, mumbled**)
When you mumble, you speak without saying the words clearly.

mumps noun
an illness that makes the sides of your face swell up

munch verb (**munches, munching, munched**)
When you munch something, you chew it noisily. ▶ *Tom was munching an apple.*

mural noun (*plural* **murals**)
a large picture painted onto a wall

murder verb (**murders, murdering, murdered**)
To murder someone means to kill them on purpose.

murmur verb (**murmurs, murmuring, murmured**)
When you murmur, you speak in a very soft, low voice.

muscle noun (*plural* **muscles**)
Your muscles are the strong parts of your body that you use to make your body move.

museum noun (*plural* **museums**)
a place where things from the past are kept for people to go and see

mushroom noun (*plural* **mushrooms**)
a small plant with a stem and a grey, round top that you can eat

music noun
the nice sound that you make when you sing or play instruments

musical *adjective*
A musical instrument is an instrument that you use to play music.

musician *noun* (*plural* **musicians**)
a person who plays or composes music

Muslim *noun* (*plural* **Muslims**)
someone who follows the religion of Islam

mussel *noun* (*plural* **mussels**)
a small sea creature that you can eat

must *verb*
If you must do something, you have to do it. ▶ *You must go to school.*

mustard *noun*
a cold, yellow sauce with a hot, strong taste

mutiny *noun* (*plural* **mutinies**)
When there is a mutiny, soldiers or sailors attack the officers who are in charge of them.

mutter *verb* (**mutters, muttering, muttered**)
When you mutter, you speak in a quiet voice because you do not want people to hear you.

muzzle *noun* (*plural* **muzzles**)
1 An animal's muzzle is its nose and mouth.
2 A muzzle is a cover that you put over an animal's mouth so that it cannot bite people.

mysterious *adjective*
Something that is mysterious is strange and puzzling.
❶ A **mystery** is something strange and puzzling.

myth *noun* (*plural* **myths**)
a very old story, often one about gods and goddesses ▶ *Do you like reading Greek myths?*
❶ A **mythical** animal or person is in a myth.

Nn

nag *verb* (**nags, nagging, nagged**)
To nag someone means to keep telling them to do something.

nail *noun* (*plural* **nails**)
1 Your nails are the hard parts at the ends of your fingers and toes.
2 A nail is a small thin piece of metal with a sharp point at the end. You bang nails into wood with a hammer to hold pieces of wood together.

nail *verb* (**nails, nailing, nailed**)
When you nail pieces of wood together, you join them together with nails.

naked *adjective*
If you are naked, you have no clothes on.

name *noun* (*plural* **names**)
Your name is what people call you.

name *verb* (**names, naming, named**)
To name someone means to give them a name.

nanny *noun* (*plural* **nannies**)
someone whose job is to look after children while their parents are at work

nappy *noun* (*plural* **nappies**)
a piece of paper or cloth that you put round a baby's bottom to keep it clean and dry

narrator *noun* (*plural* **narrators**)
the person who tells a story

narrow *adjective* (**narrower, narrowest**)
Something that is narrow is not very wide. ▶ *We drove along a very narrow road.*

nasty

nasty *adjective* (**nastier, nastiest**)
1 Something that is nasty is horrible. ▶ *There was a nasty smell in the classroom.*
2 Someone who is nasty is mean or unkind.

nation *noun* (*plural* **nations**)
a country
ℹ Something that is **national** belongs to a country. Your **nationality** is the country that you come from and belong to.

natural *adjective*
1 Something that is natural has been made by nature, not by people or machines.
2 Something that is natural is normal. ▶ *It is natural to feel upset sometimes.*

nature *noun*
1 everything in the world that was not made by people, for example mountains, rivers, animals, and plants
2 Your nature is the type of person that you are. ▶ *Salim has a very kind nature.*

naughty *adjective* (**naughtier, naughtiest**) (*pronounced* **nor**-tee)
If you are naughty, you behave badly.

navigate *verb* (**navigates, navigating, navigated**)
When you navigate, you make sure that a ship, aeroplane, or car is going in the right direction.

navy *noun* (*plural* **navies**)
an army that fights at sea, in ships

navy blue *adjective*
Something that is navy blue is very dark blue.

near *adjective, adverb* (**nearer, nearest**)
not far away ▶ *We live near the school.*

nearly *adverb*
almost ▶ *It's nearly 3 o'clock.*

neat *adjective* (**neater, neatest**)
Something that is neat is clean and tidy.
ℹ If you do something in a neat way, you do it **neatly**.

necessary *adjective*
If something is necessary, it has to be done. ▶ *It is necessary to water plants in dry weather.*

neck *noun* (*plural* **necks**)
Your neck is the part of your body that joins your head to your shoulders.

necklace *noun* (*plural* **necklaces**)
a chain or string of beads or jewels that you wear around your neck

nectar *noun*
a sweet liquid inside flowers. Bees collect nectar to make honey.

nectarine *noun* (*plural* **nectarines**)
a fruit that is like a peach but has a smooth skin

need *verb* (**needs, needing, needed**)
1 If you need something, you have to have it.
2 If you need to do something, you have to do it. ▶ *You need to tidy your room.*

need *noun* (*plural* **needs**)
1 Your needs are the things that you need.
2 If someone is in need, they do not have enough money, food, or clothes.

needle *noun* (*plural* **needles**)
1 a thin, pointed piece of metal with a hole at one end that you use for sewing
2 A knitting needle is a long, thin stick that you use for knitting.
3 The needles on a pine tree are its thin, pointed leaves.

negative *adjective*
A negative sentence is one that has the word 'not' or 'no' in it. 'Rebecca is not very happy' is a negative sentence.

neglect verb (**neglects, neglecting, neglected**)
If you neglect something, you do not look after it properly.

neigh verb (**neighs, neighing, neighed**)
When a horse neighs, it makes a loud, high sound.

neighbour noun (*plural* **neighbours**)
Your neighbours are the people who live near you.

nephew noun (*plural* **nephews**)
Your nephew is the son of your brother or sister.

nerve noun (*plural* **nerves**)
The nerves in your body are the parts that carry messages to and from your brain, so that your body can feel and move.

nervous adjective
If you feel nervous, you feel afraid and excited because something important is going to happen to you.

nest noun (*plural* **nests**)
a home that a bird or small animal makes for its babies

net noun (*plural* **nets**)
a piece of material with small holes in it. You use a net for catching fish.

netball noun
a game in which two teams of players try to score goals by throwing a ball through a round net on a pole

nettle noun (*plural* **nettles**)
a plant with leaves that can sting you if you touch them

never adverb
not ever ▶ *I will never tell a lie again!*

new adjective (**newer, newest**)
1 Something that is new has just been made or bought and is not old. ▶ *She got a new bike for her birthday.*
2 Something that is new is different. ▶ *We're moving to a new house.*

news noun
The news is all the things that are happening in the world, which you can see on television or read about in newspapers.

newspaper noun (*plural* **newspapers**)
a big, thin book that gives you information about things that are happening in the world

newt noun (*plural* **newts**)
a small animal that lives near water. Newts are amphibians, and have four legs and a long tail.

next adjective
1 The next thing is the one that is nearest to you. ▶ *My friend lives in the next street.*
2 The next thing is the one that comes after this one. ▶ *We're going on holiday next week.*

nibble verb (**nibbles, nibbling, nibbled**)
When you nibble something, you eat it by biting off a little bit at a time.

nice adjective (**nicer, nicest**)
1 Something that is nice is pleasant or enjoyable.
2 Someone who is nice is kind.
❶ If you do something in a nice way, you do it **nicely**.

nickname noun (*plural* **nicknames**)
a friendly name that your family or friends call you

niece noun (*plural* **nieces**)
Your niece is the daughter of your brother or sister.

night noun (*plural* **nights**)
the time when it is dark

nightie noun (*plural* **nighties**)
a dress that a woman or girl wears in bed

nightmare noun (*plural* **nightmares**)
a very frightening dream

nil

nil *noun*
nothing, the number 0 ▶ *The score was three nil to our team.*

nine *noun* (*plural* **nines**)
the number 9

nineteen *noun*
the number 19

ninety *noun*
the number 90

nip *verb* (**nips, nipping, nipped**)
1 To nip someone means to bite or pinch them.
2 If you nip somewhere, you go there quickly.

nit *noun* (*plural* **nits**)
a silly person

nits *noun*
Nits are the eggs that headlice sometimes lay on your head. They make your head itch.

noble *adjective* (**nobler, noblest**)
A noble person comes from a rich, important family.

nobody *pronoun*
no person ▶ *There's nobody here.*

nocturnal *adjective*
Nocturnal animals move around and feed at night.

nod *verb* (**nods, nodding, nodded**)
When you nod, you move your head up and down to show that you agree with someone.

noise *noun* (*plural* **noises**)
a sound that you can hear, especially a loud or strange one ▶ *Did you hear a noise?*
❶ Something that makes a lot of noise is **noisy**.

none *pronoun*
not any ▶ *I wanted some cake but there was none left.*

non-fiction *noun*
books that have information in that is true

nonsense *noun*
something silly that does not mean anything

noodles *noun*
a type of pasta that is shaped like pieces of string

noon *noun*
twelve o'clock in the middle of the day

normal *adjective*
Something that is normal is ordinary and not different or surprising.
❶ If you **normally** do something, you usually do it.

north *noun*
North is one of the directions in which you can face or travel. On a map, north is the direction towards the top of the page.
❶ The **northern** part of a country is the part in the north.

nose *noun* (*plural* **noses**)
Your nose is the part of your face that you use for breathing and smelling.

nostril *noun* (*plural* **nostrils**)
Your nostrils are the two holes at the end of your nose, which you breathe through.

nosy *adjective* (**nosier, nosiest**)
If you are nosy, you try to find out about things that other people are doing.

note *noun* (*plural* **notes**)
1 a short letter
2 A musical note is one sound in a piece of music. ▶ *I'll play the first few notes, then you join in.*
3 A note is a piece of paper money.

nothing *noun*
not anything ▶ *There was nothing in the box.*

notice *noun* (*plural* **notices**)
1 a written message that is put up on a wall for people to see
2 If you take no notice of something, you ignore it.

notice verb (notices, noticing, noticed)
If you notice something, you see it. ▶ *I noticed that the fire had gone out.*

nought noun (plural **noughts**)
nothing, the number 0

noun noun (plural **nouns**)
a word that is the name of a person, place, thing, or idea. Words like *chair*, *cat*, *London*, and *love* are all nouns.

novel noun (plural **novels**)
a book that tells a long story ▶ *'Oliver Twist' is a novel by Charles Dickens.*

novelty noun (plural **novelties**)
something small that is new or unusual

November noun
the eleventh month of the year

now adverb
at this time ▶ *Do you want to go now?*

nowhere adverb
not anywhere

nuclear adjective
Nuclear power is power that is produced by splitting atoms.

nude adjective
If you are nude, you have no clothes on.

nudge verb (nudges, nudging, nudged)
When you nudge someone, you push them with your elbow to make them notice something.

nugget noun (plural **nuggets**)
a small piece of something

nuisance noun (plural **nuisances**)
(pronounced **new**-sans)
If something is a nuisance, it is annoying. ▶ *It's a nuisance that we missed the bus.*

numb adjective
If a part of your body is numb, you cannot feel anything with it. ▶ *My toes were numb with cold.*

number noun (plural **numbers**)
a word or sign that tells you how many things there are. 1, 2, and 3 are numbers.

numeracy noun
Numeracy is being able to count and work with numbers.

numerous adjective
If there are numerous things, there are a lot of them.

nun noun (plural **nuns**)
a woman who lives a special religious way of life

nurse noun (plural **nurses**)
someone who works in a hospital and looks after people who are ill or hurt

nurse verb (nurses, nursing, nursed)
When you nurse someone who is ill, you look after them.

nursery noun (plural **nurseries**)
1 a place where very young children go to play and be looked after
2 a place where people grow plants to sell

nut noun (plural **nuts**)
1 a hard fruit that grows on some trees and plants. You can eat some types of nuts.
2 a piece of metal with a hole in it which you screw on the end of a long piece of metal called a **bolt** ▶ *You use nuts and bolts to fix things together.*
3 a very silly person

nuzzle verb (nuzzles, nuzzling, nuzzled)
When an animal nuzzles against you, it rubs against you with its nose.

nylon noun
a type of thin, strong material that is used for making clothes and other things

Oo

oak noun (plural **oaks**)
a large tree that produces nuts called acorns

oar noun (plural **oars**)
a pole with a flat part at one end. You use oars for rowing a boat.

oasis noun (plural **oases**) (pronounced oh-**ay**-sis)
a place in a desert where there is water, and where trees and plants grow

oats noun
a plant grown by farmers. We use oats for feeding animals and for making food such as porridge.

obedient adjective
If you are obedient, you do what other people tell you to do.

obey verb (**obeys, obeying, obeyed**)
When you obey someone, you do what they tell you to do.

object noun (plural **objects**)
1 anything that you can see, touch, or hold ▶ *There were some interesting objects in the museum.*
2 the noun in a sentence that shows which person or thing receives the action of the verb. For example, in the sentence 'The cat chased the dog', *dog* is the object of the verb.

object verb (**objects, objecting, objected**)
If you object to something, you say that you do not like it.

oblong noun (plural **oblongs**)
a shape that looks like a long square. An oblong is also called a **rectangle**.

obnoxious adjective
Someone who is obnoxious behaves in a horrible, rude way to people.

observe verb (**observes, observing, observed**)
When you observe something, you watch it carefully. ▶ *We observed the bird building its nest.*

obsessed adjective
If you are obsessed with something, you think about it all the time.

obstacle noun (plural **obstacles**)
something that is in your way and stops you doing what you want to do

obstinate adjective
Someone who is obstinate refuses to change their mind.

obstruct verb (**obstructs, obstructing, obstructed**)
If you obstruct someone, you get in their way.

obtain verb (**obtains, obtaining, obtained**)
When you obtain something, you get it.

obvious adjective
If something is obvious, it is very easy to see or understand.
❶ If something is **obviously** true, it is easy to see that it is true.

occasion noun (plural **occasions**)
an important event ▶ *Your birthday is a special occasion.*

occasionally adverb
If you do something occasionally, you so it sometimes.

occupation noun (plural **occupations**)
Someone's occupation is their job.

occupy verb (**occupies, occupying, occupied**)
1 If a place is occupied, someone is using it or living in it. ▶ *Is this seat occupied?*
2 To occupy someone means to keep them busy. ▶ *The teacher gave us some work to keep us occupied.*

occur *verb* (**occurs, occurring, occurred**)
1 When something occurs, it happens. ▶ *The accident occurred at six o'clock last night.*
2 When something occurs to you, you think of it.

ocean *noun* (*plural* **oceans**)
a big sea ▶ *They sailed across the Atlantic Ocean.*

o'clock *adverb*
a word you use to say what time it is ▶ *I'll meet you at one o'clock.*

octagon *noun* (*plural* **octagons**)
a shape with eight straight sides

October *noun*
the tenth month of the year

octopus *noun* (*plural* **octopuses**)
a sea creature with eight tentacles

odd *adjective* (**odder, oddest**)
1 Something that is odd is strange.
2 An odd number is not even. ▶ *Five is an odd number.*

odour *noun* (*plural* **odours**)
a smell

of *preposition*
1 made from ▶ *He had a sword of solid gold.*
2 belonging to ▶ *The handle of my bag is broken.*

off *adverb, preposition*
1 down from something or away from something ▶ *He fell off the wall.*
2 not switched on ▶ *The heating's off.*

offend *verb* (**offends, offending, offended**)
To offend someone means to hurt their feelings.

offer *verb* (**offers, offering, offered**)
1 If you offer something to someone, you ask if they would like it. ▶ *She offered me a piece of cake.*
2 If you offer to do something, you say that you will do it. ▶ *Tom offered to lay the table.*

office *noun* (*plural* **offices**)
a room with desks, where people work

officer *noun* (*plural* **officers**)
1 a person in the army, navy, or air force who is in charge of other people and gives them orders
2 a policeman or policewoman

official *adjective*
Something that is official is decided or done by a person in charge. ▶ *I got an official letter about my prize.*

often *adverb*
many times ▶ *We often go swimming on Saturday.*

ogre *noun* (*plural* **ogres**)
a big, cruel giant in stories

oil *noun*
a thick, slippery liquid. You can use some types of oil as fuel, or to make machines work more smoothly. You use other types of oil in cooking.

ointment *noun* (*plural* **ointments**)
a cream that you put on sore skin or cuts

OK, **okay** *adjective*
Something that is OK is all right.

old *adjective* (**older, oldest**)
1 Someone who is old has lived for a long time.
2 Something that is old was made a long time ago. ▶ *Our car is quite old.*

old-fashioned *adjective*
Something that is old-fashioned looks old and not modern. ▶ *She was wearing very old-fashioned clothes.*

omelette *noun* (*plural* **omelettes**)
a dish that you make by beating eggs together and then frying them

omit *verb* (**omits, omitting, omitted**)
If you omit something, you leave it out.

on *preposition, adverb*
1 on top of ▶ *Put your books on your desk.*
2 on the subject of ▶ *I've got a new book on dinosaurs.*
3 working ▶ *Is the heating on?*

once

once *adverb*
1 one time ▶ *She only missed school once this term.*
2 at one time ▶ *Once dinosaurs roamed the earth.*

one *noun* (*plural* **ones**)
the number 1

onion *noun* (*plural* **onions**)
a round, white vegetable that has a very strong smell and taste

online *adjective*
When you work online on a computer, the computer is connected to the Internet.

only *adjective*
An only child is a child who has no brothers or sisters.

only *adverb*
not more than ▶ *It's only four o'clock.*

onto *preposition*
on ▶ *I stuck a label onto the parcel.*

onwards *adverb*
forwards ▶ *We walked onwards until we came to the river.*

ooze *verb* (**oozes, oozing, oozed**)
When a liquid oozes, it comes slowly through a hole or small opening.

opaque *adjective*
If something is opaque, you cannot see through it.

open *adjective*
1 When a door or window is open, it is not shut.
2 When a shop is open, you can go into it and buy things.

open *verb* (**opens, opening, opened**)
1 When you open a door or window, you move it so that it is open. ▶ *The teacher opened the window.*
2 When a shop opens, you can go into it and buy things.

opening *noun* (*plural* **openings**)
a space or hole in something

opera *noun* (*plural* **operas**)
a play in which people sing the words instead of saying them

operation *noun* (*plural* **operations**)
When you have an operation, doctors mend or take out a part of your body to make you healthy again.

opinion *noun* (*plural* **opinions**)
Your opinion is what you think about something. ▶ *In your opinion, which colour looks best?*

opponent *noun* (*plural* **opponents**)
Your opponent is the person that you are fighting or playing a game against. ▶ *We beat our opponents easily.*

opportunity *noun* (*plural* **opportunities**)
If you have an opportunity to do something, you have the chance to do it.

opposite *adjective, preposition*
1 facing something ▶ *The school is opposite the library.*
2 Things that are opposite are completely different. ▶ *North is the opposite direction to south.*

opposite *noun* (*plural* **opposites**)
The opposite of something is the thing that is completely different to it. ▶ *Big is the opposite of small.*

opposition *noun*
The opposition is the person or team that you are playing a game against.

optician *noun* (*plural* **opticians**)
someone who tests people's eyes and sells glasses to help them see better

optimistic *adjective*
If you are optimistic, you think that something good will happen.

option *noun* (*plural* **options**)
something that you can choose to do ▶ *I had to go for help – there was no other option.*

orange *noun* (*plural* **oranges**)
a round, juicy fruit with a thick, orange skin and sweet, juicy flesh

orange *adjective*
Something that is orange is the colour that you make when you mix red and yellow together.

orang-utan *noun* (*plural* **orang-utans**)
an ape with orange fur that lives in tropical forests in Asia

orbit *noun* (*plural* **orbits**)
When something is in orbit, it is moving round the sun or a planet.

orchard *noun* (*plural* **orchards**)
a field where a lot of fruit trees grow

orchestra *noun* (*plural* **orchestras**)
(-ch- in this word sounds like -k-)
a large group of people who play musical instruments together

ordeal *noun* (*plural* **ordeals**)
something very bad or frightening that happens to you

order *noun* (*plural* **orders**)
1 When you give someone an order, you tell them what they must do.
2 The order that things are in is the way that they are arranged, one after the other. ▶ *The words in a dictionary are in alphabetical order.*

order *verb* (**orders, ordering, ordered**)
1 If you order someone to do something, you tell them that they must do it.
2 If you order something in a shop or restaurant, you ask for it. ▶ *He ordered fish and chips.*

ordinary *adjective*
Something that is ordinary is normal and not different or special.

organ *noun* (*plural* **organs**)
1 a musical instrument like a piano with large air pipes where the sound comes out
2 Your organs are the parts inside your body like your heart and brain, that each do a particular job.

organic *adjective*
Food that is organic has been grown without using strong chemicals.

organize *verb* (**organizes, organizing, organized**)
When you organize something, you plan it and arrange it. ▶ *My mum helped me to organize the party.*

organization *noun* (*plural* **organizations**)
a large number of people who work together to do a job

origin *noun* (*plural* **origins**)
The origin of something is the way in which it started.

original *adjective*
1 An original part of something was there when it was first made. ▶ *My dad's old bike still has its original tyres.*
2 Something that is original is new and has not been copied from something else. ▶ *Try to think of some original ideas.*
❶ **Originally** means in the beginning, when something was first made.

ornament *noun* (*plural* **ornaments**)
something that you put in a place to make it look pretty

orphan *noun* (*plural* **orphans**)
a child whose mother and father are dead

ostrich *noun* (*plural* **ostriches**)
a very large bird with long legs and a heavy body. Ostriches can run very fast, but they cannot fly.

other *adjective, pronoun*
The other thing is a different thing, not this one. ▶ *I can't find my other shoe.*

otherwise *adverb*
or else ▶ *Hurry up otherwise we'll be late.*

otter *noun* (*plural* **otters**)
a furry animal that lives near water and catches fish to eat

ought

ought verb (pronounced **ort**)
If you ought to do something, you should do it. ▶ *You really ought to tidy your bedroom.*

ounce noun (plural **ounces**)
We can measure weight in ounces. One ounce is about 28 grams.

out adverb
1 away from ▶ *He pulled a rabbit out of his hat.*
2 not at home ▶ *I'm afraid Salim's out at the moment.*

outfit noun (plural **outfits**)
a set of clothes that you wear together ▶ *Mum bought me a new outfit to wear at the wedding.*

outing noun (plural **outings**)
a trip to a place

outlaw noun (plural **outlaws**)
someone long ago who had broken the law and as a punishment was no longer protected by the law

outline noun (plural **outlines**)
The outline of something is its shape.

output noun
The output is the information that you get out of a computer. The information that you put in is the **input**.

outside noun
The outside of something is the part around the edge of it, not the part in the middle.

outside preposition, adverb
not inside ▶ *We went outside to play in the garden.*

outstanding adjective
Something that is outstanding is extremely good.

oval noun
a shape that looks like an egg

oven noun (plural **ovens**)
the part of a cooker where you can bake or roast food

over adverb, preposition
1 above or on top of ▶ *He put a plaster over the cut.*
2 more than ▶ *There were over 200 people there.*
3 about ▶ *They were fighting over some sweets.*

overall noun (plural **overalls**)
something that you wear over other clothes to keep them clean

overboard adverb
If you fall overboard, you fall from a boat into the water.

overcoat noun (plural **overcoats**)
a thick, warm coat

overcome verb (**overcomes, overcoming, overcame, overcome**)
If you overcome a feeling, you manage to control it. ▶ *He managed to overcome his nervousness.*

overdue adjective
If something is overdue, it is late.

overflow verb (**overflows, overflowing, overflowed**)
When water overflows, it comes over the sides of the container that it is in.

overgrown adjective
A place that is overgrown is covered with messy plants.

overhead adverb
above your head ▶ *We saw a plane flying overhead.*

overhear verb (**overhears, overhearing, overheard**)
If you overhear something, you hear what other people are saying.

overjoyed adjective
If you are overjoyed, you are very happy. ▶ *We were overjoyed when we found the kitten again.*

overseas adverb
When you go overseas, you go to another country.

oversleep *verb* (oversleeps, oversleeping, overslept)
When you oversleep, you sleep for too long. ▶ *I overslept this morning and was late for school.*

overtake *verb* (overtakes, overtaking, overtook, overtaken)
To overtake someone means to catch them up and go past them. ▶ *We overtook a bus on the motorway.*

overturn *verb* (overturns, overturning, overturned)
If you overturn something, you knock it over.

overweight *adjective*
Someone who is overweight is too heavy and should lose some weight.

owe *verb* (owes, owing, owed)
If you owe money to someone, you have to pay it to them.

owl *noun* (*plural* **owls**)
a bird with large eyes that hunts at night for small animals

own *adjective, pronoun*
1 Something that is your own belongs to you.
2 If you are on your own, no one is with you.

own *verb* (owns, owning, owned)
If you own something, it is yours and it belongs to you.
❶ The **owner** of something is the person who owns it.

ox *noun* (*plural* **oxen**)
a large animal that is sometimes used for pulling carts

oxygen *noun* (*pronounced* **ox**-i-jen)
the gas in the air that everyone needs to breathe in order to stay alive

oyster *noun* (*plural* **oysters**)
a sea creature that you can eat. Oysters have hard shells.

ozone *noun*
a type of oxygen. The **ozone layer** is a layer of ozone high above the earth which protects us from the dangerous rays of the sun.

Pp

pace *noun* (*plural* **paces**)
a step forwards or backwards

pack *noun* (*plural* **packs**)
1 A pack of things is a number of things that you buy together. ▶ *I bought a pack of three chocolate bars.*
2 A pack of cards is a set of cards that you use for playing games.
3 A pack of dogs or wolves is a large group of them.

pack *verb* (packs, packing, packed)
When you pack things into a box, bag, or suitcase, you put them in.

package *noun* (*plural* **packages**)
a parcel

packaging *noun*
the box or paper that something is wrapped in when you buy it

packed *adjective*
If a place is packed, it is very full of people.

packet *noun* (*plural* **packets**)
a small box or bag that you buy things in ▶ *We bought a packet of biscuits.*

pad *noun* (*plural* **pads**)
1 A pad is a piece of thick, soft material that you use as a cushion or to protect something.
2 A helicopter pad is a place on the ground where a helicopter can land.
3 A pad of paper is a set of sheets that are joined together.

pad *verb* (pads, padding, padded)
If something is padded, it is thick and soft because it is filled with thick, soft material. ▶ *Goalkeepers wear special padded trousers.*

paddle

paddle noun (plural **paddles**)
a short pole with a flat part at one end. You use a paddle to make a canoe move.

paddle verb (**paddles, paddling, paddled**)
1 When you paddle, you walk about in shallow water. ▶ *We went paddling in the sea.*
2 When you paddle a canoe, you make it move through water.

padlock noun (plural **padlocks**)
a lock that you can put on a gate or bicycle

page noun (plural **pages**)
a piece of paper that is part of a book

paid verb SEE **pay**

pail noun (plural **pails**)
a bucket

pain noun (plural **pains**)
the feeling that you have in your body when something hurts ▶ *I've got a pain in my leg.*
ⓘ Something that is **painful** hurts you.

paint noun (plural **paints**)
a coloured liquid that you use for making pictures or for putting onto walls

paint verb (**paints, painting, painted**)
When you paint, you use paints to make a picture or decorate a wall.
ⓘ A **painter** is someone who paints. A **painting** is a picture that someone has painted.

pair noun (plural **pairs**)
two things that belong together ▶ *I need a new pair of shoes.*

pal noun (plural **pals**)
a friend

palace noun (plural **palaces**)
a very large house where a king or queen lives

pale adjective (**paler, palest**)
1 If you look pale, your face looks white because you are ill.
2 A pale colour is light and not dark.
▶ *She was wearing a pale green jumper.*

palm noun (plural **palms**)
1 Your palm is the inside part of your hand.
2 A palm tree is a tree that grows in tropical countries.

pamper verb (**pampers, pampering, pampered**)
To pamper someone means to spoil them by treating them too kindly.

pamphlet noun (plural **pamphlets**)
a small book that gives you information about something

pan noun (plural **pans**)
a metal pot that you use for cooking

pancake noun (plural **pancakes**)
a flat cake that you make by mixing together flour, milk, and eggs and then frying the mixture in a pan

panda noun (plural **pandas**)
an animal that looks like a large black and white bear. Pandas live in China and eat bamboo.

pander verb (**panders, pandering, pandered**)
If you pander to someone, you give them something that they want just to keep them happy.

pane noun (plural **panes**)
A pane of glass is a piece of glass in a window.

panel noun (plural **panels**)
1 a flat piece of wood that is part of a door or wall
2 a group of people who talk about something

panic verb (**panics, panicking, panicked**)
If you panic, you suddenly feel very frightened and cannot think what to do. ▶ *He panicked when he saw the fire.*

pant *verb* (**pants, panting, panted**)
When you pant, you take short, quick breaths because you have been running.

panther *noun* (*plural* **panthers**)
a wild animal that looks like a very big black cat

pantomime *noun* (*plural* **pantomimes**)
a special play with jokes and songs, which people perform at Christmas

pantry *noun* (*plural* **pantries**)
a small room where you keep food

pants *noun*
a piece of clothing that you wear over your bottom, underneath your other clothes

paper *noun* (*plural* **papers**)
1 Paper is the thin material that you use to write and draw on.
2 A paper is a newspaper.

parachute *noun* (*plural* **parachutes**)
a large piece of cloth that opens over your head and stops you from falling too quickly when you jump out of an aeroplane

parade *noun* (*plural* **parades**)
a long line of people marching along, while other people watch them

paradise *noun*
a wonderful place where everyone is happy

paraffin *noun*
a liquid that is made from oil. You can burn paraffin in lamps and heaters.

paragraph *noun* (*plural* **paragraphs**)
one section in a long piece of writing. You begin each new paragraph on a new line.

parallel *adjective*
Parallel lines are straight lines that go in the same direction and are always the same distance away from each other.

paralysed *adjective*
Someone who is paralysed cannot move or feel a part of their body.

parcel *noun* (*plural* **parcels**)
something that is wrapped up in paper

parched *adjective*
1 If you are parched, you are very thirsty.
2 Land that is parched is very dry.

pardon *verb* (**pardons, pardoning, pardoned**)
If you pardon someone, you forgive them.

parent *noun* (*plural* **parents**)
Your parents are your mother and father.

park *noun* (*plural* **parks**)
a large space with grass and trees where people can walk or play

park *verb* (**parks, parking, parked**)
When you park a car, you leave it in a place until you need it again.

parliament *noun* (*plural* **parliaments**)
the people who make the laws of a country

parrot *noun* (*plural* **parrots**)
a bird with brightly coloured feathers that lives in tropical forests

parsley *noun*
a plant with small, curly leaves that are sometimes added to food to make it taste nice

parsnip *noun* (*plural* **parsnips**)
a long, pale yellow vegetable

part *noun* (*plural* **parts**)
One part of something is one bit of it.
▶ *I've only read the first part of the story.*

participle *noun* (*plural* **participles**)
a part of a verb that can be used as an adjective, for example *frightened* or *frightening*

particular

particular *adjective*
1 only this one and no other ▶ *I wanted this particular colour.*
2 Someone who is particular is fussy and will only choose certain things. ▶ *She's particular about what she eats.*

particularly *adverb*
especially ▶ *I particularly like this book.*

partly *adverb*
not completely ▶ *The new school is only partly built.*

partner *noun* (*plural* **partners**)
Your partner is the person you are doing something with, for example when you are working or dancing.

part of speech *noun* (*plural* **parts of speech**)
a name that we give to different types of words. Adjectives, nouns, and verbs are different parts of speech.

party *noun* (*plural* **parties**)
a time when people get together to have fun and celebrate something

pass *verb* (**passes, passing, passed**)
1 When you pass something, you go past it. ▶ *I pass the sweet shop every day on my way to school.*
2 If you pass something to someone, you pick it up and give it to them. ▶ *Please could you pass me the milk?*
3 If you pass a test, you do well and are successful.

passage *noun* (*plural* **passages**)
a corridor ▶ *We got out through a secret underground passage.*

passenger *noun* (*plural* **passengers**)
a person who is travelling in a bus, train, ship, or aeroplane

Passover *noun*
a Jewish religious festival

passport *noun* (*plural* **passports**)
a special book or piece of paper with your name and photograph on it. Your passport shows who you are, and you must take it with you when you go to another country.

password *noun* (*plural* **passwords**)
a secret word that you use to go into a place or to use a computer

past *noun*
the time that has already gone ▶ *In the past people used candles instead of electric lights.*

past *preposition*
1 If you go past something, you go from one side of it to the other side. ▶ *We drove past the school.*
2 If it is past a certain time, it is after that time. ▶ *We didn't get home until past midnight.*

pasta *noun*
a type of food made from flour and water. Spaghetti and macaroni are kinds of pasta.

paste *noun*
something that is like a very thick, sticky liquid

pastime *noun* (*plural* **pastimes**)
something that you do to enjoy yourself in your free time

pastry *noun*
a mixture of flour, fat, and water that you roll flat and use for making pies

pat *verb* (**pats, patting, patted**)
When you pat something, you touch it gently with your hand. ▶ *Tom patted the dog on the head.*

patch *noun* (*plural* **patches**)
a small piece of material that you put over a hole in your clothes

path *noun* (*plural* **paths**)
a narrow road that you can walk along but not drive along

patient *noun* (*plural* **patients**)
someone who is ill and being looked after by a doctor

patient *adjective*
If you are patient, you can wait without getting cross or bored. ▶ *You will all have to be very patient and wait your turn.*

patio *noun* (*plural* **patios**)
a place next to a house where there are paving stones and people can sit

patrol *noun* (*plural* **patrols**)
a group of soldiers or policemen who walk around a place and guard it

pattern *noun* (*plural* **patterns**)
a design with lines, shapes, and colours ▶ *I drew a pattern round the edge of the page.*
❶ Something that is **patterned** has a pattern on it.

pause *noun* (*plural* **pauses**)
a short time when you stop what you are doing

pause *verb* (**pauses, pausing, paused**)
When you pause, you stop what you are doing for a short time.

pavement *noun* (*plural* **pavements**)
the path that people walk on along the side of a street

pavilion *noun* (*plural* **pavilions**)
a building next to a sports ground where players can get changed

paw *noun* (*plural* **paws**)
An animal's paws are its feet.

pay *verb* (**pays, paying, paid**)
When you pay for something, you give someone money so that you can have it.

PC *noun* (*plural* **PCs**)
a small computer for one person to use. PC is short for **personal computer**.

PE *noun*
a lesson at school in which you do sports and games. PE is short for **physical education**.

pea *noun* (*plural* **peas**)
a small, round, green vegetable

peace *noun*
1 When there is peace, there is no war.
2 When there is peace, there is no noise. ▶ *We enjoy the peace and quiet when the baby is asleep.*
❶ When a place is **peaceful**, there is no war and no noise.

peach *noun* (*plural* **peaches**)
a round, soft, juicy fruit with yellow flesh and a large stone in the middle

peacock *noun* (*plural* **peacocks**)
a large bird with long, brightly coloured tail feathers

peak *noun* (*plural* **peaks**)
1 A mountain peak is the top of a mountain.
2 The peak on a cap is the part that sticks out in front.

peanut *noun* (*plural* **peanuts**)
a small, round nut that grows in a pod in the ground

pear *noun* (*plural* **pears**)
a sweet, juicy fruit that is narrow at the top and round at the bottom

pearl *noun* (*plural* **pearls**)
a small, shiny, white ball that grows inside the shells of some oysters. People use pearls for making jewellery.

pebble *noun* (*plural* **pebbles**)
a small, round stone ▶ *We collected pebbles on the beach.*

pecan *noun* (*plural* **pecans**)
a nut that you can eat

peck *verb* (**pecks, pecking, pecked**)
When a bird pecks something, it touches it or picks it up with its beak.

peckish *adjective*
If you feel peckish, you feel a little bit hungry.

peculiar *adjective*
Something that is peculiar is strange. ▶ *This ice cream has a peculiar taste.*

pedal noun (plural **pedals**)
a part of a machine that you push with your foot to make it go

pedestrian noun (plural **pedestrians**)
someone who is walking

peek verb (**peeks, peeking, peeked**)
If you peek at something, you look at it quickly.

peel noun
The peel on a fruit or vegetable is its skin.

peel verb (**peels, peeling, peeled**)
When you peel fruit or vegetables, you take their skin off.

peep verb (**peeps, peeping, peeped**)
If you peep at something, you look at it quickly.

peer verb (**peers, peering, peered**)
If you peer at something, you look at it for a long time because you cannot see it very well.

peg noun (plural **pegs**)
1 a small clip that you use for fixing washing onto a line
2 a piece of metal or wood that you can hang things on ▶ *You can hang your coats on the pegs in the hall.*

pelican noun (plural **pelicans**)
a bird with a very large beak. Pelicans live near water and use their large beak for catching fish.

pellet noun (plural **pellets**)
a tiny ball of something

pelt verb (**pelts, pelting, pelted**)
If you pelt someone with things, you throw a lot of things at them. ▶ *They pelted the boys with snowballs.*

pen noun (plural **pens**)
something that you hold in your hand and use for writing with ink

pencil noun (plural **pencils**)
something that you hold in your hand and use for writing or drawing

pendant noun (plural **pendants**)
a piece of jewellery that you wear round your neck on a chain

pendulum noun (plural **pendulums**)
a weight that swings backwards and forwards. Some large old-fashioned clocks have pendulums to make them work.

penguin noun (plural **penguins**)
a large black and white bird that swims in the sea but cannot fly. Penguins live at the South Pole, and catch and eat fish.

penknife noun (plural **penknives**)
a small knife that folds up so that you can carry it safely

penny noun (plural **pence**)
a coin

pentagon noun (plural **pentagons**)
a shape with five straight sides

people noun
men, women, and children

pepper noun
1 Pepper is a powder with a hot taste that you add to food.
2 A pepper is a green, yellow, or red vegetable.

peppermint noun (plural **peppermints**)
a sweet that tastes of mint

pepperoni noun
a type of sausage with a hot, spicy flavour that is often put on pizzas

perch noun (plural **perches**)
a place where a bird rests when it is not flying

perch verb (**perches, perching, perched**)
When you perch somewhere, you sit there.

percussion noun
any musical instruments that you play by banging, hitting, or shaking them. Drums, cymbals, and tambourines are percussion instruments.

perfect *adjective*
Something that is perfect is so good that it cannot be any better.
❶ If you do something in a perfect way, you do it **perfectly**.

perform *verb* (**performs, performing, performed**)
When you perform, you do something in front of people to entertain them. ▶ *We performed the school play in front of our parents.*
❶ A **performance** is something like a play, dance, or song that you do in front of people.

perfume *noun* (*plural* **perfumes**)
a liquid with a nice smell that you put on your skin

perhaps *adverb*
possibly ▶ *Perhaps it will rain tomorrow.*

peril *noun* (*plural* **perils**)
danger ▶ *We are in great peril here.*

perimeter *noun*
The perimeter of something is the distance right round its edge. ▶ *We measured the perimeter of the field.*

period *noun* (*plural* **periods**)
a length of time ▶ *We all had to leave the building for a period of two hours.*

perish *verb* (**perishes, perishing, perished**)
To perish means to die. ▶ *The sailors perished in the storm.*

permanent *adjective*
Something that is permanent will last for ever.

permit *verb* (**permits, permitting, permitted**)
If you permit someone to do something, you allow them to do it.
❶ When you permit someone to do something, you give them **permission** to do it.

perplexed *adjective*
If you feel perplexed, you feel confused because you do not understand something.

persist *verb* (**persists, persisting, persisted**)
If you persist, you carry on doing something no matter what happens.

person *noun* (*plural* **people** or **persons**)
a man, woman, or child

personal *adjective*
Your personal things are the things that belong just to you.
❶ If you do something **personally**, you do it yourself.

personality *noun* (*plural* **personalities**)
Your personality is the type of person you are.

persuade *verb* (**persuades, persuading, persuaded**)
If you persuade someone to do something, you make them agree to do it. ▶ *Anita persuaded her mum to take her swimming.*

pessimistic *adjective*
If you are pessimistic, you think that something bad will happen.

pest *noun* (*plural* **pests**)
a person, animal, or plant that causes damage to things or annoys people

pester *verb* (**pesters, pestering, pestered**)
When you pester someone, you keep annoying them until they do what you want them to do. ▶ *I pestered my mum to let me have a dog.*

pet *noun* (*plural* **pets**)
an animal which you keep and look after

petal *noun* (*plural* **petals**)
The petals on a flower are the coloured parts.

petrified *adjective*
If you are petrified, you are very frightened.

petrol *noun*
a liquid that you put in cars to make them go

phantom

phantom noun (plural **phantoms**)
a ghost

Pharaoh noun (plural **Pharaohs**)
a king in ancient Egypt

phenomenal adjective
Something that is phenomenal is amazing or wonderful.

phone noun (plural **phones**)
a telephone

phone verb (**phones, phoning, phoned**)
When you phone someone, you use a telephone to speak to them.

phoneme noun (plural **phonemes**)
one sound in a language. Sometimes one phoneme can be written in different ways. For example, the phoneme 'n' can be written as 'n' (in the word 'new'), or it can be written as 'kn' (in the word 'knee').

phonics noun
Phonics are the different sounds that letters represent when they are written down. You can use phonics to help you learn to read by saying the sound of each letter in a word and then putting them all together to make the whole word.

photo noun (plural **photos**)
a photograph

photocopier noun (plural **photocopiers**)
a machine which can make a copy of a piece of writing or a picture
❶ When you **photocopy** something, you make a copy of it using a photocopier.

photograph noun (plural **photographs**)
a picture that you take with a camera

photograph verb (**photographs, photographing, photographed**)
When you photograph something, you take a photograph of it.
❶ A **photographer** is someone who takes photographs of people.

phrase noun (plural **phrases**)
a group of words that you use together. 'How do you do?' is a phrase.

physical adjective (pronounced **fizz-ic-al**)
Physical activities are activities that you do with your body, for example running and jumping.

piano noun (plural **pianos**)
a large musical instrument which has white and black keys that you press with your fingers to make different musical notes
❶ A **pianist** is someone who plays the piano.

pick verb (**picks, picking, picked**)
1 When you pick something, you choose it. ▶ *We picked Joshua to be the captain of our team.*
2 When you pick something up, you lift it up with your hand. ▶ *I picked up some shells on the beach.*
3 When you pick a flower or fruit, you take it off a plant.

picnic noun (plural **picnics**)
a meal of cold food that you eat outside

pictogram noun (plural **pictograms**)
a small picture that you use instead of a word

picture noun (plural **pictures**)
1 a painting, drawing, or photograph ▶ *She drew a picture of her cat.*
2 When you go to the pictures, you go to a cinema to watch a film.

pie noun (plural **pies**)
a type of food that has meat, vegetables, or fruit in the middle and pastry on the outside ▶ *We're having apple pie for pudding.*

piece noun (plural **pieces**)
A piece of something is a bit of it.
▶ *Would you like a piece of my birthday cake?*

pier noun (plural **piers**)
a long platform that is built out over the sea for people to walk on

pierce verb (**pierces, piercing, pierced**)
When you pierce something, you make a hole through it. ▶ *My mum says I'm too young to have my ears pierced.*

pig noun (plural **pigs**)
an animal with a large snout and a curly tail that is kept on farms for its meat

pigeon noun (plural **pigeons**)
a grey bird that often lives in towns

pig-headed adjective
Someone who is pig-headed will not change their mind.

piglet noun (plural **piglets**)
a young pig

pigtail noun (plural **pigtails**)
If you wear your hair in a pigtail, you twist it into a plait.

pile noun (plural **piles**)
A pile of things is a lot of things all on top of each other. ▶ *There was a huge pile of books on his desk.*

pill noun (plural **pills**)
a small tablet with medicine in, which you swallow when you are ill

pillar noun (plural **pillars**)
a wooden or stone post that helps to hold up a building

pillow noun (plural **pillows**)
a cushion that you rest your head on in bed

pilot noun (plural **pilots**)
someone who flies an aeroplane

pin noun (plural **pins**)
a thin piece of metal with a sharp point. You use pins to hold pieces of material together when you are sewing.

pincers noun
An animal's pincers are the claws that it uses for holding or catching things. Crabs have pincers.

pinch verb (**pinches, pinching, pinched**)
1 If you pinch someone, you squeeze their skin between your thumb and finger so that it hurts.
2 To pinch something means to steal it. ▶ *Who's pinched my pencil?*

pine noun (plural **pines**)
a tree with leaves like needles that do not fall in winter

pine verb (**pines, pining, pined**)
To pine for someone means to be very unhappy because you are missing them so much.

pineapple noun (plural **pineapples**)
a large fruit with yellow flesh that grows in hot countries

pink adjective
Something that is pink is very pale red.

pint noun (plural **pints**)
We can measure liquids in pints. One pint is about half a litre.

pip noun (plural **pips**)
a seed of a fruit such as an apple or orange

pipe noun (plural **pipes**)
1 a hollow tube that gas or liquid can go along
2 a tube with a small bowl at one end. People put tobacco in the bowl and smoke it through the tube.

pirate noun (plural **pirates**)
someone who sails in a ship and attacks and robs other ships at sea

pistol noun (plural **pistols**)
a small gun that you hold in one hand

pit noun (plural **pits**)
a deep hole in the ground

pitch noun (plural **pitches**)
A sports pitch is a piece of ground that is marked out so that you can play a game on it.

pity *noun*
1 If you feel pity for someone, you feel sorry for them.
2 If something is a pity, it is a shame. ▶ *What a pity that it's raining!*

pity *verb* (**pities, pitying, pitied**)
If you pity someone, you feel sorry for them.

pizza *noun* (*plural* **pizzas**)
a flat piece of dough with tomatoes, cheese, and other things on top

place *noun* (*plural* **places**)
a building or area of land ▶ *This looks like a nice place for a picnic.*

place *verb* (**places, placing, placed**)
When you place something somewhere, you put it there. ▶ *Place your rubbish in the bin.*

plaice *noun* (the plural is the same)
a sea fish that you can eat

plain *adjective* (**plainer, plainest**)
Something that is plain is ordinary, and not different or special. ▶ *I just made a plain cake.*

plain *noun* (*plural* **plains**)
a large area of flat ground ▶ *You can see for miles over the plain.*

plait *noun* (*plural* **plaits**) (*pronounced* **platt**)
a length of hair with three bits that have been twisted together

plait *verb* (**plaits, plaiting, plaited**) (*pronounced* **platt**)
When you plait hair, you twist three pieces together by crossing them over and under each other.

plan *noun* (*plural* **plans**)
1 If you have a plan, you have an idea about how to do something. ▶ *We need a clever plan if we want to escape from here.*
2 a map of a building or a town

plan *verb* (**plans, planning, planned**)
When you plan something, you decide what you are going to do and how you are going to do it.

plane *noun* (*plural* **planes**)
an aeroplane

planet *noun* (*plural* **planets**)
a very large object in space that moves around a star or around our sun. The earth is a planet.

plank *noun* (*plural* **planks**)
a long, flat piece of wood

plant *noun* (*plural* **plants**)
a living thing that grows in the soil. Trees, flowers, and vegetables are all plants.

plant *verb* (**plants, planting, planted**)
When you plant something, you put it in the ground to grow.

plaster *noun* (*plural* **plasters**)
1 a piece of sticky material that you put over a cut to keep it clean
2 a soft mixture that goes hard when it dries. Plaster is put onto the walls of buildings. A different sort of plaster is put onto someone's arm or leg when they have broken a bone.

plastic *noun*
a light strong material that is made in factories and is used for making all kinds of things

plasticine *noun*
a soft, coloured substance you can play with and use to make models

plate *noun* (*plural* **plates**)
a flat dish that you eat food from

platform *noun* (*plural* **platforms**)
1 the place in a station where people wait beside the railway lines for a train to come
2 a small stage in a hall

play *verb* (**plays, playing, played**)
1 When you play, you have fun. ▶ *Let's go and play.*
2 When you play an instrument, you use it to make music. ▶ *Can you play the piano?*
❶ A **player** is someone who is playing a game.

play *noun* (*plural* **plays**)
a story which people act so that other people can watch

playground *noun* (*plural* **playgrounds**)
a place outside where children can play

playgroup *noun* (*plural* **playgroups**)
a place where young children can go to play and learn things

plead *verb* (**pleads, pleading, pleaded**)
If you plead with someone, you beg them to do something. ▶ *She pleaded with her parents to buy a dog.*

pleasant *adjective*
Something that is pleasant is nice.

please *verb* (**pleases, pleasing, pleased**)
1 To please someone means to make them happy.
2 the polite word you say to someone when you are asking for something ▶ *Please may I have another biscuit?*

pleasure *noun*
the feeling that you have when you are happy and enjoying yourself

pleat *noun* (*plural* **pleats**)
a fold in the material of a dress or skirt

plenty *noun*
If there is plenty of something, there is as much as you need. ▶ *We've got plenty of food.*

pliers *noun*
a tool that you use for holding things tightly or for bending or breaking wire

plimsoll *noun* (*plural* **plimsolls**)
a type of light shoe made of cloth which you wear for doing sport

plod *verb* (**plods, plodding, plodded**)
When you plod along, you walk very slowly.

plot *noun* (*plural* **plots**)
a secret plan

plot *verb* (**plots, plotting, plotted**)
When you plot, you plan something secretly.

plough *noun* (*plural* **ploughs**)
(rhymes with *how*)
a large machine that is used on farms for digging and turning over the soil so that crops can be planted

pluck *verb* (**plucks, plucking, plucked**)
1 When you pluck something, you take it from the place where it is growing. ▶ *He plucked an apple from the tree.*
2 When you pluck a musical instrument, you play it by pulling on the strings with your fingers.

plug *noun* (*plural* **plugs**)
1 a round piece of plastic that you put into the hole in a bath or sink to stop the water from running out
2 the part of an electric machine or tool that you put into an electric socket to make it work

plum *noun* (*plural* **plums**)
a juicy fruit with a stone in the middle

plumber *noun* (*plural* **plumbers**)
a person whose job is to fit and mend water pipes and taps

plump *adjective* (**plumper, plumpest**)
Someone who is plump is quite fat.

plunge *verb* (**plunges, plunging, plunged**)
If you plunge into water, you jump in.

plural *noun* (*plural* **plurals**)
the form of a word that you use when you are talking about more than one person or thing. The plural of *book* is *books*.

plus *preposition*
add ▶ *Three plus three is six, 3 + 3 = 6.*

pneumonia

pneumonia noun (pronounced new-moan-ee-a)
a serious illness in your chest that makes it painful when you breathe

poach verb (**poaches, poaching, poached**)
1 When you poach food, you cook it gently in boiling water.
2 To poach animals means to hunt them on someone else's land, when you are not allowed to do this.

pocket noun (*plural* **pockets**)
a part of a piece of clothing that is like a small bag that you can keep things in

pocket money noun
money which someone gives you each week to buy things that you want

pod noun (*plural* **pods**)
a long thin part of a plant that has seeds inside. Peas grow in pods.

poem noun (*plural* **poems**)
a piece of writing that is written in lines and uses rhythms and rhymes in a clever way
ⓘ A **poet** is someone who writes poems. **Poetry** is poems.

point noun (*plural* **points**)
1 a thin, sharp part on the end of something ▶ *You should always hold scissors with the points down.*
2 a particular place or time ▶ *We should soon reach the point where we can see the sea.*
3 a mark that you score in a game ▶ *Our team scored the most points.*

point verb (**points, pointing, pointed**)
1 When you point at something, you show it to someone by holding your finger out towards it.
2 When you point a weapon at something, you aim the weapon towards it.

pointed adjective
something that is pointed has a sharp point at one end

poison noun (*plural* **poisons**)
something that will kill you or make you ill if you swallow it
ⓘ Something that is a poison is **poisonous**.

poke verb (**pokes, poking, poked**)
If you poke something, you push it with your finger or with a stick. ▶ *He poked the seaweed with a stick.*

poker noun (*plural* **pokers**)
a metal stick that you use for poking a fire

polar bear noun (*plural* **polar bears**)
a very large, white bear that lives near the North Pole

pole noun (*plural* **poles**)
a long stick

police noun
The police are the people whose job is to catch criminals and make sure that people do not break the law.

polish noun (*plural* **polishes**)
a liquid or cream that you rub into something to make it shine

polish verb (**polishes, polishing, polished**)
When you polish something, you rub it to make it shine. ▶ *I think you should polish your shoes!*

polite adjective (**politer, politest**)
Someone who is polite has good manners and is not rude to people.
ⓘ If you say or do something in a polite way, you do it **politely**.

politician noun (*plural* **politicians**)
a person who works in the government of a country

politics noun
the work that the government of a country does

pollen noun
a yellow powder that you find inside flowers. Pollen is carried from one flower to another by the wind or by insects so that the flowers can produce seeds.

pollute verb (pollutes, polluting, polluted)
To pollute air or water means to make it dirty. ▶ *Some factories pollute rivers by tipping chemicals into them.*
ℹ **Pollution** is dirt in the air or in water.

polyester noun
a type of material that is used for making clothes and other things

polythene noun
a type of plastic material that is used for making bags

pond noun (plural **ponds**)
a small lake

pony noun (plural **ponies**)
a small horse

ponytail noun (plural **ponytails**)
If you wear your hair in a ponytail, you wear it tied in a long bunch at the back of your head.

poodle noun (plural **poodles**)
a type of dog with thick, curly hair

pool noun (plural **pools**)
a small area of water

poor adjective (poorer, poorest)
1 Someone who is poor does not have very much money.
2 Something that is poor is bad. ▶ *This is very poor work*
3 A poor person is unlucky or unhappy. ▶ *You poor child!*

poorly adjective
If you are poorly, you are ill.

pop verb (pops, popping, popped)
If something pops, it bursts with a loud bang.

pop noun
Pop is modern music that people dance to.

popcorn noun
a food that is made by heating grains of corn until they burst and become big and fluffy

poppy noun (plural **poppies**)
a bright red wild flower

popular adjective
If something is popular, a lot of people like it. ▶ *Football is a very popular sport.*

population noun
The population of a place is the number of people who live there.

porch noun (plural **porches**)
a place in front of the door of a building where people can wait before they go in

porcupine noun (plural **porcupines**)
an animal with a lot of stiff, sharp hairs on its back

pork noun
meat from a pig

porpoise noun (plural **porpoises**)
a sea animal that is like a small whale

porridge noun
a hot food that you make by cooking oats in water or milk. People sometimes eat porridge for breakfast.

port noun (plural **ports**)
a place on the coast where ships can come to the land to load or unload goods

portable adjective
If something is portable, you can carry it or move it easily. ▶ *My parents bought me a portable television.*

porter noun (plural **porters**)
someone whose job is to carry other people's luggage in a hotel or at a railway station

portion noun (plural **portions**)
A portion of food is an amount that you give to one person. ▶ *I bought a small portion of chips.*

portrait noun (plural **portraits**)
a painting or drawing of a person

posh adjective (posher, poshest)
Something that is posh is very smart and expensive.

position

position noun (plural **positions**)
1 The position of something is the place where it is. ▶ *We don't know the exact position of the ship at the moment.*
2 Your position is the way that you are standing, sitting, or lying. ▶ *I had to sit in a very uncomfortable position.*

positive adjective
If you are positive about something, you are completely sure about it.

possess verb (**possesses, possessing, possessed**)
If you possess something, you own it.

possible adjective
If something is possible, it can happen or it might happen. ▶ *It's possible that it will rain this afternoon.*

post noun (plural **posts**)
1 A post is a pole that is fixed in the ground.
2 The post is all the letters and parcels that are delivered to people's houses.

post verb (**posts, posting, posted**)
When you post a letter or parcel, you send it to someone.

postcard noun (plural **postcards**)
a piece of card with a picture on one side. You write on the other side and send it to someone.

postcode noun (plural **postcodes**)
letters and numbers that you put at the end of someone's address when you are sending them a letter

poster noun (plural **posters**)
a large picture or notice that you put up on a wall

postman noun (plural **postmen**)
a man who delivers letters and parcels to people's houses. A woman who does this is a **postwoman**.

post office noun (plural **post offices**)
a place where you can go to buy stamps and post letters and parcels

postpone verb (**postpones, postponing, postponed**)
If you postpone something, you decide to do it later.

pot noun (plural **pots**)
a round container that you can put or keep things in

potato noun (plural **potatoes**)
a round white vegetable that you dig out of the ground

potion noun (plural **potions**)
a drink with medicine or poison in it

pottery noun
cups, plates, and other things that are made from clay

pouch noun (plural **pouches**)
1 a small bag that you can keep things in
2 a pocket of skin that some animals have on their bodies for carrying their young

poultry noun
birds such as hens, ducks, and turkeys that are kept on farms for their meat and eggs

pounce verb (**pounces, pouncing, pounced**)
To pounce on something means to attack it by jumping on it suddenly.

pound noun (plural **pounds**)
1 We can measure weight in pounds. One pound is about half a kilogram. ▶ *We'll need two pounds of sugar.*
2 an amount of money. Pounds are used in Britain and some other countries.

pour verb (**pours, pouring, poured**)
1 When you pour a liquid, you tip it into a container. ▶ *Dad poured some milk into a glass.*
2 When a liquid is pouring out of something, it is coming out very quickly. ▶ *Water was pouring out of the burst pipe.*

powder noun
a substance like flour that is dry and made of lots of tiny bits

power noun (plural **powers**)
1 If you have power, you can do what you want, or make other people do what you want. ▶ *Teachers have a lot of power.*
2 If you have special powers, you are able to do magic things.
3 Power is energy that makes machines work. ▶ *There isn't enough power in these old batteries.*

powerful adjective
1 Someone who is powerful has a lot of power over other people. ▶ *He was a rich and powerful king.*
2 Something that is powerful is very strong. ▶ *We had to use a very powerful digging machine.*

practical adjective
A practical person is good at working with their hands and doing useful things.

practical joke noun (plural **practical jokes**)
a trick that you play on someone

practically adverb
almost ▶ *The model is practically finished.*

practice noun
practice is when you do something again and again so that you will get better at it ▶ *You must do your piano practice every day.*

practise verb (**practises, practising, practised**)
When you practise, you keep doing something over and over again so that you will get better at it. ▶ *If you keep practising you will soon improve.*

prairie noun (plural **prairies**)
a large area of land with long grass growing on it

praise verb (**praises, praising, praised**)
To praise someone means to tell them that they have done well.

pram noun (plural **prams**)
a bed on wheels in which you can push a baby along

prance verb (**prances, prancing, pranced**)
If you prance around, you jump and dance around.

prank noun (plural **pranks**)
a trick that you play on someone for fun

prawn noun (plural **prawns**)
a small sea creature with a shell. You can cook and eat prawns.

pray verb (**prays, praying, prayed**)
When people pray, they talk to a god.
❶ When people pray, they say a **prayer**.

preach verb (**preaches, preaching, preached**)
When someone preaches, they talk to people about religion.

precious adjective (pronounced **presh-uss**)
Something that is precious is worth a lot of money, or is very special to someone. ▶ *She hid the precious jewels under her bed.*

precise adjective
Something that is precise is exact and correct.

predator noun (plural **predators**)
an animal that hunts and kills other animals for food

predict verb (**predicts, predicting, predicted**)
If you predict something, you say that it will happen in the future.

prefer verb (**prefers, preferring, preferred**)
If you prefer one thing to another, you like it more. ▶ *I prefer singing to dancing.*

prefix noun (plural **prefixes**)
letters that are added to the front of a word to change its meaning ▶ *'Un-' and 'dis-' are prefixes.*

pregnant

pregnant *adjective*
A woman who is pregnant has a baby growing inside her.

prehistoric *adjective*
Prehistoric times were times long ago.

prejudice *noun* (*plural* **prejudices**)
If you have a prejudice against someone, you do not like them but have no reason not to like them.

prepare *verb* (**prepares, preparing, prepared**)
When you prepare something, you get it ready. ▶ *We prepared lunch.* ▶ *We spent the afternoon preparing for the party.*

preposition *noun* (*plural* **prepositions**)
a word such as *in* or *on*, that goes in front of a noun

prescription *noun* (*plural* **prescriptions**)
a note from a doctor that says what medicine you need

present *adjective*
1 If you are present in a place, you are there.
2 The present time is the time that is happening now.

present *noun* (*plural* **presents**)
1 something that you give to someone ▶ *I gave Katy a book for her birthday present.*
2 The present is the time that is happening now.

present *verb* (**presents, presenting, presented**)
1 If you present something to someone, you give it to them. ▶ *The head presented the prizes to the winners.*
2 When someone presents a show, they introduce it.
ⓘ A **presenter** is someone who presents a show on television.

preserve *verb* (**preserves, preserving, preserved**)
To preserve something means to keep it safe and in good condition. ▶ *It is important to preserve these beautiful old buildings.*

president *noun* (*plural* **presidents**)
someone who rules a country

press *verb* (**presses, pressing, pressed**)
When you press something, you push it with your finger. ▶ *What will happen if I press this button?*

press *noun*
The press is a general name for newspapers.

pressure *noun*
1 Pressure is a force which pushes against something. ▶ *If you cut yourself, you need to apply pressure to the cut to stop it bleeding.*
2 If you put pressure on someone, you try to make them do something.

presume *verb* (**presumes, presuming, presumed**)
If you presume that something is true, you suppose that it is true but you do not know for certain.

pretend *verb* (**pretends, pretending, pretended**)
When you pretend, you say things or do things that are not really true. ▶ *We all thought that Ali was hurt, but he was only pretending.*

pretty *adjective* (**prettier, prettiest**)
1 Something that is pretty is nice to look at. ▶ *That's a very pretty dress.*
2 A pretty girl or woman has a beautiful face.

prevent *verb* (**prevents, preventing, prevented**)
If you prevent something from happening, you stop it from happening. ▶ *He shut the door to prevent anyone from leaving.*

previous *adjective*
The previous thing is the one that came just before this one. ▶ *We had got things ready on the previous day.*

prey *noun*
An animal's prey is the animal that it hunts and kills.

price *noun* (*plural* **prices**)
The price of something is the amount of money you have to pay for it.

priceless *adjective*
Something that is priceless is very valuable indeed.

prick *verb* (**pricks, pricking, pricked**)
When you prick something, you make a tiny hole in it with something sharp. ▶ *I pricked my finger with a needle.*

prickle *noun* (*plural* **prickles**)
Prickles are sharp points on a plant.

pride *noun*
the feeling you have when you are proud

priest *noun* (*plural* **priests**)
a person who leads other people in religious ceremonies

primary school *noun* (*plural* **primary schools**)
a school for children from five up to eleven years old

prime minister *noun* (*plural* **prime ministers**)
the leader of a country's government

prime number *noun* (*plural* **prime numbers**)
a number that can only be divided by the number 1 and by itself. 3 and 7 are prime numbers.

primrose *noun* (*plural* **primroses**)
a small, pale yellow flower that comes out early in the spring

prince *noun* (*plural* **princes**)
the son of a king or queen

princess *noun* (*plural* **princesses**)
1 the daughter of a king or queen
2 the wife of a prince

principle *noun* (*plural* **principles**)
an important rule that you follow ▶ *One of our principles is that all children must take part in sports day.*

print *verb* (**prints, printing, printed**)
1 When you print words, you write them with letters that are not joined together. ▶ *Please print your name at the top of the page.*
2 When a machine prints words or pictures, it puts them onto paper.
❶ A **printer** is a machine that can print words and pictures from a computer onto paper.

prison *noun* (*plural* **prisons**)
a place where people are kept as a punishment

prisoner *noun* (*plural* **prisoners**)
someone who is locked up in a place and not allowed to leave

private *adjective*
Something that is private is only for some people, not for everyone. ▶ *The hotel has its own private beach.*

prize *noun* (*plural* **prizes**)
something that you get if you win a game or competition

probable *adjective*
If it is probable that something will happen, it is very likely that it will happen.
❶ If something will **probably** happen, it is very likely that it will happen.

problem *noun* (*plural* **problems**)
something that is difficult ▶ *I would love to come to your party, but the problem is I can't get there.*

process *noun* (*plural* **processes**)
a series of actions that you do one after the other, and that take a long time. ▶ *We had to wash all the clothes by hand, which was a very long process.*

procession *noun* (*plural* **processions**)
a group of people who are walking or driving along in a long line

prod

prod verb (**prods, prodding, prodded**)
If you prod something, you push it with your finger or with a stick.

produce verb (**produces, producing, produced**)
1 To produce something means to make it. ▶ *Cows produce milk.*
2 If you produce something, you bring it out of a box or bag. ▶ *Anita produced a camera from her bag.*

product noun (*plural* **products**)
something that has been made so that it can be sold to people in shops

professional adjective
Someone who is professional does something as their job, not just for fun. ▶ *It is very difficult to become a professional dancer.*

professor noun (*plural* **professors**)
someone who teaches in a university

profit noun (*plural* **profits**)
If you make a profit, you make money by selling something for more than you paid to buy it or make it.

program noun (*plural* **programs**)
A computer program is a list of instructions that the computer follows.

programme noun (*plural* **programmes**)
1 a show on the radio or television
2 a small book that tells you what will happen at an event

progress noun
When you make progress, you get better at doing something. ▶ *You have made a lot of progress with your maths this term.*

project noun (*plural* **projects**)
a piece of work where you find out as much as you can about something interesting and write about it ▶ *We're doing a project on India.*

projector noun (*plural* **projectors**)
a machine that shows pictures or films on a screen

promise verb (**promises, promising, promised**)
If you promise to do something, you say that you will definitely do it. ▶ *Don't forget – you promised to help me wash the car.*

prompt adjective (**prompter, promptest**)
If you are prompt, you do something quickly, without waiting and without being late.

prone adjective
If you are prone to an illness, you often get it.

prong noun (*plural* **prongs**)
The prongs on a fork are the thin, pointed parts.

pronoun noun (*plural* **pronouns**)
a word that you use instead of a noun. *He*, *she*, and *it* are all pronouns.

pronounce verb (**pronounces, pronouncing, pronounced**)
The way you pronounce a word is the way you say it. ▶ *How do you pronounce your name?*
❶ The **pronunciation** of a word is the way in which you say it.

proof noun
If there is proof that something happened, there is something that shows that it definitely happened. ▶ *We think we know who stole the books, but we have no proof.*

prop verb (**props, propping, propped**)
If you prop something somewhere, you lean it there so that it does not fall over. ▶ *He propped his bicycle against the wall.*

propeller noun (*plural* **propellers**)
a set of blades that spin round to make something move

proper *adjective*
The proper thing is the correct or right one. ▶ *Put the books back in their proper places.*
❶ If you do something in the correct way, you do it **properly**. ▶ *Make sure you clean your teeth properly.*

proper noun *noun* (*plural* **proper nouns**)
a noun that is the name of a person or place. For example, *London* and *Tom* are proper nouns.

property *noun* (*plural* **properties**)
If something is your property, it belongs to you.

prophet *noun* (*plural* **prophets**)
1 someone who says what will happen in the future
2 a great religious teacher

propose *verb* (**proposes, proposing, proposed**)
If you propose something, you suggest it as an idea. ▶ *I propose that we go to the seaside for the day.*

prosperous *adjective*
Someone who is prosperous is rich and successful.

protect *verb* (**protects, protecting, protected**)
To protect someone means to keep them safe and stop them being hurt. ▶ *A mother cat will always protect her young.*
❶ If something protects you, it gives you **protection**.

protein *noun*
something that is found in some types of food, for example meat, eggs, and cheese. Your body needs protein to help you grow.

protest *verb* (**protests, protesting, protested**)
If you protest about something, you say that you do not like it or do not agree with it.

proud *adjective* (**prouder, proudest**)
If you are proud of something, you are pleased with it and think that it is very good. ▶ *I'm very proud of this painting.*
❶ **Pride** is the feeling you have when you are proud.

prove *verb* (**proves, proving, proved**)
To prove that something is true means to show that it is definitely true. ▶ *These footprints prove that someone has been in the garden.*

proverb *noun* (*plural* **proverbs**)
a short, well-known saying which gives you advice about something

provide *verb* (**provides, providing, provided**)
If you provide something for people, you give it to them. ▶ *The school provides us with books and pencils.*

prowl *verb* (**prowls, prowling, prowled**)
To prowl means to walk around very quietly and secretly.

prune *noun* (*plural* **prunes**)
a dried plum

pry *verb* (**pries, prying, pried**)
If you pry, you try to find out about something that has nothing to do with you. ▶ *You shouldn't pry into other people's business.*

pub *noun* (*plural* **pubs**)
a place where people can go to have a drink and meet friends

public *adjective*
Something that is public can be used by everyone. ▶ *Is there a public swimming pool in your town?*

publish *verb* (**publishes, publishing, published**)
To publish a book means to print it and sell it.

pudding *noun* (*plural* **puddings**)
any sweet food which you eat after the main part of a meal ▶ *What are we having for pudding?*

puddle

puddle noun (plural **puddles**)
a small pool of water

puff verb (**puffs, puffing, puffed**)
1 When a train puffs, it blows out smoke as it goes along.
2 If you are puffing, you are out of breath because you have been running.

puffin noun (plural **puffins**)
a bird that lives near the sea and has a large orange and blue beak

pull verb (**pulls, pulling, pulled**)
When you pull something, you get hold of it and move it towards you.

pullover noun (plural **pullovers**)
a jumper

pulse noun
Your pulse is the regular pumping of blood round your body. You can feel your pulse in your neck or wrist.

pump noun (plural **pumps**)
a machine that pushes air or water into something or out of something
▶ *You use a bicycle pump to put air into tyres.*

pump verb (**pumps, pumping, pumped**)
When you pump water or air, you force it into something or out of something. ▶ *The firemen pumped all the water out of the flooded house.*

pumpkin noun (plural **pumpkins**)
a very large, round orange vegetable

pun noun (plural **puns**)
a joke that is funny because it uses words that sound the same, or words that have two different meanings. For example, 'eggs are very eggs-pensive' is a pun.

punch verb (**punches, punching, punched**)
If you punch someone, you hit them with your fist.

punctual adjective
If you are punctual, you arrive exactly on time.

punctuation noun
all the marks such as commas and full stops that you put into a piece of writing to make it easier to read

puncture noun (plural **punctures**)
a small hole in a tyre

punish verb (**punishes, punishing, punished**)
To punish someone means to make them suffer because they have done something wrong. ▶ *The teacher punished us by keeping us inside at lunch time.*
❶ A **punishment** is something nasty that happens to you when you have done something wrong.

pupil noun (plural **pupils**)
1 A pupil is a child who goes to school. ▶ *This school has 500 pupils.*
2 Your pupils are the black circles in the middle of your eyes.

puppet noun (plural **puppets**)
a small doll that you can move by pulling on strings, or by putting it over your hand like a glove and then moving your hand

puppy noun (plural **puppies**)
a young dog

pure adjective (**purer, purest**)
Something that is pure is one thing only, with nothing else mixed in.
▶ *She was wearing a necklace made of pure gold.*

purple adjective
Something that is purple is the colour that you make by mixing red and blue together.

purpose noun (plural **purposes**)
The purpose of something is the reason why you are doing it.
on purpose If you do something on purpose, you do it deliberately.
▶ *I didn't bump into you on purpose.*

purr verb (**purrs, purring, purred**)
When a cat purrs, it makes a low, rumbling sound because it is happy.

purse noun (plural **purses**)
a small bag that you carry money in

push verb (**pushes, pushing, pushed**)
When you push something, you use your hands to move it away from you.

pushchair noun (plural **pushchairs**)
a chair on wheels that you can push a small child in

pussy noun (plural **pussies**)
a cat or kitten

put verb (**puts, putting, put**)
1 When you put something in a place, you move it so that it is there. ▶ *Please put the book back on the shelf.*
2 If you put something off, you decide to do it later instead of now.

puzzle noun (plural **puzzles**)
1 a game in which you have to do something difficult or find the answer to a difficult question
2 If something is a puzzle, no one can explain it or understand it. ▶ *The disappearance of the jewels is still a puzzle.*

puzzle verb (**puzzles, puzzling, puzzled**)
If something puzzles you, it seems strange and you do not understand it.

pyjamas noun
loose trousers and a top that you wear in bed

pylon noun (plural **pylons**)
a tall metal tower that holds up high electric cables

pyramid noun (plural **pyramids**)
a large, stone building that was made by the ancient Egyptians to bury a dead king or queen

python noun (plural **pythons**)
a large snake that kills animals by wrapping its body around them and crushing them

Qq

quack verb (**quacks, quacking, quacked**)
When a duck quacks, it makes a loud sound.

quadrilateral noun (plural **quadrilaterals**)
any shape that has four straight sides. A square is a type of quadrilateral.

quaint adjective (**quainter, quaintest**)
Something that is quaint is pretty and old-fashioned. ▶ *What a quaint little cottage!*

quake verb (**quakes, quaking, quaked**)
When you quake, you shake because you are very frightened.

qualify verb (**qualifies, qualifying, qualified**)
1 When you qualify, you pass a test or exam so that you are allowed to do a job. ▶ *My mum has just qualified as a doctor.*
2 When you qualify in a competition, you get enough points to go on to the next part of the competition.
▶ *England managed to qualify for the World Cup.*

quality noun (plural **qualities**)
The quality of something is how good or bad it is. ▶ *You need good quality paper for model-making.*

quantity noun (plural **quantities**)
A quantity is an amount. ▶ *We measured the quantity of water in the jug.*

quarrel verb (**quarrels, quarrelling, quarrelled**)
When people quarrel, they argue with each other in an angry way.

quarry

quarry noun (plural **quarries**)
a place where people cut stone out of the ground so that it can be used for building

quarter noun (plural **quarters**)
One quarter of something is one of four equal parts that the thing is divided into. It can also be written as $\frac{1}{4}$.

quay noun (plural **quays**) (sounds like **key**)
a place where ships can be loaded and unloaded

queasy adjective
If you feel queasy, you feel sick.

queen noun (plural **queens**)
a woman who rules a country. A woman becomes queen because she is born into a royal family, or because she marries a king.

queer adjective (**queerer**, **queerest**)
Something that is queer is very strange.

quench verb (**quenches**, **quenching**, **quenched**)
When you quench your thirst, you drink something so that you do not feel thirsty any more.

query noun (plural **queries**)
a question

quest noun (plural **quests**)
a long journey in which you are searching for something

question noun (plural **questions**)
When you ask a question, you ask someone something because you want to know the answer.

question mark noun (plural **question marks**)
a mark like this ? that you use in writing. You put a question mark at the end of a sentence to show that it is a question.

questionnaire noun (plural **questionnaires**)
a sheet of paper with a lot of questions on it to collect information from people

queue noun (plural **queues**) (pronounced **kyoo**)
a line of people who are waiting for something

queue verb (**queues, queueing, queued**)
When people queue, they wait in a queue.

quiche noun (plural **quiches**)
a type of food with pastry on the bottom and sides and a filling made from eggs, cheese, and other things

quick adjective (**quicker, quickest**)
Something that is quick does not take very long. ▶ *We had a quick lunch and then set out.*
❶ If you do something in a quick way, you do it **quickly**.

quiet adjective (**quieter, quietest**)
1 If a place is quiet, there is no noise there. ▶ *The school was deserted and all the classrooms were quiet.*
2 Something that is quiet is not very loud. ▶ *He spoke in a very quiet voice.*
❶ If you do something in a quiet way, you do it **quietly**.

quilt noun (plural **quilts**)
a thick, warm cover for a bed

quit verb (**quits, quitting, quitted**)
1 If you quit doing something, you stop doing it.
2 When you quit a file or program on a computer, you close it.

quite adverb
1 slightly, but not very ▶ *The film was quite good.*
2 completely ▶ *We haven't quite finished.*

quiver verb (**quivers, quivering, quivered**)
If you quiver, you shake because you are very cold or frightened.

quiz *noun* (*plural* **quizzes**)
a game in which people try to answer a lot of questions

quote *verb* (**quotes, quoting, quoted**)
When you quote words from a book or poem, you repeat them. ▶ *The teacher quoted some lines from a poem.*

quotation marks *noun*
marks like this ' ' or this " " that you use in writing. You put these marks round words to show that someone has spoken them.

Rr

rabbi *noun* (*plural* **rabbis**)
a Jewish religious leader

rabbit *noun* (*plural* **rabbits**)
a small furry animal with long ears. Rabbits live in holes in the ground and use their strong back legs to hop about.

race *verb* (**races, racing, raced**)
When people race, they run or swim against each other to find out who is the fastest.

race *noun* (*plural* **races**)
1 a competition in which people run or swim against each other to find out who is the fastest
2 a group of people who come from the same part of the world and look the same because they have the same colour skin, the same type of hair, and so on

racist *noun* (*plural* **racists**)
someone who treats other people unfairly because they have different colour skin or come from a different country

rack *noun* (*plural* **racks**)
a shelf made of bars that you can put things on

racket *noun* (*plural* **rackets**)
1 a bat that you use for hitting a ball in a game of tennis or badminton. It has a round frame with strings stretched across it.
2 If someone is making a racket, they are making a lot of loud noise.

radar *noun*
a way of finding where a ship or aeroplane is when you cannot see it by using radio waves

radiator *noun* (*plural* **radiators**)
a metal heater which hot water flows through to keep a room warm

radio *noun* (*plural* **radios**)
a machine that picks up signals that are sent through the air and changes them into music or talking that you can listen to

radish *noun* (*plural* **radishes**)
a small, round, red vegetable that you eat raw in salads

radius *noun* (*plural* **radii**)
The radius of a circle is how much it measures from the centre to the edge.

raffle *noun* (*plural* **raffles**)
a competition in which people buy tickets with numbers on them. If their tickets are chosen, they win a prize.

raft *noun* (*plural* **rafts**)
a flat boat made of logs joined together

rag *noun* (*plural* **rags**)
A rag is a torn piece of cloth.
ℹ Clothes that are **ragged** are old and torn.

rage *noun* (*plural* **rages**)
a feeling of very strong anger ▶ *His face was scarlet with rage.*

raid

raid *noun* (*plural* **raids**)
When people carry out a raid, they attack a place because they want to steal something or find something.

rail *noun* (*plural* **rails**)
1 A rail is a metal or wooden bar that is part of a fence.
2 Rails are the long metal bars that trains travel on.
3 When you travel by rail, you travel in a train.

railings *noun*
a fence made of a row of metal bars that stand upright next to each other

railway *noun* (*plural* **railways**)
1 A railway line is the long metal bars that trains travel on.
2 When you travel on the railway, you travel by train.

rain *noun*
drops of water that fall from the sky

rain *verb* (**rains, raining, rained**)
When it rains, drops of water fall from the sky. ▶ *We'll go out when it stops raining.*

rainbow *noun* (*plural* **rainbows**)
a curved band of different colours you see in the sky when the sun shines through rain

rainforest *noun* (*plural* **rainforests**)
a large forest in a tropical part of the world, where there is a lot of rain

raise *verb* (**raises, raising, raised**)
1 When you raise something, you lift it up so that it is higher.
2 When you raise money, you collect it so that you can give it to a school or charity.

raisin *noun* (*plural* **raisins**)
a dried grape that you use to make fruit cakes

rake *noun* (*plural* **rakes**)
a tool that you use in the garden for making the soil smooth

rake *verb* (**rakes, raking, raked**)
When you rake the ground, you pull a rake over it to make it smooth. ▶ *He raked up the dead leaves.*

rally *noun* (*plural* **rallies**)
1 a big meeting for a lot of people, which is held outside
2 a race for cars or motorcycles
3 When there is a rally in a game of tennis, the players hit the ball over the net several times before someone wins a point.

ram *noun* (*plural* **rams**)
a male sheep

ram *verb* (**rams, ramming, rammed**)
When you ram something into a place, you push it there very hard.

Ramadan *noun*
the ninth month of the Muslim year. During Ramadan, Muslims do not eat or drink anything during the day, from the time the sun comes up each morning until it sets in the evening.

ramble *verb* (**rambles, rambling, rambled**)
When you go rambling, you go for a long walk in the country.

ramp *noun* (*plural* **ramps**)
a slope that you can walk or drive up to go from one level to another level

ran *verb* SEE **run**

ranch *noun* (*plural* **ranches**)
a large farm in America where a lot of cows or horses are kept

rancid *adjective*
Rancid butter is old and has a nasty taste.

random *adjective*
If things happen in a random way, they do not happen in a particular order.

rang *verb* SEE **ring**

range noun (plural **ranges**)
1 A range of mountains or hills is a line of them.
2 A range of things is a collection of different things. ▶ *The shop sells a wide range of toys and books.*

rank noun (plural **ranks**)
Someone's rank is the title that they have, which shows how important they are. ▶ *He joined the navy and rose to the rank of captain.*

ransack verb (**ransacks, ransacking, ransacked**)
To ransack a place means to leave it in a very untidy mess because you have been looking for something.

ransom noun (plural **ransoms**)
When someone demands a ransom, they demand money before they will give back something that they have stolen.

rap noun (plural **raps**)
1 A rap on a door is a knock on a door.
2 Rap is a type of poetry that you speak aloud with a strong rhythm.

rapid adjective
Something that is rapid happens very quickly.

rare adjective (**rarer, rarest**)
If something is rare, you do not see it or find it very often. ▶ *Pandas are very rare animals.*
❶ If something happens **rarely**, it does not happen very often.

rascal noun (plural **rascals**)
a naughty child

rash noun (plural **rashes**)
If you have a rash, you have red spots on your skin.

raspberry noun (plural **raspberries**)
a soft, sweet, red berry

rat noun (plural **rats**)
an animal that looks like a large mouse

rate noun (plural **rates**)
The rate at which something happens is how quickly it happens. ▶ *The tide was coming in at an alarming rate.*

rather adverb
1 quite ▶ *It's rather cold today.* ▶ *The teacher was rather cross with us.*
2 If you would rather do something, you would prefer to do it. ▶ *I don't like shopping - I'd rather stay at home.*

ration noun (plural **rations**)
an amount of food that one person is allowed to have when there is not very much

rattle verb (**rattles, rattling, rattled**)
When something rattles, it makes a loud noise because it is being shaken.

rattle noun (plural **rattles**)
a toy for a baby which makes a noise when you shake it

rave verb (**raves, raving, raved**)
If you rave about something, you talk about it in a very excited way, and say how good it is.

raven noun (plural **ravens**)
a large, black bird

raw adjective
Food that is raw has not been cooked. ▶ *Do you like raw carrots?*

ray noun (plural **rays**)
A ray of light or heat is a beam of it that shines onto something. ▶ *A suncream will protect your skin from the sun's rays.*

razor noun (plural **razors**)
a very sharp blade that people use for shaving hair off their body

reach verb (**reaches, reaching, reached**)
1 When you reach a place, you get there. ▶ *We reached home by 6 o'clock.*
2 When you reach for something, you put out your hand to touch it or pick it up. ▶ *He reached for a cake.*

react

react *verb* (**reacts, reacting, reacted**)
The way that you react to something is the way that you behave when it happens. ▶ *How did the children react to the news that the school would have to close for the day?*
❶ Your **reaction** to something is the way in which you react.

read *verb* (**reads, reading, read**)
When you read words that are written down, you look at them and understand them. ▶ *My little brother is just learning to read.*

ready *adjective*
1 If you are ready, you are prepared so that you can do something straight away. ▶ *Are you ready to leave?*
2 If something is ready, it is finished and you can have it or use it straight away. ▶ *Is dinner ready?*

real *adjective*
1 Something that is real is true, and not made-up or imaginary. ▶ *There are no unicorns in real life.*
2 Something that is real is genuine, and not a copy. ▶ *I want a real dog, not a toy one!*

realistic *adjective*
Something that is realistic looks real. ▶ *We used tomato sauce for blood, and it was quite realistic.*

realize *verb* (**realizes, realizing, realized**)
When you realize something, you suddenly notice it or know that it is true. ▶ *I suddenly realized that everyone was looking at me.*

really *adverb*
1 very ▶ *The water's really cold!*
2 If something is really true, it is true in real life. ▶ *Is your dad really a spy?*

rear *noun*
The rear of something is the part at the back of it.

rear *verb* (**rears, rearing, reared**)
To rear young animals means to look after them until they are big. ▶ *She helped her mother rear the puppies.*

reason *noun* (*plural* **reasons**)
The reason for something is why it happens. ▶ *I told the teacher the reason why I was late.*

reasonable *adjective*
Something that is reasonable is fair and right. ▶ *It is reasonable to expect children to tidy their own bedrooms.*

reassure *verb* (**reassures, reassuring, reassured**)
If you reassure someone, you tell them that they do not need to worry about something. ▶ *He reassured me that the money was in a safe place.*

rebel *verb* (**rebels, rebelling, rebelled**)
If people rebel, they decide not to obey the people in charge of them.

recall *verb* (**recalls, recalling, recalled**)
When you recall something, you remember it.

receipt *noun* (*plural* **receipts**)
a piece of paper which proves that you have paid for something

receive *verb* (**receives, receiving, received**)
When you receive something, someone gives it to you or sends it to you. ▶ *I haven't received your letter yet.*

receiver *noun* (*plural* **receivers**)
the part of a telephone that you hold in your hand and speak into

recent *adjective*
Something that is recent happened only a short time ago. ▶ *They are still celebrating their recent victory.*
❶ Something that happened **recently** happened only a short time ago.

reception *noun* (*plural* **receptions**)
1 When you give someone a reception, you welcome them to a place. ▶ *We gave the visitors a warm reception.*
2 The reception in a large building is the place where people go when they first arrive. There is someone there to help people and answer their questions.

recipe *noun* (*plural* **recipes**)
a list of the things you need to cook something, and instructions that tell you how to cook it

recite *verb* (**recites, reciting, recited**)
When you recite something, you say it out loud from memory. ▶ *I've got to recite a poem in the Christmas concert.*

reckless *adjective*
Someone who is reckless is not careful, but does silly or dangerous things.

reckon *verb* (**reckons, reckoning, reckoned**)
If you reckon that something is true, you think that it is true. ▶ *I reckon we stand a good chance of winning on Saturday.*

recognize *verb* (**recognizes, recognizing, recognized**)
If you recognize someone, you know who they are because you have seen them before.

recommend *verb* (**recommends, recommending, recommended**)
1 When you recommend something, you tell people that it is good. ▶ *I would recommend this book to anyone who loves adventure stories.*
2 When you recommend something, you tell someone that they should do it. ▶ *I recommend that you see a doctor.*

record *noun* (*plural* **records**)
1 The record for something is the best that anyone has ever done. ▶ *She has set a new world record for the women's high jump.*
2 If you keep a record of something, you write it down. ▶ *We keep a record of the birds we see.*

record *verb* (**records, recording, recorded**)
1 When you record music or pictures, you store them on a tape or CD. ▶ *We can record the film and watch it later.*
2 When you record information, you write it down.

recorder *noun* (*plural* **recorders**)
a musical instrument that you play by blowing into one end and covering holes with your fingers to make different notes

recover *verb* (**recovers, recovering, recovered**)
1 When you recover, you get better after you have been ill. ▶ *Have you recovered from your cold?*
2 When you recover something that you have lost, you get it back. ▶ *The police recovered the stolen car.*

rectangle *noun* (*plural* **rectangles**)
a shape with four straight sides and four right angles. A rectangle looks like a long square and is also called an **oblong**.

recycle *verb* (**recycles, recycling, recycled**)
To recycle things means to use them again instead of throwing them away. Glass and paper can be recycled.

red *adjective*
Something that is red is the colour of blood.

reduce *verb* (**reduces, reducing, reduced**)
When you reduce something, you make it smaller or less. ▶ *Reduce speed when you approach a bend.*

reed

reed noun (plural **reeds**)
a plant that looks like tall grass and grows near water

reek verb (**reeks, reeking, reeked**)
If something reeks, it smells very nasty.

reel noun (plural **reels**)
a round object that something like cotton or film is wound around ▶ *We made a snake out of old cotton reels.*

refer verb (**refers, referring, referred**)
When you refer to something, you talk about it. ▶ *We will never refer to this again.*

referee noun (plural **referees**)
someone who is in charge of a game and makes sure that all the players keep to the rules

reference book noun (plural **reference books**)
a book that gives you information. Dictionaries are reference books.

reflect verb (**reflects, reflecting, reflected**)
1 If something reflects light, it makes the light shine back off it.
2 When something is reflected in glass or water, you can see a picture of it there. ▶ *The trees were reflected in the still water.*
❶ A **reflection** is a picture of something that you can see in glass or water.

reflex noun (plural **reflexes**)
a way in which your body moves without you thinking about it or controlling it

refresh verb (**refreshes, refreshing, refreshed**)
If something refreshes you, it makes you feel fresh and less tired.

refreshments noun
drinks and snacks

refrigerator noun (plural **refrigerators**)
a fridge

refugee noun (plural **refugees**)
someone who has had to leave their own country because of a war

refund noun (plural **refunds**)
an amount of money that you get back when you take back something that you had bought

refuse verb (**refuses, refusing, refused**)
If you refuse to do something, you say that you will not do it. ▶ *She refused to tidy her room.*

refuse noun
rubbish

regard verb (**regards, regarding, regarded**)
The way in which you regard someone is the way you think about them. ▶ *I have always regarded Tom as my best friend.*

regiment noun (plural **regiments**)
a large group of soldiers

region noun (plural **regions**)
one part of a country ▶ *These snakes live in the desert regions of Africa.*

register noun (plural **registers**)
a book in which people write down lists of names or other important information

regret verb (**regrets, regretting, regretted**)
If you regret doing something, you are sorry that you did it.

regular adjective
1 Something that is regular happens at the same time every day or every week. ▶ *There is a regular bus service into the city centre.*
2 A regular pattern stays the same and does not change.

3 A regular shape has sides and angles that are all equal.
ⓘ Something that happens in a regular way happens **regularly**.
▶ *We go swimming quite regularly.*

rehearse verb (**rehearses, rehearsing, rehearsed**)
When you rehearse, you practise something before you do it in front of an audience. ▶ *We need to rehearse our play again.*
ⓘ When you rehearse something, you have a **rehearsal**.

reign verb (**reigns, reigning, reigned**) (*pronounced* **rain**)
When a king or queen reigns, they rule over a country.

reign noun (*plural* **reigns**) (*pronounced* **rain**)
The reign of a king or queen is the time when they are ruling a country.

reindeer noun (the plural is the same)
a deer with large antlers that lives in very cold countries

reins noun
the two long straps that you hold when you are riding a horse and use for guiding the horse

reject verb (**rejects, rejecting, rejected**)
If you reject something, you do not accept it. ▶ *The teacher rejected our ideas.*

rejoice verb (**rejoices, rejoicing, rejoiced**)
When people rejoice, they are very happy about something.

relate verb (**relates, relating, related**)
When you relate a story, you tell it.

related adjective
People who are related belong to the same family.

relation noun (*plural* **relations**)
Your relations are all the people who belong to your family.

relative noun (*plural* **relatives**)
Your relatives are all the people who belong to your family.

relax verb (**relaxes, relaxing, relaxed**)
When you relax, you do things that make you calm and happy.
▶ *Sometimes I just want to sit down and relax in front of the TV.*
ⓘ When you are **relaxed**, you are calm and happy and not worried about anything.

relay noun (*plural* **relays**)
a race for teams of people, in which each person in the team runs or swims one part of the race

release verb (**releases, releasing, released**)
To release someone means to set them free.

relent verb (**relents, relenting, relented**)
If someone relents, they give in and become less strict or less angry.
▶ *Mum relented and let us watch the film.*

reliable adjective
If someone is reliable, you can trust them.

relief noun
the feeling you have when you are no longer worried about something ▶ *It was such a relief when we got home safely!*

relieved adjective
If you feel relieved, you feel happy because you are no longer worried about something.

religion noun (*plural* **religions**)
a set of ideas that people have about a god or gods. Different religions worship different gods, and have different festivals and traditions.
ⓘ Something that is **religious** is to do with religion.

reluctant adjective
If you are reluctant to do something, you do not want to do it.

rely

rely verb (relies, relying, relied)
If you rely on something, you need it. If you rely on someone, you need them to do something for you.
▶ *Dogs rely on their owners to feed them and look after them.*

remain verb (remains, remaining, remained)
To remain means to stay. ▶ *Please remain in your seats.*

remainder noun
an amount that is left over after you have worked out a sum

remains noun
The remains of a building are the parts that are left after it has fallen down. ▶ *We visited the remains of a Roman fort.*

remark verb (remarks, remarking, remarked)
To remark means to say something. ▶ *'It's very hot today,' she remarked.*

remark noun (plural **remarks**)
something that you say ▶ *He made some rude remarks about my clothes.*

remarkable adjective
Something that is remarkable is very good and surprising.

remedy noun (plural **remedies**)
something that makes you better when you are ill ▶ *Hot lemon is a good remedy for colds.*

remember verb (remembers, remembering, remembered)
If you can remember something, you can think of it and have not forgotten it. ▶ *Can you remember his name?*

remind verb (reminds, reminding, reminded)
If you remind someone about something, you tell them about it again so that they do not forget it. ▶ *My mum reminded me that I needed to take my PE kit to school.*

remote adjective (remoter, remotest)
A place that is remote is far away from towns and cities.

remote control noun (plural **remote controls**)
something that you hold in your hand and use to switch a television on and off from a distance

remove verb (removes, removing, removed)
When you remove something, you take it off or take it away. ▶ *Please remove your muddy boots.*

rent noun
an amount of money that you pay each week to live in a house that belongs to another person

rent verb (rents, renting, rented)
When you rent a house, you pay someone an amount of money each week so that you can live in it.

repair verb (repairs, repairing, repaired)
When you repair something, you mend it. ▶ *Can you repair my bike?*

repay verb (repays, repaying, repaid)
When you repay money, you pay it back to someone.

repeat verb (repeats, repeating, repeated)
When you repeat something, you say it or do it again.
❶ If you do something **repeatedly**, you do it again and again.

replace verb (replaces, replacing, replaced)
1 When you replace something, you put it back in the place where it was before. ▶ *He replaced the book on the shelf.*
2 When you replace something, you change it for something else. ▶ *This computer is getting quite old now, so we will have to replace it soon.*

replica noun (plural **replicas**)
a model of something that looks exactly like the real thing

reply noun (plural **replies**)
an answer ▶ *I knocked on the door, but there was no reply.*

reply verb (**replies, replying, replied**)
When you reply to someone, you answer them. ▶ *I asked him his name, but he didn't reply.*

report verb (**reports, reporting, reported**)
to tell someone about something that has happened ▶ *We reported the accident to the police.*
❶ A **reporter** is someone who works for a newspaper, writing reports about things that have happened.

report noun (plural **reports**)
1 When you write a report, you write about something that has happened. ▶ *We had to write a report on the burglary.*
2 A school report is something that teachers write about each child, to say how well they have been working.

represent verb (**represents, representing, represented**)
If a drawing or picture represents something, it is meant to be that thing. ▶ *These red lines on the map represent roads.*

reptile noun (plural **reptiles**)
an animal that is cold-blooded, has a dry, smooth skin, and lays eggs. Snakes and crocodiles are reptiles.

repulsive adjective
Something that is repulsive is horrible and disgusting.

reputation noun (plural **reputations**)
Your reputation is what other people think about you. ▶ *She's got a reputation for messing about in lessons.*

request verb (**requests, requesting, requested**)
When you request something, you ask for it politely.

request noun (plural **requests**)
something that you ask for politely

require verb (**requires, requiring, required**)
If you require something, you need it. ▶ *To make this model you will require some old egg boxes and a cereal packet.*

rescue verb (**rescues, rescuing, rescued**)
If you rescue someone, you save them from danger. ▶ *The firemen rescued the children from the burning building.*

research noun
When you do research, you find out about something so that you can learn about it.

resemble verb (**resembles, resembling, resembled**)
To resemble something means to look like it. ▶ *We saw a strange animal that resembled an elephant.*

resent verb (**resents, resenting, resented**)
If you resent something, you feel angry about it. ▶ *Sarah resented having to tidy up everyone else's mess.*

reserve verb (**reserves, reserving, reserved**)
If you reserve something, you ask someone to keep it for you. ▶ *The train will be very busy, so you need to reserve seats.*
❶ If something is **reserved**, no one can use it because it is being kept for someone.

reserve noun (plural **reserves**)
an extra player who will play in a game if another player is hurt or gets tired

reservoir noun (plural **reservoirs**)
a big lake that has been built to store water in

resident noun (plural **residents**)
The residents of a place are the people who live in that place.

resign

resign verb (**resigns, resigning, resigned**)
When someone resigns, they give up their job.

resist verb (**resists, resisting, resisted**)
When you resist something, you fight against it.

resolution noun (plural **resolutions**)
When you make a resolution, you decide that you are definitely going to do something. ▶ *She made a resolution to stop eating chocolate.*

resort noun (plural **resorts**)
a place where a lot of people go on holiday

resort verb (**resorts, resorting, resorted**)
If you resort to doing something, you do it because there is nothing else you can do.

resource noun (plural **resources**)
something that is useful to people
▶ *Oil is an important natural resource.*

respect noun
If you have respect for someone, you like them and admire them.

respect verb (**respects, respecting, respected**)
If you respect someone, you like them and admire them.

respond verb (**responds, responding, responded**)
When you respond, you answer someone. ▶ *I called his name, but he didn't respond.*

responsible adjective
1 If you are responsible for doing something, it is your job to do it.
▶ *You are responsible for feeding the fish.*
2 If you are responsible for something, you did it or made it happen. ▶ *Who is responsible for all this mess?*
3 Someone who is responsible behaves in a sensible way.
❶ If you are responsible for doing a job, it is your **responsibility**.

rest noun (plural **rests**)
1 When you have a rest, you sleep or sit still for a while.
2 The rest means all the others.
▶ *Only half the children are here, so where are the rest?*

rest verb (**rests, resting, rested**)
When you rest, you sit or lie still for a while. ▶ *We sat down to rest.*

restaurant noun (plural **restaurants**)
a place where you can buy a meal and eat it

restless adjective
If you feel restless, you feel as if you want to move around and do things rather than sit still.

restore verb (**restores, restoring, restored**)
When you restore something, you mend it and make it as good as it was before. ▶ *The old theatre has now been restored.*

result noun (plural **results**)
1 If something happens as a result of something else, it happens because of it. ▶ *Some buildings were damaged as a result of the explosion.*
2 The result at the end of a game is the score.

retire verb (**retires, retiring, retired**)
When someone retires, they stop working because they are too old or ill.

retreat verb (**retreats, retreating, retreated**)
If you retreat, you go back because it is too dangerous to go forwards.

return verb (**returns, returning, returned**)
1 If you return to a place, you go back there. ▶ *We returned home at tea time.*
2 If you return something to someone, you give it back to them.
▶ *You must return all your books to the library by next week.*

reveal verb (reveals, revealing, revealed)
To reveal something means to uncover it so that people can see it. ▶ *He drew the curtain back and revealed a huge statue.*

revenge noun
If you take revenge on someone, you do something nasty to them because they have hurt you or one of your friends.

reverse verb (reverses, reversing, reversed)
When you reverse, you go backwards in a car.

review noun (plural **reviews**)
a piece of writing that describes what a book or film is about, and says whether it is good or not

revise verb (revises, revising, revised)
When you revise, you learn something again so that you are ready for a test.

revolting adjective
Something that is revolting is horrible and disgusting.

revolution noun (plural **revolutions**)
If there is a revolution, the people in a country fight to get rid of their government and put a new kind of government in its place.

revolve verb (revolves, revolving, revolved)
When something revolves, it turns round and round like a wheel.

revolver noun (plural **revolvers**)
a small gun that you hold in one hand

reward noun (plural **rewards**)
something that is given to someone because they have done something good, or done something to help someone ▶ *We offered a reward of £20 to anyone who could find our kitten.*

rhinoceros noun (plural **rhinoceroses**) (pronounced rye-**noss**-er-us)
a very big, wild animal that lives in Africa and Asia and has one or two large horns on its nose. A rhinoceros is also called a **rhino**.

rhubarb noun (pronounced **roo**-barb)
a plant with long pink stalks that you can cook with sugar and eat

rhyme noun (plural **rhymes**) (pronounced **rime**)
A rhyme is a word that has the same sound as another word. ▶ *Can you think of a rhyme for 'hat'?*

rhyme verb (rhymes, rhyming, rhymed)
If two words rhyme, they sound the same. ▶ *Fish rhymes with dish.*

rhythm noun (plural **rhythms**) (pronounced **rith**-um)
The rhythm in a piece of music is its regular beat. The rhythm in a poem is the regular pattern that the words make as you read them.

rib noun (plural **ribs**)
Your ribs are the curved bones in your chest that protect your heart and lungs.

ribbon noun (plural **ribbons**)
a strip of coloured material that you tie round a parcel or in your hair

rice noun
white or brown grains that you cook and eat

rich adjective (richer, richest)
Someone who is rich has a lot of money.

rid verb
When you get rid of something, you throw it away or give it to someone else so that you no longer have it.

riddle noun (plural **riddles**)
a clever question or puzzle that is difficult to answer because it is a trick or joke

ride

ride verb (rides, riding, rode, ridden)
1 When you ride on a horse or bicycle, you sit on it while it moves along.
2 When you ride in a car, bus, or train, you sit in it while it moves along.

ride noun (plural **rides**)
When you go for a ride, you ride on a horse or bicycle, or in a bus, train, or car.

ridge noun (plural **ridges**)
a part of something that is high up and is long and thin. The line along the roof of a house is called a ridge, and some mountains have a long ridge at the top rather than a point.

ridiculous adjective
Something that is ridiculous is very silly and makes people laugh.

rifle noun (plural **rifles**)
a long gun that you hold with both hands and put up against your shoulder when you want to fire it

rigging noun
The rigging on a sailing ship is all the ropes that support the sails.

right adjective
1 The right side of something is the side that is opposite the left side. Most people write with their right hand, not their left hand. ▶ *She was holding a torch in her right hand.*
2 Something that is right is correct. ▶ *Yes, that's the right answer.*
3 Something that is right is fair and honest. ▶ *It is not right to cheat.*

right angle noun (plural **right angles**)
an angle that measures 90 degrees. A square has four right angles.

rigid adjective
Something that is rigid is stiff and hard, and does not bend easily.

rim noun (plural **rims**)
1 The rim of a cup or jug is the edge around the top of it.
2 The rim of a wheel is the edge around the outside of it.

rind noun
the hard skin on bacon, cheese, or fruit

ring noun (plural **rings**)
1 a circle ▶ *The children sat down in a ring around the fire.*
2 a circle of gold or silver that you wear on your finger

ring verb (rings, ringing, rang, rung)
1 When something rings, it makes a sound like a bell. ▶ *The doorbell rang.*
2 When you ring someone, you phone them.

ringleader noun (plural **ringleaders**)
someone who leads a group of people and encourages them to do things that are wrong

rink noun (plural **rinks**)
an area of ice that people can skate on

rinse verb (rinses, rinsing, rinsed)
When you rinse something, you wash it in clean water after you have washed it using soap.

riot noun (plural **riots**)
When there is a riot, a lot of people behave in a very noisy, violent way.

rip verb (rips, ripping, ripped)
If you rip something, you tear it.

ripe adjective (riper, ripest)
Fruit that is ripe is soft and ready to eat.

ripple noun (plural **ripples**)
a tiny wave on the surface of water ▶ *The rain was making ripples on the surface of the pond.*

rise verb (rises, rising, rose, risen)
1 When something rises, it moves upwards.
2 When you rise, you stand up.
3 When the sun or moon rises, it moves up into the sky.

risk noun (plural **risks**)
If there is a risk, there is a danger that something bad or dangerous might happen. ▶ *When you go parachuting, there is always a risk that your parachute will not open.*

rival noun (plural **rivals**)
someone who is trying to beat you in a competition or game

river noun (plural **rivers**)
a large stream of water that flows into the sea

road noun (plural **roads**)
a wide path that cars, buses, and lorries go along

roam verb (**roams, roaming, roamed**)
When you roam, you travel around without going in any particular direction. ▶ *Some children are just left to roam the streets on their own.*

roar verb (**roars, roaring, roared**)
When an animal like a lion roars, it makes a loud, fierce sound.

roast verb (**roasts, roasting, roasted**)
When you roast meat or vegetables, you cook them in the oven. ▶ *We'll roast the chicken in the oven.*

rob verb (**robs, robbing, robbed**)
To rob someone means to steal something from them. ▶ *A band of thieves attacked him and robbed him.*
❶ A **robber** is someone who robs people. A **robbery** is a crime in which someone is robbed.

robe noun (plural **robes**)
a long, loose piece of clothing ▶ *The magician wore a long black robe.*

robin noun (plural **robins**)
a small, brown bird with a red patch on its chest

robot noun (plural **robots**)
a machine that can do some of the jobs that a person can do ▶ *In some factories cars are made by robots.*

rock noun (plural **rocks**)
1 A rock is a very big stone. ▶ *They hurled huge rocks into the sea.*
2 Rock is the hard, stony substance that mountains, hills, and the ground are made of.

rock verb (**rocks, rocking, rocked**)
When something rocks, it moves gently backwards and forwards or from side to side.

rocket noun (plural **rockets**)
1 a firework that shoots high into the air and then explodes with bright lights or a loud bang
2 something that can travel very fast through the air or into space. Some rockets are used as weapons, and some are used to take people up into space.

rod noun (plural **rods**)
A fishing rod is a long, thin piece of wood or metal. You attach a piece of thin fishing line to it and use it for catching fish.

rodent noun (plural **rodents**)
an animal that has big front teeth, which it uses for biting and chewing things. Rats and mice are rodents.

role noun (plural **roles**)
Your role in a play or film is the character that you play.

roll verb (**rolls, rolling, rolled**)
When something rolls, it moves along on wheels or by turning over and over like a ball. ▶ *The can rolled down the hill.*

roll noun (plural **rolls**)
1 A roll of cloth or paper is a piece that has been rolled up into the shape of a tube.
2 A roll is a very small loaf of bread for one person. ▶ *We had warm rolls for breakfast.*

roller skate noun (plural **roller skates**)
Roller skates are special shoes with wheels on the bottom.

romantic

romantic *adjective*
Something that is romantic is exciting because it makes you think of love.

romp *verb* (**romps, romping, romped**)
When people romp, they play in a rough, noisy way.

roof *noun* (*plural* **roofs**)
the sloping part on the top of a building

room *noun* (*plural* **rooms**)
1 The rooms in a building are the different parts inside it. ▶ *How many rooms are there in your house?*
2 If there is room for something, there is enough space for it.

roost *verb* (**roosts, roosting, roosted**)
When birds roost, they settle somewhere high up for the night.

root *noun* (*plural* **roots**)
the part of a plant that grows under the ground

root word *noun* (*plural* **root words**)
a word to which a prefix or suffix can be added to make a new word ▶ *In the word 'unhappy', 'un' is a prefix and 'happy' is the root word.*

rope *noun* (*plural* **ropes**)
a long piece of thick, strong material which you use for tying things together

rose *noun* (*plural* **roses**)
a flower which has a sweet smell and sharp thorns on its stem

rose *verb* SEE **rise**

rosy *adjective* (**rosier, rosiest**)
Something that is rosy is pink or red. ▶ *The children all had rosy cheeks.*

rot *verb* (**rots, rotting, rotted**)
When something rots, it goes bad and soft and sometimes smells nasty.

rotten *adjective*
1 Something that is rotten is not fresh, but has gone bad and soft.
2 Something that is rotten is bad or nasty. ▶ *That was a rotten thing to do!*

rough *adjective* (**rougher, roughest**) (*pronounced* **ruff**)
1 Something that is rough is not smooth or flat. ▶ *With this bike, you can ride over rough ground.*
2 Someone who is rough is not gentle.
3 Something that is rough is more or less right, but not exactly right. ▶ *He looks about fifteen, but that's only a rough guess.*

roughly *adverb*
1 If you touch or hold something roughly, you do it in a way that is not gentle.
2 about, but not exactly ▶ *There will be roughly twenty people at my party.*

round *adjective*
Something that is round is shaped like a circle or ball. ▶ *You can make your picture either round or square.*

round *adverb, preposition*
1 turning in a circle ▶ *The wheels spun round and round.*
2 on all sides of something ▶ *There was a high wall round the garden.*

roundabout *noun* (*plural* **roundabouts**)
1 a circle in the middle of the road which cars must drive round
2 a big machine that you can ride on at a fair

rounders *noun*
a game in which two teams try to hit a ball with a special bat and score points by running round a square

route *noun* (*plural* **routes**) (*pronounced* **root**)
The route that you follow is the way you go to get to a place.

routine *noun* (*plural* **routines**)
Your routine is the way in which you usually do things at the same time and in the same way. ▶ *My routine in the morning is to get up, get dressed, then have my breakfast.*

row noun (plural **rows**) (rhymes with *toe*)
A row of people or things is a long, straight line of them.

row verb (**rows, rowing, rowed**) (rhymes with *toe*)
When you row a boat, you push oars through the water to make it move along.

row noun (plural **rows**) (rhymes with *how*)
1 When you make a row, you make a lot of loud noise.
2 When people have a row, they have an angry, noisy argument.

rowdy adjective
When people are rowdy, they make a lot of noise.

royal adjective
Royal things belong to a king or queen.

rub verb (**rubs, rubbing, rubbed**)
1 When you rub something, you move your hands backwards and forwards over it. ▶ *I rubbed my hands together to keep warm.*
2 When you rub out something that you have written, you make it disappear by rubbing it.

rubber noun (plural **rubbers**)
1 Rubber is a type of soft material that stretches, bends, and bounces. Rubber is used for making car tyres.
2 A rubber is a small piece of rubber that you use for rubbing out pencil marks.

rubbish noun
1 things that you have thrown away because you do not want them any more ▶ *The garden was full of rubbish.*
2 If something that you say is rubbish, it is silly and not true.

ruby noun (plural **rubies**)
a red jewel

rucksack noun (plural **rucksacks**)
a bag that you carry on your back

rudder noun (plural **rudders**)
a flat piece of wood or metal at the back of a boat or aeroplane. You move the rudder to make the boat or aeroplane go left or right.

rude adjective (**ruder, rudest**)
Someone who is rude says or does things that are not polite.

rug noun (plural **rugs**)
1 a small carpet
2 a thick blanket

rugby noun
a game in which two teams throw, kick, and carry a ball, and try to score points by taking it over a line at one end of the pitch

ruin noun (plural **ruins**)
a building that has fallen down ▶ *We visited the ruins of a Roman fort.*

ruin verb (**ruins, ruining, ruined**)
To ruin something means to spoil it completely. ▶ *You've ruined my picture!*

rule noun (plural **rules**)
something that tells you what you must and must not do ▶ *In netball you are not allowed to run with the ball – it's against the rules.*

rule verb (**rules, ruling, ruled**)
The person who rules a country is in charge of it.

ruler noun (plural **rulers**)
1 someone who rules a country
2 a flat, straight piece of wood, metal, or plastic that you use for measuring things and drawing lines

rumble verb (**rumbles, rumbling, rumbled**)
When something rumbles, it makes a loud, deep sound, like the sound of thunder.

rumour

rumour *noun* (*plural* **rumours**)
something that a lot of people are saying, although it might not be true ▶ *There's a rumour that our teacher might be leaving at the end of this term.*

run *verb* (**runs, running, ran, run**)
1 When you run, you move along quickly by taking very quick steps.
2 When you run something, you control it and are in charge of it. ▶ *The year 4 children run the school tuck shop.*
❶ A **runner** is someone who runs fast or runs in a race.

rung *noun* (*plural* **rungs**)
The rungs on a ladder are the bars that you step on.

rung *verb* SEE **ring**

runner-up *noun* (*plural* **runners-up**)
the person who comes second in a race or competition

runny *adjective* (**runnier, runniest**)
Something that is runny is like a liquid. ▶ *The jelly hasn't set yet – it's still runny.*

runway *noun* (*plural* **runways**)
a strip of land where an aeroplane can take off and land

rush *verb* (**rushes, rushing, rushed**)
When you rush, you run or do something very quickly. ▶ *I rushed home to see the new puppy.*

rusk *noun* (*plural* **rusks**)
a type of biscuit for babies to chew

rust *noun*
a rough, red stuff that you see on metal that is old and has got wet ▶ *The old car was covered in rust.*

rustle *verb* (**rustles, rustling, rustled**)
When something rustles, it makes a soft sound like the sound of dry leaves or paper being squashed.

Ss

sack *noun* (*plural* **sacks**)
a large, strong bag

sacred *adjective*
Something that is sacred is special because it is to do with religion.

sad *adjective* (**sadder, saddest**)
If you feel sad, you feel unhappy.
❶ **Sadness** is the feeling you have when you are sad.

saddle *noun* (*plural* **saddles**)
the seat that you sit on when you are riding a bicycle or a horse

safari *noun* (*plural* **safaris**)
a trip to see lions and other large animals in the wild

safe *adjective* (**safer, safest**)
1 If you are safe, you are not in any danger.
2 If something is safe, you will not get hurt if you go on it or use it. ▶ *Is this bridge safe?*

safe *noun* (*plural* **safes**)
a strong metal box with a lock where you can keep money and jewellery

safety *noun*
Safety is being safe and not in danger. ▶ *After crossing the river we finally reached safety.*

sag *verb* (**sags, sagging, sagged**)
If something sags, it goes down in the middle. ▶ *The bed sagged under his weight.*

said *verb* SEE **say**

sail *noun* (*plural* **sails**)
A sail is a large piece of strong cloth which is attached to a boat. The wind blows into the sail and makes the boat move along.

sail *verb* (sails, sailing, sailed)
When you sail, you go somewhere in a boat. ▶ *We sailed across the lake to the island.*

sailor *noun* (*plural* **sailors**)
someone who works on a ship

saint *noun* (*plural* **saints**)
In the Christian religion, a saint is a person who did very good and holy things during their life.

sake *noun*
If you do something for someone's sake, you do it to help them.

salad *noun* (*plural* **salads**)
a mixture of vegetables that you eat raw or cold

salary *noun* (*plural* **salaries**)
Someone's salary is the money that they get for doing their job.

sale *noun* (*plural* **sales**)
1 If something is for sale, people can buy it. ▶ *Are these puppies for sale?*
2 When a shop has a sale, it sells things at lower prices than usual.

saliva *noun*
the liquid in your mouth

salmon *noun* (the plural is the same)
a large fish that you can eat.

salon *noun* (*plural* **salons**)
a shop where a hairdresser works

salt *noun*
a white powder that you add to food to give it a nicer flavour
ⓘ Food that tastes of salt tastes **salty**.

salute *verb* (salutes, saluting, saluted)
When you salute, you touch your forehead with your hand to show that you respect someone. Soldiers often salute each other.

same *adjective*
1 Things that are the same are like each other. ▶ *Your hat is the same as mine.*
2 If two people share the same thing, they share one thing and do not have two different ones. ▶ *We both go to the same school.*

sample *noun* (*plural* **samples**)
a small amount of something that you can try to see what it is like

sand *noun* (*plural* **sands**)
a powder made from tiny bits of crushed rock. You find sand in a desert or on a beach.

sandal *noun* (*plural* **sandals**)
Sandals are shoes with straps that you wear in warm weather.

sandwich *noun* (*plural* **sandwiches**)
two slices of bread and butter with a layer of a different food in between them

sang *verb* SEE **sing**

sank *verb* SEE **sink**

sap *noun*
the sticky liquid inside a plant. Sap carries water and food to all parts of the plant.

sapphire *noun* (*plural* **sapphires**)
(*pronounced* **saff**-ire)
a blue jewel

sarcastic *adjective*
If you are sarcastic, you say something that sounds nice, but you say it in a nasty way to show that you do not really mean it.

sardine *noun* (*plural* **sardines**)
a small sea fish you can eat

sari *noun* (*plural* **saris**)
a type of dress that women and girls from India and other countries in Asia wear. It is a long piece of cloth that you wrap round your body.

sat *verb* SEE **sit**

satellite *noun* (*plural* **satellites**)
a machine that is sent into space to collect information and send signals back to Earth. Satellites travel in orbit round the Earth. Some satellites collect information about the weather, and some receive radio and television signals and send them back to Earth.

satin *noun*
a type of smooth, shiny cloth

satisfactory *adjective*
Something that is satisfactory is not very good, but is good enough.

satisfy

satisfy verb (satisfies, satisfying, satisfied)
If something satisfies you, it is good enough to make you feel pleased or happy.

satsuma noun (plural satsumas)
a fruit like a small, sweet orange

saturated adjective
If something is saturated, it is completely wet through.

Saturday noun (plural Saturdays)
the day after Friday

sauce noun (plural sauces)
a thick liquid that you put over food
▶ *Do you like tomato sauce?*

saucepan noun (plural saucepans)
a metal pan that you use for cooking

saucer noun (plural saucers)
a small plate that you put a cup on

sausage noun (plural sausages)
minced meat that has been made into a long, thin shape and cooked

savage adjective
A savage animal is wild and fierce.

save verb (saves, saving, saved)
1 If you save someone, you take them away from danger and make them safe.
2 When you save money, you keep it so that you can use it later.
ⓘ Your **savings** are money that you are keeping to use later.

saw noun (plural saws)
a tool that you use to cut wood. It has a row of sharp teeth which you push backwards and forwards over the wood to cut it.

saw verb (saws, sawing, sawed, sawn)
When you saw wood, you cut it with a saw.

saw verb SEE **see**

sawdust noun
a powder that comes from wood when you cut it with a saw

say verb (says, saying, said)
When you say something, you speak.
▶ *'Hello,' he said.*

saying noun (plural sayings)
a well-known sentence that people often say because it tells you something that is true or gives you advice about something

scab noun (plural scabs)
a piece of hard skin that grows over a cut or graze while it is getting better

scabbard noun (plural scabbards)
a cover for the blade of a sword

scaffolding noun
a lot of planks that are fixed to poles and put round a building so that builders and painters can stand on them to work on the building

scald verb (scalds, scalding, scalded)
If you scald yourself, you burn yourself with very hot liquid.

scale noun (plural scales)
1 A scale is a line of numbers that you use for measuring something.
2 The scale of a map is how big things on the map are compared to how big they are in real life.
3 The scales on a fish are the small, round pieces of hard skin all over its body.

scales noun
something that you use for weighing things

scalp noun (plural scalps)
Your scalp is the skin on your head, under your hair.

scamper verb (scampers, scampering, scampered)
To scamper around means to run around quickly.

scan *verb* (**scans, scanning, scanned**)
When a machine scans something, it moves a beam of light over it to make a picture of it.

scar *noun* (*plural* **scars**)
a mark that is left on your skin after a cut or burn has healed

scarce *adjective* (**scarcer, scarcest**)
If something is scarce, there is not very much of it. ▶ *Water is scarce in the desert.*

scarcely *adverb*
hardly ▶ *He was so frightened he could scarcely speak.*

scare *verb* (**scares, scaring, scared**)
If something scares you, it makes you feel frightened.
❶ If you are **scared**, you are frightened. Something that is **scary** makes you feel frightened.

scarecrow *noun* (*plural* **scarecrows**)
something that looks like a person and is put in a field to frighten away birds

scarf *noun* (*plural* **scarves**)
a piece of material that you wear round your neck to keep you warm

scarlet *adjective*
Something that is scarlet is bright red.

scatter *verb* (**scatters, scattering, scattered**)
1 When you scatter things, you throw them all around you. ▶ *She scattered some crumbs for the birds.*
2 When people scatter, they all run away in different directions.

scene *noun* (*plural* **scenes**)
1 The scene of something is the place where it happens. ▶ *Police are still examining the scene of the crime.*
2 A scene in a play is one part of the play.

scenery *noun*
1 things that you can see around you when you are out in the country ▶ *We drove up into the mountains to see the beautiful mountain scenery.*
2 things that you put on the stage of a theatre to make it look like a real place

scent *noun* (*plural* **scents**)
1 perfume that you put on your skin so that you will smell nice
2 a pleasant smell ▶ *The garden was full of the scent of roses.*
3 An animal's scent is its smell.

scheme *noun* (*plural* **schemes**) (*pronounced* **skeme**)
a clever plan

scholarship *noun* (*plural* **scholarships**) (*pronounced* **skol**-ar-ship)
money that is given to someone so that they can go to a school or college

school *noun* (*plural* **schools**)
1 a place where children go to learn things
2 A school of fish is a large group of them swimming together.

science *noun* (*plural* **sciences**)
the subject in which you study the things in the world around you, for example plants and animals, wood and metal, light, and electricity
❶ Someone who studies science is a **scientist**.

science fiction *noun*
stories about things that happen in the future or on other planets

scissors *noun*
a tool that you use for cutting paper or cloth

scoff *verb* (**scoffs, scoffing, scoffed**)
To scoff at something means to laugh at it and say that it is silly.

scold *verb* (**scolds, scolding, scolded**)
To scold someone means to tell them off. ▶ *He scolded her for being late.*

scoop

scoop noun (plural **scoops**)
a deep spoon that you use for serving ice cream

scoop verb (**scoops, scooping, scooped**)
If you scoop something up, you pick it up with both hands.

scooter noun (plural **scooters**)
1 a motorbike with a small engine
2 a toy with two wheels that you ride by standing on it with one foot and pushing the ground with the other foot.

scorch verb (**scorches, scorching, scorched**)
To scorch something means to burn it and make it go brown. ▶ *The hot sun had scorched the grass.*

score noun (plural **scores**)
The score in a game is the number of points that each player or team has.

score verb (**scores, scoring, scored**)
When you score in a game, you get a point or a goal.

scorn noun
If you treat something with scorn, you show that you think it is no good.

scowl verb (**scowls, scowling, scowled**)
When you scowl, you look cross. ▶ *The man scowled at me.*

scrabble verb (**scrabbles, scrabbling, scrabbled**)
If you scrabble around for something, you feel for it with your hands.

scramble verb (**scrambles, scrambling, scrambled**)
If you scramble over things, you climb over them using your hands and feet.

scrap noun (plural **scraps**)
1 A scrap of paper or cloth is a small piece.
2 Scrap is anything that you do not want anymore.

scrape verb (**scrapes, scraping, scraped**)
1 If you scrape something off, you get it off by pushing it with something sharp. ▶ *Scrape the mud off your shoes.*
2 If you scrape a part of your body, you cut it by rubbing it against something. ▶ *I fell over and scraped my knee.*

scratch verb (**scratches, scratching, scratched**)
1 To scratch something means to cut it or make a mark on it with something sharp. ▶ *Mind you don't scratch the paint on the new car.*
2 When you scratch, you rub your skin because it is itching.

scream verb (**screams, screaming, screamed**)
When you scream, you shout or cry loudly because you are frightened or hurt.

screech verb (**screeches, screeching, screeched**)
When you screech, you shout or cry in a loud, high voice. ▶ *The children were screeching with excitement.*

screen noun (plural **screens**)
1 the part of a television or computer where the words and pictures appear
2 the large, flat surface at a cinema, on which films are shown

screw noun (plural **screws**)
a pointed piece of metal that you use for fixing pieces of wood together. You fix a screw into wood by turning it round with a screwdriver.

screw verb (**screws, screwing, screwed**)
1 When you screw things together, you fix them together using screws.
2 When you screw a lid on or off, you put it on or take it off by turning it round and round.

screwdriver noun (plural **screwdrivers**)
a tool that you use for fixing screws into wood

scribble verb (**scribbles, scribbling, scribbled**)
When you scribble, you write or draw something quickly, in an untidy way.

script noun (plural **scripts**)
The script of a play is all the words that the characters say.

scroll noun (plural **scrolls**)
a piece of writing on a long sheet of paper that is rolled up

scroll verb (**scrolls, scrolling, scrolled**)
When you scroll up or down on a computer screen, you move up or down on the screen to see what comes before or after.

scrub verb (**scrubs, scrubbing, scrubbed**)
When you scrub something, you rub it hard to clean it.

scruffy adjective (**scruffier, scruffiest**)
Something that is scruffy is untidy and dirty.

sculpture noun (plural **sculptures**)
a statue made out of stone or wood

scurry verb (**scurries, scurrying, scurried**)
To scurry means to run quickly, using small steps.

scuttle verb (**scuttles, scuttling, scuttled**)
To scuttle means to run away quickly.

sea noun (plural **seas**)
The sea is the salty water that covers large parts of the earth.
❶ The **seabed** is the bottom of the sea. A **seagull** is a bird that lives near the sea.

seal noun (plural **seals**)
an animal that has flippers and lives in the sea. Seals have thick fur to keep them warm in cold water.

seal verb (**seals, sealing, sealed**)
When you seal an envelope, you close it.

seam noun (plural **seams**)
a line of sewing that joins two pieces of material together ▶ *You can see a seam down the side of your trouser leg.*

search verb (**searches, searching, searched**)
When you search for something, you look for it very carefully.

seaside noun
a place by the sea where people go on holiday to enjoy themselves

season noun (plural **seasons**)
1 The four seasons are the four parts of the year, which are spring, summer, autumn, and winter.
2 The season for a sport is the time of year when it is played. ▶ *When does the cricket season start?*

seat noun (plural **seats**)
anything that you can sit on

seat belt noun (plural **seat belts**)
a strap that you wear round your body to keep you safe in a car

seaweed noun
a plant that grows in the sea

second adjective
The second thing is the one that comes after the first.

second noun (plural **seconds**)
We measure time in seconds. There are sixty seconds in one minute.

secondary school noun (plural **secondary schools**)
a school for children from the age of eleven to sixteen or eighteen

second-hand adjective
Something that is second-hand has already been owned and used by someone else.

second person

second person *noun*
When you use the second person, you use the word 'you' to write about someone in a story.

secret *adjective*
A secret thing is one that not very many people know about. ▶ *There is a secret passage from the library to the kitchen.*

secret *noun* (*plural* **secrets**)
If something is a secret, not many people know about it and you must not tell anyone.

secretary *noun* (*plural* **secretaries**)
someone whose job is to type letters and answer the telephone in an office

section *noun* (*plural* **sections**)
one part of something ▶ *The front section of the aeroplane broke off.*

secure *adjective* (**securer, securest**)
1 Something that is secure is safe and firm. ▶ *Make sure the ladder is secure before you climb it.*
2 If you feel secure, you feel safe.

see *verb* (**sees, seeing, saw, seen**)
1 When you see something, you notice it with your eyes.
2 When you can see something, you can understand it. ▶ *Do you see what I mean?*

seed *noun* (*plural* **seeds**)
a small thing that a new plant grows from

seedling *noun* (*plural* **seedlings**)
a young plant

seek *verb* (**seeks, seeking, sought**)
When you are seeking something, you are trying to find it.

seem *verb* (**seems, seeming, seemed**)
To seem means to look, sound, or appear. ▶ *All the children seem very happy today.*

see-saw *noun* (*plural* **see-saws**)
a toy that children can play on. It is made of a long piece of wood that is balanced on something in the middle so that someone can sit on each end and make it go up and down.

segment *noun* (*plural* **segments**)
one small part of something ▶ *Would you like a segment of orange?*

seize *verb* (**seizes, seizing, seized**)
(rhymes with *sneeze*)
When you seize something, you grab it roughly. ▶ *The thief seized the bag and ran away.*

seldom *adverb*
not very often ▶ *We seldom stay out after dark.*

select *verb* (**selects, selecting, selected**)
When you select something, you choose it. ▶ *She opened the box and selected a chocolate.*
❶ A **selection** is one or more things that someone has chosen.

selfish *adjective*
If you are selfish you only think about yourself and do not care what other people want. ▶ *It was very selfish of you to eat all the chocolate.*

sell *verb* (**sells, selling, sold**)
When you sell something, you give it to someone and they give you money for it. ▶ *I sold some of my old toys.*

Sellotape *noun*
(*trademark*) a type of sticky tape that you use for sticking pieces of paper together

semicircle *noun* (*plural* **semicircles**)
half of a circle

semi-colon *noun* (*plural* **semi-colons**)
a mark like this ; that you use in writing

semi-final *noun* (*plural* **semi-finals**)
a match that is played to decide who plays in the final

send *verb* (**sends, sending, sent**)
1 When you send something somewhere, you arrange for someone to take it there. ► *She sent me a birthday card.*
2 When you send someone somewhere, you tell them to go there. ► *He was sent to the headteacher for behaving badly.*

senior *adjective*
Someone who is senior is older or more important than other people.

sensation *noun* (*plural* **sensations**)
If you have a sensation in your body, you have a feeling. ► *The cold water gave me a tingling sensation.*

sense *noun* (*plural* **senses**)
1 Your senses are your ability to see, hear, smell, feel, and taste. ► *Dogs have a good sense of smell.*
2 If you have good sense, you know what is the right thing to do. ► *She had the sense to call an ambulance.*

sensible *adjective*
If you are sensible, you think carefully and you do the right thing.
❶ If you behave in a sensible way, you behave **sensibly**.

sensitive *adjective*
1 Someone who is sensitive is easily upset by other people. ► *Tom is a very sensitive boy.*
2 Something that is sensitive reacts to things around it. ► *Some people have very sensitive skin.*

sent *verb* SEE **send**

sentence *noun* (*plural* **sentences**)
1 a group of words that mean something together. A sentence begins with a capital letter and ends with a full stop.
2 a punishment that is given to someone by a judge

sentry *noun* (*plural* **sentries**)
a soldier who guards a building

separate *adjective*
Things that are separate are not joined together or not connected with each other.
❶ If things are kept apart from each other, they are kept **separately**.

separate *verb* (**separates, separating, separated**)
When you separate people or things, you take them away from each other so that they are no longer together.

September *noun*
the ninth month of the year

sequel *noun* (*plural* **sequels**)
a book or film which continues the story of an earlier book or film ► *Do you think there will be a sequel to this film?*

sequence *noun* (*plural* **sequences**)
a series of numbers that come after each other in a regular order. For example, 2, 4, 6, 8 is a sequence.

sergeant *noun* (*plural* **sergeants**)
a policeman or soldier

serial *noun* (*plural* **serials**)
a story that is told in parts on television or radio

series *noun* (the plural is the same)
1 a number of things that come one after another ► *We have had a series of accidents in the playground.*
2 a television show that is on regularly and is about the same thing each week ► *There's a new TV series on rainforests starting next week.*

serious *adjective*
1 Something that is serious is very important. ► *This is a very serious matter.*
2 Someone who is serious does not smile or joke, but thinks carefully about things.
3 Something that is serious is very bad. ► *There has been a serious accident on the motorway.*
❶ **Seriously** means in a serious way. ► *You could be seriously hurt if you fall off there.*

serpent

serpent noun (plural **serpents**)
a large snake

servant noun (plural **servants**)
someone who works at another person's home, doing jobs such as cleaning and cooking

serve verb (**serves, serving, served**)
1 To serve someone in a shop means to help them find and buy the things that they want.
2 To serve food means to put it on people's plates.
3 When you serve in a game of tennis, you start the game by hitting the ball to the other player.

service noun (plural **services**)
something that is done to help people or give them something that they need ▶ *Letters are delivered by the postal service.*

serviette noun (plural **serviettes**)
a square of cloth or paper that you use for wiping your hands and mouth while you are eating

session noun (plural **sessions**)
an amount of time that you spend doing one thing ▶ *The next training session will be on Saturday.*

set verb (**sets, setting, set**)
1 When you set a machine, you change the controls to a particular position. ▶ *We set the alarm clock for six o'clock.*
2 When something sets, it goes hard. ▶ *Has the glue set yet?*
3 When the sun sets, it goes down at the end of the day.
4 To set off means to leave.

set noun (plural **sets**)
a group of people or things that belong together ▶ *I'm trying to collect the whole set of these cards.*

settee noun (plural **settees**)
a long, comfortable seat for more than one person

settle verb (**settles, settling, settled**)
1 When you settle an argument, you agree and decide what to do about it.
2 When you settle down somewhere, you sit or lie down comfortably. ▶ *I settled down to watch a film on TV.*

seven noun (plural **sevens**)
the number 7

seventeen noun
the number 17

seventy noun
the number 70

several adjective
Several things means quite a lot of them. ▶ *The teacher told him several times to be quiet.*

severe adjective (**severer, severest**)
Something that is severe is very bad. ▶ *She had a severe headache.*

sew verb (**sews, sewing, sewed, sewn**) (pronounced **so**)
When you sew, you use a needle and thread to join pieces of cloth together.

sex noun (plural **sexes**)
The sex of a person or an animal is whether they are male or female.

shabby adjective (**shabbier, shabbiest**)
Something that is shabby is very old and tatty.

shade noun (plural **shades**)
1 If a place is in the shade, it is quite dark because the light of the sun cannot get to it.
2 The shade of a colour is how light or dark it is. ▶ *Do you like this shade of pink?*

shade verb (**shades, shading, shaded**)
When you shade something, you stop the sun from shining onto it.

shadow noun (plural **shadows**)
the dark shape that forms on the ground when something is blocking out the light

shake verb (**shakes, shaking, shook, shaken**)
1 When you shake something, you move it about quickly.
2 When something shakes, it moves about. ▶ *The ground shook as the giant came nearer.*
3 When you shake, you cannot keep your body still because you are very cold or frightened.

shall verb
I shall do something means that I will do it.

shallow adjective
Something that is shallow is not very deep. ▶ *The water is quite shallow here.*

shame noun
the feeling you have when you are unhappy because you have done wrong

shampoo noun (plural **shampoos**)
liquid soap that you use to wash your hair

shape noun (plural **shapes**)
The shape of something is what its outline looks like, for example whether it is square, round, or oval. ▶ *What shape is this room?*
ℹ You can say what shape something is by saying how it is shaped. ▶ *He was wearing slippers shaped like huge feet.*

share verb (**shares, sharing, shared**)
1 When you share something, you give some of it to other people. ▶ *I hope you're going to share those sweets!*
2 When people share something, they both use it. ▶ *I share a bedroom with my sister.*

shark noun (plural **sharks**)
a big, fierce sea fish that has sharp teeth and hunts and kills other fish to eat

sharp adjective (**sharper, sharpest**)
1 Something that is sharp can cut things because it is thin or pointed. ▶ *Be careful, those scissors are quite sharp.*
2 If you have sharp eyes or ears, you see or hear things easily.
3 A sharp turn is very sudden. ▶ *There was a sharp bend in the road.*
ℹ To **sharpen** something means to make it sharper.

shatter verb (**shatters, shattering, shattered**)
When something shatters, it breaks into tiny pieces. ▶ *A stone hit the window and the glass shattered.*

shave verb (**shaves, shaving, shaved**)
If you shave a part of your body, you cut all the hair off it to make it smooth.

shawl noun (plural **shawls**)
a large piece of cloth. Babies are sometimes wrapped in shawls, and women sometimes wear shawls round their shoulders.

shears noun
a tool that looks like a very large pair of scissors. You use shears for cutting hedges or for clipping wool from sheep.

sheath noun (plural **sheathes**)
a cover for the blade of a knife

shed noun (plural **sheds**)
a small wooden building ▶ *We keep our bikes in the garden shed.*

shed verb (**sheds, shedding, shed**)
To shed something means to let it fall off. ▶ *Trees shed their leaves in winter.* ▶ *A lorry shed its load on the motorway.*

sheep

sheep *noun* (the plural is the same)
an animal that is kept on farms for its wool and meat

sheer *adjective*
1 complete ▶ *There was a look of sheer misery on his face.*
2 A sheer drop goes straight down.

sheet *noun* (*plural* **sheets**)
1 a large piece of cloth that you put on a bed to sleep on
2 A sheet of something is a thin, flat piece of it. ▶ *I need another sheet of paper.*

shelf *noun* (*plural* **shelves**)
a piece of wood that is fastened to a wall so that you can put things on it ▶ *Please put the books back on the shelf.*

shell *noun* (*plural* **shells**)
1 a hard part on the outside of something. Eggs and nuts have shells, and some animals such as snails and tortoises have a shell on their back.
2 a large bullet that explodes when it hits something

shellfish *noun*
Shellfish are small sea animals with shells on their backs.

shelter *noun* (*plural* **shelters**)
a place that protects people from bad weather or from danger ▶ *We'll wait in the bus shelter.*

shelter *verb* (**shelters, sheltering, sheltered**)
1 To shelter someone means to keep them safe from bad weather or danger.
2 When you shelter, you stay in a place that is safe from bad weather or danger. ▶ *We sheltered from the storm in an old barn.*

shepherd *noun* (*plural* **shepherds**)
someone whose job is to look after sheep

sheriff *noun* (*plural* **sheriffs**)
In America, a sheriff is a person who makes sure that people do not break the law in their part of the country.

shield *noun* (*plural* **shields**)
something that soldiers or the police hold in front of their bodies to protect themselves during a battle

shield *verb* (**shields, shielding, shielded**)
To shield someone means to protect them from danger.

shift *verb* (**shifts, shifting, shifted**)
When you shift something, you move it. ▶ *I can't shift this rock.*

shimmer *verb* (**shimmers, shimmering, shimmered**)
When something shimmers, it shines or glows.

shin *noun* (*plural* **shins**)
Your shins are the front parts of your legs below your knees.

shine *verb* (**shines, shining, shone**)
When something shines, it gives out light or looks very bright. ▶ *The sun shone all day.*
❶ Something that is **shiny** looks very bright.

ship *noun* (*plural* **ships**)
a very large boat

shipwreck *noun* (*plural* **shipwrecks**)
When there is a shipwreck, a ship breaks up and sinks at sea.

shirt *noun* (*plural* **shirts**)
a piece of clothing that you wear on the top half of your body. A shirt has buttons down the front, sleeves, and a collar.

shiver *verb* (**shivers, shivering, shivered**)
When you shiver, you shake because you are cold or frightened.

shoal noun (plural **shoals**)
A shoal of fish is a big group of fish all swimming together.

shock noun (plural **shocks**)
1 If something is a shock, you were not expecting it and it upsets you when it happens. ▶ *It was a terrible shock when my grandmother died.*
2 If you get an electric shock, electricity gets into your body and hurts you.

shock verb (**shocks, shocking, shocked**)
If something shocks you, it gives you a nasty surprise and upsets you. ▶ *His bad behaviour shocked the other children.*
ℹ If you are **shocked**, you are very surprised and upset.

shoe noun (plural **shoes**)
something that you wear on your feet to keep them warm and dry when you go outside

shone verb SEE **shine**

shook verb SEE **shake**

shoot noun (plural **shoots**)
a new part of a plant that has just grown

shoot verb (**shoots, shooting, shot**)
1 When you shoot with a gun or other weapon, you fire it.
2 When you shoot in a game such as football, you try to score a goal.

shop noun (plural **shops**)
a place where you can go to buy things

shop verb (**shops, shopping, shopped**)
When you shop, you go into a shop to buy something.
ℹ When you shop, you go **shopping**.

shore noun (plural **shores**)
the land by the edge of the sea ▶ *We swam towards the shore.*

short adjective (**shorter, shortest**)
1 Someone who is short is not very tall.
2 Something that is short is not very long. ▶ *This piece of string is too short.*
3 Something that is short does not last very long. ▶ *We only get a short holiday for half term.*

shortly adverb
very soon ▶ *The train should be here shortly.*

shorts noun
short trousers that only cover the top part of your legs

shot noun (plural **shots**)
1 the sound of someone firing a gun. ▶ *Suddenly, we heard a shot.*
2 a photograph ▶ *There are some lovely shots of you.*
3 one kick or hit of the ball in a game such as football or tennis ▶ *That was a brilliant shot!*

shot verb SEE **shoot**

should verb
If you should do something, you ought to do it. ▶ *I should go home now.*

shoulder noun (plural **shoulders**)
Your shoulders are the parts of the body between your neck and your arms.

shout verb (**shouts, shouting, shouted**)
When you shout, you speak in a very loud voice.

shove verb (**shoves, shoving, shoved**)
When you shove something, you push it hard.

shovel noun (plural **shovels**)
a large spade that you use for lifting things such as coal or sand

show noun (plural **shows**)
something that people perform for other people to watch at the theatre or on television

show

show verb (**shows, showing, showed, shown**)
1 When you show something to someone, you let them see it.
2 If you show someone how to do something, you do it so that they can watch you and learn how to do it. ▶ *Can you show me how to print this out from the computer?*
3 If something shows, people can see it. ▶ *Your vest is showing!*

shower noun (*plural* **showers**)
1 When there is a shower, it rains or snows for a short time.
2 When you have a shower, you stand under a stream of water to wash yourself.

shrank verb SEE **shrink**

shred noun (*plural* **shreds**)
a small, thin piece of something ▶ *She tore the paper into shreds.*

shriek verb (**shrieks, shrieking, shrieked**)
If you shriek, you shout or scream in a high voice. ▶ *The girls were shrieking with laughter.*

shrill adjective (**shriller, shrillest**)
A shrill sound is high and loud.

shrimp noun (*plural* **shrimps**)
a small sea animal that you can eat

shrine noun (*plural* **shrines**)
a place that is special and holy because it is connected with a god or an important religious person

shrink verb (**shrinks, shrinking, shrank, shrunk**)
When something shrinks, it gets smaller. ▶ *Clothes sometimes shrink when they are washed.*

shrivel verb (**shrivels, shrivelling, shrivelled**)
When something shrivels, it becomes very hard and dry.

shrub noun (*plural* **shrubs**)
a bush in someone's garden

shrug verb (**shrugs, shrugging, shrugged**)
When you shrug your shoulders, you lift them up to show that you do not know something or do not care about it.

shrunk verb SEE **shrink**

shudder verb (**shudders, shuddering, shuddered**)
If you shudder, you shake slightly because you are frightened or because something is disgusting.

shuffle verb (**shuffles, shuffling, shuffled**)
1 When you shuffle, you walk slowly, without lifting your feet off the ground. ▶ *He shuffled round the room in his slippers.*
2 When you shuffle cards, you mix them up so that they are ready for a game.

shut verb (**shuts, shutting, shut**)
1 When you shut something, you close it. ▶ *Don't forget to shut the door when you go out.*
2 When a shop shuts, it closes and people cannot use it.
3 When you shut down a computer, you close all the programs and switch it off.

shutter noun (*plural* **shutters**)
a wooden cover that fits over a window

shuttle noun (*plural* **shuttles**)
1 a train, bus, or plane which goes backwards and forwards between two places
2 A space shuttle is something that can carry people into space and back.

shy adjective (**shyer, shyest**)
If you are shy, you feel frightened and nervous when you meet people you do not know.

sick *adjective* (**sicker, sickest**)
 1 If you are sick, you are ill.
 2 If you are sick, food comes back up out of your mouth after you have eaten it.

side *noun* (*plural* **sides**)
 1 The sides of something are the parts on the left and right of it, not at the back or the front. ▶ *There were some people standing at one side of the field.*
 2 Your sides are the parts of your body on your left and right. ▶ *He had a big bruise on his right side.*
 3 The sides of something are its edges. ▶ *A triangle has three sides.*
 4 The two sides of a piece of paper or cloth are its front and back. ▶ *You can write on both sides of the paper.*
 5 One side in a game or fight is one group that is playing or fighting against another group. ▶ *Whose side are you on?*

sideboard *noun* (*plural* **sideboards**)
 a piece of furniture that has drawers and cupboards for keeping things in

sideways *adverb*
 If you move sideways, you move towards the side rather than forwards or backwards.

siege *noun* (*plural* **sieges**)
 If there is a siege, an army surrounds a town or castle so that people and things cannot get in or out.

sieve *noun* (*plural* **sieves**) (rhymes with *give*)
 a dish with a lot of very small holes in. You use a sieve for separating something liquid from something solid, or for removing lumps from a powder.

sigh *verb* (**sighs, sighing, sighed**)
 When you sigh, you breathe out heavily because you are sad or tired.

sight *noun*
 1 Your sight is how well you can see things. ▶ *You are lucky to have good sight.*
 2 A sight is something that you see. ▶ *He was a funny sight in that hat.*

sign *noun* (*plural* **signs**)
 1 a picture or mark that means something ▶ *The sign for a dollar is $.*
 2 a notice that tells you something ▶ *The sign said "Keep off the grass".*
 3 If you give someone a sign, you move your body to tell them something. ▶ *He raised his arm as a sign that the race was about to start.*
 ❶ **Sign language** is a way of using your hands to make words. Some deaf people use sign language.

sign *verb* (**signs, signing, signed**)
 When you sign something, you write your name on it.

signal *noun* (*plural* **signals**)
 a light, sound, or movement that tells people what they should do, or tells them that something is going to happen ▶ *A red light is a signal for cars to stop.*

signal *verb* (**signals, signalling, signalled**)
 If you signal to someone, you do something which gives them a message, for example you nod your head or lift your arm.

signature *noun* (*plural* **signatures**)
 Your signature is your own special way of writing your name.

significant *adjective*
 Something that is significant is important.

Sikh *noun* (*plural* **Sikhs**)
 a person who follows the Indian religion of **Sikhism**

silent *adjective*
 1 Something that is silent does not make any noise. Someone who is silent does not speak or make a noise. ▶ *The teacher told us all to be silent.*

silk

2 If a place is silent, there is no noise in it.
❶ If you do something **silently**, you do it without making any noise. If there is **silence**, there is no noise.

silk *noun*
a type of smooth cloth that is made from threads spun by insects called **silkworms**

sill *noun* (*plural* **sills**)
a ledge underneath a window

silly *adjective* (**sillier**, **silliest**)
Something that is silly is stupid, not clever or sensible. Someone who is silly behaves in a silly way. ▶ *That was a really silly thing to do!*

silver *noun*
a shiny, white metal that is very valuable

similar *adjective*
Things that are similar are the same in some ways, but not exactly the same. ▶ *Your dress is quite similar to mine.*

simple *adjective* (**simpler**, **simplest**)
1 Something that is simple is very easy. ▶ *That's a really simple question.*
2 Something that is simple is plain and not fancy. ▶ *I did quite a simple design for my poster.*

simply *adverb*
completely ▶ *That's simply wonderful!*

sin *noun* (*plural* **sins**)
something that your religion says you should not do because it is very bad

since *adverb, conjunction, preposition*
1 from that time ▶ *We have been friends since last summer.*
2 because ▶ *We couldn't play outside since it was raining.*

sincere *adjective*
If you are sincere, you really mean what you say. ▶ *I could tell he was being sincere when he wished me good luck.*

sing *verb* (**sings**, **singing**, **sang**, **sung**)
When you sing, you use your voice to make music.
❶ A **singer** is someone who sings.

singe *verb* (**singes**, **singeing**, **singed**)
If you singe something, you burn it slightly so that it goes a little bit brown.

single *adjective*
1 only one ▶ *The tree has a single apple.*
2 Someone who is single is not married.

singular *noun*
the form of a word you use when you are talking about only one person or thing. *Children* is a plural, and the singular is *child*.

sink *noun* (*plural* **sinks**)
a large bowl with taps where you can wash things

sink *verb* (**sinks**, **sinking**, **sank**, **sunk**)
1 When something sinks, it goes under water.
2 When something sinks, it goes downwards. ▶ *The sun sank behind the mountains.*

sip *verb* (**sips**, **sipping**, **sipped**)
When you sip a drink, you drink it slowly, a little bit at a time.

sir *noun*
a word you use when you are speaking politely to a man ▶ *Excuse me, sir, is this your hat?*

siren *noun* (*plural* **sirens**)
a machine that makes a loud sound to warn people about something

sister *noun* (*plural* **sisters**)
Your sister is a girl who has the same parents as you.

sit *verb* (**sits**, **sitting**, **sat**)
1 When you sit you rest on your bottom.
2 If something is sitting somewhere, it is there. ▶ *My school bag was sitting by the back door, where I had left it.*

site *noun* (*plural* **sites**)
a piece of ground that is used for something. For example, a camp site is a place where people can camp.

sitting room *noun* (*plural* **sitting rooms**)
the room in a house with comfortable chairs, where people sit and talk or watch television

situation *noun* (*plural* **situations**)
all the things that are happening to you and to the people around you ▶ *Because so many children have left, the school is now in a very difficult situation.*

six *noun* (*plural* **sixes**)
the number 6

sixteen *noun*
the number 16

sixty *noun*
the number 60

size *noun* (*plural* **sizes**)
The size of something is how big or small it is. ▶ *These trousers are the wrong size for me.*

sizzle *verb* (**sizzles, sizzling, sizzled**)
When something sizzles, it makes a hissing sound as it cooks.

skate *noun* (*plural* **skates**)
1 a boot with a special blade on the bottom, which you use for skating on ice
2 a special shoe or boot with wheels on the bottom

skate *verb* (**skates, skating, skated**)
When you skate, you move smoothly over ice or over the ground wearing ice skates or roller skates.
ℹ When you skate, you go **skating**.

skateboard *noun* (*plural* **skateboards**)
a small board on wheels that you can stand on and ride.
ℹ When you ride on a skateboard, you are **skateboarding**.

skeleton *noun* (*plural* **skeletons**)
Your skeleton is all the bones that are in your body.

sketch *verb* (**sketches, sketching, sketched**)
When you sketch something, you draw it quickly and roughly.

ski *noun* (*plural* **skis**)
Skis are long, flat sticks that you strap to your feet and use for moving over snow.

ski *verb* (**skis, skiing, skied**)
When you ski, you move over snow on skis.

skid *verb* (**skids, skidding, skidded**)
If a car skids, it slides out of control because the road is wet or slippery.

skill *noun* (*plural* **skills**)
If you have skill, you can do something well. ▶ *You need a lot of skill to do gymnastics.*
ℹ Someone who has a lot of skill is **skilful**.

skim *verb* (**skims, skimming, skimmed**)
If something skims across water, it moves quickly across it, only just touching the surface.

skimpy *adjective* (**skimpier, skimpiest**)
Skimpy clothes are small and do not cover all of your body.

skin *noun* (*plural* **skins**)
1 Your skin is the part of you that covers all of your body.
2 The skin on a fruit or vegetable is the tough part on the outside of it.

skinny *adjective* (**skinnier, skinniest**)
Someone who is skinny is very thin.

skip *verb* (**skips, skipping, skipped**)
1 When you skip, you run along lightly taking a little jump with each step.
2 When you skip, you turn a rope over your head and under your feet and jump over it each time it goes under your feet.

skirt

skirt noun (plural **skirts**)
a piece of clothing that a woman or girl wears. It fastens around her waist and hangs down over her legs.

skittle noun (plural **skittles**)
Skittles are pieces of wood or plastic that you try to knock down with a ball as a game.

skull noun (plural **skulls**)
Your skull is the bony part of your head, which protects your brain.

skunk noun (plural **skunks**)
an animal with a large, bushy tail. Skunks give off a nasty smell when they are frightened.

sky noun (plural **skies**)
The sky is the space above the earth where you can see the sun, moon, and stars.

skyscraper noun (plural **skyscrapers**)
a very tall building

slab noun (plural **slabs**)
A slab of something is a flat, thick piece of it. ▶ *The old well was covered with a slab of concrete.*

slack adjective (**slacker**, **slackest**)
If something is slack, it is not pulled tight. ▶ *Some of the ropes round the tent were too slack.*

slam verb (**slams**, **slamming**, **slammed**)
If you slam a door, you push it shut so that it makes a loud bang.

slang noun
words that you use when you are talking to your friends, but not when you are writing or talking politely to people

slant verb (**slants**, **slanting**, **slanted**)
If something slants, it slopes and is not straight.

slap verb (**slaps**, **slapping**, **slapped**)
To slap someone means to hit them with the front of your hand.

slash verb (**slashes**, **slashing**, **slashed**)
1 To slash something means to make long cuts in it.
2 When a shop slashes its prices, it makes them a lot lower.

slate noun (plural **slates**)
a type of smooth, grey rock. Pieces of slate are sometimes used to cover the roofs of houses.

slaughter verb (**slaughters**, **slaughtering**, **slaughtered**)
To slaughter an animal means to kill it.

slave noun (plural **slaves**)
someone who belongs to another person and has to work for them without being paid

slay verb (**slays**, **slaying**, **slew**, **slain**)
To slay someone means to kill them.

sledge noun (plural **sledges**)
a piece of wood or plastic, which you sit on to slide along on snow or ice

sleek adjective (**sleeker**, **sleekest**)
Sleek hair or fur is smooth and shiny.

sleep verb (**sleeps**, **sleeping**, **slept**)
When you sleep, you close your eyes and rest your body and your mind.
❶ When you feel **sleepy**, you are tired.

sleet noun
a mixture of rain and snow

sleeve noun (plural **sleeves**)
The sleeves on a shirt, jumper, or coat are the parts that cover your arms.

sleigh noun (plural **sleighs**) (*pronounced* **slay**)
a large sledge that is pulled along by animals

slender adjective
Someone who is slender is thin and graceful.

slept verb SEE **sleep**

slew verb SEE **slay**

slice noun (plural **slices**)
A slice of something is a thin piece that has been cut off. ▶ *Would you like a slice of meat?*

slide verb (**slides, sliding, slid**)
When something slides, it moves along smoothly. ▶ *We slid on the ice.*

slide noun (plural **slides**)
1 a toy that children can play on. It is made of steps that you climb up, and a long sloping part that you can slide down.
2 a clip that girls sometimes wear in their hair to keep it tidy

slight adjective (**slighter, slightest**)
Something that is slight is small and not very important or not very bad. ▶ *I've got a slight headache.*
❶ **Slightly** means only a little bit.

slim adjective (**slimmer, slimmest**)
Someone who is slim is thin.

slime noun
nasty wet, slippery stuff
❶ Something that is covered with slime is **slimy**.

sling verb (**slings, slinging, slung**)
If you sling something somewhere, you throw it there roughly.

sling noun (plural **slings**)
a piece of cloth that goes round your arm and is tied round your neck. You wear a sling to support your arm if you have hurt it.

slip verb (**slips, slipping, slipped**)
1 If you slip, your foot accidentally slides on the ground. ▶ *Sam slipped and fell over.*
2 When you slip somewhere, you go there quickly and quietly. ▶ *She slipped out of the room while the teacher wasn't looking.*

slip noun (plural **slips**)
A slip of paper is a small piece of paper.

slipper noun (plural **slippers**)
Slippers are soft shoes that you wear indoors.

slippery adjective
If something is slippery, it is smooth or wet and difficult to get hold of or walk on. ▶ *We had to drive slowly because the road was slippery.*

slit noun (plural **slits**)
a long, narrow cut in something

slither verb (**slithers, slithering, slithered**)
To slither along means to move along the ground. ▶ *The snake slithered into the bushes.*

slob noun (plural **slobs**)
a very lazy person

slobber verb (**slobbers, slobbering, slobbered**)
When an animal slobbers, liquid comes out of its mouth.

slogan noun (plural **slogans**)
a short phrase that is used to advertise something

slop verb (**slops, slopping, slopped**)
When water slops, it splashes around and spills. ▶ *The bucket was so full that some water slopped out.*

slope verb (**slopes, sloping, sloped**)
Something that slopes is not flat but goes up or down at one end. ▶ *Our playground slopes slightly.*
❶ Something that slopes is **sloping**.

slope noun (plural **slopes**)
a piece of ground that goes up or down like the side of a hill

sloppy adjective (**sloppier, sloppiest**)
1 A sloppy substance is thin and wet, like water.
2 Sloppy work is messy and careless.

slosh verb (**sloshes, sloshing, sloshed**)
When water sloshes around, it moves around and splashes.

slot noun (plural **slots**)
a narrow opening that you can put a coin into ▶ *Put a coin in the slot and you'll get a ticket.*

slouch

slouch verb (slouches, slouching, slouched)
If you slouch, you walk or sit with your shoulders bent forwards.

slow adjective (slower, slowest)
1 Something that is slow does not move very quickly. Someone who is slow does not do things quickly.
2 If a clock or watch is slow, it shows a time that is earlier than the right time. ▶ *I'm sorry I'm late, but my watch is slow.*
ℹ If you do something in a slow way, you do it **slowly**.

slug noun (plural slugs)
a small, soft animal that looks like a snail but has no shell

slurp verb (slurps, slurping, slurped)
If you slurp, you drink something in a noisy way.

slush noun
melting snow

sly adjective (slyer, slyest)
Someone who is sly is clever at tricking people secretly to get what they want.

smack verb (smacks, smacking, smacked)
To smack someone means to hit them with the front of your hand.

small adjective (smaller, smallest)
Something that is small is not very big. ▶ *We live in quite a small house.*

smart adjective (smarter, smartest)
1 If you look smart, you look clean and neat and have nice clothes on.
2 Someone who is smart is clever.

smart verb (smarts, smarting, smarted)
If a part of your body smarts, it hurts with a stinging pain. ▶ *The smoke made my eyes smart.*

smash verb (smashes, smashing, smashed)
When something smashes, it breaks into a lot of pieces with a loud noise. ▶ *I dropped a glass and it smashed.*

smear verb (smears, smearing, smeared)
To smear something means to spread it in a messy way. ▶ *The baby had smeared jam all over his face.*

smell verb (smells, smelling, smelled or smelt)
1 When you smell something, you notice it through your nose. ▶ *I can smell something burning.*
2 If something smells, you can notice it through your nose. ▶ *Your feet smell!*
ℹ Something that smells nasty is **smelly**.

smell noun (plural smells)
1 A smell is something that you can notice with your nose. ▶ *There was a strange smell in the kitchen.*
2 Your sense of smell is how well you can smell things. ▶ *Dogs have a very good sense of smell.*

smile verb (smiles, smiling, smiled)
When you smile, you move your mouth to show that you are happy.

smog noun
dirty air that is caused by pollution in a town or city

smoke noun
grey or black gas from a fire

smoke verb (smokes, smoking, smoked)
1 When something smokes, smoke comes off it. ▶ *The bonfire was still smoking the next morning.*
2 If someone smokes a cigarette they put it in their mouth and breathe in the smoke from it.

smooth adjective (smoother, smoothest)
Something that is smooth is flat and level, with no bumps or rough parts. ▶ *Babies have lovely smooth skin.*

smother verb (smothers, smothering, smothered)
To smother someone means to cover their mouth and nose so that they cannot breathe.

smoulder verb (smoulders, smouldering, smouldered)
When something smoulders, it burns slowly with a lot of smoke but not many flames.

smudge noun (plural smudges)
a dirty mark on something

smudge verb (smudges, smudging, smudged)
If you smudge paint or ink, you touch it while it is still wet and make it messy.

smuggle verb (smuggles, smuggling, smuggled)
To smuggle something into a place or out of a place means to take it there secretly.
❶ Someone who smuggles things into a country is a **smuggler**.

snack noun (plural snacks)
something you can eat quickly instead of a meal

snag noun (plural snags)
a small problem

snail noun (plural snails)
a small animal with a soft body, no legs, and a hard shell on its back

snake noun (plural snakes)
an animal with a long, thin body and no legs

snap verb (snaps, snapping, snapped)
1 If something snaps, it breaks suddenly. ▶ *The rope snapped.*
2 If an animal snaps at you, it tries to bite you.
3 To snap at someone means to shout at them angrily. ▶ *"Go away," she snapped.*

snare noun (plural snares)
a trap for catching animals

snarl verb (snarls, snarling, snarled)
When an animal snarls, it makes a fierce sound and shows its teeth.

snatch verb (snatches, snatching, snatched)
If you snatch something, you grab it quickly.

sneak verb (sneaks, sneaking, sneaked)
When you sneak somewhere, you go there quietly so that people do not see you or hear you.

sneer verb (sneers, sneering, sneered)
To sneer at someone means to make fun of them.

sneeze verb (sneezes, sneezing, sneezed)
When you sneeze, air suddenly comes out of your nose with a loud noise. ▶ *The dust made me sneeze.*

sniff verb (sniffs, sniffing, sniffed)
When you sniff, you breathe in noisily through your nose. ▶ *You shouldn't sniff when you have a cold.*

snigger verb (sniggers, sniggering, sniggered)
When you snigger, you laugh quietly.

snip verb (snips, snipping, snipped)
When you snip a piece off something, you cut it off.

snivel verb (snivels, snivelling, snivelled)
If you snivel, you cry and sniff a lot.

snob noun (plural snobs)
someone who thinks they are better than other people

snooker noun
a game that you play on a special table with coloured balls. You hit the balls with a long stick, and try to get them into holes round the edge of the table.

snoop verb (snoops, snooping, snooped)
To snoop means to look round a place secretly to try to find things.

snooze *verb* (snoozes, snoozing, snoozed)
When you snooze, you have a short sleep.

snore *verb* (snores, snoring, snored)
If you snore, you breathe very noisily while you are asleep.

snorkel *noun* (*plural* snorkels)
a tube that you hold in your mouth and use to breathe through while you are swimming under water

snort *verb* (snorts, snorting, snorted)
To snort means to make a loud noise by pushing air out through your nose. ▶ *The horse snorted and stamped its feet.*

snout *noun* (*plural* snouts)
A pig's snout is its long nose.

snow *noun*
small, light flakes of frozen water that fall from the sky when it is very cold

snowboard *noun* (*plural* snowboards)
a narrow board that you stand on to slide down a slope over snow
❶ When you use a snowboard, you go **snowboarding**.

snowdrop *noun* (*plural* snowdrops)
a small white flower that you see in January and February

snug *adjective* (snugger, snuggest)
If you feel snug, you feel warm, cosy, and comfortable.

snuggle *verb* (snuggles, snuggling, snuggled)
When you snuggle somewhere, you curl up there so that you are warm and comfortable.

soak *verb* (soaks, soaking, soaked)
1 To soak something means to make it very wet. ▶ *The rain got in and soaked the carpet.*
2 If something soaks up water, the water goes into it.

soap *noun* (*plural* soaps)
1 Soap is something that you use with water for washing yourself.
2 A soap is a regular television series about the lives of ordinary people. A soap is also called a **soap opera**.

soar *verb* (soars, soaring, soared)
When something soars, it goes high up into the air.

sob *verb* (sobs, sobbing, sobbed)
If you sob, you cry in a noisy way.

soccer *noun*
the game of football

sociable *adjective*
Someone who is sociable likes being with other people.

society *noun* (*plural* societies)
1 A society is all the people who live together in the same country.
2 A society is a club. ▶ *You should join your local drama society.*

sock *noun* (*plural* socks)
a piece of clothing that you wear over your feet

socket *noun* (*plural* sockets)
a place on a wall that an electric plug fits into

sofa *noun* (*plural* sofas)
a long, comfortable seat for more than one person

soft *adjective* (softer, softest)
1 Something that is soft is not hard or stiff. ▶ *I slept on a lovely soft bed.*
2 A soft sound is not very loud. ▶ *There was soft music playing in the background.*
❶ If you do something **softly**, you do it gently or quietly.

soft drink *noun* (*plural* soft drinks)
a sweet drink that has no alcohol in it. Orange squash and lemonade are soft drinks.

software *noun*
the programs that you put into a computer to make it work

soggy *adjective* (**soggier, soggiest**)
Something that is soggy is wet and soft. ▶ *The cardboard box went all soggy in the rain.*

soil *noun*
the brown earth that plants grow in

solar *adjective*
Solar means to do with the sun. ▶ *Some houses now use solar energy.*

sold *verb* SEE **sell**

soldier *noun* (*plural* **soldiers**)
someone who is a member of an army

sole *noun* (*plural* **soles**)
The sole of your foot or shoe is the part underneath it.

solid *adjective*
1 Something that is solid is not hollow in the middle. ▶ *Tennis balls are hollow but cricket balls are solid.*
2 Something that is solid is hard and firm. ▶ *Water becomes solid when it freezes.*

solid *noun* (*plural* **solids**)
any substance that is hard and is not a liquid or a gas. Wood, rock, and plastic are all solids.

solo *noun* (*plural* **solos**)
a piece of music or a dance that one person performs on their own

solution *noun* (*plural* **solutions**)
The solution to a puzzle or problem is the answer.

solve *verb* (**solves, solving, solved**)
When you solve a puzzle or problem, you find the answer to it.

some *adjective, pronoun*
1 a few ▶ *Some of us can swim, but the others can't.*
2 an amount of something ▶ *Would you like some cake?*

somebody, someone *pronoun*
a person ▶ *Somebody's taken my pencil!*

somehow *adverb*
in some way ▶ *We must find him somehow.*

somersault *noun* (*plural* **somersaults**)
When you do a somersault, you roll over forwards or backwards.

something *pronoun*
a thing ▶ *I'm sure I have forgotten something.*

sometimes *adverb*
at some times ▶ *Sometimes I cycle to school, sometimes I walk.*

somewhere *adverb*
in some place ▶ *I put the book somewhere but I've forgotten where.*

son *noun* (*plural* **sons**)
Someone's son is their male child.

song *noun* (*plural* **songs**)
a piece of music with words that you sing

soon *adverb*
in a very short time ▶ *We must go home soon.*

soot *noun*
black powder that is left behind after coal or wood has been burnt

soothe *verb* (**soothes, soothing, soothed**)
To soothe someone means to make them feel calm and less upset.

sorcerer *noun* (*plural* **sorcerers**)
someone in stories who can use magic. A woman who does this is a **sorceress**.

sore *adjective* (**sorer, sorest**)
If a part of your body is sore, it hurts. ▶ *I've got a sore throat.*

sorrow *noun* (*plural* **sorrows**)
a very sad feeling

sorry *adjective* (**sorrier, sorriest**)
1 If you are sorry that you did something, you are sad about it and wish that you had not done it. ▶ *I'm very sorry that I broke your window.*
2 If you feel sorry for someone, you feel sad because something nasty has happened to them.

sort noun (plural **sorts**)
a kind ▶ *Which sort of ice cream do you like?*

sort verb (**sorts, sorting, sorted**)
When you sort things, you put them into different groups. ▶ *We sorted the books into different piles.*

sought verb SEE **seek**

soul noun (plural **souls**)
the part of a person that some people believe goes on living after the person has died

sound noun (plural **sounds**)
anything that you can hear ▶ *I heard a strange sound.*

sound verb (**sounds, sounding, sounded**)
If a bell or alarm sounds, it makes a noise.

soundly adverb
When you sleep soundly, you are fast asleep.

soundtrack noun (plural **soundtracks**)
The soundtrack of a film is the music that is played during the film.

soup noun (plural **soups**)
a hot liquid made from meat or vegetables

sour adjective (**sourer, sourest**)
Something that is sour has a nasty bitter taste, like a lemon.

source noun (plural **sources**)
The source of something is the place where it comes from, or the place where it starts. ▶ *The source of the river is up in the hills.*

south noun
South is one of the directions in which you can face or travel. On a map, south is the direction towards the bottom of the page.
❶ The **southern** part of a country is the part in the south.

souvenir noun (plural **souvenirs**)
something that you keep because it reminds you of a person or place ▶ *We brought back some shells as a souvenir.*

sow verb (**sows, sowing, sowed, sown**) (rhymes with *low*)
When you sow seeds, you put them into the ground so that they will grow.

sow noun (plural **sows**) (rhymes with *cow*)
a female pig

soya noun
a plant that produces beans that people can eat. The beans can also be made into soya oil for cooking, or into a liquid that you can drink like milk.

space noun (plural **spaces**)
1 Space is the place around the Earth and far beyond the Earth, where the stars and planets are. ▶ *Would you like to go up into space?*
2 A space is a place with nothing in it. ▶ *There is a space here for you to write your name.*
❶ A **spacecraft** or a **spaceship** is a machine like a large aeroplane that can travel through space.

spade noun (plural **spades**)
a tool with a long handle and a wide blade that you use for digging

spaghetti noun
a type of pasta that is made in long, thin pieces

spank verb (**spanks, spanking, spanked**)
To spank someone means to smack them on the bottom because they have done something wrong.

spanner noun (plural **spanners**)
a tool that you use for tightening and undoing nuts

spare verb (**spares, sparing, spared**)
If you can spare something, you have some extra that you can give to someone else. ▶ *Can you spare a bit of money for our collection?*

spare *adjective*
If something is spare, you are not using it at the moment but you can use it if you need it. ▶ *I always have a spare pencil in my pencil case.*

spark *noun* (*plural* **sparks**)
1 a tiny flash of electricity ▶ *There was a spark as the wires touched.*
2 a tiny piece of something burning that shoots out from a fire ▶ *I was worried that a spark from the fire might set fire to the rug.*

sparkle *verb* (**sparkles, sparkling, sparkled**)
When something sparkles, it shines brightly. ▶ *The sea sparkled in the sunlight.*

sparrow *noun* (*plural* **sparrows**)
a small, brown bird that you often see in people's gardens

spat *verb* SEE **spit**

spawn *noun*
Frog spawn is eggs that are laid by frogs in water. They are surrounded and held together by something that looks like clear jelly.

speak *verb* (**speaks, speaking, spoke, spoken**)
When you speak, you say something. ▶ *I spoke to my grandmother on the phone.*

spear *noun* (*plural* **spears**)
a long stick with a sharp point that is used as a weapon

special *adjective*
1 Something that is special is different and more important than other things. ▶ *Your birthday is a very special day.*
2 A special thing is for one particular person or job. ▶ *You use a special tool to tune the strings on a piano.*
❶ Something that is for one particular person or job is **specially** for that person or job.

species *noun* (*plural* **species**)
a type of animal or plant ▶ *The giant panda is now an endangered species.*

speck *noun* (*plural* **specks**)
A speck of something is a tiny bit of it. ▶ *There were some specks of dust on the computer screen.*

speckled *adjective*
Something that is speckled has a lot of small spots on it. ▶ *Some birds lay speckled eggs.*

spectacles *noun*
glasses that you wear over your eyes to help you see. Spectacles are sometimes called **specs**.

spectacular *adjective*
Something that is spectacular is very exciting or impressive. ▶ *We watched a spectacular fireworks display.*

spectator *noun* (*plural* **spectators**)
Spectators are people who watch a sporting event or game.

speech *noun* (*plural* **speeches**)
1 Speech is the ability to speak. ▶ *People use speech to communicate with each other.*
2 A speech is a talk that someone gives to a group of people.

speech marks *noun*
marks like this ' ' or this " " that you use in writing. You put these marks round words to show that someone has spoken them.

speed *noun*
The speed of something is how fast it moves or how quickly it happens. ▶ *We were driving along at a speed of 100 kilometres an hour.*

speed *verb* (**speeds, speeding, sped**)
To speed means to run or go along very fast. ▶ *He sped past me on his bike.*

spell

spell *verb* (**spells, spelling, spelled** or **spelt**)
The way in which you spell a word is the letters that you use when you write it. ▶ *I can't spell your name.*
ℹ The **spelling** of a word is the letters you use to spell it.

spell *noun* (*plural* **spells**)
A spell is a set of words that people say in stories when they want something magic to happen.

spend *verb* (**spends, spending, spent**)
1 When you spend money, you use it to pay for things. ▶ *I've already spent all my pocket money.*
2 When you spend time doing something, you use the time to do that thing. ▶ *I spent all day working.*

sphere *noun* (*plural* **spheres**)
the shape of a ball

spice *noun* (*plural* **spices**)
a part of a plant that is dried and used in cooking to make food taste nice. Pepper is a spice.
ℹ **Spicy** food has a strong taste because it has been cooked with a lot of spices.

spider *noun* (*plural* **spiders**)
a small animal with eight legs that spins sticky webs to catch insects for food

spike *noun* (*plural* **spikes**)
a thin piece of metal with a sharp point

spill *verb* (**spills, spilling, spilled** or **spilt**)
If you spill something, you let some of it fall out onto the floor. ▶ *Mind you don't spill your drink.*

spin *verb* (**spins, spinning, spun**)
1 Something that spins turns round and round.
2 To spin thread from wool or cotton means to make it.
3 To spin a web means to make it. ▶ *The spider spun a web.*

spinach *noun*
a vegetable with large, dark green leaves that you can cook and eat

spine *noun* (*plural* **spines**)
1 Your spine is the long line of bones down the middle of your back.
2 The spines on a plant or animal are sharp points on it.

spinning wheel *noun* (*plural* **spinning wheels**)
a machine that you use for spinning thread from wool or cotton

spiral *noun* (*plural* **spirals**)
a line that keeps going round and round in circles, with each circle getting slightly bigger

spire *noun* (*plural* **spires**)
a tall, pointed part on the top of a tower on a building

spirit *noun* (*plural* **spirits**)
1 the part of a person that some people believe goes on living after the person has died
2 a ghost
3 If you have a lot of spirit, you are brave and determined.

spit *verb* (**spits, spitting, spat**)
If you spit, you push water or food out of your mouth.

spite *noun*
If you do something out of spite, you do it to hurt or upset someone.

spiteful *adjective*
Someone who is spiteful does nasty things to hurt or upset other people.

splash *verb* (**splashes, splashing, splashed**)
If you splash water, you hit it so that it makes a noise and flies up into the air.

splendid *adjective*
Something that is splendid is very good.

splinter noun (plural **splinters**)
a small, sharp bit of wood or glass

split verb (**splits, splitting, split**)
1 When something splits, it breaks or tears. ▶ *The bag split open and all the shopping fell out.*
2 When you split something, you break it into pieces. ▶ *He split the log with an axe.*

splutter verb (**splutters, spluttering, spluttered**)
If you splutter, you cough while you are speaking, especially because you are very surprised or shocked about something. ▶ *'What did you say?' he spluttered.*

spoil verb (**spoils, spoiling, spoiled** or **spoilt**)
1 To spoil something means to damage it so that it is not as good or as nice as it was before. ▶ *You'll spoil your new shoes if you get them all muddy.*
2 To spoil a child means to give them everything that they want so that they always expect to get their own way and behave badly if they do not.

spoke noun (plural **spokes**)
The spokes on a wheel are the pieces of metal that go from the centre of the wheel to the edge.

spoke, spoken verb SEE **speak**

sponge noun (plural **sponges**)
1 a thick, soft thing with a lot of small holes in. A sponge soaks up water easily, and you use it for washing things.
2 a type of cake

sponsor verb (**sponsors, sponsoring, sponsored**)
If you sponsor someone, you promise to give them money if they do something difficult.

spooky adjective (**spookier, spookiest**)
A place that is spooky is frightening because you think there might be ghosts in it.

spoon noun (plural **spoons**)
a thing that you use for eating soft or liquid foods such as soup and ice cream

sport noun (plural **sports**)
a game that you play or something difficult that you do to exercise your body. Football and tennis are sports.
❶ Someone who likes sport and is good at it is **sporty**. A **sportsman** is a man who does a sport. A **sportswoman** is a woman who does a sport.

spot noun (plural **spots**)
1 a small round mark on something ▶ *Leopards have spots all over their bodies.*
2 a small, sore, red lump on your skin ▶ *Teenagers often get spots on their faces.*

spot verb (**spots, spotting, spotted**)
If you spot something, you see it. ▶ *I spotted a policeman coming towards us.*

spotless adjective
Something that is spotless is perfectly clean.

spotlight noun (plural **spotlights**)
a strong light that can shine on one small area. Spotlights are used to light up different parts of a stage when people are performing a show.

spout noun (plural **spouts**)
The spout of a jug or teapot is the part that you pour liquid out of.

sprain verb (**sprains, spraining, sprained**)
If you sprain your wrist or ankle, you hurt it quite badly.

sprang verb SEE **spring**

sprawl

sprawl verb (sprawls, sprawling, sprawled)
When you sprawl, you sit or lie with your arms and legs spread out.

spray verb (sprays, spraying, sprayed)
When you spray water on something, you cover it with tiny drops of water.

spread verb (spreads, spreading, spread)
1 To spread something means to open it out to its full size. ▶ *The huge bird spread its wings and flew away.*
2 When you spread butter or jam, you put a thin layer of it onto bread.

spring verb (springs, springing, sprang, sprung)
To spring means to jump. ▶ *The cat sprang off the wall.*

spring noun (plural **springs**)
1 a piece of metal that is wound into rings so that it jumps back into shape after it has been pressed down
2 the time of the year when plants start to grow and the days get lighter and warmer

sprinkle verb (sprinkles, sprinkling, sprinkled)
When you sprinkle something, you shake a few drops or small pieces of it over something else. ▶ *She sprinkled some sugar on top of the cake.*

sprint verb (sprints, sprinting, sprinted)
When you sprint, you run as fast as you can over a short distance.

sprout verb (sprouts, sprouting, sprouted)
When a plant sprouts, it starts to grow new parts.

sprout noun (plural **sprouts**)
a vegetable that looks like a very small cabbage. Sprouts are also called **Brussels sprouts**.

sprung verb SEE **spring** verb

spun verb SEE **spin**

spurt verb (spurts, spurting, spurted)
When water spurts out of something, it shoots out very quickly.

spy noun (plural **spies**)
someone who works secretly to find out information about another person or country

spy verb (spies, spying, spied)
1 When you spy on someone, you watch them secretly.
2 When you spy something, you see it.

squabble verb (squabbles, squabbling, squabbled)
When people squabble, they argue about something that is not important.

squad noun (plural **squads**)
all the players in a sports team

square noun (plural **squares**)
1 a shape with four straight sides and four right angles. The sides of a square are all the same length.
2 an open space in a town with buildings all round it ▶ *We sat in the square to eat our lunch.*

squash verb (squashes, squashing, squashed)
When you squash something, you press it hard so that it becomes flat. ▶ *My sandwiches got squashed at the bottom of my bag.*

squash noun
a sweet drink made from fruit juice and sugar ▶ *Would you like some orange squash?*

squat verb (squats, squatting, squatted)
When you squat, you bend your knees under you so that your bottom is almost touching the ground.

squawk verb (squawks, squawking, squawked)
When a bird squawks, it makes a loud, rough sound in its throat.

squeak verb (squeaks, squeaking, squeaked)
To squeak means to make a very high sound. ▶ *Did you hear that mouse squeak?* ▶ *The door squeaked as it opened.*

squeal verb (squeals, squealing, squealed)
When you squeal, you shout or cry in a high voice. ▶ *The children were squealing with delight.*

squeeze verb (squeezes, squeezing, squeezed)
1 When you squeeze something, you press it hard with your hands. ▶ *Squeeze the tube to get some toothpaste out.*
2 If you squeeze something into a place, you push it in even though there is not very much room. ▶ *Can we squeeze another person in the car?*

squelch verb (squelches, squelching, squelched)
When something squelches, it makes a sound like someone walking through thick mud.

squirm verb (squirms, squirming, squirmed)
When you squirm, you wriggle with all of your body.

squirrel noun (plural squirrels)
a small animal with a thick, bushy tail. Squirrels live in trees and eat nuts and seeds.

squirt verb (squirts, squirting, squirted)
When water squirts out of something, it shoots out quickly.

stab verb (stabs, stabbing, stabbed)
To stab something means to push something sharp into it. To stab someone means to hurt them by pushing something sharp into their skin. ▶ *He stabbed a bit of sausage with his fork.*

stable noun (plural stables)
a building in which horses are kept

stack noun (plural stacks)
A stack of things is a neat pile of them.

stadium noun (plural stadiums)
a large building where people can watch sports and games

staff noun
The staff in a school, shop, or office are all the people who work there.

stag noun (plural stags)
a male deer

stage noun (plural stages)
The stage in a theatre or hall is the raised part on which people act, sing, or dance to entertain other people.

stagger verb (staggers, staggering, staggered)
1 When you stagger, you walk with unsteady legs, almost falling over with each step.
2 If something staggers you, it surprises you a lot.

stagnant adjective
Stagnant water does not flow but stays in a pool, and so is not fresh or clean.

stain noun (plural stains)
a dirty mark on something that does not come out when you wash it or rub it
❶ Something that has stains on it is **stained**.

stair noun (plural stairs)
Stairs are steps inside a building.

staircase noun (plural staircases)
a set of stairs inside a building

stake noun (plural stakes)
a thick, pointed wooden stick

stale adjective (staler, stalest)
Something that is stale is not fresh. ▶ *We had nothing to eat except stale bread.*

stalk

stalk noun (plural **stalks**)
The stalk of a flower, leaf, or fruit, is the part that joins it to the plant.

stall noun (plural **stalls**)
1 a table that things are arranged on so that they can be sold, for example in a market
2 a place for one animal in a stable

stallion noun (plural **stallions**)
a male horse.

stammer verb (**stammers, stammering, stammered**)
If you stammer, you keep repeating the sounds at the beginning of words when you speak.

stamp noun (plural **stamps**)
a small piece of sticky paper with a picture on it. You stick a stamp on a letter or parcel to show that you have paid to post it.

stamp verb (**stamps, stamping, stamped**)
When you stamp your feet, you bang them heavily on the ground.

stand verb (**stands, standing, stood**)
1 When you stand, you are on your feet, not sitting or lying down. ▶ *He was standing by the door.* ▶ *The teacher asked us all to stand up.*
2 If you cannot stand something, you do not like it at all.

stand noun (plural **stands**)
something that you can put things on ▶ *Put your music on the music stand.*

standard noun (plural **standards**)
The standard of something is how good or bad it is. ▶ *The standard of your work has really improved this term.*

standard adjective
Something that is standard is ordinary and not special. ▶ *This software will run on any standard computer.*

stank verb SEE **stink**

staple noun (plural **staples**)
Staples are small pieces of wire that you use to join pieces of paper together. You use a special machine called a **stapler** to push the pieces of wire through the paper and press them flat.

star noun (plural **stars**)
1 Stars are the tiny, bright lights you see in the sky at night.
2 A star is a shape that has five or more points sticking out all round it.
3 A star is a famous person.

star verb (**stars, starring, starred**)
If someone stars in a film or show, they have an important part in it.

stare verb (**stares, staring, stared**)
If you stare at something, you keep looking at it for a long time, without moving your eyes.

starling noun (plural **starlings**)
a small, dark-coloured bird

start verb (**starts, starting, started**)
1 When you start to do something, you begin to do it. ▶ *The little boy started to cry.*
2 When something starts, it begins. ▶ *What time does the concert start?*

start noun (plural **starts**)
The start of something is when it begins.

startle verb (**startles, startling, startled**)
If something startles you, it gives you a sudden shock. ▶ *The sudden noise startled me.*

starve verb (**starves, starving, starved**)
To starve means to be ill or to die because you have not got enough food.
❶ If someone starves to death, they die of **starvation**. If you are **starving**, you feel very hungry.

state *noun* (*plural* **states**)
1 The state that something is in is the condition it is in, for example whether it is clean, tidy, or broken. ▶ *Your room is in a very untidy state.*
2 A state is a country or one part of a country that has its own laws and government.

station *noun* (*plural* **stations**)
1 a place where trains and buses stop so that people can get on and off
2 a building where the police or fire fighters work

stationary *adjective*
If a car is stationary, it is not moving.

stationery *noun*
paper, pens, and other things that you use for writing and drawing

statue *noun* (*plural* **statues**)
a model of a person made from stone, wood, or metal

stay *verb* (**stays, staying, stayed**)
1 If you stay somewhere, you remain there and do not go away. ▶ *Please stay in your seats.*
2 If you stay in a place, you live there for a while. ▶ *I'm going to stay with my grandma for the summer holidays.*
3 To stay means to remain. ▶ *I hope it stays dry for sports day.*

steady *adjective* (**steadier, steadiest**)
1 Something that is steady is firm and does not shake or move about.
2 If something moves in a steady way, it moves along at the same speed all the time.

steak *noun* (*plural* **steaks**)
a thick slice of meat or fish

steal *verb* (**steals, stealing, stole, stolen**)
To steal something means to take something that belongs to someone else. ▶ *Someone's stolen my bike!*

steam *noun*
the hot gas that comes off water when it boils

steel *noun*
a type of strong, shiny metal

steep *adjective* (**steeper, steepest**)
Something that is steep slopes sharply up or down. ▶ *Children were sledging down the steep hill.*

steer *verb* (**steers, steering, steered**)
When you steer a car or bicycle, you make it go in the direction you want.

stem *noun* (*plural* **stems**)
the long, thin part of a plant that grows up out of the ground

stencil *noun* (*plural* **stencils**)
a piece of card or plastic with a pattern or picture cut into it. You paint or draw through the holes to make a picture on paper.

step *noun* (*plural* **steps**)
1 When you take a step, you move one foot forwards or backwards.
2 Steps are stairs. ▶ *You have to go down a few steps to get into the garden.*

stepbrother *noun* (*plural* **stepbrothers**)
A stepbrother is a boy whose father or mother has married your father or mother.

stepfather *noun* (*plural* **stepfathers**)
Your stepfather is a man who has got married to your mother but is not your real father.

stepmother *noun* (*plural* **stepmothers**)
Your stepmother is a woman who has got married to your father but is not your real mother.

stepsister *noun* (*plural* **stepsisters**)
A stepsister is a girl whose father or mother has married your father or mother.

stereo *noun* (*plural* **stereos**)
a machine that plays music from tapes or CDs through two speakers

stern

stern adjective (**sterner, sternest**)
Someone who is stern is serious and strict. ▶ *The teacher had a stern expression on her face.*

stethoscope noun (*plural* **stethoscopes**)
a special tube that a doctor uses to listen to someone's heart and breathing

stew noun (*plural* **stews**)
a mixture of meat or vegetables cooked in a sauce

stew verb (**stews, stewing, stewed**)
to cook food slowly in liquid

stick noun (*plural* **sticks**)
a long, thin piece of wood

stick verb (**sticks, sticking, stuck**)
1 If you stick a pin or nail into something, you push it in. ▶ *She stuck a pin in me!*
2 When you stick things together, you fix them together using glue. ▶ *I stuck the pictures into my book.*
3 If something sticks, it gets jammed and you cannot move it. ▶ *Sometimes the door sticks a bit.*

sticker noun (*plural* **stickers**)
a small piece of paper with a picture or writing on one side and glue on the other side

sticky adjective (**stickier, stickiest**)
Something that is sticky will stick to things when it touches them.

stiff adjective (**stiffer, stiffest**)
Something that is stiff is hard and does not bend easily. ▶ *Use a piece of stiff cardboard for the base of your model.*

still adjective (**stiller, stillest**)
1 Something that is still is not moving. ▶ *The water in the lake was still and calm.*
2 A still drink is not fizzy.

still adverb
1 When you stand, sit, or lie still, you do not move.
2 even now ▶ *He's still asleep.*

stilts noun
Stilts are long sticks with parts for your feet near the top, so that you can stand on them and walk about high above the ground.

sting verb (**stings, stinging, stung**)
If an insect stings you, it jabs you with a sharp part of its body and hurts you.

sting noun (*plural* **stings**)
An insect's sting is a sharp part of its body with poison in it.

stink verb (**stinks, stinking, stank** or **stunk**)
If something stinks, it smells nasty.

stir verb (**stirs, stirring, stirred**)
1 When you stir something, you move it about with a spoon.
2 When someone stirs, they move after they have been asleep.

stirrup noun (*plural* **stirrups**)
a metal loop that hangs down on each side of a horse's saddle for you to put your foot in

stitch noun (*plural* **stitches**)
1 Stitches are the loops of thread that you make when you are sewing or knitting.
2 A stitch is a sudden pain in your side that you sometimes get when you have been running.

stoat noun (*plural* **stoats**)
a small furry wild animal with a long body and short legs

stock noun (*plural* **stocks**)
A stock of things is an amount that you keep in a place ready to be used.

stock verb (**stocks, stocking, stocked**)
If a shop stocks something, it keeps it in the shop so that people can buy it.

stocking noun (plural **stockings**)
a piece of clothing that a woman wears over her legs and feet

stocky adjective (**stockier, stockiest**)
Someone who is stocky has a strong, solid body.

stole, stolen verb SEE **steal**

stomach noun (plural **stomachs**)
Your stomach is the part inside your body where your food goes after you have eaten it.

stone noun (plural **stones**)
1 Stone is rock. ▶ *The castle is built of solid stone.*
2 A stone is a small piece of rock. ▶ *He threw a stone into the water.*
3 A stone is the hard seed in the middle of some fruits such as a cherry or peach.
4 We can measure weight in stones. One stone is just under $6\frac{1}{2}$ kilograms.

stood verb SEE **stand**

stool noun (plural **stools**)
a small seat without a back

stoop verb (**stoops, stooping, stooped**)
When you stoop, you bend your body forwards. ▶ *He stooped to pick up a stone.*

stop verb (**stops, stopping, stopped**)
1 When you stop something, you make it stand still. ▶ *The policeman stopped the traffic.*
2 When something stops, it stands still. ▶ *The bus stopped outside the school.*
3 When you stop doing something, you no longer do it. ▶ *The baby finally stopped crying.*

store verb (**stores, storing, stored**)
When you store things, you keep them until you need them.

store noun (plural **stores**)
a large shop

storey noun (plural **storeys**)
One storey of a tall building is one floor.

stork noun (plural **storks**)
a large bird with very long legs and a long beak

storm noun (plural **storms**)
When there is a storm, there is a strong wind and a lot of rain or snow.

story noun (plural **stories**)
something in a book that tells you about things that have happened

stout adjective (**stouter, stoutest**)
Someone who is stout is quite fat.

stove noun (plural **stoves**)
something that gives out heat for warming a room or for cooking

stowaway noun (plural **stowaways**)
someone who gets onto a boat or an aeroplane secretly and travels without paying

straight adjective (**straighter, straightest**)
Something that is straight does not bend or curl. ▶ *Have you got straight hair or curly hair?*
❶ When you make something straight, you **straighten** it.

strain verb (**strains, straining, strained**)
1 If you strain a muscle, you hurt it by stretching it too much.
2 If you strain to do something, you try very hard to do it by pushing or stretching with your body. ▶ *I had to strain to reach the handle.*
3 When you strain a liquid, you pour it through a sieve to take out lumps.

stranded adjective
If you are stranded in a place, you are stuck there and cannot get away.

strange

strange *adjective* (**stranger, strangest**)
1 Something that is strange is unusual and surprising. ▶ *What a strange animal!*
2 A strange place is one that you have not seen before. ▶ *She was very frightened to find herself alone in a strange place.*

stranger *noun* (*plural* **strangers**)
A stranger is someone you do not know. ▶ *You shouldn't talk to strangers.*

strangle *verb* (**strangles, strangling, strangled**)
To strangle someone means to kill them by pressing their throat until they cannot breathe.

strap *noun* (*plural* **straps**)
a strip of leather or cloth that you hold when you are carrying something or use for fastening things ▶ *My watch strap has broken.*

straw *noun* (*plural* **straws**)
1 Straw is dry stalks of corn or wheat that you put on the ground for animals to lie on.
2 A straw is a thin tube that you sometimes put into a drink and use to drink through.

strawberry *noun* (*plural* **strawberries**)
a small, red, juicy fruit

stray *adjective*
A stray dog or cat does not have a home but lives outside.

streak *noun* (*plural* **streaks**)
A streak of something is a long, thin line of it. ▶ *He had a few streaks of mud on his face.*

stream *noun* (*plural* **streams**)
1 a small river
2 A stream of things is a moving line of them. ▶ *There was a stream of cars coming out of the car park.*

streamer *noun* (*plural* **streamers**)
a long strip of coloured paper or ribbon that is used to decorate a place

streamlined *adjective*
Something that is streamlined has a smooth, flat shape that means it can move very fast.

street *noun* (*plural* **streets**)
a road in a town or city with houses along each side

streetwise *adjective*
Someone who is streetwise is clever and knows how to look after themselves in a town or city.

strength *noun*
The strength of something is how strong it is. ▶ *We need to test the strength of the rope.*

strengthen *verb* (**strengthens, strengthening, strengthened**)
To strengthen something means to make it stronger.

stress *noun*
If you are suffering from stress, you are very worried or upset about something.

stretch *verb* (**stretches, stretching, stretched**)
1 When you stretch something, you pull it so that it becomes longer or bigger. ▶ *He had to stretch the trousers a bit to get them on.*
2 When you stretch, you move your arms or legs as far as you can. ▶ *I stretched over to reach the telephone.*

stretcher *noun* (*plural* **stretchers**)
a big piece of cloth with a pole on each side, which is used for carrying a person who is injured or ill

strict *adjective* (**stricter, strictest**)
Someone who is strict does not allow people to behave badly. ▶ *The new teacher is very strict.*

stride *verb* (strides, striding, strode)
When you stride along, you walk with long steps.

stride *noun* (*plural* strides)
a long step ▶ *He took three strides forward.*

strike *verb* (strikes, striking, struck)
1 To strike something means to hit it. To strike someone means to hit or slap them. ▶ *His father had never once struck him.*
2 When you strike a match, you rub it so that it makes a flame.
3 When a clock strikes, it makes a sound. ▶ *The old clock in the hall struck two.*

string *noun* (*plural* strings)
1 String is thin rope. ▶ *We tied the parcel up with string.*
2 The strings on a guitar or violin are the parts that you touch to make music.

strip *verb* (strips, stripping, stripped)
When you strip, you take off all your clothes.

strip *noun* (*plural* strips)
A strip of something is a long, narrow piece of it.

stripe *noun* (*plural* stripes)
A stripe is a band of colour on something. ▶ *His shirt was blue with white stripes.*
❶ Something that has stripes is **striped** or **stripy**.

strode *verb* SEE **stride**

stroke *verb* (strokes, stroking, stroked)
When you stroke something, you move your hand over it gently. ▶ *Would you like to stroke the kitten?*

stroll *verb* (strolls, strolling, strolled)
When you stroll, you walk along slowly.

strong *adjective* (stronger, strongest)
1 If you are strong, you can lift and move heavy things.
2 Something that is strong will not break easily. ▶ *Is this rope strong enough to hold my weight?*
3 A strong taste is not mild or weak.

struck *verb* SEE **strike**

structure *noun* (*plural* structures)
A structure is anything that has been built. ▶ *Next to the house is a small wooden structure.*

struggle *verb* (struggles, struggling, struggled)
1 When you struggle, you fight with your arms and legs to try to get free.
2 If you struggle to do something, you work hard to do it because it is difficult. ▶ *I struggled a bit with some of the maths questions.*

stubborn *adjective*
Someone who is stubborn will not change their mind even though they might be wrong.

stuck *verb* SEE **stick** *verb*

student *noun* (*plural* students)
someone who is studying at college or university

studio *noun* (*plural* studios)
1 a place where people make films or radio or television programmes
2 a room where an artist or photographer works

study *verb* (studies, studying, studied)
1 When you study a subject, you learn about it. ▶ *We are studying rivers in geography.*
2 When you study something, you look at it very carefully. ▶ *He studied the map, looking for the farmhouse.*

study *noun* (*plural* studies)
a room in a house where someone works or studies

stuff noun
anything that you can see and touch ▶ *There was some nasty slimy stuff on the floor.* ▶ *We cleared all the old stuff out of the cupboards.*

stuff verb (**stuffs, stuffing, stuffed**)
1 When you stuff something, you fill it with things.
2 When you stuff something somewhere, you push it there roughly. ▶ *She stuffed the sweets into her pocket.*

stuffy adjective (**stuffier, stuffiest**)
A room that is stuffy smells nasty because there is no fresh air in it. ▶ *The attic was small and stuffy.*

stumble verb (**stumbles, stumbling, stumbled**)
If you stumble, you trip and fall over.

stump noun (*plural* **stumps**)
1 A stump is the part of something that is left after the main part has been broken off. ▶ *We sat down on an old tree stump.*
2 The stumps in a game of cricket are the three sticks that you put at each end of the pitch.

stun verb (**stuns, stunning, stunned**)
If something stuns you, it hits you on the head and makes you feel dizzy or weak.

stung verb SEE **sting**

stunk verb SEE **stink**

stunt noun (*plural* **stunts**)
something clever and dangerous that someone does in a film or to entertain people

stupid adjective
1 Something that is stupid is very silly. ▶ *That was a really stupid thing to do.*
2 Someone who is stupid is not very clever.

sturdy adjective (**sturdier, sturdiest**)
Something that is sturdy is strong and will not break easily.

stutter verb (**stutters, stuttering, stuttered**)
If you stutter, you keep repeating the sounds at the beginning of words when you speak.

sty noun (*plural* **sties**)
a building where a pig is kept

style noun (*plural* **styles**)
The style of something is its shape and design. ▶ *I like the colour of this jacket, but I don't like the style.*

subject noun (*plural* **subjects**)
1 something that you learn about at school. Maths, English, history, and art are all subjects.
2 The subject of a sentence is the person or thing that does the action of the verb. In the sentence 'William ate an apple', *William* is the subject of the sentence.
3 The subjects of a king or queen are the people they rule over.

submarine noun (*plural* **submarines**)
a ship that can go under the water

subordinate clause noun (*plural* **subordinate clauses**)
an extra clause in a sentence, which adds more information but could not be a sentence on its own

substance noun (*plural* **substances**)
anything that is a liquid, solid, or gas ▶ *Glue is a sticky substance.*

substitute noun (*plural* **substitutes**)
1 If you use something as a substitute for another thing, you use it instead of the other thing. ▶ *We didn't have any orange juice, so we used apple juice as a substitute.*
2 In a sport, a substitute is someone who plays if another player is injured or gets tired.

subtract *verb* (**subtracts, subtracting, subtracted**)
When you subtract one number from another, you take it away to make a smaller number. ▶ *If you subtract 6 from 9, you get 3.*
❶ When you subtract numbers, you do **subtraction**.

suburb *noun* (*plural* **suburbs**)
a part of a city that is a long way from the city centre ▶ *A lot of people live in the suburbs of London.*

subway *noun* (*plural* **subways**)
a path that goes under a busy road

succeed *verb* (**succeeds, succeeding, succeeded**)
If you succeed, you manage to do something. ▶ *I finally succeeded in getting the door open.*

success *noun* (*plural* **successes**)
If something is a success, it works well and people like it. ▶ *The concert was a great success.*

successful *adjective*
1 If you are successful, you manage to do something.
2 If something is successful, it works well and people like it. ▶ *Our trip to France was very successful.*

such *adjective*
so much ▶ *That was such fun!*

suck *verb* (**sucks, sucking, sucked**)
1 When you suck something into your mouth, you pull it in. ▶ *I sucked milk through a straw.*
2 When you suck on something, you keep moving it about in your mouth without chewing it or swallowing it. ▶ *He was sucking a sweet.*

sudden *adjective*
Something that is sudden happens quickly without any warning. ▶ *There was a sudden change in the weather.*
❶ Something that is sudden happens **suddenly**.

suede *noun*
a type of soft, rough leather

suffer *verb* (**suffers, suffering, suffered**)
When you suffer, something hurts you or upsets you.

sufficient *adjective*
If an amount of something is sufficient, it is enough. ▶ *Have you got sufficient money for your journey?*

suffix *noun* (*plural* **suffixes**)
letters that are added to the end of a word to change its meaning ▶ *The suffix '-ly' changes an adjective into an adverb.*

suffocate *verb* (**suffocates, suffocating, suffocated**)
If someone suffocates, they die because they cannot breathe.

sugar *noun*
a sweet powder that you add to drinks and other foods to make them taste sweet

suggest *verb* (**suggests, suggesting, suggested**)
If you suggest something, you say that it would be a good idea. ▶ *I suggested that we should call for help.*
❶ Something that you suggest is a **suggestion**.

suicide *noun*
To commit suicide means to kill yourself.

suit *noun* (*plural* **suits**)
a jacket and a pair of trousers or a skirt that are made of the same material and meant to be worn together

suit *verb* (**suits, suiting, suited**)
If something suits you, it looks nice on you. ▶ *Blue really suits you.*

suitable

suitable *adjective*
Something that is suitable is the right type of thing. ▶ *Are these shoes suitable for wearing in wet weather?*

suitcase *noun* (*plural* **suitcases**)
a bag with stiff sides that you use for carrying clothes and other things on journeys

suite *noun* (*plural* **suites**)
a set of two armchairs and a sofa

sulk *verb* (**sulks, sulking, sulked**)
When you sulk, you are bad-tempered and do not speak to people because you are cross about something.

sultana *noun* (*plural* **sultanas**)
a dried grape

sum *noun* (*plural* **sums**)
1 The sum of two numbers is the number that you get when you add them together. ▶ *The sum of 7 and 3 is 10.*
2 When you do a sum, you find an answer to a question in arithmetic by working with numbers. ▶ *Have you done all your sums yet?*
3 A sum of money is an amount of money.

summary *noun* (*plural* **summaries**)
When you give a summary of something, you describe the important parts of it and leave out the parts that are not so important.

summer *noun* (*plural* **summers**)
the time of the year when the weather is hot and it stays light for longer in the evenings

summit *noun* (*plural* **summits**)
The summit of a mountain is the top of it.

sun *noun*
1 the star that we see shining in the sky during the day. The sun gives the earth heat and light.
2 If you are in the sun, the sun is shining on you. ▶ *You shouldn't stay out in the sun for too long otherwise you will burn.*
❶ **Sunglasses** are dark glasses that you wear to protect your eyes from the bright sun. **Sunlight** is light from the sun. **Sunscreen** is a liquid that you put on your skin to protect it from the sun. **Sunshine** is the light and heat that come from the sun.

Sunday *noun* (*plural* **Sundays**)
the day of the week after Saturday

sunflower *noun* (*plural* **sunflowers**)
a big yellow flower that grows very tall and always turns to face the sun

sung *verb* SEE **sing**

sunk *verb* SEE **sink** *verb*

sunny *adjective* (**sunnier, sunniest**)
When the weather is sunny, the sun is shining.

super *adjective*
Something that is super is very good. ▶ *That's a super drawing!*

superb *adjective*
Something that is superb is wonderful.

superlative *adjective*
The superlative form of an adjective is the part that means 'most', for example 'biggest' is the superlative form of 'big'.

supermarket *noun* (*plural* **supermarkets**)
a large shop where you can buy food and other things

superstitious *adjective*
Someone who is superstitious believes that some things will bring you good luck or bad luck.
❶ A **superstition** is a belief that some things will bring you good luck or back luck.

supervise *verb* (**supervises, supervising, supervised**)
To supervise something means to watch it and make sure that it is done properly.

supper *noun* (*plural* **suppers**)
a meal or snack that you eat in the evening

supple *adjective*
Someone who is supple can bend their body easily.

supply *verb* (**supplies, supplying, supplied**)
If someone supplies you with something, they give it or sell it to you.

supply *noun* (*plural* **supplies**)
If you have a supply of things, you have some things that you are keeping ready to be used when you need them. ▶ *We keep a supply of paper in the cupboard.*

support *verb* (**supports, supporting, supported**)
1 To support something means to hold it up and stop it from falling down. ▶ *These pieces of wood support the roof.*
2 If you support someone, you help them and encourage them to do well. ▶ *Which football team do you support?*

suppose *verb* (**supposes, supposing, supposed**)
If you suppose that something is true, you think that it is true although you do not know for sure.

sure *adjective*
1 If you are sure about something, you know that it is definitely true. ▶ *I'm sure she lives in this street.*
2 If something is sure to happen, it will definitely happen.

surf *noun*
white foam that you see on the top of big waves in the sea

surf *verb* (**surfs, surfing, surfed**)
1 When you surf, you stand on a special board called a **surfboard** and ride in towards the shore on big waves.
2 When you surf the Internet, you look at different websites to find information.

surface *noun* (*plural* **surfaces**)
The surface of something is the top or outside part, not the middle. ▶ *We polished the tables to give them a shiny surface.*

surgeon *noun* (*plural* **surgeons**)
a doctor who is trained to do operations on people

surgery *noun* (*plural* **surgeries**)
the room where you go to see a doctor or dentist

surname *noun* (*plural* **surnames**)
Your surname is your last name, which is the name you share with other members of your family.

surprise *noun* (*plural* **surprises**)
1 If something is a surprise, you were not expecting it to happen. ▶ *We mustn't tell anyone about the party because it's going to be a surprise.*
2 Surprise is the feeling you have when something happens that you were not expecting. ▶ *She looked at me in surprise.*

surprise *verb* (**surprises, surprising, surprised**)
If something surprises you, you were not expecting it to happen. ▶ *It surprised everyone when Tom won the race.*
❶ If something surprises you, you are **surprised** by it.

surrender *verb* (**surrenders, surrendering, surrendered**)
When people surrender, they stop fighting or hiding and give themselves up.

surround

surround verb (surrounds, surrounding, surrounded)
To surround a place means to form a circle all around it.

survey noun (plural **surveys**)
a set of questions that you ask people to find out information about something

survive verb (survives, surviving, survived)
If you survive, you do not die but carry on living. ▶ *A few people survived the plane crash.*

susceptible adjective
If you are susceptible to an illness, you often get it.

suspect verb (suspects, suspecting, suspected)
If you suspect that something is true, you have a feeling that it might be true.

suspicious adjective
1 If someone behaves in a suspicious way, they behave in a strange, secret way which makes you think they are doing something wrong.
2 If you are suspicious of someone, you have a feeling that they have done something wrong and you do not trust them.

swallow verb (swallows, swallowing, swallowed)
When you swallow something, you make it go down your throat.

swallow noun (plural **swallows**)
a small bird with a dark blue body

swam verb SEE **swim**

swamp noun (plural **swamps**)
an area of very soft, wet ground

swan noun (plural **swans**)
a big white bird with a long neck that lives near water and often swims on the water

swap verb (swaps, swapping, swapped)
When you swap something, you give it to someone and get something else in return.

swarm noun (plural **swarms**)
A swarm of insects is a lot of them all flying together.

sway verb (sways, swaying, swayed)
To sway means to move gently from side to side. ▶ *We all swayed in time to the music.*

swear verb (swears, swearing, swore, sworn)
1 If you swear that something is true, you promise that it is true. ▶ *I swear I didn't take your money.*
2 If you swear, you say rude words.

sweat verb (sweats, sweating, sweated)
When you sweat, salty liquid comes out from your skin when you are very hot.

sweat noun
salty liquid that comes out from your skin when you are very hot

sweater noun (plural **sweaters**)
a warm jumper

sweatshirt noun (plural **sweatshirts**)
a jumper made of thick cotton cloth

sweep verb (sweeps, sweeping, swept)
When you sweep a floor, you clean it by pushing a brush over it.

sweet adjective (sweeter, sweetest)
1 Something that is sweet tastes of sugar.
2 Something that is sweet is very nice. ▶ *What a sweet little girl!*

sweet noun (plural **sweets**)
1 something small and sweet which you eat as a snack ▶ *You shouldn't eat too many sweets.*
2 a pudding ▶ *We had chocolate ice cream for sweet.*

sweetcorn noun
the yellow seeds of a corn plant, which you cook and eat as a vegetable

swell verb (swells, swelling, swelled, swollen)
When something swells, it gets bigger.
ⓘ Something that has swelled a lot is **swollen**. ▶ *My wrist is still very swollen where I bumped it.* A **swelling** is a part of your body that is swollen.

swept verb SEE **sweep**

swerve verb (swerves, swerving, swerved)
If a car swerves, it suddenly moves to the side so that it does not hit something. ▶ *The bus swerved to avoid a dog in the road.*

swift adjective (swifter, swiftest)
Something that is swift moves very quickly.

swim verb (swims, swimming, swam, swum)
When you swim, you move through water by floating and moving your arms and legs.
ⓘ When you swim, you go **swimming**. A **swimmer** is someone who swims.

swimming costume noun (plural swimming costumes)
a piece of clothing that a woman or girl wears when she goes swimming

swimming pool noun (plural swimming pools)
a large pool that has been built for people to swim in

swimming trunks noun
a piece of clothing that a man or boy wears when he goes swimming

swing verb (swings, swinging, swung)
When something swings, it moves backwards and forwards in the air.
▶ *The monkey was swinging from a tree.*

swing noun (plural swings)
a seat that hangs down from a frame. You can sit on it and move backwards and forwards.

swipe verb (swipes, swiping, swiped)
To swipe someone means to hit them.

swirl verb (swirls, swirling, swirled)
When water swirls around, it moves round and round in circles.

swish verb (swishes, swishing, swished)
If something swishes, it makes a rushing sound by moving quickly through the air. ▶ *The horse swished its tail.*

switch noun (plural switches)
something that you turn or press to make a machine work or a light come on ▶ *Where's the light switch?*

switch verb (switches, switching, switched)
When you switch something on, you turn or press a control so that it starts working. When you switch something off, you turn or press a control so that it stops working.

swivel verb (swivels, swivelling, swivelled)
To swivel means to turn round and face in the other direction. ▶ *I heard a voice behind me and swivelled round to see who it was.*

swollen verb SEE **swell**

swoop verb (swoops, swooping, swooped)
When a bird swoops down, it flies downwards quickly. ▶ *The owl swooped down on its prey.*

swop verb (swops, swopping, swopped)
Swop is another spelling of **swap**.

sword noun (plural swords)
a weapon that has a handle and a long, thin, sharp blade

swore, **sworn** verb SEE **swear**

swum verb SEE **swim**

swung *verb* SEE **swing** *verb*

sycamore *noun* (*plural* **sycamores**)
a large tree

syllable *noun* (*plural* **syllables**)
one of the sounds or beats in a word. The word *chim-pan-zee* has three syllables.

symbol *noun* (*plural* **symbols**)
a sign which stands for something or means something. The + symbol means that you add numbers together.

symmetrical *adjective*
A shape that is symmetrical has two halves that are exactly alike.

sympathy *noun*
If you have sympathy for someone, you feel sorry for them. ▶ *Everyone gave me a lot of sympathy when I broke my arm.*

synagogue *noun* (*plural* **synagogues**)
a building where Jews pray and worship

synonym *noun* (*plural* **synonyms**)
a word that means the same as another word ▶ *Courageous is a synonym of brave.*

synthetic *adjective*
A synthetic material is not found in nature but is made in a factory. ▶ *Wood is a natural material, but plastic is a synthetic material.*

syringe *noun* (*plural* **syringes**)
a needle that a doctor uses to give you an injection

syrup *noun* (*plural* **syrups**)
a very sweet, sticky, liquid

system *noun* (*plural* **systems**)
1 If you have a system for doing something, you do it in a particular order or way every time.
2 A system is a set of machines that work together. ▶ *The school has a new heating system.*

Tt

table *noun* (*plural* **tables**)
1 a piece of furniture with a flat top that you can put things on
2 a list of numbers or words arranged in rows or columns

tablet *noun* (*plural* **tablets**)
a small pill with medicine in, which you swallow when you are ill

table tennis *noun*
a game in which players use a bat to hit a small ball over a table that has a net across the middle

tackle *verb* (**tackles, tackling, tackled**)
1 When you tackle a difficult job, you start doing it.
2 If you tackle someone in a game such as football or rugby, you try to get the ball from them.

tackle *noun*
Your tackle is all the things you need for doing something. ▶ *We collected up our fishing tackle and went home.*

tactful *adjective*
If you are tactful, you are careful not to upset someone by saying something unkind.

tadpole *noun* (*plural* **tadpoles**)
a tiny animal that lives in water and will turn into a frog, toad, or newt. Tadpoles have long tails and no legs.

tag *noun* (*plural* **tags**)
a label that is tied or attached to something

tail *noun* (*plural* **tails**)
 1 An animal's tail is the long part at the end of its body. ▶ *The dog wagged its tail.*
 2 The tail of something is the part at the back of it. ▶ *There was smoke coming out from the tail of the aeroplane.*

tailor *noun* (*plural* **tailors**)
 someone whose job is to make suits and coats for people

take *verb* (**takes, taking, took, taken**)
 1 When you take something, you get hold of it. ▶ *I offered him a sweet, and he took one.*
 2 If you take something to a place, you have it with you when you go there. ▶ *Can I take my new book to school?*
 3 If someone takes something, they steal it.
 4 If someone takes you to a place, you go there with them. ▶ *Dad promised to take us to the cinema.*
 5 If you take one number away from another, you subtract it.
 6 When a rocket takes off, it goes up into space.

takeaway *noun* (*plural* **takeaways**)
 a meal that you buy from a shop and eat at home

talc, **talcum powder** *noun*
 a fine powder you put on your skin to make it feel smooth and smell nice

tale *noun* (*plural* **tales**)
 a story ▶ *I read this story in a book of fairy tales.*

talent *noun* (*plural* **talents**)
 If you have a talent for something, you can do it very well. ▶ *Aneeta has a talent for singing.*
 ❶ Someone who has a talent for something is **talented**.

talk *verb* (**talks, talking, talked**)
 When you talk, you speak to someone.

tall *adjective* (**taller, tallest**)
 1 Someone who is tall measures a lot from their head to their feet. ▶ *I'm quite tall for my age.*
 2 A tall tree or building is very high.

Talmud *noun*
 The Talmud is a book of writings about the Jewish religion.

talon *noun* (*plural* **talons**)
 A bird's talons are its sharp claws.

tambourine *noun* (*plural* **tambourines**)
 a musical instrument that you hold in your hand and shake or hit with your fingers to make a rhythm

tame *adjective* (**tamer, tamest**)
 An animal or bird that is tame is not wild or fierce, and is not afraid of people.

tan *noun*
 When you have a tan, your skin is darker than usual because you have been in the hot sun.

tangerine *noun* (*plural* **tangerines**)
 a small, sweet orange

tangle *noun* (*plural* **tangles**)
 If things are in a tangle, they are all twisted or knotted together and it is difficult to separate them.
 ❶ Things that are in a tangle are **tangled**.

tank *noun* (*plural* **tanks**)
 1 a very large container that you keep liquid in ▶ *There was a leak in the water tank.*
 2 a very strong, heavy truck that is used in war and moves on metal tracks, not wheels

tanker *noun* (*plural* **tankers**)
 1 a large ship that carries oil
 2 a large lorry that carries milk or petrol

tantrum *noun* (*plural* **tantrums**)
 If someone has a tantrum, they become very angry and shout a lot because they want something that they cannot have.

tap noun (plural **taps**)
a handle which you turn to start or stop water flowing through a pipe

tap verb (**taps, tapping, tapped**)
When you tap something, you hit it gently. ► *I tapped on the window.*

tape noun (plural **tapes**)
1 Sticky tape is a strip of sticky paper that you use for sticking things together.
2 Tape is a special magnetic strip that you can record sound and picture on.

tape verb (**tapes, taping, taped**)
To tape sound or pictures means to record them.

tape measure noun (plural **tape measures**)
a long strip of cloth or plastic with measurements marked on it, which you use for measuring things

tape recorder noun (plural **tape recorders**)
a machine that you use for recording music on tape and playing it back

tapestry noun (plural **tapestries**)
a picture that is made of stitches of different coloured threads

tar noun
a thick, sticky, black liquid that is used for making roads

target noun (plural **targets**)
something that you aim at and try to hit when you are shooting or throwing something

tart noun (plural **tarts**)
a type of food that has pastry on the bottom and fruit, meat, or vegetables on top

tartan noun
a type of woollen material from Scotland with a special pattern of coloured squares on it

task noun (plural **tasks**)
a job that you have to do ► *I had the task of washing-up.*

taste verb (**tastes, tasting, tasted**)
1 When you taste food, you eat a small amount to see what it is like.
2 The way something tastes is the flavour that it has. ► *The food tasted horrible.*

taste noun
1 The taste of something is what it is like when you eat it. ► *I don't like the taste of bananas.*
2 Your sense of taste is how well you can recognize things when you eat them.

tattered adjective
Something that is tattered is badly torn. ► *He was reading a tattered old book.*

tattoo noun (plural **tattoos**)
a picture that has been printed on someone's skin

taught verb SEE **teach**

taunt verb (**taunts, taunting, taunted**)
To taunt someone means to tease them in a very unkind way.

tax noun (plural **taxes**)
money that people have to pay to the government

taxi noun (plural **taxis**)
a car that you can travel in if you pay the driver

tea noun
1 a hot drink that you make by pouring boiling water over the dried leaves of the tea plant
2 a meal that you eat in the afternoon or early evening

teach verb (**teaches, teaching, taught**)
When you teach someone something, you tell them about it or show them how to do it. ► *Miss Cummings teaches us maths.*
🛈 A **teacher** is someone who teaches people.

team *noun* (*plural* **teams**)
a group of people who work together or play together on the same side in a game

teapot *noun* (*plural* **teapots**)
a container with a spout that you use for making and pouring tea

tear *verb* (**tears, tearing, tore, torn**) (rhymes with *fair*)
When you tear something, you pull it apart so that it splits or makes a hole. ▶ *Mind you don't tear your dress.*

tear *noun* (*plural* **tears**) (rhymes with *fear*)
Tears are drops of salty water that come from your eyes when you cry.

tease *verb* (**teases, teasing, teased**)
To tease someone means to make fun of them. ▶ *People often tease me because I'm short.*

technology *noun*
technology is using science and machines to help people in their lives

teddy bear *noun* (*plural* **teddy bears**)
a stuffed toy bear

teenager *noun* (*plural* **teenagers**)
someone who is between thirteen and nineteen years old

teeth *noun* SEE **tooth**

telegraph pole *noun* (*plural* **telegraph poles**)
a tall pole that holds up telephone wires

telephone *noun* (*plural* **telephones**)
a machine that you use to speak to someone who is far away from you. A telephone is also called a **phone**.

telephone *verb* (**telephones, telephoning, telephoned**)
When you telephone someone, you use a telephone to speak to them.

telescope *noun* (*plural* **telescopes**)
a tube with special lenses in. When you look through a telescope, things that are far away look bigger and closer.

television *noun* (*plural* **televisions**)
a machine that picks up signals that are sent through the air and changes them into pictures and sound so that people can watch them

tell *verb* (**tells, telling, told**)
1 When you tell someone something, you speak to them about it. ▶ *The teacher told us to tidy our books away.*
2 If you can tell the time, you can look at a clock and say what time it is.
3 To tell someone off means to speak to them angrily because they have done something wrong.

telly *noun* (*plural* **tellies**)
a television

temper *noun*
1 Your temper is how you are feeling. If you are in a good temper, you are happy and cheerful. If you are in a bad temper, you are cross and grumpy.
2 If you are in a temper, you are very angry. If you lose your temper, you suddenly become very angry.

temperature *noun*
1 The temperature of something is how hot or cold it is. ▶ *The temperature today is 22 degrees.*
2 If you have a temperature, your body is hotter than usual because you are ill.

temple *noun* (*plural* **temples**)
a place where people go to pray and worship a god

temporary *adjective*
Something that is temporary only lasts for a short time. ▶ *We are having lessons in a temporary classroom until the new classroom is ready.*

tempt

tempt verb (tempts, tempting, tempted)
If something tempts you, it seems nice and you want it, but you think it would be wrong or dangerous.

ten noun (plural tens)
the number 10

tend verb (tends, tending, tended)
If something tends to happen, it usually happens. ▶ *Men tend to be taller than women.*

tender adjective (tenderer, tenderest)
1 Someone who is tender is kind and loving. ▶ *She gave the child a tender smile.*
2 food that is tender is soft and easy to eat ▶ *The meat was lovely and tender.*

tennis noun
a game in which players use a special racket to hit a ball backwards and forwards over a net

tense adjective
If you are tense, you are nervous and worried.

tense noun (plural tenses)
The different tenses of a verb are the different forms that you use to show whether you are talking about the past, present, or future. ▶ *The past tense of come is came.*

tent noun (plural tents)
a shelter made of cloth that is stretched over poles. You sleep in a tent when you go camping.

tentacle noun (plural tentacles)
The tentacles of a sea animal such as an octopus are the long parts that it can move about.

tepid adjective
Tepid water or food is only slightly warm.

term noun (plural terms)
A school term is a time when you go to school and are not on holiday.

terminal noun (plural terminals)
a place where people begin or end their journeys by aeroplane or ship ▶ *Our flight leaves from Terminal 3.*

terrace noun (plural terraces)
a row of houses that are all joined together

terrible adjective
Something that is terrible is very bad.

terrier noun (plural terriers)
a type of small dog

terrific adjective
Something that is terrific is very good. ▶ *I had a terrific idea.*

terrify verb (terrifies, terrifying, terrified)
If something terrifies you, it makes you feel very frightened.
ⓘ If you are **terrified**, you are very frightened.

territory noun (plural territories)
Someone's territory is the land that they own or use.

terror noun
a feeling of very great fear

terrorist noun (plural terrorists)
someone who hurts or kills people to try to make a government do what he or she wants

test noun (plural tests)
a set of questions that you have to answer to show what you have learned ▶ *I got all the words right in my spelling test.*

test verb (tests, testing, tested)
1 To test someone means to give them questions to answer to show what they have learned.
2 To test something means to use it so that you can find out whether it works. ▶ *Now it is time to test our new invention.*

tether verb (tethers, tethering, tethered)
To tether an animal means to tie it up.

text *noun* (*plural* **texts**)
a piece of writing

text *verb* (**texts, texting, texted**)
When you text someone, you send them a text message.

textbook *noun* (*plural* **textbooks**)
a book which gives you information about a subject

text message *noun* (*plural* **text messages**)
a written message that you send to someone on a mobile phone

than *conjunction, pronoun*
compared with another person or thing ▶ *You are smaller than me.*

thank *verb* (**thanks, thanking, thanked**)
When you thank someone, you tell them that you are grateful for something they have given you or done for you. ▶ *I thanked my uncle and aunt for their present.*

that, **those** *adjective*
the one there ▶ *That book is mine.*

thatched *adjective*
A thatched house has a roof made of reeds or straw.

thaw *verb* (**thaws, thawing, thawed**)
When something thaws, it melts and is no longer frozen. ▶ *The sun came out and the snow began to thaw.*

theatre *noun* (*plural* **theatres**)
a place where plays and shows are performed and people can go to watch them

theft *noun*
Theft is the crime of stealing something.

theme *noun* (*plural* **themes**)
The theme of a book or film is the main idea that it is about.

theme park *noun* (*plural* **theme parks**)
a place where you can go on rides and take part in fun activities

then *adverb*
1 after that ▶ *I had breakfast and then I went to school.*
2 at that time ▶ *We didn't know about it then.*

theory *noun* (*plural* **theories**)
an idea that someone suggests as a way of explaining how something works

there *adverb*
in that place ▶ *You can sit there.*

therefore *adverb*
so ▶ *We haven't got very much money and therefore we can't go on holiday.*

thermal *adjective*
Thermal clothes will hold in heat and keep you warm in cold weather.

thermometer *noun* (*plural* **thermometers**)
something that you use for measuring temperature

thesaurus *noun* (*plural* **thesauruses**)
a book which gives you lists of words that have similar meanings

these *adjective* SEE **this**

thick *adjective* (**thicker, thickest**)
1 Something that is thick is wide and not thin. ▶ *He cut himself a thick slice of chocolate cake.*
2 Thick clothes are made of heavy material.
3 A thick liquid is not very runny.

thief *noun* (*plural* **thieves**)
someone who steals things

thigh *noun* (*plural* **thighs**)
Your thighs are the top parts of your legs.

thimble *noun* (*plural* **thimbles**)
a cover that you wear on the end of your finger when you are sewing

thin *adjective* (**thinner, thinnest**)
1 Something that is thin is not very thick or wide. ▶ *Cut the bread into thin slices.*
2 Someone who is thin is not very fat.
3 A thin liquid is runny.

thing

thing *noun* (*plural* **things**)
an object, or anything that is not a person, animal, or plant ▶ *A pen is a thing you use to write with.*

think *verb* (**thinks, thinking, thought**)
1 When you think, you have thoughts and ideas in your mind. ▶ *Think carefully before you answer the question.*
2 If you think that something is true, you believe that it is true, but you do not know for sure. ▶ *I think we break up next Friday.*

third *adjective*
The third thing is the one that comes after the second.

third *noun*
One third of something is one of three equal parts that the thing is divided into. It can also be written as $\frac{1}{3}$.

third person *noun*
When you use the third person, you use the words 'he' or 'she' to write about someone in a story.

thirsty *adjective* (**thirstier, thirstiest**)
If you are thirsty, you feel that you want to drink something.

thirteen *noun*
the number 13

thirty *noun*
the number 30

this, these *adjective*
the one here ▶ *This pencil is mine.* ▶ *These books are very interesting.*

thistle *noun* (*plural* **thistles**)
a wild plant that has prickly leaves and purple flowers

thorn *noun* (*plural* **thorns**)
a sharp, prickly point that grows on some plants

thoroughly *adverb*
1 If you do a job thoroughly, you do it carefully and properly.
2 completely ▶ *I was thoroughly exhausted.*

those *adjective* SEE **that**

though *adverb*
although ▶ *It was very cold though it didn't snow.*

thought *verb* SEE **think**

thought *noun* (*plural* **thoughts**)
an idea you think of

thoughtful *adjective*
1 If you look thoughtful, you look quiet, as if you are thinking about something.
2 If you are thoughtful, you are kind and think about what other people want.

thousand *noun* (*plural* **thousands**)
the number 1000

thrash *verb* (**thrashes, thrashing, thrashed**)
To thrash someone means to hit them with a stick lots of times.

thread *noun* (*plural* **threads**)
a long, thin piece of cotton that you use for sewing

thread *verb* (**threads, threading, threaded**)
When you thread a needle, you put a thread through it so that you can use it for sewing.

threaten *verb* (**threatens, threatening, threatened**)
To threaten someone means to say that you will do something nasty to them. ▶ *The teacher threatened to keep us in at lunch time if we didn't get on with our work.*

three *noun* (*plural* **threes**)
the number 3

three-dimensional *adjective*
a three-dimensional object is solid rather than flat. A cube is a three-dimensional shape.

threw *verb* SEE **throw**

thrill noun (*plural* **thrills**)
If something gives you a thrill, it is very exciting and enjoyable.
❶ Something that is **thrilling** is very exciting and enjoyable.

throat noun (*plural* **throats**)
Your throat is the part at the back of your mouth where you swallow food and drink.

throb verb (**throbs, throbbing, throbbed**)
If a part of your body throbs, it hurts a lot. ▶ *My knee was throbbing and I could hardly walk.*

throne noun (*plural* **thrones**)
a special chair that a king or queen sits on

through preposition (rhymes with *threw*)
from one side of something to the other ▶ *He climbed through the window.*

throughout preposition
all the time while something is happening ▶ *They talked throughout the film.*

throw verb (**throws, throwing, threw, thrown**)
1 When you throw something, you hold it in your hand and then push it away so that it flies through the air. ▶ *Throw the ball to me.*
2 When you throw something away, you get rid of it because you do not want it any more.

thrush noun (*plural* **thrushes**)
a bird that has a speckled brown breast and sings beautifully

thrust verb (**thrusts, thrusting, thrust**)
To thrust something somewhere means to put it there roughly.

thud noun (*plural* **thuds**)
a dull banging sound ▶ *The book fell to the ground with a thud.*

thumb noun (*plural* **thumbs**)
Your thumb is the short, thick finger at the side of your hand.

thump verb (**thumps, thumping, thumped**)
To thump someone means to hit them hard.

thunder noun
the loud, rumbling noise that you hear after a flash of lightning in a storm

thunder verb (**thunders, thundering, thundered**)
When it thunders, there is a storm with thunder.

Thursday noun (*plural* **Thursdays**)
the day after Wednesday

tick noun (*plural* **ticks**)
a small mark like this ✓ that shows that something is right

tick verb (**ticks, ticking, ticked**)
1 When you tick something, you put a tick next to it. ▶ *I ticked all the right answers.*
2 When a clock ticks, it makes a regular clicking sound.

ticket noun (*plural* **tickets**)
a piece of paper that you buy so that you can travel on a bus or train or get into a place such as a cinema or theatre

tickle verb (**tickles, tickling, tickled**)
When you tickle someone, you touch them lightly with your fingers to make them laugh.
❶ Someone who is **ticklish** laughs easily when they are tickled.

tide noun (*plural* **tides**)
The tide is the regular movement of the sea towards the land and then away from the land.

tidy adjective (**tidier, tidiest**)
If a place is tidy, everything is in the right place and there is no mess. ▶ *Is your room tidy?*

tie *verb* (**ties, tying, tied**)
To tie something means to fasten it with a knot or a bow. ▶ *I tied my shoelaces.*

tie *noun* (*plural* **ties**)
1 a strip of material that you wear round your neck, under the collar of a shirt
2 If there is a tie in a game, two people or teams have the same number of points. ▶ *The match ended in a tie.*

tiger *noun* (*plural* **tigers**)
a big wild cat that lives in Asia. It has orange fur with black stripes. A female tiger is called a **tigress**.

tight *adjective* (**tighter, tightest**)
1 Tight clothes fit your body closely and are not loose or baggy. ▶ *Those trousers look a bit tight.*
2 A tight knot is tied very firmly and is difficult to undo.
ⓘ If something fits or is tied **tightly**, it is tight. To **tighten** something means to make it tighter.

tightrope *noun* (*plural* **tightropes**)
a rope that is stretched tight above the ground for circus performers to walk on and do tricks on

tights *noun*
a piece of clothing that women and girls wear over their feet, legs, and bottom

tile *noun* (*plural* **tiles**)
Tiles are thin pieces of baked clay that people use to cover walls or floors.

till *conjunction, preposition*
until ▶ *Wait till I'm ready!*

till *noun* (*plural* **tills**)
a machine that people use in a shop to keep money in and add up how much customers have to pay

tilt *verb* (**tilts, tilting, tilted**)
To tilt something means to tip it up so that it slopes.

timber *noun*
wood that people use for making things

time *noun* (*plural* **times**)
1 Time is the thing that we measure in seconds, minutes, hours, days, weeks, months, and years. ▶ *What time is it?*
2 If it is time to do something, it should be done now. ▶ *It's time for tea.*
3 If you do something one or two times, you do it once or twice. ▶ *I've already called you three times!*

times *preposition*
One number times another number is one number multiplied by another number. ▶ *Two times four equals eight.*

timetable *noun* (*plural* **timetables**)
a list of times when things will happen or buses or trains will leave

timid *adjective*
Someone who is timid is shy and not very brave.

tin *noun* (*plural* **tins**)
1 a round metal container that food is sold in ▶ *I'll open a tin of beans for tea.*
2 a metal container for putting things in
ⓘ Food that is **tinned** is sold in tins.

tingle *verb* (**tingles, tingling, tingled**)
When your skin tingles, it stings a little bit. ▶ *The cold water made my skin tingle.*

tinkle *verb* (**tinkles, tinkling, tinkled**)
If something tinkles, it makes a light, ringing sound.

tinsel *noun*
strips of shiny silver or gold stuff that people use for decorating their homes at Christmas

tiny *adjective* (**tinier, tiniest**)
Something that is tiny is very small.

tip noun (plural **tips**)
1 The tip of something long and thin is the part right at the end of it.
2 If you give someone a tip, you give them a small amount of money to thank them for helping you.
3 A tip is a rubbish dump.

tip verb (**tips, tipping, tipped**)
When you tip something, you move it so that it is no longer straight.
▶ *Don't tip your chair back.*

tiptoe verb (**tiptoes, tiptoeing, tiptoed**)
When you tiptoe, you walk quietly on your toes.

tired adjective
1 If you are tired, you feel as if you need to sleep.
2 If you are tired of something, you are bored or fed up with it.

tissue noun (plural **tissues**)
1 Tissue paper is very thin, soft paper that you use for wrapping up things made of glass or china to stop them breaking.
2 A tissue is a paper handkerchief.

title noun (plural **titles**)
1 The title of a book, film, picture, or piece of music is its name.
2 Someone's title is the word like Dr, Mr, and Mrs that is put in front of their name.

to preposition
When you go to a place, you go there. ▶ *We're going to Spain next week.*

toad noun (plural **toads**)
an animal that looks like a big frog. It has rough, dry skin and lives on land.

toadstool noun (plural **toadstools**)
a plant that looks like a mushroom but is poisonous to eat

toast noun
a slice of bread that has been cooked until it is crisp and brown

tobacco noun
a plant whose leaves are dried and used to make cigars and cigarettes

toboggan noun (plural **toboggans**)
a sledge that you use for sliding down slopes covered in snow

today noun, adverb
this day ▶ *I'm not very well today.*

toddler noun (plural **toddlers**)
a young child who is just beginning to walk

toe noun (plural **toes**)
Your toes are the parts of your body on the ends of your feet.

toffee noun (plural **toffees**)
a type of sweet

together adverb
1 When you join or put things together, you put them with each other. ▶ *I stuck two pieces of paper together.*
2 When people do something together, they do it at the same time as each other. ▶ *They sang together.*

toilet noun (plural **toilets**)
a large bowl with a seat that you use when you need to empty waste from your body

token noun (plural **tokens**)
a small piece of plastic or paper that you can use instead of money to pay for something. ▶ *I got a book token for my birthday.*

told verb SEE **tell**

tomato noun (plural **tomatoes**)
a soft, round, red fruit that you can eat raw in a salad or cook as a vegetable

tomb noun (plural **tombs**) (rhymes with *room*)
a place where a dead person's body is buried

tomorrow noun, adverb
the day after today ▶ *I'll see you tomorrow.*

ton

ton *noun* (*plural* **tons**)
We can measure weight in tons. One ton is about 1,016 kilograms.

tone *noun* (*plural* **tones**)
The tone of your voice is how it sounds when you speak, for example whether it sounds happy or angry. ▶ *He spoke in an angry tone of voice.*

tongs *noun*
a tool that you use for picking things up

tongue *noun* (*plural* **tongues**) (rhymes with *sung*)
Your tongue is the part inside your mouth that you can move about and use for speaking.

tonight *noun*
this evening or night ▶ *We're going to a disco tonight.*

tonne *noun* (*plural* **tonnes**)
We can measure weight in tons. One tonne is 1,000 kilograms.

tonsils *noun*
Your tonsils are a part of your throat that sometimes become sore. When your tonsils are very sore, you have an illness called **tonsillitis**.

too *adverb*
1 also ▶ *Can I come too?*
2 more than you need ▶ *Don't use too much salt.*

took *verb* SEE **take**

tool *noun* (*plural* **tools**)
something that you use to help you to do a job. Hammers and saws are tools.

tooth *noun* (*plural* **teeth**)
1 Your teeth are the hard, white parts inside your mouth which you use for biting and chewing.
2 The teeth on a comb or saw are the sharp, pointed parts.
❶ **Toothache** is a pain in one of your teeth. A **toothbrush** is a small brush that you use for cleaning your teeth. **Toothpaste** is a special thick cream that you use for cleaning your teeth.

top *noun* (*plural* **tops**)
1 The top of something is the highest part of it. ▶ *We climbed right to the top of the hill.*
2 The top on a bottle or jar is the lid.
3 A top is a piece of clothing that you wear on the top part of your body, over your chest and arms. ▶ *She was wearing black trousers and a red top.*

topic *noun* (*plural* **topics**)
a subject that you are writing or talking about

topple *verb* (**topples, toppling, toppled**)
If something topples over, it falls over. ▶ *The pile of books toppled over.*

torch *noun* (*plural* **torches**)
an electric light that you can carry about with you

tore, **torn** *verb* SEE **tear** *verb*

torment *verb* (**torments, tormenting, tormented**)
To torment someone means to tease them in a very unkind or cruel way.

tornado *noun* (*plural* **tornadoes**)
a very strong wind

torpedo *noun* (*plural* **torpedoes**)
a type of long, round bomb that can be fired under water to destroy ships and submarines

tortoise *noun* (*plural* **tortoises**)
an animal that has four legs and a hard shell over its body. Tortoises move slowly and hide their head and legs inside their shell when they are in danger.

torture *verb* (**tortures, torturing, tortured**)
To torture someone means to do horrible things to them to hurt them.

toss *verb* (tosses, tossing, tossed)
1 When you toss something, you throw it through the air. ► *They tossed the ball to each other.*
2 When you toss a coin, you throw it into the air to see which way it lands.

total *noun*
The total is the amount that you get when you have added everything up.

total *adjective*
complete ► *There was total silence in the hall.*
❶ **Totally** means completely. ► *That idea is totally ridiculous!*

touch *verb* (touches, touching, touched)
1 When you touch something, you feel it with your hand.
2 When two things are touching, they are right next to each other, with no space between them.

tough *adjective* (tougher, toughest) (pronounced **tuff**)
1 Something that is tough is very strong. ► *The ropes are made of tough nylon.*
2 Someone who is tough is brave and strong.

tour *noun* (plural **tours**)
When you go on a tour, you visit a lot of different places.

tourist *noun* (plural **tourists**)
someone who is visiting a place on holiday

tournament *noun* (plural **tournaments**)
a competition in which a lot of different people or teams play matches against each other until a winner is found

tow *verb* (tows, towing, towed) (rhymes with *low*)
To tow something means to pull it along. ► *The car was towing a caravan.*

towards *preposition*
in the direction of ► *He walked towards the school.*

towel *noun* (plural **towels**)
a piece of cloth that you use for drying things that are wet

tower *noun* (plural **towers**)
a tall, narrow part of a building

town *noun* (plural **towns**)
a place where a lot of people live close to each other. A town is smaller than a city.

toy *noun* (plural **toys**)
something that children can play with

trace *noun* (plural **traces**)
A trace of something is a mark that it has left behind.

trace *verb* (traces, tracing, traced)
1 When you trace a picture, you copy it using thin paper that you can see through.
2 To trace something means to find it by getting information and following clues.

track *noun* (plural **tracks**)
1 The tracks that a person or animal leaves are the marks that they leave on the ground as they walk.
2 a path ► *We walked along a narrow track by the river.*
3 A railway track is a railway line.
4 A racing track is a piece of ground with lines marked on it so that people can use it for racing.

tracksuit *noun* (plural **tracksuits**)
a loose top and pair of trousers that you wear for doing sport

tractor *noun* (plural **tractors**)
a strong, heavy truck with large wheels that people drive on a farm and use for pulling farm machines

trade *noun*
When people do trade, they buy and sell things. ► *The shops do a lot of trade at Christmas.*

trade verb (trades, trading, traded)
When people trade, they buy and sell things.

trademark noun (plural **trademarks**)
a picture or name that a company always puts on the things that it makes

tradition noun (plural **traditions**)
If something is a tradition, people have done it in the same way for a very long time. ▶ *Giving presents to children at Christmas is a tradition.*
❶ Something that is a tradition is **traditional**.

traffic noun
cars, buses, bicycles, lorries, and other things that travel on roads
▶ *It's dangerous to play on the road because of the traffic.*

tragedy noun (plural **tragedies**)
something very sad that happens, especially something in which people are hurt or killed

trail noun (plural **trails**)
1 a rough path across fields or through woods
2 the smells or marks that an animal leaves behind as it goes along ▶ *We were able to follow the animal's trail.*

trail verb (trails, trailing, trailed)
If something trails, it drags along the ground.

trailer noun (plural **trailers**)
1 a truck that is pulled along behind a car or lorry and used for carrying things
2 a short part of a film or television programme that is shown to people to encourage them to watch it

train noun (plural **trains**)
something that carries passengers or goods on a railway

train verb (trains, training, trained)
1 To train a person or animal means to teach them how to do something.
▶ *He trained his dog to fetch a ball.*
2 When you train, you practise the skills you need to do a sport.

trainer noun (plural **trainers**)
1 A trainer is someone who trains people or animals.
2 Trainers are shoes that you wear for running or doing sport.

traitor noun (plural **traitors**)
someone who gives away a secret or gives information to the enemy

tram noun (plural **trams**)
a type of bus which runs along rails in the road

tramp noun (plural **tramps**)
someone who has no job and nowhere to live

trample verb (tramples, trampling, trampled)
If you trample on something, you tread on it and squash it. ▶ *Don't trample on the flowers!*

trampoline noun (plural **trampolines**)
a large piece of thick cloth that is joined to a metal frame and is used for jumping up and down on

transfer verb (transfers, transferring, transferred)
If you transfer something from one place to another, you move it. ▶ *I transferred some pencils from the tin into my pencil case.*

transform verb (transforms, transforming, transformed)
To transform something means to change it so that it is completely different.

translate verb (translates, translating, translated)
If you translate something, you change it from one language into another.

transmit *verb* (transmits, transmitting, transmitted)
To transmit radio or television signals means to send them out.

transparent *adjective*
If something is transparent, you can see through it. ▶ *Glass is a transparent material.*

transport *verb* (transports, transporting, transported)
To transport something from one place to another means to move it there.

transport *noun*
anything that is used to take people, animals, or things from one place to another ▶ *Buses, trains, and lorries are all forms of transport.*

trap *noun* (plural **traps**)
something that is used to catch a person or an animal ▶ *You can catch wild animals in traps.* ▶ *The police laid a trap to catch the robbers.*

trapdoor *noun* (plural **trapdoors**)
a door in the floor or ceiling which you can open to make people fall through

trapeze *noun* (plural **trapezes**)
a bar that hangs down from two ropes and is used by acrobats for swinging on and performing tricks

trapped *adjective*
If you are trapped in a place, you are stuck there and cannot get out.

trash *noun*
rubbish

travel *verb* (travels, travelling, travelled)
When you travel, you go from one place to another. ▶ *They travelled right across America.*

trawler *noun* (plural **trawlers**)
a big fishing boat that pulls a large net along the sea bottom to catch a lot of fish

tray *noun* (plural **trays**)
a flat piece of wood, metal, or plastic that you use for carrying cups, plates, and other things

treacherous *adjective*
1 If someone is treacherous, you cannot trust them.
2 Something that is treacherous is very dangerous. ▶ *The pavement was treacherous because it was so icy.*

treacle *noun*
a thick, sweet, sticky liquid

tread *verb* (treads, treading, trod, trodden)
If you tread on something, you walk on it. ▶ *Mind you don't tread on that spider.*

treason *noun*
a crime in which someone does something to harm their own country, for example helping the enemy during a war

treasure *noun*
gold, silver, jewels, and other valuable things ▶ *The children found a box of buried treasure.*

treat *verb* (treats, treating, treated)
1 The way in which you treat someone is the way you behave towards them. ▶ *Some people don't treat their animals very well.*
2 When doctors treat someone, they give them medicine or do things to them to make them better when they are ill.
❶ When doctors treat someone, they give them **treatment**.

treat *noun* (plural **treats**)
something special that you enjoy ▶ *We went to the cinema as a birthday treat.*

tree *noun* (plural **trees**)
a tall plant that has a thick trunk, branches, and leaves ▶ *Do you like climbing trees?*

tremble

tremble verb (trembles, trembling, trembled)
When you tremble, your body shakes because you are cold or frightened.

tremendous adjective
Something that is tremendous is huge or very good. ▶ *The play was a tremendous success.*

trench noun (plural **trenches**)
a long, narrow ditch

trendy adjective
Something that is trendy is very fashionable. Someone who is trendy wears fashionable clothes.

trespass verb (trespasses, trespassing, trespassed)
To trespass means to go onto someone else's land, without asking them if you can.

trial noun (plural **trials**)
1 When you give something a trial, you try it to see how well it works.
2 When there is a trial, a prisoner and witnesses are questioned in a court to decide whether the prisoner has done something wrong.

triangle noun (plural **triangles**)
a shape with three straight edges and three angles

tribe noun (plural **tribes**)
a group of people who live together and are ruled by a chief

trick noun (plural **tricks**)
1 something that you do to cheat someone or make them look silly ▶ *We played a trick on the teacher.*
2 something clever that you have learned to do ▶ *Can you do any card tricks?*

trick verb (tricks, tricking, tricked)
To trick someone means to make them believe something that is not true.

trickle verb (trickles, trickling, trickled)
When water trickles, it moves very slowly.

tricky adjective (trickier, trickiest)
Something that is tricky is difficult.

tricycle noun (plural **tricycles**)
a bicycle with three wheels

tried verb SEE **try**

trigger noun (plural **triggers**)
the part of a gun that you pull with your finger to fire it

trim verb (trims, trimming, trimmed)
To trim something means to cut it so that it looks neat and tidy. ▶ *I had my hair trimmed.*

trio noun (plural **trios**)
a group of three people

trip verb (trips, tripping, tripped)
If you trip, you catch your foot on something and nearly fall over.

trip noun (plural **trips**)
a short journey ▶ *We went on a school trip to the seaside.*

triumph noun (plural **triumphs**)
If something is a triumph, it is a great success.

trivial adjective
Something that is trivial is not very important.

trod verb SEE **tread**

troll noun (plural **trolls**)
a fierce giant in stories

trolley noun (plural **trolleys**)
a large container on wheels that you can put things in and push along

troops noun
soldiers

trophy noun (plural **trophies**)
a cup that you can win

tropical adjective
A tropical place has a very hot, wet climate. ▶ *A lot of endangered animals live in tropical rainforests.*

trot verb (trots, trotting, trotted)
When a horse trots, it runs but does not gallop. When a person trots, they run quite slowly.

trouble noun (plural troubles)
1 If something causes trouble for you, it causes problems for you or upsets you.
2 If you are in trouble, you have a problem or someone is cross with you. ▶ *You'll be in trouble when dad sees this mess!*

trough noun (plural troughs) (pronounced **troff**)
a long, narrow container that holds food or water for farm animals

trousers noun
a piece of clothing that you wear over your legs and bottom

trout noun (the plural is the same)
a fish that lives in rivers and lakes and can be cooked and eaten

trowel noun (plural trowels)
a tool that is like a very small spade with a short handle

truant noun (plural truants)
To play truant means to stay away from school without permission.

truce noun (plural truces)
an agreement between two people to stop fighting or arguing for a while

truck noun (plural trucks)
a small lorry

trudge verb (trudges, trudging, trudged)
When you trudge along, you walk along slowly, with heavy steps.

true adjective (truer, truest)
Something that is true is real and not made-up or pretended. ▶ *Is this really a true story?*

trumpet noun (plural trumpets)
a musical instrument made of brass. You blow into it and press down buttons to make different notes.

truncheon noun (plural truncheons)
a stick that a police officer carries and uses

trunk noun (plural trunks)
1 The trunk on a tree is the thick stem that grows up out of the ground.
2 An elephant's trunk is its long nose.
3 A trunk is a large box that you use for carrying things on a journey.

trust verb (trusts, trusting, trusted)
If you trust someone, you believe that they are good and honest and will not hurt you or tell you lies.

truth noun
The truth is something that is true. ▶ *Is he telling the truth?*

try verb (tries, trying, tried)
1 If you try to do something, you make an effort to do it. ▶ *I tried to climb that tree, but I couldn't.*
2 If you try something, you do it or use it to see what it is like. ▶ *Have you ever tried ice skating?*

T-shirt noun (plural T-shirts)
a piece of clothing that you wear on the top half of your body. It has a round neck and short sleeves.

tub noun (plural tubs)
a container ▶ *We bought a tub of chocolate ice cream.*

tube noun (plural tubes)
1 a long, thin container that you can squeeze a thick liquid out of ▶ *We bought a tube of toothpaste.*
2 a long, round, hollow thing ▶ *The picture came rolled up in a tube.*

tuck verb (tucks, tucking, tucked)
If you tuck a piece of clothing in, you push the ends of it into another piece of clothing. ▶ *He tucked his shirt into his trousers.*

twig

Tuesday noun (plural **Tuesdays**)
the day after Monday

tuft noun (plural **tufts**)
a small bunch of hair, feathers, or grass

tug verb (tugs, tugging, tugged)
When you tug something, you pull it hard. ▶ *I tugged the door, but it wouldn't open.*

tulip noun (plural **tulips**)
a spring flower that is shaped like a cup

tumble verb (tumbles, tumbling, tumbled)
To tumble means to fall. ▶ *He tumbled off the wall.*

tumble-drier noun (plural **tumble-driers**)
a machine that dries clothes by turning them over and over in warm air

tumbler noun (plural **tumblers**)
a glass with a flat bottom and straight sides

tummy noun (plural **tummies**)
Your tummy is your stomach.

tuna noun (the plural is the same)
a large sea fish that you can eat

tune noun (plural **tunes**)
a group of musical notes which make a nice sound when they are played in order

tunnel noun (plural **tunnels**)
a long hole under the ground that you can walk or drive through

turban noun (plural **turbans**)
a long piece of material that you wear wrapped round your head

turf noun
short grass

turkey noun (plural **turkeys**)
a large bird that is kept on farms for its meat

turn verb (turns, turning, turned)
1 When you turn round, you move round. ▶ *I turned round to see who was behind me.*
2 When you turn something, you move it round. ▶ *He turned the key in the lock.*
3 To turn means to become. ▶ *A lot of leaves turn red and orange in the autumn.*
4 To turn into something means to change and become that thing. ▶ *Tadpoles turn into frogs.*

turn noun (plural **turns**)
If it is your turn to do something, you are the person who should do it next. ▶ *It's your turn to collect the books in.*

turnip noun (plural **turnips**)
a round, white vegetable

turquoise adjective
Something that is turquoise is blue-green in colour.

turret noun (plural **turrets**)
a small tower on a castle

turtle noun (plural **turtles**)
a sea animal that looks like a tortoise

tusk noun (plural **tusks**)
An elephant's tusks are its two very long, pointed teeth.

TV noun (plural **TVs**)
a television

tweezers noun
a tool that you use for picking up very small things

twelve noun
the number 12

twenty noun
the number 20

twice adverb
If something happens twice, it happens two times.

twig noun (plural **twigs**)
a very small, thin branch on a tree

twin noun (plural **twins**)
Twins are two children who are born to the same mother at the same time.

twinkle verb (**twinkles, twinkling, twinkled**)
If something twinkles, it shines with little flashes of light. ▶ *We could see the stars twinkling in the sky above us.*

twirl verb (**twirls, twirling, twirled**)
To twirl means to spin round and round.

twist verb (**twists, twisting, twisted**)
1 When you twist something, you turn it round. ▶ *She twisted the lid off the jar.*
2 When you twist things together, you turn them round each other so that they become fixed together.

twitch verb (**twitches, twitching, twitched**)
If a part of your body twitches, it keeps making little movements. ▶ *The rabbit twitched its nose.*

twitter verb (**twitters, twittering, twittered**)
When birds twitter, they make a lot of short, light sounds.

two noun (plural **twos**)
the number 2

type noun (plural **types**)
A type is a kind or sort. ▶ *What type of car have your parents got?*

type verb (**types, typing, typed**)
When you type, you write with a typewriter or computer keyboard.

typewriter noun (plural **typewriters**)
a machine that prints letters and numbers when you press down keys with your fingers

typical adjective
Something that is typical is normal and usual.

tyre noun (plural **tyres**)
a circle of rubber that goes round the outside of a wheel

Uu

ugly adjective (**uglier, ugliest**)
Something that is ugly is horrible to look at.

umbrella noun (plural **umbrellas**)
a round cover that you hold over your head to keep the rain off you

umpire noun (plural **umpires**)
someone who is in charge of a game of cricket or tennis and makes sure that the players keep to the rules

unable adjective
If you are unable to do something, you cannot do it. ▶ *I'm afraid I am unable to come to your party.*

unbearable adjective
If something is unbearable, you cannot stand it. ▶ *The heat was unbearable.*

unbelievable adjective
If something is unbelievable, it is so strange that you cannot believe it.

uncertain adjective
If you are uncertain about something, you are not sure about it. ▶ *She was uncertain what to do next.*

uncle noun (plural **uncles**)
Your uncle is the brother of your mother or father, or your aunt's husband.

uncomfortable adjective
1 If you are uncomfortable, part of your body hurts or is not relaxed.
2 If a chair or bed is uncomfortable, it does not feel nice when you sit on it or lie on it.

uncommon *adjective*
If something is uncommon, it is not very normal or ordinary and you do not see it very often.

unconscious *adjective*
When you are unconscious, you are in a very deep sleep and cannot understand what is happening around you. ▶ *If you bang your head, sometimes you might be unconscious for a few minutes.*

uncover *verb* (**uncovers, uncovering, uncovered**)
When you uncover something, you take a cover off it so that people can see it.

under *preposition*
1 below ▶ *The cat is under the table.*
2 less than ▶ *If you are under 17 you are not allowed to drive a car.*

underground *adjective*
Something that is underground is under the ground. ▶ *They escaped and hid in an underground cave.*

underground *noun*
An underground is a railway that runs through tunnels under the ground. ▶ *You can travel around London by bus or on the Underground.*

undergrowth *noun*
bushes and plants that grow thickly together under trees

underline *verb* (**underlines, underlining, underlined**)
When you underline a word, you draw a straight line underneath it.

underneath *preposition*
under ▶ *The cat was sitting underneath the table.*

underpants *noun*
pants that a boy or man wears

understand *verb* (**understands, understanding, understood**)
If you can understand something, you know what it means or how it works. ▶ *I don't understand what you're saying.*

underwater *adjective*
Something that is underwater is under the water. ▶ *They use special underwater cameras to film sea creatures.*

underwear *noun*
clothes such as vests and pants that your wear under your other clothes

undo *verb* (**undoes, undoing, undid, undone**)
When you undo something, you open it so that it is no longer tied or fastened. ▶ *I can't undo my shoelaces.*

undress *verb* (**undresses, undressing, undressed**)
When you undress, you take your clothes off.

uneasy *adjective*
If you are uneasy about something, you are slightly worried about it.

unemployed *adjective*
Someone who is unemployed does not have a job.

uneven *adjective*
Something that is uneven is not smooth or flat. ▶ *The road was quite uneven and bumpy.*

uneventful *adjective*
An uneventful time is a time when nothing exciting or interesting happens.

unexpected *adjective*
If something is unexpected, it is surprising because you did not expect it to happen. ▶ *We had an unexpected visitor.*

unfair *adjective*
If something is unfair, it is not fair or right because it treats some people badly.

unfasten *verb* (**unfastens, unfastening, unfastened**)
When you unfasten something, you untie it or undo it.

unfit *adjective*
If you are unfit, you are not very fit so you cannot run around very well.

unfortunate *adjective*
If something is unfortunate, it happens because of bad luck. ▶ *It was unfortunate that the other team scored right at the end of the game.*

unfriendly *adjective*
Someone who is unfriendly is not friendly to people.

ungrateful *adjective*
If you are ungrateful, you do not thank someone when they have helped you or given you something.

unhappy *adjective* (**unhappier, unhappiest**)
If you are unhappy, you are sad and not happy.

unhealthy *adjective*
1 If you are unhealthy, you are not strong and healthy.
2 Things that are unhealthy are not good for you and can make you ill.

unicorn *noun* (*plural* **unicorns**)
an animal in stories that has one long, straight horn growing from the front of its head

uniform *noun* (*plural* **uniforms**)
a special set of clothes that everyone in the same school, job, or club wears

union *noun* (*plural* **unions**)
an organization that helps workers ask for more money and better working conditions

unique *adjective*
If something is unique, there is nothing else like it. ▶ *This volcano is unique.*

unisex *adjective*
Something that is unisex is for both men and women.

unit *noun* (*plural* **units**)
1 In maths, units are ones. When you add or subtract big numbers, you work with hundreds, tens, and units.
2 A unit is something that you use for measuring or counting things. Centimetres and metres are units of length.

unite *verb* (**unites, uniting, united**)
When people unite, they join together and work together.

universe *noun*
everything in space, including the earth, the sun, and all the stars and planets

university *noun* (*plural* **universities**)
a place where you can go to study after you have left school

unkind *adjective* (**unkinder, unkindest**)
Someone who is unkind is nasty or cruel to another person.

unknown *adjective*
If something is unknown, no one knows about it.

unleaded *adjective*
Unleaded petrol does not have any lead in it.

unless *conjunction*
if something does not happen ▶ *I'm going to be very cross unless you tidy this room now!*

unlikely *adjective*
If something is unlikely, it is not very likely that it will happen. ▶ *It's unlikely to rain today.*

unload *verb* (**unloads, unloading, unloaded**)
When you unload things, you take them out of a car, lorry, ship, or aeroplane.

unlock *verb* (**unlocks, unlocking, unlocked**)
When you unlock something, you open its lock with a key. ▶ *We need a key to unlock the door.*

unlucky *adjective* (**unluckier, unluckiest**)
If you are unlucky, you have bad luck. ▶ *We were very unlucky to lose that game.*

unnatural *adjective*
Something that is unnatural is not natural or normal.

unnecessary

unnecessary *adjective*
If something is unnecessary, you do not need it.

unpack *verb* (**unpacks, unpacking, unpacked**)
When you unpack things, you take them out of a bag, box, or suitcase.

unpleasant *adjective*
Something that is unpleasant is nasty or horrible. ▶ *The meat had a rather unpleasant taste.*

unpopular *adjective*
If something is unpopular, not many people like it. If someone is unpopular, not many people like them.

unsafe *adjective*
Something that is unsafe is dangerous and not safe.

unscrew *verb* (**unscrews, unscrewing, unscrewed**)
When you unscrew something, you make it looser by turning it round and round.

unselfish *adjective*
If you are unselfish, you think about other people and are not selfish.

unsuccessful *adjective*
If you are unsuccessful, you do not manage to do something.

unsuitable *adjective*
Something that is unsuitable is not right or suitable.

untidy *adjective* (**untidier, untidiest**)
A place that is untidy is messy and not tidy.

untie *verb* (**unties, untying, untied**)
When you untie a piece of rope or string, you undo a knot in it. ▶ *I can't untie my shoelaces.*

until *conjunction, preposition*
up to a certain time ▶ *I stayed up until midnight.*

untrue *adjective*
Something that is untrue is not true or correct.

unusual *adjective*
Something that is unusual is strange and not normal or usual.

unwell *adjective*
If you are unwell, you are ill.

unwind *verb* (**unwinds, unwinding, unwound**)
If you unwind something, you undo it so that it is no longer wound up.

unwrap *verb* (**unwraps, unwrapping, unwrapped**)
When you unwrap something, you take off the paper that is wrapped round it.

up *adverb, preposition*
towards a higher place ▶ *She ran up the hill.*

upon *preposition*
on ▶ *He was sitting upon a little stool.*

upper *adjective*
The upper part of something is the part that is nearest the top. ▶ *The upper half of the building was destroyed by the fire.*

upright *adjective*
Something that is upright is standing up straight.

uproar *noun*
If there is an uproar, a lot of people shout and make a noise.

upset *adjective*
If you are upset, you are sad or crying.

upset *verb* (**upsets, upsetting, upset**)
1 To upset someone means to make them feel sad and disappointed.
2 To upset something means to knock it over. ▶ *Mind you don't upset your glass of milk.*

upside-down *adjective*
If something is upside-down, it is turned over so that the bottom is at the top.

upwards *adverb*
When something goes upwards, it goes towards a higher place. ▶ *The rocket zoomed upwards.*

urge *noun* (*plural* **urges**)
If you have an urge to do something, you suddenly feel that you want to do it. ▶ *I had a sudden urge to laugh.*

urge *verb* (**urges, urging, urged**)
If you urge someone to do something, you tell them they should do it. ▶ *I urged him to hurry up.*

urgent *adjective*
If something is urgent, you have to do it immediately. ▶ *Please get here quickly - it's urgent.*
ⓘ If you must do something **urgently**, you must do it immediately.

use *verb* (**uses, using, used**)
1 When you use something, you do a job with it. ▶ *I used paper and glue to make my model.*
2 If you used to do something, you did it in the past but you do not do it now. ▶ *I used to go to swimming lessons.*

use *noun* (*plural* **uses**)
If something has a use, you can use it to make something or do a job. ▶ *I'm sure we can find a use for these old wheels.*

useful *adjective*
Something that is useful is good and helpful. ▶ *Mobile phones are very useful.*

useless *adjective*
If something is useless, you cannot use it. ▶ *This old bicycle is useless!*

user-friendly *adjective*
A machine that is user-friendly is easy to understand and use.
▶ *Modern computers are very user-friendly.*

usual *adjective*
Something that is usual is normal and happens quite often. ▶ *I got up at my usual time of eight o'clock.*
ⓘ If something **usually** happens, it normally happens.

Vv

vacant *adjective*
A place that is vacant has no one in it.

vacation *noun* (*plural* **vacations**)
a holiday

vaccination *noun* (*plural* **vaccinations**)
an injection that stops you getting an illness
ⓘ To **vaccinate** someone means to give them an injection to stop them getting an illness.

vacuum cleaner *noun* (*plural* **vacuum cleaners**)
a machine that cleans floors by sucking up dust and dirt

vague *adjective* (**vaguer, vaguest**)
Something that is vague is not clear or certain.

vain *adjective* (**vainer, vainest**)
1 If you are vain, you think too much about how nice you look and how clever you are.
2 If you try in vain to do something, you try to do it but do not manage it.

valley *noun* (*plural* **valleys**)
low land between two hills

valuable

valuable *adjective*
Something that is valuable is worth a lot of money, or is very useful.
▶ *Some of these paintings are very valuable.*

value *noun*
The value of something is how much money it is worth, or how important or useful it is.

vampire *noun* (*plural* **vampires**)
a creature that sucks people's blood in stories

van *noun* (*plural* **vans**)
a type of car with a large, covered part at the back for carrying things in

vandal *noun* (*plural* **vandals**)
someone who deliberately breaks things that belong to other people
ⓘ To **vandalize** something means to break it deliberately.

vanilla *noun*
something that is added to ice cream and other sweet food to make it taste nice

vanish *verb* (**vanishes, vanishing, vanished**)
If something vanishes, it disappears.

variety *noun* (*plural* **varieties**)
1 A variety of things is a lot of different things. ▶ *We have a variety of colours to choose from.*
2 One variety of something is one type. ▶ *That shop sells twenty varieties of ice cream.*

various *adjective*
Various things means a lot of different things. ▶ *There were various things to eat.*

varnish *noun* (*plural* **varnishes**)
a clear liquid that you paint onto wood or metal to make it shiny

vary *verb* (**varies, varying, varied**)
If something varies, it changes and is not always the same. ▶ *The date of Easter varies each year.*

vase *noun* (*plural* **vases**)
a pot that you put flowers in

vast *adjective*
Something that is vast is very big.
▶ *Australia is a vast country.*

vegetable *noun* (*plural* **vegetables**)
part of a plant that we can eat. Potatoes, carrots, and beans are vegetables.

vegetarian *noun* (*plural* **vegetarians**)
a person who does not eat meat

vegetation *noun*
plants and trees

veggie burger *noun* (*plural* **veggie burgers**)
a mixture of vegetables that has been made into a burger and cooked

vehicle *noun* (*plural* **vehicles**)
anything that can travel on land and take people or things from one place to another. Cars, vans, buses, trains, and lorries are vehicles.

veil *noun* (*plural* **veils**)
a piece of thin material that some women or girls wear over their face or head

vein *noun* (*plural* **veins**)
Your veins are the narrow tubes inside your body that carry blood to your heart.

velvet *noun*
a type of thick, soft cloth ▶ *The room had red velvet curtains.*

ventriloquist *noun* (*plural* **ventriloquists**)
someone who can speak without moving their lips, and entertains people by holding a dummy and seeming to make it speak

verb *noun* (*plural* **verbs**)
a word that describes what someone or something is doing. Words like *eat* and *bring* are verbs.

verdict *noun* (*plural* **verdicts**)
When the jury in a court of law reach a verdict, they decide whether someone is guilty or not guilty.

verge *noun* (*plural* **verges**)
grass that grows along the edge of a road or path

verruca *noun* (*plural* **verrucas**)
a sore lump that you sometimes get on your foot

verse *noun* (*plural* **verses**)
1 One verse of a song or poem is one part of it that is not the chorus.
2 Verse is poetry.

version *noun* (*plural* **versions**)
One version of something is one form of it, which is slightly different from all the other forms. ▶ *The latest version of this game is even better.*

versus *preposition*
against ▶ *Are you going to watch the Leeds versus Arsenal match?*

vertical *adjective*
Something that is vertical is standing or pointing straight up.

very *adverb*
extremely ▶ *I'm very hungry.*
▶ *Australia is a very big country.* ▶ *That was a very silly thing to do.*

vessel *noun* (*plural* **vessels**)
a ship or boat

vest *noun* (*plural* **vests**)
a piece of clothing that you wear on the top half of the body under your other clothes

vet *noun* (*plural* **vets**)
a doctor for animals

via *preposition*
When you go via a place, you go through that place to get somewhere else.

vibrate *verb* (**vibrates, vibrating, vibrated**)
When something vibrates, it shakes.
▶ *The whole house vibrates when a lorry goes past.*

vicar *noun* (*plural* **vicars**)
In the Christian religion, a vicar is someone who is in charge of a church.

vicious *adjective*
Someone who is vicious is violent and cruel.

victim *noun* (*plural* **victims**)
someone who has been hurt, robbed, or killed ▶ *We must help the victims of this terrible earthquake.*

victory *noun* (*plural* **victories**)
A victory is when you win a game or battle.

video *noun* (*plural* **videos**)
1 a tape with a film or television programme recorded on it ▶ *Can we watch a video?*
2 a machine that records and plays back television programmes on a special magnetic tape

video *verb* (**videos, videoing, videoed**)
When you video a television programme, you record it on a video so that you can watch it later.

view *noun* (*plural* **views**)
The view from a place is everything that you can see from that place.
▶ *There is a beautiful view of the sea from our window.*

view *verb* (**views, viewing, viewed**)
When you view something, you look at it. ▶ *We viewed the stars through a telescope.*

viewer *noun* (*plural* **viewers**)
Viewers are the people who watch a television programme.

vigorous *adjective*
Vigorous exercise is hard and uses a lot of energy.

vile *adjective* (**viler, vilest**)
Something that is vile is horrible.

village

village noun (plural **villages**)
a small group of houses and other buildings in the country. A village is smaller than a town.

villain noun (plural **villains**)
a bad or wicked person

vinegar noun
a sour liquid which you use in cooking to give a sharp, sour taste to food

vinyl noun
a type of soft plastic

violent adjective
1 Someone who is violent hits or kicks other people.
2 Something that is violent is sudden and very powerful. ▶ *We were caught in the middle of a violent storm.*
ⓘ **Violence** is behaviour that is violent.

violin noun (plural **violins**)
a musical instrument made of wood with strings across it. You hold a violin under your chin and play it by pulling a bow across the strings.

virtual adjective
A virtual place is one that you can look at on a computer screen. You feel as if you are really in the place because you can use the controls to move around inside it.

virtually adverb
very nearly ▶ *Our food had virtually run out.*

virus noun (plural **viruses**)
a tiny living thing that can make you ill if it gets into your body

visible adjective
If something is visible, you can see it. ▶ *Stars are only visible at night.*

vision noun
Your vision is how well you can see things. ▶ *Glasses will improve your vision.*

visit verb (**visits, visiting, visited**)
When you visit a person, you go to see them. When you visit a place, you go there to see what it is like.
ⓘ A **visitor** is someone who is visiting a person or place.

visual adjective
Visual things are things that you can see.

vital adjective
Something that is vital is very important.

vitamin noun (plural **vitamins**)
something that is found in your food. Your body needs vitamins to stay strong and healthy. ▶ *Oranges are full of vitamin C.*

vivid adjective
1 Vivid colours are very bright.
2 A vivid dream or memory is so clear that it seems real.

vixen noun (plural **vixens**)
a female fox

vocabulary noun
all the words that someone knows and uses ▶ *You must try to improve your vocabulary as you get older.*

voice noun (plural **voices**)
Your voice is the sound you make with your mouth when you are speaking or singing. ▶ *He spoke in a deep, gruff voice.*

volcano noun (plural **volcanoes**)
a mountain or other place on the earth's surface from which hot, liquid rock sometimes bursts from inside the earth

volley noun (plural **volleys**)
A volley is when you hit or kick a ball while it is still in the air, before it touches the ground.

volleyball noun
a game in which players hit a ball over a high net with their hands

volume noun (plural **volumes**)
1 The volume of something is how much space it takes up. ▶ *We measured the volume of liquid in the bottle.*
2 The volume of a sound is how loud it is. ▶ *Please could you turn down the volume on your radio?*
3 one book that is part of a set of books ▶ *I have read all three volumes of this story.*

volunteer verb (**volunteers, volunteering, volunteered**)
If you volunteer to do a job, you offer to do it.

volunteer noun (plural **volunteers**)
someone who offers to do a job

vomit verb (**vomits, vomiting, vomited**)
When you vomit, you are sick and food comes back up out of your stomach.

vote verb (**votes, voting, voted**)
When you vote, you say which person or thing you choose.

voucher noun (plural **vouchers**)
a piece of printed paper you can use instead of money to pay for something

vow verb (**vows, vowing, vowed**)
If you vow that you will do something, you promise that you will do it.

vowel noun (plural **vowels**)
Vowels are the letters, **a, e, i, o, u,** and sometimes **y**. All the other letters of the alphabet are **consonants**.

voyage noun (plural **voyages**)
a long journey in a boat or spacecraft

vulgar adjective
Someone who is vulgar is rude and does not have good manners.

vulture noun (plural **vultures**)
a large bird that eats dead animals

waddle verb (**waddles, waddling, waddled**)
To waddle means to walk with short steps, like a duck.

wade verb (**wades, wading, waded**)
When you wade through water, you walk through it.

wafer noun (plural **wafers**)
a very thin biscuit

wag verb (**wags, wagging, wagged**)
When a dog wags its tail, it moves it quickly from side to side because it is happy or excited.

wages noun
the money that someone gets for doing a job

waggle verb (**waggles, waggling, waggled**)
To waggle something means to move it about. ▶ *Can you waggle your ears?*

wagon noun (plural **wagons**)
a cart with four wheels that is pulled by horses

wail verb (**wails, wailing, wailed**)
If you wail, you give a long, sad cry.

waist noun (plural **waists**)
Your waist is the narrow part in the middle of your body.

waistcoat noun (plural **waistcoats**)
a short jacket with no sleeves that you wear over a shirt

wait verb (**waits, waiting, waited**)
If you wait, you stay in a place until someone comes or until something happens. ▶ *Wait here until I get back.*

waiter noun (plural **waiters**)
a man who brings food to people in a restaurant

waitress

waitress noun (plural **waitresses**)
a woman who brings food to people in a restaurant

wake verb (**wakes, waking, woke, woken**)
When you wake up, you stop sleeping. ▶ *I woke up at six o'clock.*

walk verb (**walks, walking, walked**)
When you walk, you move along on your feet. ▶ *I walked down the road to my friend's house.*

walk noun (plural **walks**)
When you go for a walk, you walk somewhere.

wall noun (plural **walls**)
1 The walls of a building are the parts that hold up the roof and separate the building into different rooms.
2 A wall is something built from bricks or stone around a garden or field.

wallet noun (plural **wallets**)
a small, flat, case that you carry money in

wallpaper noun
colourful paper that you stick onto the walls of a room to make it look nice

walnut noun (plural **walnuts**)
a nut that you can eat

waltz noun (plural **waltzes**)
a type of dance in which you hold a partner and dance round and round

wand noun (plural **wands**)
a stick that you use for casting magic spells or doing magic tricks

wander verb (**wanders, wandering, wandered**)
When you wander about, you walk about in no particular direction.

want verb (**wants, wanting, wanted**)
If you want something, you would like to have it or do it. ▶ *Do you want a sweet?*

war noun (plural **wars**)
When there is a war, two countries fight against each other.

ward noun (plural **wards**)
a room that patients sleep in when they are in a hospital

wardrobe noun (plural **wardrobes**)
a cupboard where you hang clothes

warehouse noun (plural **warehouses**)
a large building where things can be stored

warm adjective (**warmer, warmest**)
Something that is warm is quite hot. ▶ *The water's lovely and warm.* ▶ *It was a warm, sunny day.*

warn verb (**warns, warning, warned**)
If you warn someone about a danger, you tell them about it.
ⓘ When you warn someone, you give them a **warning**.

warren noun (plural **warrens**)
a place with a lot of holes in the ground where a lot of rabbits live

warrior noun (plural **warriors**)
someone who fights in battles

wart noun (plural **warts**)
a dry, hard lump on someone's skin

wary adjective (**warier, wariest**)
If you are wary of something, you are slightly nervous or frightened of it.

wash verb (**washes, washing, washed**)
1 When you wash something, you clean it with water.
2 When you wash up, you wash the plates, knives, and forks at the end of a meal.

washing noun
clothes that need to be washed or are being washed ▶ *There was dirty washing all over the floor!*

washing machine noun (plural **washing machines**)
a machine for washing clothes

wasp noun (plural **wasps**)
an insect with black and yellow stripes on its body. Wasps can sting you.

waste noun
something that is left over and cannot be used ▶ *The factory used to pour all the waste chemicals into the river.*

waste verb (**wastes, wasting, wasted**)
If you waste something, you use more of it than you really need to. ▶ *Write on both sides so that you don't waste paper.*

watch verb (**watches, watching, watched**)
When you watch something, you look at it. ▶ *Mum, watch me!* ▶ *I never watch the television.*

watch noun (plural **watches**)
a small clock that you wear on your wrist

water noun
the clear liquid that is in rivers and seas. All living things need water to live.

water verb (**waters, watering, watered**)
1 When you water a plant, you pour water onto it to help it to grow.
2 When your eyes water, tears come into them. ▶ *The smoke made my eyes water.*

waterfall noun (plural **waterfalls**)
part of a river where the water falls down over rocks

waterlogged adjective
If the ground is waterlogged, it is very wet and the water cannot drain away.

waterpistol noun (plural **waterpistols**)
a toy gun that fires water

waterproof adjective
Something that is waterproof is made of material that does not let water through. ▶ *I think you should wear a waterproof coat today.*

water-ski verb (**water-skis, water-skiing, water-skied**)
When you water-ski, you have special skis on your feet and you are pulled over the surface of water by a boat.

watertight adjective
Something that is watertight is closed so tightly that no water can get through. ▶ *Is this lid watertight?*

wave verb (**waves, waving, waved**)
1 When you wave, you lift up your hand and move it from side to side.
2 When something waves, it moves backwards and forwards or from side to side. ▶ *The flags were waving in the wind.*

wave noun (plural **waves**)
1 Waves in the sea are the parts that move up and down across the top of it.
2 A wave is an up-and-down movement. Light, heat, and sound all move in waves.

wavy adjective
Wavy hair is not straight, but has bends or curves in it.

wax noun
the substance that candles are made from

way noun (plural **ways**)
1 The way to a place is the roads or paths you follow to get there.
▶ *Please could you tell me the way to the station.*
2 The way you do something is how you do it. ▶ *This is the easiest way to cook potatoes.*

WC noun (plural **WCs**)
a toilet

weak adjective (**weaker, weakest**)
1 Someone who is weak is not very strong.
2 Something that is weak will break easily. ▶ *Some of the wood was very old and weak.*
3 A weak drink has a lot of water in it and so does not have a very strong taste.

wealthy

wealthy *adjective* (**wealthier, wealthiest**)
Someone who is wealthy is rich.

weapon *noun* (*plural* **weapons**)
something that a person can use to hurt or kill someone. Knives and guns are weapons.

wear *verb* (**wears, wearing, wore, worn**)
1 When you wear clothes, you have them on your body.
2 When something wears out, it becomes so old that you cannot use it any more.

weary *adjective* (**wearier, weariest**)
If you feel weary, you feel very tired.

weasel *noun* (*plural* **weasels**)
a small furry wild animal with a long body and short legs

weather *noun*
The weather is what it is like outside, for example whether the sun is shining, or it is rainy, or windy.

weave *verb* (**weaves, weaving, wove, woven**)
To weave cloth means to make it from threads.

web *noun* (*plural* **webs**)
1 A web is a thin net that a spider spins to trap insects.
2 The web is the World Wide Web, where information is kept on computers all over the world and people can use it by using the Internet.

webbed *adjective*
Animals with webbed feet have skin between the toes of their feet. Ducks have webbed feet.

website *noun* (*plural* **websites**)
a place on the Internet where you can find information about something ▶ *Visit our website to find out more about all our toys and games.*

wedding *noun* (*plural* **weddings**)
the time when a man and woman get married

wedge *noun* (*plural* **wedges**)
A wedge of something is a thick piece of it.

Wednesday *noun* (*plural* **Wednesdays**)
the day after Tuesday

weed *noun* (*plural* **weeds**)
Weeds are wild plants that grow in a garden or field when you do not want them to.

weedy *adjective* (**weedier, weediest**)
Someone who is weedy is very weak.

week *noun* (*plural* **weeks**)
a period of seven days ▶ *I'll see you next week.*

weekend *noun* (*plural* **weekends**)
The weekend is Saturday and Sunday.

weep *verb* (**weeps, weeping, wept**)
When you weep, you cry.

weigh *verb* (**weighs, weighing, weighed**)
1 When you weigh something, you use a machine to find out how heavy it is. ▶ *The shop assistant weighed the apples.*
2 The amount that something weighs is how heavy it is. ▶ *How much do you weigh?*

weight *noun* (*plural* **weights**)
1 The weight of something is how heavy it is. ▶ *We measured the height and weight of each child in the class.*
2 Weights are pieces of metal that you use for weighing things.
3 Weights are heavy pieces of metal that people lift to make their bodies stronger.
❶ **Weightlifting** is the sport of lifting heavy weights to show how strong you are.

weird *adjective* (**weirder, weirdest**)
Something that is weird is very strange.

welcome *verb* (welcomes, welcoming, welcomed)
If you welcome someone, you show that you are pleased when they arrive.

welfare *noun*
Someone's welfare is how healthy and happy they are. ▶ *We are concerned about the children's welfare.*

well *noun* (*plural* **wells**)
a deep hole in the ground from which you can get water or oil.

well *adverb* (**better, best**)
1 If you do something well, you do it in a good or successful way. ▶ *I can play the piano quite well now.*
2 If you do something well, you do it a lot. ▶ *Shake the bottle well before you open it.*
as well also ▶ *Can I come as well?*

well *adjective*
If you are well, you are healthy and not ill. ▶ *I hope you are well.*

wellington *noun* (*plural* **wellingtons**)
Wellington boots are long rubber boots that you wear to keep your feet dry.

well-known *adjective*
If something is well-known, a lot of people know about it. If someone is well-known, a lot of people know them.

went *verb* SEE **go**

west *noun*
West is the direction where the sun sets in the evening.
❶ The **western** part of a country is the part in the west.

western *noun* (*plural* **westerns**)
a film about cowboys

wet *adjective* (**wetter, wettest**)
1 Something that is wet is covered or soaked in water. ▶ *My shoes are all wet!*
2 When the weather is wet, it rains. ▶ *We had to stay in because it was wet outside.*

whack *verb* (whacks, whacking, whacked)
To whack something means to hit it hard.

whale *noun* (*plural* **whales**)
a very large sea animal. Whales are mammals and breathe air, but they live in the sea like fish.

what *adjective, pronoun*
Use this word when you are asking about something. ▶ *What is your name?*

whatever *adjective, pronoun*
1 any ▶ *These animals eat whatever food they can find.*
2 no matter what ▶ *Whatever happens, I'll help you.*

wheat *noun*
a plant that farmers grow. It is used to make flour.

wheel *noun* (*plural* **wheels**)
Wheels are the round objects that cars, buses, bicycles, and trains go along on.

wheelbarrow *noun* (*plural* **wheelbarrows**)
a small cart that you push along and use for carrying things

wheelchair *noun* (*plural* **wheelchairs**)
a chair on wheels for a person who cannot walk very well

wheeze *verb* (wheezes, wheezing, wheezed)
When you wheeze, you find it hard to breathe and you make a whistling noise in your chest as you breathe.

when *adverb, conjunction*
Use this word when you are talking about the time that something happens. ▶ *When will the others be here?*

whenever *conjunction*
at any time ▶ *Come to play whenever you like.*

where

where *adverb, conjunction*
Use this word when you are talking about the place that something happens. ▶ *Where do you live?*

whereabouts *adverb*
where ▶ *Whereabouts do you live?*

wherever *adverb, conjunction*
no matter where ▶ *I'll find you, wherever you are.*

whether *conjunction*
if ▶ *The teacher asked whether I had finished my work.*

which *adjective, pronoun*
Use this word when you are choosing one thing or talking about one particular thing. ▶ *Which dress do you like best?*

whichever *adjective, pronoun*
any person or thing ▶ *You can choose whichever book you want.*

while *conjunction*
during the time that something else is happening ▶ *I'll lay the table while you make the tea.*

whimper *verb* (whimpers, whimpering, whimpered)
To whimper means to cry softly because you are frightened or hurt.

whine *verb* (whines, whining, whined)
1 To whine means to make a long, high sad sound. ▶ *The dog was whining to go outside.*
2 If you whine about something, you complain about it.

whinge *verb* (whinges, whingeing, whinged)
If you whinge about something, you keep complaining about it.

whip *noun* (*plural* whips)
a long piece of rope or leather that is used for hitting people or animals

whip *verb* (whips, whipping, whipped)
1 To whip a person or animal means to hit them with a whip.
2 When you whip cream, you stir it quickly until it goes thick.

whirl *verb* (whirls, whirling, whirled)
To whirl round means to turn round and round very fast.

whirlpool *noun* (*plural* whirlpools)
a place in a river or sea where the water spins round and round very quickly and pulls things down with it

whirlwind *noun* (*plural* whirlwinds)
a strong wind that spins round and round very quickly as it moves along

whirr *verb* (whirrs, whirring, whirred)
When a machine whirrs, it makes a gentle humming sound.

whisk *verb* (whisks, whisking, whisked)
When you whisk eggs or cream, you stir them round round and round very fast.

whisker *noun* (*plural* whiskers)
1 An animal's whiskers are the long, stiff hairs near its mouth.
2 If a man has whiskers, he has a beard or hair on the sides of his face.

whisky *noun*
a type of strong alcoholic drink that is made especially in Scotland and Ireland

whisper *verb* (whispers, whispering, whispered)
When you whisper, you speak very quietly.

whistle *verb* (whistles, whistling, whistled)
When you whistle, you make a high sound by blowing air through your lips.

whistle *noun* (*plural* whistles)
something that you can blow into to make a loud, high sound

white *adjective* (whiter, whitest)
1 Something that is white is the colour of snow.
2 Someone who is white has a skin that is naturally pale in colour.
3 White bread is made with just the white part of the wheat grain, not the whole grain.

whizz *verb* (whizzes, whizzing, whizzed)
If something whizzes along, it moves along very quickly.

who *pronoun*
which person ▶ *Who broke my mug?*

whoever *pronoun*
no matter what person ▶ *Whoever broke that window should own up.*

whole *adjective*
1 A whole thing is all of it, with nothing left out. ▶ *We ate the whole cake.*
2 in one piece ▶ *The bird swallowed the fish whole.*

wholemeal *adjective*
Wholemeal bread is brown bread.

whooping cough *noun*
an illness that gives you a very bad cough

whose *adjective, pronoun*
belonging to which person ▶ *Whose coat is this?*

why *adverb*
Use this word when you are talking about the reason that something happens. ▶ *Why are you late?*

wicked *adjective*
Someone who is wicked is very bad or cruel.

wicket *noun* (*plural* wickets)
The wicket in a game of cricket is the three stumps that you put at each end of the pitch.

wide *adjective* (wider, widest)
Something that is wide measures a lot from one side to the other. ▶ *We had to cross a wide river.*

widow *noun* (*plural* widows)
a woman whose husband has died

widower *noun* (*plural* widowers)
a man whose wife has died

width *noun* (*plural* widths)
The width of something is how wide it is. ▶ *We measured the width of the room.*

wife *noun* (*plural* wives)
A man's wife is the woman he is married to.

wig *noun* (*plural* wigs)
false hair that some people wear on their head

wiggle *verb* (wiggles, wiggling, wiggled)
To wiggle something means to move it about. ▶ *She wiggled her finger.*

wigwam *noun* (*plural* wigwams)
a type of tent that some American Indians used to live in

wild *adjective* (wilder, wildest)
1 Wild animals and plants live or grow in a natural way and are not looked after by people.
2 Wild behaviour is rough and not calm.

wilderness *noun* (*plural* wildernesses)
a place where no one lives and there are very few plants and animals

wildlife *noun*
wild animals ▶ *I watched a TV programme about African wildlife.*

will *verb* (would)
If you will do something, you are going to do it in the future. ▶ *I will be there at ten o'clock.*

will *noun* (*plural* wills)
something that a person writes down to tell other people what they want to happen to their money and other things after they have died

willing *adjective*
If you are willing to do something, you are happy to do it. ▶ *We are all willing to help.*

willow *noun* (*plural* willows)
a tree that grows near water. A weeping willow has branches that bend down towards the ground.

wilt *verb* (wilts, wilting, wilted)
If a plant wilts, it begins to droop because it does not have enough water.

wily adjective (wilier, wiliest)
Someone who is wily is clever and crafty. ▶ *Foxes are supposed to be very wily animals.*

wimp noun (plural **wimps**)
someone who is weak and afraid

win verb (**wins, winning, won**)
When you win a game, competition, or battle, you beat the other people or teams. ▶ *I won all my races on sports day.*
ⓘ The **winner** is the person or team that wins a game or competition.

wind noun (plural **winds**) (rhymes with *tinned*)
Wind is air that moves over the earth. ▶ *Everything was blowing about in the wind.*

wind verb (**winds, winding, wound**) (rhymes with *find*)
1 To wind something round means to twist or turn it round. ▶ *She wound her scarf round her neck.*
2 If a road or river winds, it has a lot of bends in it. ▶ *The road wound up the side of the mountain.*
3 When you wind up a clock or clockwork toy, you turn a key so that it will work.

wind instrument noun (plural **wind instruments**)
a musical instrument that you play by blowing into it

windmill noun (plural **windmills**)
a building with large sails that move in the wind and use the power of the wind to make a machine work

window noun (plural **windows**)
an opening in a wall that is filled with glass to let the light in ▶ *We had to climb in through the window.*

windscreen noun (plural **windscreens**)
the big window at the front of a car

windsurfing noun
When you go windsurfing, you stand on a special board on water and hold onto a large sail. You turn the sail so that the wind blows into it and you move along.

windy adjective (**windier, windiest**)
When the weather is windy, there is a strong wind.

wine noun (plural **wines**)
an alcoholic drink that is made from grapes

wing noun (plural **wings**)
1 A bird's wings are the parts that it moves up and down when it is flying.
2 The wings on an aeroplane are the parts that stick out on each side and help the aeroplane to fly smoothly.

wink verb (**winks, winking, winked**)
When you wink, you close one eye.

winner noun (plural **winners**)
The winner of a game or competition is the person or team that wins.

winter noun (plural **winters**)
the time of the year when the weather is cold and it gets dark early in the evenings

wipe verb (**wipes, wiping, wiped**)
When you wipe something, you rub it gently to clean it.

wire noun (plural **wires**)
a long, thin strip of metal. Electricity goes along wires, and wires are also used to hold things in place.

wise adjective (**wiser, wisest**)
Someone who is wise understands a lot of things and knows the most sensible thing to do.

wish verb (**wishes, wishing, wished**)
If you wish that something would happen, you say that you would really like it to happen. ▶ *I wish I had lots of money.*

wish noun (plural **wishes**)
When you make a wish, you say what you would like to happen.

witch noun (plural **witches**)
a woman in stories who uses magic

with preposition
1 If one thing is with another thing, the two things are together. ▶ *We had apple pie with custard.* ▶ *I went to town with my mum.*
2 using ▶ *You can cut paper with scissors.*

wither verb (**withers, withering, withered**)
If a plant withers, it becomes dry and dies.

within preposition
inside ▶ *You must stay within the campsite.*

without preposition
not having ▶ *The family was left without any money.*

witness noun (plural **witnesses**)
someone who sees a crime or an accident happen ▶ *There were two witnesses to the accident.*

witty adjective (**wittier, wittiest**)
Someone who is witty can say clever, funny things.

wizard noun (plural **wizards**)
a man in stories who uses magic

wizened adjective
A wizened face is very old and covered with lines.

wobble verb (**wobbles, wobbling, wobbled**)
To wobble means to move and shake about. ▶ *The ladder began to wobble.*

wok noun (plural **woks**)
a large frying pan that you use for cooking meat and vegetables

woke, woken verb SEE **wake**

wolf noun (plural **wolves**)
a wild animal that is like a large, grey dog

woman noun (plural **women**)
a grown-up female person

won verb SEE **win**

wonder noun
When you have a feeling of wonder, you feel amazed and very glad. ▶ *They stared at the gold in wonder.*

wonder verb (**wonders, wondering, wondered**)
If you wonder about something, you ask yourself about it. ▶ *I wonder who wrote that letter?*

wonderful adjective
Something that is wonderful is amazing and fantastic.

won't verb
will not ▶ *I won't put up with this bad behaviour!*

wood noun (plural **woods**)
1 Wood is the hard material that trees are made of. You can burn wood as fuel or use it for making things.
2 A wood is an area of land where a lot of trees grow. ▶ *Don't go into the wood on your own.*
❶ **Wooden** things are made of wood.

woodpecker noun (plural **woodpeckers**)
a bird that has a strong beak for making holes in wood to find insects to eat

wool noun
the thick, soft hair that sheep have on their bodies
❶ **Woollen** things are made of wool. Something that is **woolly** is thick and soft like wool.

word noun (plural **words**)
1 a group of sounds or letters that mean something ▶ *The teacher told him off for saying rude words.*
2 If you give your word, you promise.

word class noun (plural **word classes**)
a name that we give to different types of words. Adjectives, nouns, and verbs are different word classes.

word processor

word processor noun (plural **word processors**)
a computer program that you use to write things and then store them or make changes to them

wore verb SEE **wear**

work noun
a job that you have to do ▶ *Please get on with your work quietly.*

work verb (**works, working, worked**)
1 When you work, you do a job or do something useful. ▶ *We worked hard at school today.*
2 If a machine works, it does what it is meant to do. ▶ *This light doesn't work.*
3 When you work out the answer to a question, you find the answer.

workshop noun (plural **workshops**)
a place where people make or mend things

world noun
The world is all the countries and people on the earth.

World Wide Web noun
The World Wide Web is the system for keeping information on computers all over the world so that people can use it by using the Internet.

worm noun (plural **worms**)
a long, thin animal with no legs that lives in the soil

worn verb SEE **wear**

worry verb (**worries, worrying, worried**)
When you worry, you feel upset and nervous because you think something bad might happen. ▶ *My mum always worries about me.*
❶ When you worry, you feel **worried**.

worse adjective
1 If one thing is worse than another, it is less good. ▶ *My first painting was bad, and my second one was even worse!*
2 When you feel worse, you feel more ill than before.

worship verb (**worships, worshipping, worshipped**)
To worship a god means to show your love and respect.

worst adjective
The worst person or thing is the one that is worse than any other. ▶ *I'm the worst swimmer in my class.*

worth adjective
1 If something is worth an amount of money, you could sell it for that amount of money. ▶ *How much are these old coins worth?*
2 If something is worth doing or having, it is good or useful. ▶ *This film is well worth seeing.*

worthwhile adjective
Something that is worthwhile is worth doing because it is useful or enjoyable.

would verb SEE **will**

wound noun (plural **wounds**) (rhymes with *spooned*)
a cut on your body

wound verb (**wounds, wounding, wounded**) (rhymes with *spooned*)
to hurt someone.

wound verb (rhymes with *round*)
SEE **wind** verb

woven verb SEE **weave**

wrap verb (**wraps, wrapping, wrapped**)
When you wrap something, you put cloth or paper around it. ▶ *I forgot to wrap your birthday present.*
❶ A **wrapper** is a piece of paper that a sweet is wrapped in.

wreath noun (plural **wreaths**)
a circle of flowers or leaves twisted together

wreck verb (**wrecks, wrecking, wrecked**)
To wreck something means to break it or destroy it completely. ▶ *The ship was wrecked on the rocks.* ▶ *You've wrecked my CD player!*

wreck *noun* (*plural* **wrecks**)
a car, ship, or aeroplane that has been damaged in an accident

wren *noun* (*plural* **wrens**)
a small brown bird

wrestle *verb* (**wrestles, wrestling, wrestled**)
When people wrestle, they fight with each other by holding each other and trying to force each other to the ground.

wriggle *verb* (**wriggles, wriggling, wriggled**)
When you wriggle, you twist and turn with your body.

wring *verb* (**wrings, wringing, wrung**)
When you wring something, you squeeze and twist it to get the water out of it.

wrinkle *noun* (*plural* **wrinkles**)
Wrinkles are small lines in your skin that often appear as you get older.

wrist *noun* (*plural* **wrists**)
Your wrist is the thin part of your arm where it is joined to your hand.

write *verb* (**writes, writing, wrote, written**)
When you write, you put letters and words onto paper so that people can read them.
ⓘ A **writer** is someone who writes stories.

writing *noun*
1 A piece of writing is something that you have written.
2 Your writing is the way you write.
▶ Ali has got very neat writing.

wrong *adjective*
1 Something that is wrong is not right or correct. ▶ He gave the wrong answer.
2 Something that is wrong is bad. ▶ Stealing is wrong.

wrote *verb* SEE **write**

wrung *verb* SEE **wring**

Xx

X-ray *noun* (*plural* **X-rays**)
a photograph that shows the bones and other things inside your body so that doctors can see if there is anything wrong

xylophone *noun* (*plural* **xylophones**)
(*pronounced* **zye**-lo-fone)
a musical instrument with a row of wooden or metal bars that you hit with small hammers

Yy

yacht *noun* (*plural* **yachts**)
a boat with sails that people use for racing or for pleasure

yam *noun* (*plural* **yams**)
a vegetable that grows in tropical countries

yap *verb* (**yaps, yapping, yapped**)
When a dog yaps, it makes short, high barking sounds.

yard *noun* (*plural* **yards**)
1 We can measure length in yards. One yard is just under one metre.
2 a piece of ground that is next to a building and has a wall round it

yawn *verb* (**yawns, yawning, yawned**)
When you yawn, you open your mouth and breathe in deeply because you are tired.

year

year *noun* (*plural* **years**)
a period of twelve months, or three hundred and sixty-five days

yell *verb* (**yells, yelling, yelled**)
If you yell, you shout very loudly.

yellow *adjective*
Something that is yellow is the colour of a lemon.

yelp *verb* (**yelps, yelping, yelped**)
If an animal yelps, it gives a cry because it is in pain.

yesterday *noun*
the day before today ▶ *I went to the cinema yesterday.*

yet *adverb, preposition*
1 until now ▶ *He hasn't arrived yet.*
2 If you do not want to do something yet, you do not want to do it until later. ▶ *I don't want anything to eat yet.*
3 but ▶ *He hates football, yet he loves rugby.*

yoghurt *noun*
a thick liquid that is made from milk and has a slightly sour taste

yolk *noun* (*plural* **yolks**)
The yolk of an egg is the yellow art inside it.

young *adjective* (**younger, youngest**)
Someone who is young is not very old. ▶ *My mum lived in London when she was young.* ▶ *My sister is younger than me.*

ⓘ A **youngster** is someone who is young.

youth *noun* (*plural* **youths**)
1 a youth is a boy or young man
2 Your youth is the time in your life when you are young.

yo-yo *noun* (*plural* **yo-yos**)
a toy that spins round as you bounce it up and down on a piece of string

yuletide *noun*
Christmas

Zz

zap *verb* (**zaps, zapping, zapped**)
1 To zap someone in a computer game means to shoot them.
2 When you zap between channels on the television, you keep changing channels.

zebra *noun* (*plural* **zebras**)
an animal that looks like a horse and has black and white stripes on its body

zebra crossing *noun* (*plural* **zebra crossings**)
a place where there are black and white stripes across a road to show that cars must stop to let people cross the road

zero *noun* (*plural* **zeros**)
the number 0

zigzag *noun* (*plural* **zigzags**)
a line with a lot of sudden, sharp turns in it like this WWWW

zip, zipper *noun* (*plural* **zips** or **zippers**)
a fastener for joining two pieces of cloth. It has two lines of teeth that come together and grip each other when you close it

zone *noun* (*plural* **zones**)
an area of land that has a special use ▶ *The town centre is now a pedestrian zone.*

zoo *noun* (*plural* **zoos**)
a place where different kinds of wild animals are kept so that people can go and see them

zoom *verb* (**zooms, zooming, zoomed**)
To zoom means to move along very quickly. ▶ *Lorries were zooming along the motorway.*

Appendices

Word origins

The words that we use today have come into the English language in a lot of different ways. Some have been part of our language since the times of the Angles and Saxons, around 1500 years ago. Others have been borrowed from different languages, for example Latin, French, and Italian. The word origins on these pages will help you to understand where some of the words in our language come from and how they have changed their meaning over time to become the words that we use today.

Days of the week

Monday Monday is the 'moon's day', and is named after the moon.

Tuesday Tuesday is 'Tiu's day', and is named after Tiu, the ancient Germanic god of war.

Wednesday Wednesday is 'Woden's day', and is named after Woden, or Odin, a god in Norse mythology.

Thursday Thursday is 'Thor's day', and is named after Thor, the god of thunder in Norse mythology.

Friday Friday is 'Frigga's day', and is named after Frigga, the wife of Odin in Norse mythology.

Saturday Saturday is 'Saturn's day', and is named after Saturn, an ancient Roman god.

Sunday Sunday is the day of the sun.

Months of the year

January January is named after Janus, an ancient Roman god.

February February gets its name from the Latin word, 'februum', which means 'purification', because a Roman festival of purification was held at this time of year.

March March is the month of Mars, the ancient Roman god of war.

April April gets its name from the Latin word 'aperio', which means 'to open', because flowers open in the spring.

May May is the month of Maia, an ancient Roman goddess.

June June is the month of Juno, an ancient Roman goddess.

July July is the month in which Julius Caesar was born, and it was named after him by the ancient Romans.

August August gets its name from the name of the first Roman emperor, Augustus Caesar.

September September gets its name from the Latin word 'septem', meaning 'seven', because September was the seventh month of the ancient Roman year.

October October gets its name from the Latin word 'octo', meaning 'eight', because October was the eighth month of the ancient Roman year.

November November gets its name from the Latin word 'novem', meaning 'nine', because November was the ninth month of the ancient Roman year.

December December gets its name from the Latin word 'decem', meaning 'ten', because December was the tenth month of the ancient Roman year.

Words to do with food and drink

barbecue This word comes from a word in a Carribbean language meaning 'a wooden frame'.

biscuit This word comes from the Old French word 'bescoit', which means 'twice baked', because biscuits were often baked twice to make them hard and crisp.

breakfast The word breakfast comes from the words 'break' and 'fast'. A 'fast' is a time when you do not eat anything, so in the morning you 'break' your 'fast' and eat something.

champagne This word has come into English from French. Champagne is a part of France where this type of wine is made.

chocolate This word comes from an Aztec word 'chocolatl'.

curry This word comes from the word 'kari', which is a Tamil word from southern India and means 'a spicy sauce'.

gateau This word has come into English from a French word which means 'a cake'.

hamburger The hamburger is named after the city of Hamburg in Germany.

jelly This word comes from the Latin word 'gelare', which means 'to freeze'.

kebab This word has come into English from Arabic.

ketchup This word has come into English from the Cantonese words 'k'e chap', which mean 'tomato juice'.

lasagne This word has come into English from Italian.

macaroni This word has come into English from Italian.

mango This word comes from the Tamil word 'mankay', which means 'a mango'.

meringue This word has come into English from French.

muesli This word has come into English from Swiss German.

noodles This word has come into English from German.

omelette This word has come into English from French.

pasta This word has come into English from Italian.

pepperoni This word comes from the Italian word 'peperone', which means 'chilli' (a spice with a hot flavour).

pizza This word has come into English from Italian.

potato This word has come into English from Taino, a South American language.

quiche This word has come into English from French.

salad This word has come into English from French.

sandwich This word is named after the Earl of Sandwich, who invented sandwiches so that he could eat a meal quickly, while he was doing other things.

satsuma This word is named after Satsuma, a part of Japan where satsumas are grown.

spaghetti This word comes from an Italian word which means 'little pieces of string'.

tangerine This word comes from the name of the city of Tangier, on the northern coast of Morocco, where these oranges come from.

tomato This word has come into English from a Mexican language.

whisky This word comes from a Scottish Gaelic phrase which means 'the water of life'.

Words to do with animals

alligator This word comes from the Spanish words 'el lagarto', which mean 'the lizard'.

amphibian This word comes from the Greek words 'amphi bios', which mean 'both lives', because an amphibian has two ways of life.

canary Canaries were first brought to Britain from the Canary Islands, and that is why they are called canaries.

carnivore This word comes from the Latin word 'carnis', which means 'meat'.

caterpillar This word comes from the Latin words 'catta pilosa', which mean 'a hairy cat'.

cheetah This word has come into English from a Hindi word.

chimpanzee This word has come into English from an African language.

cobra This word comes from the Portuguese words 'cobra de capello', which mean 'a snake with a hood'.

cobweb 'Coppe' was an Old English word for a spider, so a 'cobweb' is a 'spider's web'.

crocodile This word comes from the Greek word 'krokodilos', which means 'worm of the stones'.

cuckoo The cuckoo gets its name from the call that it gives, which sounds like 'cuck-oo'.

dinosaur This word comes from the Greek words 'deinos sauros', which mean 'terrible lizard'.

dragon This word comes from the Greek word 'drakon', which means 'a snake'.

elephant This word comes from the Greek word 'elephas', which means 'ivory' (which elephants' tusks are made of).

giraffe This word has come into English from Arabic.

herbivore This word comes from the Latin word 'herba', meaning 'grass'.

hippopotamus This word comes from the Greek words 'hippo ho potamius', which mean 'horse of the river'.

insect This word comes from the Latin word 'insectum', meaning 'cut up', because an insect's body is divided into several different parts.

koala This word has come into English from an Australian Aboriginal language.

mosquito This word comes from a Spanish word which means 'a little fly'.

orang-utan This word comes from the Malay words 'orang hutan', which mean 'man of the forest'.

porcupine This word comes from the Old French words 'porc espin', which mean 'spiny pig'.

python This word comes from the Greek word 'Puthon', which was the name of a huge monster in ancient Greek stories.

reptile This word comes from the Latin word 'reptilis', which means 'crawling'.

rhinoceros This word comes from the Greek words 'rhinos keras', which mean 'nose horn'.

rodent This word comes from the Latin word 'rodens', which means 'gnawing'.

serpent This word comes from the Latin word 'serpens', which means 'creeping'.

spider This word comes from the Old English word 'spithra', which means 'a spinner'.

squirrel This word comes from the Greek word 'skiouros', which means 'shadow tail'.

tadpole This word comes from the words 'toad' and 'poll', meaning 'toad's head'.

turtle This word comes from the French word 'tortue', which means 'a tortoise'.

Words to do with clothes

anorak This word has come into English from an Eskimo language.

cardigan The cardigan is named after James Thomas Brudenel, the Earl of Cardigan, who first made cardigans popular.

jeans Jeans get their name from the city of Genoa in Italy, where the cloth used for making jeans was once made.

jodhpurs Jodhpurs are named after the city of Jodhpur in India, where trousers like these are worn.

leotard This word comes from the name of the French man, Jules Leotard, who invented it.

pyjamas This word comes from the Urdu word 'paejama', which means 'trousers'.

sandal This word comes from the Greek word 'sandalon', which means 'a wooden shoe'.

sari This word has come into English from Hindi.

turban This word has come into English from a Persian word.

vest This word comes from the Latin word 'vestis', which means 'a piece of clothing'.

wellington Wellington boots were named after the Duke of Wellington, who wore long leather boots.

Words to do with sports and hobbies

acrobat This word comes from a Greek word meaning 'to walk on tiptoe'.

badminton The game of badminton was named after the place, Badminton House, where people first played it.

ballet This is a French word. It comes originally from an Italian word 'balletto', which means 'a little dance'.

boomerang This word has come into English from an Australian Aboriginal language.

judo This word comes from the Japanese words 'ju do', which mean 'the gentle way'.

karaoke This word has come into English from Japanese.

karate This word comes from the Japanese words 'kara te', which mean 'empty hands'.

marathon This word is named after the town of Marathon in Greece. In ancient times, a messenger ran from Marathon to Athens (which is about 40 kilometres) to announce that the Greek army had defeated its enemies.

martial art The word **martial** comes from a Latin word which means 'belonging to Mars, the god of war'.

rugby The game of rugby was named after Rugby School, where the game was first played.

ski This word has come into English from Norwegian.

soccer This word is short for the word 'Association', because football was originally called 'Association football'.

toboggan This word has come into English from a Native American language.

Words to do with buildings

bungalow This word comes from the Gujarati word 'bangalo', which means 'a house built in the style of Bengal'.

cafe This is a French word and means 'coffee' or 'a coffee shop'.

factory This word comes from the Latin word 'factorium', which means 'a place where things are made'.

fort This word comes from the Latin word 'fortis', which means 'strong'.

gym This word comes from the Greek word 'gymnos', meaning 'naked', because in ancient Greece men used to do exercises and sports with no clothes on.

hospital This word comes from the Latin word 'hospitalis', meaning 'receiving guests', because a hospital used to be a place where guests could stay.

igloo This word comes from the Inuit word 'iglu', meaning 'a house'.

laboratory This word comes from the Latin word 'laboratorium', which means 'a place where people work'.

palace This word comes from the Latin word 'Palatium', the name of a hill in ancient Rome where the house of the emperor Augustus was.

pavilion This word comes from the French word 'pavillon', which means 'a tent'.

temple This word comes from the Latin word 'templum', which means 'a holy place'.

theatre This word comes from the Greek word 'theatron', which means 'a place for seeing things'.

turret This word comes from the old French word 'tourete', which means 'a little tower'.

Words to do with technology

camcorder This word was first formed by joining together the words 'camera' and 'recorder'.

computer This word comes from the Latin word 'computare', which means 'to work things out together', because the first computers were used for doing mathematical calculations.

email The word **email** is short for 'electronic mail', which means mail sent using electrical signals.

helicopter This word comes from the Greek words 'helix' and 'pteron', which mean 'spiral wings'.

motor This word comes from a Latin word which means 'a mover'.

movie The word **movie** is short for 'moving picture'.

photograph This word comes from the Greek word 'photo' (meaning 'light') and 'graphos' (meaning 'writing'), because a camera uses light to make a picture.

submarine This word comes from the Latin words 'sub', which means 'under', and 'mare', which means 'the sea'.

tele- The Greek word 'tele' means 'far off', and many words in English that begin with **tele-** have meanings to do with things that happen at a distance. **Telecommunications** are ways of communicating with people who are a long way away. You use a **telephone** for talking to people at a distance. You use a **telescope** to look at things that are far away. A **television** allows you to see pictures that are sent over a distance.

video This word comes from the Latin word 'video', which means 'I see'.

Words to do with nature and the world around us

aqua- The Latin word 'aqua' means 'water', and a lot of words in English that begin with **aqua-** are to do with water. **Aquatic** animals live in water. You keep fish in a container called an **aquarium**. **Sub-aqua** diving is diving under the water.

astro- The Greek word 'astron' means 'star', and a lot of words in English that begin with **astro-** have meanings to do with the stars. **Astrology** is the study of how the stars affect our lives. An **astronaut** is someone who travels in space. An **astronomer** is a scientist who studies the stars. **Astronomy** is the study of the sun, the stars, and the planets.

cactus This word comes from the Greek word 'kaktos', which was the name of a different type of prickly plant.

comet This word comes from the Greek words 'aster kometes', which mean 'long-haired star' because the tail of a comet looks like long hair.

constellation This word comes from the Latin word 'stella', which means 'a star'.

crystal This word comes from the Greek word 'krystallos', which means 'ice'.

cyclone This word comes from the Greek word 'kykloma', which means 'a wheel'.

daisy This word comes from the words 'day's eye', because daisies close their petals at night and open them again in the morning.

dandelion This word comes from the French words 'dent de lion', which mean 'lion's tooth' because dandelion plants have leaves with jagged edges that look like sharp teeth.

fossil This word comes from the latin word 'fossilis', which means 'dug up', because fossils are dug up out of the ground.

galaxy This word comes from the Greek word 'galaxias', which means 'milky'.

glacier This word comes from the Latin word 'glacies', which means 'ice'.

hurricane This word has come into English from a Caribbean language.

jungle This word comes from the Hindi word 'jangal', which means 'an area of wasteland'.

monsoon This word comes from the Arabic word 'mawsim', which means 'a season'.

ocean This word comes from the word 'Oceanus', the name of the river which the ancient Greeks thought surrounded the world.

orbit This word comes from the Latin word 'orbis', which means 'a circle'.

planet This word comes from the Greek word 'planetes', which means 'a wanderer', because planets seem to wander about rather than staying in the same place in the sky.

primrose This word comes from the Latin words 'prima rosa', which mean 'first rose'.

tornado This word comes from the Spanish word 'tronada', which means 'a thunderstorm'.

typhoon This word comes from the Chinese words 'tai fung', which mean 'great wind'.

volcano A volano gets its name from Vulcan, the ancient Roman god of fire.

Prefixes

Prefix	Meaning	Examples
anti-	against or opposite	anticlockwise, antibiotic (a medicine that works against an infection in your body)
co-	together with someone else	co-pilot, co-author
de-	to take something away	debug, de-ice, defrost
dis-	opposite	dislike, disagree, disobey
ex-	in the past, but not now	ex-policeman, ex-wife
in- (also **im-**)	opposite	incorrect, insane, impossible, impolite
micro-	very small	microchip, micro-computer
mid-	in the middle	midday, midnight, midsummer
mini-	very small	minibus, miniskirt
mis-	badly or wrongly	misbehave, misspell
non-	opposite	non-fiction, non-smoker, non-stop
over-	too much	oversleep, overweight
pre-	before	prehistoric (before the beginning of history), pre-school (before a child is old enough to go to school)
re-	again, for a second time	rebuild, reheat, re-open
semi-	half	semicircle, semi-final, semi-detached
sub-	under	submarine (a ship that goes under the sea), subway (a path that goes under a road)
super-	more than or bigger than	super-hero, superhuman, superstar
un-	opposite	unable, uncomfortable, undress
under-	not enough	under-fed, underweight

Suffixes

for making nouns

-hood	child – childhood, father – fatherhood
-ity	stupid – stupidity, able – ability, pure – purity
-ness	happy – happiness, kind – kindness, lazy – laziness,
-ment	enjoy – enjoyment, move – movement, replace – replacement
-ship	friend – friendship, champion – championship, partner – partnership
-sion	divide – division, persuade – persuasion
-tion	subtract – subtraction, react – reaction

for making nouns that mean a person who does something

-er, -or	paint – painter, write – writer, act – actor
-ist	science – scientist, art – artist, violin – violinist

for making feminine nouns

-ess	actor – actress, lion – lioness

for making adjectives

-able	enjoy – enjoyable, break – breakable, forgive – forgivable
-ful	hope – hopeful, colour – colourful, care – careful, pain – painful
-ible	eat – edible, reverse – reversible
-ic	science – scientific, photograph – photographic, allergy – allergic
-ish	child – childish
-ive	attract – attractive, compete – competitive, explode – explosive
-less	care – careless, fear – fearless, hope – hopeless
-like	child – childlike, life – lifelike
-y	hunger – hungry, thirst – thirsty, anger – angry, hair – hairy

for making adverbs

-ly	quick – quickly, slow – slowly, careful – carefully, normal – normally

for making verbs

-ate	active – activate, pollen – pollinate
-en	damp – dampen, short – shorten, length – lengthen
-ify	solid – solidify, pure – purify
-ize, -ise	apology – apologize, fossil – fossilize

Time

Times of the day

morning — The time before midday is called morning. The letters a.m. stand for *ante meridien* which is Latin for 'before noon'.

midday or **noon** — The time of day when the Sun is at its highest in the sky is 12 midday or noon.

afternoon — The time of day after midday is called afternoon. The letters p.m. stand for *post meridien* which is Latin for 'after noon'.

Days of the week

Sunday
Monday
Tuesday
Wednesday
Thursday
Friday
Saturday

Months of the year

January = 31 days
February = 28 or 29 days
March = 31 days
April = 30 days
May = 31 days
June = 30 days
July = 31 days
August = 31 days
September = 30 days
October = 31 days
November = 30 days
December = 31 days

Units of time

second
minute = 60 seconds
hour = 60 minutes
day = 24 hours
week = 7 days
fortnight = 14 days
month = 28–31 days
year = 12 months or 365 days
leap year = 366 days
decade = 10 years
century = 100 years

Numbers

1	one	first
2	two	second
3	three	third
4	four	fourth
5	five	fifth
6	six	sixth
7	seven	seventh
8	eight	eighth
9	nine	ninth
10	ten	tenth
11	eleven	eleventh
12	twelve	twelfth
13	thirteen	thirteenth
14	fourteen	fourteenth
15	fifteen	fifteenth
16	sixteen	sixteenth
17	seventeen	seventeenth
18	eighteen	eighteenth
19	nineteen	nineteenth
20	twenty	twentieth
21	twenty-one	twenty-first
22	twenty-two	twenty-second
30	thirty	thirtieth
40	forty	fortieth
50	fifty	fiftieth
60	sixty	sixtieth
70	seventy	seventieth
80	eighty	eightieth
90	ninety	ninetieth
100	a hundred	hundredth
101	a hundred and one	hundred and first
200	two hundred	two hundredth
1,000	a thousand	thousandth
1,000,000	a million	millionth

Countries of the world

Country	People
Afghanistan	Afghans
Albania	Albanians
Algeria	Algerians
Andorra	Andorrans
Angola	Angolans
Antigua and Barbuda	Antiguans, Barbudans
Argentina	Argentinians
Armenia	Armenians
Australia	Australians
Austria	Austrians
Azerbaijan	Azerbaijanis or Azeris
Bahamas	Bahamians
Bahrain	Bahrainis
Bangladesh	Bangladeshis
Barbados	Barbadians
Belarus	Belorussians
Belgium	Belgians
Belize	Belizians
Benin	Beninese
Bermuda	Bermudans
Bhutan	Bhutanese
Bolivia	Bolivians
Bosnia-Herzegovina	Bosnians
Botswana	Batswana or Citizens of Botswana
Brazil	Brazilians
Brunei Darussalam	People of Brunei
Bulgaria	Bulgarians
Burkina Faso	Burkinans
Burundi	People of Burundi
Cambodia	Cambodians
Cameroon	Cameroonians
Canada	Canadians
Cape Verde	Cape Verdeans
Central African Republic	People of the Central African Republic
Chad	Chadians
Chile	Chileans
China, People's Republic of	Chinese
Colombia	Colombians
Comoros	Comorans
Congo, Democratic Republic of the	Congolese
Congo, Republic of the	Congolese
Costa Rica	Costa Ricans
Côte d'Ivoire	People of the Côte d'Ivoire
Croatia	Croats
Cuba	Cubans
Cyprus	Cypriots
Czech Republic	Czechs
Denmark	Danes
Djibouti	Djiboutians
Dominica	Dominicans
Dominican Republic	Dominicans
East Timor	East Timorese
Ecuador	Ecuadoreans
Egypt	Egyptians
El Salvador	Salvadoreans
Equatorial Guinea	Equatorial Guineans
Eritrea	Eritreans
Estonia	Estonians
Ethiopia	Ethiopians
Fiji	Fijians
Finland	Finns
France	French
Gabon	Gabonese
Gambia, The	Gambians
Georgia	Georgians
Germany	Germans
Ghana	Ghanaians
Greece	Greeks
Grenada	Grenadians
Guatemala	Guatemalans
Guinea	Guineans

Country	People
Guinea-Bissau	People of Guinea-Bissau
Guyana	Guyanese
Haiti	Haitians
Honduras	Hondurans
Hungary	Hungarians
Iceland	Icelanders
India	Indians
Indonesia	Indonesians
Iran	Iranians
Iraq	Iraqis
Ireland, Republic of	Irish
Israel	Israelis
Italy	Italians
Jamaica	Jamaicans
Japan	Japanese
Jordan	Jordanians
Kazakhstan	Kazakhs
Kenya	Kenyans
Kiribati	Kiribatians
Kuwait	Kuwaitis
Kyrgyzstan	Kyrgyz
Laos	Laotians
Latvia	Latvians
Lebanon	Lebanese
Lesotho	Basotho
Liberia	Liberians
Libya	Libyans
Liechtenstein	Liechtensteiners
Lithuania	Lithuanians
Luxembourg	Luxembourgers
Macedonia (Former Yugoslav Republic of Macedonia)	Macedonians
Madagascar	Malagasies
Malawi	Malawians
Malaysia	Malaysians
Maldives	Maldivians
Mali	Malians
Malta	Maltese
Marshall Islands	Marshall Islanders
Mauritania	Mauritanians
Mauritius	Mauritians

Country	People
Mexico	Mexicans
Micronesia	Micronesians
Moldova	Moldovans
Monaco	Monégasques
Mongolia	Mongolians
Morocco	Moroccans
Mozambique	Mozambicans
Myanmar (Burma)	Burmese
Namibia	Namibians
Nauru	Nauruans
Nepal	Nepalese
Netherlands	Dutch
New Zealand	New Zealanders
Nicaragua	Nicaraguans
Niger	Nigeriens
Nigeria	Nigerians
North Korea (People's Democratic Republic of Korea)	North Koreans
Norway	Norwegians
Oman	Omanis
Pakistan	Pakistanis
Palau	Palauans
Panama	Panamanians
Papua New Guinea	Papua New Guineans
Paraguay	Paraguayans
Peru	Peruvians
Philippines	Filipinos
Poland	Poles
Portugal	Portuguese
Qatar	Qataris
Romania	Romanians
Russia (Russian Federation)	Russians
Rwanda	Rwandans
St Kitts and Nevis	People of St Kitts and Nevis
St Lucia	St Lucians
St Vincent and the Grenadines	St Vincentians
Samoa	Samoans
San Marino	People of San Marino

Country	People
São Tomé and Principe	People of São Tomé and Principe
Saudi Arabia	Saudi Arabians
Senegal	Senegalese
Seychelles	Seychellois
Sierra Leone	Sierra Leoneans
Singapore	Singaporeans
Slovakia	Slovaks
Slovenia	Slovenes
Solomon Islands	Solomon Islanders
Somalia	Somalis
South Africa	South Africans
South Korea (Republic of Korea)	South Koreans
Spain	Spaniards
Sri Lanka	Sri Lankans
Sudan	Sudanese
Suriname	Surinamers
Swaziland	Swazis
Sweden	Swedes
Switzerland	Swiss
Syria	Syrians
Taiwan	Taiwanese
Tajikistan	Tajiks
Tanzania	Tanzanians
Thailand	Thais
Togo	Togolese
Tonga	Tongans
Trinidad and Tobago	Trinidadians and Tobagans or Tobagonians
Tunisia	Tunisians
Turkey	Turks
Turkmenistan	Turkmens
Tuvalu	Tuvaluans
Uganda	Ugandans
Ukraine	Ukrainians
United Arab Emirates	People of the United Arab Emirates
United Kingdom	British
United States of America	Americans
Uruguay	Uruguayans
Uzbekistan	Uzbeks
Vanuatu	People of Vanuatu
Vatican City	Vatican citizens
Venezuela	Venezuelans
Vietnam	Vietnamese
Yemen	Yemenis
Yugoslavia (Montenegro and Serbia)	Yugoslavians (Montenegrins and Serbians)
Zambia	Zambians
Zimbabwe	Zimbabweans

OXFORD
Dictionaries and Thesauruses for home and school

Oxford Very First Dictionary

Oxford First Dictionary
Oxford First Thesaurus

Oxford Junior Illustrated Dictionary
Oxford Junior Illustrated Thesaurus

Oxford Junior Dictionary
Oxford Junior Thesaurus

Oxford Primary Dictionary
Oxford Primary Thesaurus

Oxford Children's Dictionary
Oxford Children's Thesaurus

Oxford Concise School Dictionary
Oxford Concise School Thesaurus

Oxford School Dictionary
Oxford School Thesaurus

Oxford Pocket School Dictionary
Oxford Pocket School Thesaurus

Oxford Mini School Dictionary
Oxford Mini School Thesaurus

Oxford Student's Dictionary

Large print
Oxford Young Reader's Dictionary
Oxford Young Reader's Spelling Dictionary